THIS LABYRINTH OF
DARKNESS AND LIGHT

To Hadassah

Arukhat Bat-Ammi

'I believe that when the history of Zionist

Resettlement of the land comes to be

Written, the chronicler will have to say

of the Haassah undertaking: it began as

a mere war relief measure, it entered into

the fabric of Palestinian life, into the web

and woof, as a part of the renewal and

rehabilitation Zionism stands for. From

first to last, it remained true to its

motto, 'the healing of the Daughter of my People.'

–Henrietta Szold, April, 1929.

THIS LABYRINTH OF DARKNESS AND LIGHT

Henrietta Szold, the Rescue of Children from
Hitler's Europe, and her Palestine Experience

Randy Grigsby

VALLENTINE MITCHELL
LONDON • CHICAGO

First published in 2022 by *Vallentine Mitchell*

Catalyst House,
720 Centennial Court,
Centennial Park,
Elstree WD6 3SY, UK

814 N. Franklin Street,
Chicago, Illinois,
IL 60610 USA

www.vmbooks.com

Copyright © Randy Grigsby 2022

British Library Cataloguing in Publication Data:
An entry can be found on request

ISBN 978 1 80371 024 2 (Paper)
ISBN 978 1 80371 025 9 (Ebook)

Library of Congress Cataloging in Publication Data:
An entry can be found on request

Contents

Acknowledgement

The list of people who I should thank is, unfortunately, far too long to include everyone. There are, though, those who helped me during the first book, *A Train to Palestine*, and continued to offer support and reassurance as Henrietta's story was being written. First, I would like to thank Pastor Tim Carscadden and Miss Susan, who have always encouraged me. I would also like to thank Tom and Elizabeth Arceneaux, Hadassah members and personal friends, who unselfishly opened their beautiful home to meetings, and for personal conversation when it was most needed. They also contributed from their personal collection the photograph of Henrietta on the cover of the February/March 1945 issue of 'Hadassah Newsletter,' the month after her death.

Once I had finished the third draft, I felt it was time to find an editor. I had an idea of the person I wanted, but wasn't certain if she would take on the time-consuming task. Fortunately, she did, and I can honestly say, without question, that I inherited a wonderful editor—Jo Reingold of Dallas Hadassah. And, Jo proved to be the perfect companion; her edits and recommendations were painless, softened by someone who really cared that Henrietta deserved the best. She also brought to the project a vast knowledge of Henrietta and Palestine of that time. To Jo, I say thank you.

At Vallentine Mitchell, a heartfelt thanks to Toby Harris. And to editor Sue Garfield, thank you so much for your friendship and patience. You brought to the table a wonderful, vast knowledge on how to make this book better than the manuscript that was turned in last December. Also, a sincere thank you to Heather Wolfe, of H. Wolfe Graphic Design, a wonderful graphic designer and a friend of Joyce and myself. Heather has been more than generous with her time, expertise, and talent. Heather designed the book cover, of which I am so proud. Henrietta would have liked it also, I imagine.

Lastly, to Joyce my wife. After suffering through the writing of my first book, she was well aware of the sacrifice such a project takes away from everyday life. Still, throughout the process, she always, always, offered encouragement and help. One morning during the summer, when

Henrietta's story was almost finished, I began talking to Joyce about the book and reading several chapters aloud to her. It was during those times that Joyce and I shared in laughter; at other times we simply sat in awe of Henrietta's dedication to the Holy Land; and finally, we shed tears for a life of which Henrietta once said, 'I have taken a huge burden upon myself.'

Believe me, when I admit, that it was all worth researching and writing and existing with Henrietta, as though she was, for those years, a true part of our lives.

I shall miss her greatly.

I owe a great debt to all the writers and publishers of previous books on Henrietta Szold, the history of Hadassah, and also Youth Aliyah. Without their past efforts to tell such great stories, this book would not have been written. During these years of writing my version of Henrietta's life, 1933 to 1945, I read and researched over a hundred books, far too many to list. However, a quick read of the bibliography placed within, provides a list of those books not mentioned here.

I would, however, like to name several and the particular strength each brought to this project.

Summoned to Jerusalem: The Life of Henrietta Szold by Joan Dash (1979) and *Woman of Valor: The Life of Henrietta Szold, 1860-1945* by Irving Fineman brought a detailed closeness to the story. Both writers lived in that time that allowed them to interview friends and associates close to Henrietta in Palestine. Their thoughts and interviews were priceless. Fineman, in fact, met Henrietta in Jerusalem. *Henrietta Szold: Life and Letters* by Marvin Lowenthal, published in 1942 three years before her death, provided a collection of Henrietta's letters, written so beautifully that one realizes that comments that she could have been a writer, were so true. Recha Freier, the woman who actually began Youth Aliyah that cold February day when a group of Jewish boys came to her apartment, wrote down her thoughts in *Let the Children Come: The Origins of Youth Aliyah*. I've lost count on how many times I read that short, but powerfully narrated book.

Other wonderful sources that I'd like to mention that offered Henrietta's letters and inner thoughts were *Henrietta Szold: Record of Life* by Rose Zeitlin; *There is Hope for Your Children: Youth Aliyah, Henrietta Szold and Hadassah*, written by Henrietta's friend and first Chairman of Youth Aliyah

(1936-1941), Marian G. Greenberg; and, *The Szolds of Lombard Street: A Baltimore Family, 1859-1909* by Alexandra Lee Levin, who was married to Henrietta's nephew providing her access to Henrietta's correspondence.

Many details of Henrietta's life came from three writers of that time in Palestine.

Jessie Sampter, whose story is told in *White Fire: The Life and Works of Jessie Sampter* by Bertha Badt-Strauss Eugene Kohn, was a personal friend to Henrietta and, in many ways, a prophetic writer of Palestine in the 1930s. Dorothy Kahn Bar-Adon came to Palestine in 1933, was introduced to Henrietta, and wrote for years of her days there. *Writing Palestine 1933-1950* was a later book, but *Spring Up, O Well*, published in 1936, captured the mood and insight of the people there, and of events unfolding. English journalist Barbara Board also arrived in Palestine in the mid30s. I was fortunate during the writing of *Labyrinth* to come across a rare copy of Board's book published in 1937, *Newsgirl in Palestine*. As I began reading, I was surprised to find a chapter in which Board interviewed Henrietta, affording a close analysis of her. Both of these women, at a time when most journalists were men, stepped out beyond those limitations and wrote from the heart. Board wrote with detail such as a journalist writes; Kahn wrote, at times, mystically, as a novelist.

There were among so many other books, headlines and stories from newspapers in Palestine, attributed in those books to dedicated journalists, who gave me a flavor of the news flowing through that land, especially presenting the danger during those days as General Irwin Rommel's Afrika Korp advanced toward Cairo.

For references to Hadassah itself—*Hadassah and the Zionist Project* by Erica B. Simmons. Great, informative book. Marlin Levin, former editor of *The Palestine Post* during the first years of the state of Israel, wrote two books containing eyewitness accounts: *It Takes a Dream: The Story of Hadassah*, and *Balm in Gilead: The Story of Hadassah*. For references to Youth Aliyah, I would recommend several books, that proved invaluable in my research, *Come from the Four Winds: The Story of Youth Aliya* by Chasya Pincus, and a more recent book, published in 2006 by The University of Alabama Press, *Between Home and Homeland: Youth Aliyah from Nazi Germany* written by Brian Amkraut.

Henrietta made three trips to Berlin in the thirties. To depict the transformation Germany was going through, I reference three books: *Between Dignity and Despair: Jewish Life in Nazi Germany* by Marion A. Kaplan portraited the much-needed atmosphere of what it was like as a Jew living in 1930s Germany; also, *Hitlerland: American Eyewitnesses to the Nazi*

Rise to Power by Andrew Nagorski; and, *Travels in the Reich: Foreign Authors Report from Germany: 1933-1945* edited by Oliver Lubrich.

One final note on specific books: *Till We Have Built Jerusalem: Architects of a New City* written by Adina Hoffman, in my opinion is a must read for those interested in that time in the Holy City. Hoffman writes history with a depth and literary texture that is a pleasure to read.

Beyond the sources I have written about above, if one desires to read more of Henrietta, of 1930s Palestine, or of the rescue of Jewish children from Europe, please reference the bibliography. Any of those listed, would provide for excellent reading.

Every attempt has been taken to provide attribution for quotes and descriptions. My rule going in to *Labyrinth*, a book that has over five hundred endnotes, was that any text between quotes, either from original documents or secondary sources was considered direct and thus was associated with a crediting source. Any mistakes in crediting these wonderful, gifted, past and present writers, is mine alone.

List of Images/Photo Credits

Cover Henrietta Szold at her desk 1940. Courtesy of the Jewish Museum of Maryland. Cover design by Heather Wolfe, H. Wolfe Graphic Design.

3 Headline in *Houston Post*, November 23, 1938, two weeks after Kristallnacht.

4 Map of Palestine. *New York Tribune* "The Birth of New Nations," Isaac Don Levin, June 17, 1917.

24 A Nazi rally in Weimar, 1932. Copyright: United States Holocaust Memorial Museum. Provenance: William O. McWorkman.

27 Recha Freier. David B. Green, *Jewish World*, January 30, 2013. 'This Day in Jewish History Recha Freier Founds Youth Aliya.' "Credit: Hadassah"

38 Atonement Day Crowd at the Wailing Wall, circa 1933. Library of Congress, Prints & Photographs Division, the Matson Collection: LC-M31-3987 (P&P), LC-DIG-MATPC-00236.

43 Henrietta Szold at Jordan River bathing place, 1921. Courtesy of the Jewish Museum of Maryland.

76 Henrietta Szold in her garden, Jerusalem, 1942. Courtesy of the Jewish Museum of Maryland.

86 One of the many lists of children to receive travel certificates for their immigration to Palestine, sent to Henrietta Szold by Beate Berger, Director of the Beith Ahawah Children's Home. January 1934. Photo Credit United States Holocaust Memorial Museum, courtesy Ayelet Bargur.

89 Jewish immigrants leave for Palestine on board the Polonia, 1933. Photo credit United States Holocaust Memorial Museum, courtesy of Hadassah Virshup.

'Sonata Passionata'

'There are two sides to Youth Aliyah, the one of *light*, the other of *darkness*. The youth that had come to Palestine left behind them the shame and disgrace of exile and stepped into the front ranks of the nation which had come to life on its own soil. This return of the children of Zion brought great consolation to Jews all over the world and touched the heart of every human being. This light was visible to all.

I was fated to live and to work on the other side, in darkness, affliction, and suffering...'

Recha Freier, *Let the Children Come*.[1]

By the early days of the 1930s, the once vibrant, refined heart of the German nation, had fallen into a nightfall darkness into where the consciousness of modern, civilized man had never dared venture.

In those years following, a sad, evil dusk slowly spread over Europe, unopposed; later as war swept Europe into six years of global conflict, as once great and cultural cities lay in ruins destroyed beneath furious rains of thousands of bombs, after sixty million humans had perished, then the world would glance back and wonder why someone, anyone, had not chosen light instead of the darkness. For by that time, it was much too late for recourse, as the world had sleepwalked beyond that time when all the destruction and bloodshed could have been avoided, contained with a bloodless retreat. Rabbi Stephen Wise, Austro-Hungarian born, American Reform rabbi and Zionist leader, would write in April 1933, searching for the words to describe, simply and hauntingly, of how a principled, grand Germany had slipped away; it was then that he reflected, 'the frontiers of civilization have been crossed.'[2]

This remarkable nation, struggling beneath political implications of a peace treaty signed in Paris in 1919 ending the Great War, transitioned swiftly under the political rise of the National Socialist party directly by a seemingly smallish man— Adolf Hitler. As complex, and as veiled in personal life as Hitler was, historians at times eventually found the precise

words to write, as clear and plain and simple, in an attempt to explain the complexity of evil. 'He [Hitler] was,' author Robert Payne wrote in 1973 in *The Life and Death of Adolf Hitler*, 'one of those rare men who from time to time emerge from obscurity to shake the world to its foundations ... He was himself aware of the demonic nature of his gifts, and sometimes he would exert himself sufficiently to attempt to understand them without ever coming to any satisfactory conclusions,' Payne determined. 'He was a law unto himself, and unlike other men.'[3]

Later, also, it would be understood that the promise of war stirred within Hitler's heart and soul, the true purpose cloaked behind his madness. Writer Thomas Mann reflected on the concept within, which he believed Hitler entrusted all of his purpose. 'If the idea of war, as an aim in itself, disappeared, the National Socialist system would be ... utterly senseless.'[4]

Those chroniclers who lived within that narrow window of history during the early 1930s, would finally glance up and gasp at the swiftness of Hitler's ascent, unopposed by Great Britain, France, or even the German church as antisemitism surfaced openly onto the German streets. Hardly anyone, then as it was unfolding, or later, truly understood how Germany, the nation of Chopin, Bach, and Goethe, the vibrant center of culture in Europe, waltzed stunningly, into the godless abyss.

How did this come to pass? That Germany, that brilliant nation could transform into that gathering of heartless men who killed children without conscience nor hesitancy? Over three decades later, a witness, now a frail, aged woman, interviewed by Gitta Sereny, journalist and author of *Into that Darkness: An Examination of Conscience*, walked into the woods just beyond the ruins of Treblinka, the largest of the five Nazi extermination camps. On that wintry day, among snow-laden trees, the witness accompanying Sereny, suddenly reflected upon a stirring and haunting moment, on another brutally freezing day, that had unfolded before her in 1943— 'Oh my God, the children, naked, in this terrible cold,' she cried out. Then, her voice quietened, as if dazed by images remembered, as she explained that it was here, that the children waited their turn, their naked feet frozen into the ground, waiting for those children ahead to be dead, so that when the Ukrainians with whips on both sides of the path began to drive them on, their mothers had to tear them loose . . .'[5]

At Treblinka alone, between 1941 to 1943, over 900,000 Jews were murdered. Within the constraining fences of four extermination camps, killing camps—Belsec, Sobibor, Chelmno, and Treblinka—over a seventeen-month period, an official Polish estimate, considered to be a conservative number, stated that over 2,000,000 Jews and 52,000 gypsies

were shot, gassed and burned. Only eighty-seven survived the four camps. There were no children among the survivors; they were simply murdered within hours after arriving in the camps.

But the killing camps and the mass murders would come later, throughout Poland, the Ukraine, eastern Russia, years after the deceit had begun; a scene that could have hardly been imagined in those days of the early thirties as the masses lined up along stone-floored German streets for a view of the new Fuhrer. It was a common occurrence by then, along boulevards of Cologne, or Nuremberg, or Berlin itself, those shows of unity that promised better times for Germany out from under a depression... 'a vast sea of admirers, staring out over unbroken row after row of blood-red and black Nazi flags... then, a black polished Mercedes-Benz slipping past, the Fuhrer standing in the front seat, glaring sternly over the throng, his arm stretched out in perfect salute. Nazi banners, mounted on the sedan fenders, crackled in the breeze, as the chilled air pulsated with echoing, rhythmic roars— "Seig Heil, Seig Heil, Seig Heil!"'[6]

However, there was at that moment, once the danger was truly understood as is often the situation, two women who recognized that threat; women who would stand and fight, placing light in the path of darkness, and give everything within them to save the Jewish children living in Germany.

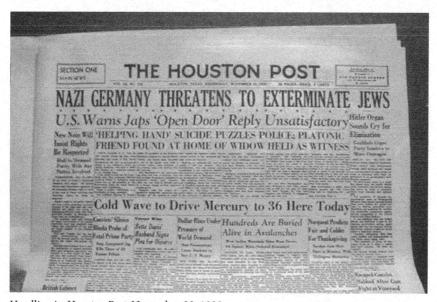

Headline in *Houston Post*, November 23, 1938.

Recha Freier, the wife of a rabbi in Berlin, would be visited on a chilled February afternoon in 1932 by six Jewish youths asking for help. She listened as they told her that they had lost their jobs simply because they were Jewish. Their stories suddenly opened Freier's heart to the perils of life for Jews in Germany. The other woman was Henrietta Szold, from America and daughter of a rabbi in Baltimore. While practically no one in Palestine knew of Freier, Szold on the other hand, had come to Palestine in 1920, and by 1933 was widely known as described by author Joyce Antler

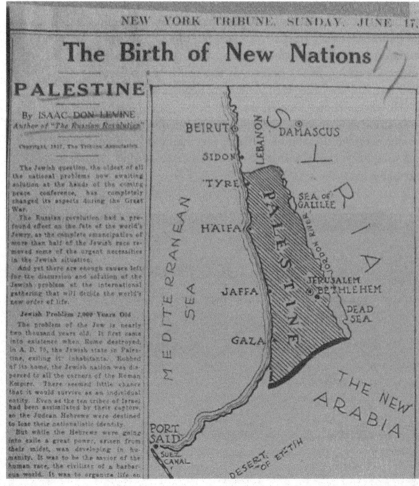

Map. Palestine. *New York Tribune* "The Birth of New Nations," Isaac Don Levin, June 17, 1917.

as 'the founder and guiding spirit of pre-state Palestine'. She was the founder of Hadassah, the Jewish Zionist women's organization, and was a controlling hand in the expanding Hadassah Hospital and medical services developed throughout Palestine. It would prove to be Hitler's triumphant ascent to power that produced the most trying and challenging period in Henrietta Szold's life.

Writing of these two women, Norman Bentwich, a lifelong Zionist and British attorney-general of Mandatory Palestine, would become forever linked with the children escaping Nazi Germany. 'Recha Freier had given the movement its ardent impulse amongst the youth. She had won for it the support of the Socialists settlements [in Palestine]. It was for Henrietta Szold, the affectionate and understanding planner and the inspiring worker, to turn that impulse and that acceptance in principle into an ordered movement. One woman was the dynamo; the other, the skilled pilot.'[7]

Jessie Sampter, Zionist pioneer, author and educator, and devoted friend of Henrietta Szold since 1912 when Szold persuaded her to write educational material for Hadassah, also sensed the doom descending over the European Jews. Growing more concerned, her letters became protected and careful. She turned, instead, to her poems to express the veil of doom approaching the Jews; an attempt to understand, to express what was incredibly unfolding in Germany. One of her poems, the 'Sonata Passionata', as biographer Bertha Badt-Strauss wrote in *White Fire: The Life and Works of Jessie Sampter*, 'tried to decipher the enigma of the German mind which can be a God and [also] a beast, a Beethoven and a Hitler.' Struggling bouts of depression that haunted her throughout her life, Sampter, though unable to fully grasp the evolution as the world turned toward madness, came to finally understand that there was, mercifully, an answer. 'Thank God,' she would write, 'that there is a haven for Jewish youth in Palestine!'[8]

That small glimmer of hope would continue to grow with the Zionist experiment. In 1936, two years before her death, Sampter could then write: 'A new light is coming into the world, as it has always come in moments of darkness and must come inevitably as the sun rises... A new synthesis of our hate of war and love of our land, of our social reconstruction and our individual deepening, of radios and music, machines and art, time and eternity, man and God ... This is the burning bush.'[9]

The poet had prophetically glimpsed into the future—foreseeing the breathtaking task that lay ahead for Recha Freier and Henrietta Szold— that, to save thousands of Jewish children from perishing in the cruel fires that would soon ignite within the killing camps of Nazi Germany, and beyond, and set the landscape of a once civilized Europe, aflame.

PART ONE

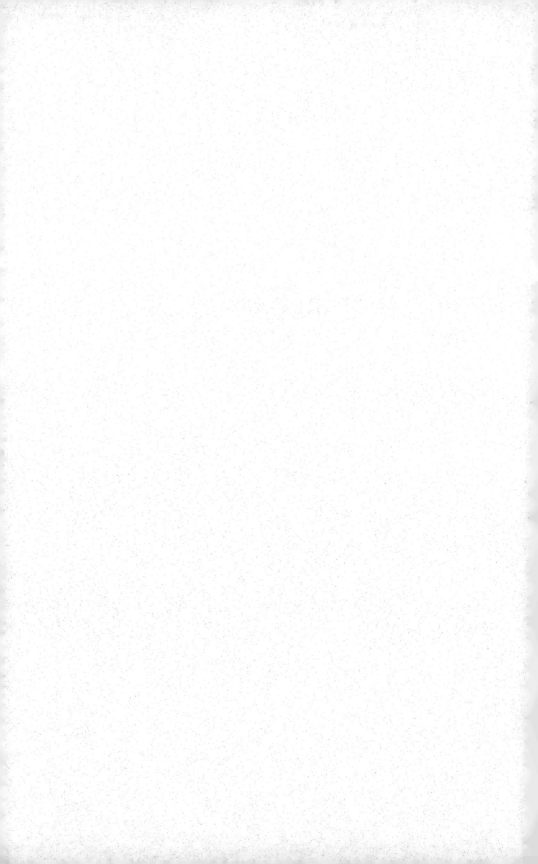

1

A Winter Morning in 1865

'Biographers are the shadow of the tombstone in the garden.'
-Saul Bellow, novelist

As a crisp, clear dawn broke over Baltimore, five-year-old Henrietta Szold stirred, suddenly awake, aware that something was terribly amiss in her small, young world. She went quickly downstairs and, after discovering that her father had not yet returned home from his business trip, sat in her tiny rocking chair in the corner of his book-lined study and wrote him a letter: 'I am so glad my dear Papa, so glad that I am able to write to let you know how things get on at home.'[10]

Written in her diminutive, precise handwriting, even at such an early age, that note to a father who she adored, was the first of hundreds of letters Henrietta would write throughout her lengthy life. In fact, her last letter would be written to sister Bertha on 26 November 1944 from her Jerusalem hospital room, nearly eighty years later, as her final days in Palestine faded. A gifted writer, her letters, diary entries, and articles, published over the years, contain a scholarly brilliance and pure honesty reflected in her detailed words. In those later years, finding herself alone after, often, a fifteen-hour workday, it was her habit to sit at her desk on twilight evenings in the little stone house among a tree-planted garden on the outskirts of Jerusalem, located north and just beyond the Old City walls. Taking a long moment, she would admire the view along the Vale of Jehoshaphat eastward, glance along the rows of worn, ashen gravestones lining the Mount of Olives, and then finally return to writing a letter to one of her sisters, or a dear friend, or perhaps to an associate concerning a pressing issue. It was her father after all, Rabbi Szold, as he had so often guided his daughter in many ways of her early life, who had instructed Henrietta in letter writing, insisting that she not delegate the task to others, nor to quickly write her thoughts, but instead to write out personally from her heart, richly, and thoughtfully. Henrietta, as she put pen to paper understanding that letters were a method to communicate, also let the words serve as a form of inner healing that she sought out at those times in

her life, when all that she treasured had vanished—the devastating loss of the love for a man whom she admired; the dream of having children of her own; and then to simply know her purpose in life, a calling designed by God, she believed. Henrietta sought consolation from bitter disillusionment by writing, and at the same time found a peace among the tranquil solitude.

That this woman possessed the skills to have lived the life of a literary figure was never doubted by those who received her letters, read her vibrant accounts of life in a careworn Palestine, or her stirring articles on Zionism. To have followed the path of a writer would have been a much easier way than the journey that she eventually chose to follow. Or, as she often assured in conversation, the purpose that chose her. It was her colleagues, who many times over the years, stated that it was a pity that Henrietta didn't take the time to write her autobiography; that, yes, she was that gifted to have accomplished just that, but by then precious years had slipped away. When urged by some, especially her sisters, to retire and settle back into her dear father's old rocking chair from her childhood in Baltimore and write of her life, Henrietta would quietly remember her boxes of diaries stored away in her sister Bertha's cellar, and personal papers in Adele's barn in Connecticut, and then, once again after a long moment, turn aside such foolish ideas.

Locked away in a battered trunk found in a basement of her Forest Park home in Baltimore, in the mid-1950s, Alexandra Lee Levin, wife of M. Jastrow Levin, found the papers of her husband's aunt, Henrietta Szold. From that cache of documents, Levin, a self-taught writer, wrote *The Szolds of Lombard Street*, published in 1960. A book detailing of that time when Henrietta lived in that wonderfully warm, splendid upbringing, filled with love and books and learning, that childhood on Lombard Street. In many ways, it told of those mysteries that detailed the fiber of her existence, this woman who lived in 1930s Palestine, and fought against Nazi Germany to free her children.

'A year ago, a large wooden chest, long forgotten, was opened for the first time in half a century. Among its contents was found a mass of correspondence dating back to the 1850s, letters in English, in old German script, in Hebrew script, in Slavic, letters from Europe, letters from America,' Mrs. Levin wrote in the foreword of her book in February 1960. 'Many of the whys and wherefores of the world figure, Henrietta Szold, had been known before; many pieces from the puzzle were still lacking. Out of the old wooden chest, within the past year, have come the answers to many questions.'[11]

Henrietta's life until the age of sixty was one of an austere existence filled with the long hours editing papers for the *Jewish Publication Society of*

America; her nights occupied translating Professor Louis Ginzberg's major work, *Legends of the Jews*. Henrietta seldom received the credit for the work she completed, her name often left off the list of contributors on certain manuscripts. Recognition eluded her many times, even when it was deserved. However, her work ethic taught to her by her father, didn't escape being noticed by those who came to know her.

Louis Lipsky, American Zionist leader, President of the Zionist Organization of America, and one of the first Zionists leaders, in 1931, to warn of Hitler's menacing promises toward the Jews, wrote of Szold's labors and energies: 'Her contributions to Zionism were not as an orator on the platform, the ready writer on Zionist theme [or as] a controversialist in the "general" debate. Instead, she was "the humble maid of all work, the housewife whose work was never done.'[12] Writer and Zionist leader, Abraham Goldberg, would write in 1945 that Szold 'was more concerned with solving problems practically than discussing them theoretically.' Reflecting on her work in the previous two decades, Goldberg would conclude that 'in shouldering and discharging faithfully her obligations, she found satisfaction and the fulfillment of the meaning of life.'[13]

In her book, *Writing A Woman's Life*, author Carolyn Heilbrun relates a similar evaluation of George Eliot's career, the British writer, which could draw comparisons to Henrietta: 'Whether deliberately, unconsciously, or accidently . . . [she] composed her own life so that its fitful, rudderless, and self-doubting first half was alchemized into gold in the second half.'[14]

And so, it was with Henrietta. In her later days, she finally realized her life as terribly 'rudderless,' after suffering a tragic and devastating lost love; a life bookended with two epiphanies that would redirect that later part of her life… 'It seems to me I have lived not one life, but several,' Henrietta would write, 'each one bearing its own character and insignia.'[15]

… it was, she would later confess to friends, when she described those events that lifted her life in a different direction, indeed 'a late awakening.'

<p align="center">✴✴✴</p>

Her story of falling in love for the first time, was a story with all the elements of a great melodrama; the spurned love of a younger man, and her downfall that would cause great pain and tragedy; and all that heartbreak would oddly lead her to her greatest accomplishments. She had met Louis Ginzberg, the brilliant German-trained scholar, thirteen years her junior, at the Jewish Publication Society in the spring of 1903. Despite initially refusing his request for her to translate his manuscripts, Henrietta

eventually accepted, working as long as twelve-hour days translating Ginzberg's work such as his major writing, *The Legend of the Jews*. On most days, she translated four thousand words from his book. 'They all say that he exploited me intellectually—as I myself say,' she would later confess. 'I was his intellectual mistress.'[16]

She had never felt such an emotional attraction as she had toward him, as the relationship deepened and they became endless friends. Szold fell deeply in love with him, hoping that he felt the same about her, in fact actions and gifts given her led her to believe that, and that it would lead to marriage and children. However, on his return from a trip to Berlin, in the autumn of 1907, he announced that he was engaged to be married to a younger woman than she.

Szold was distraught.

'But his supreme, cherished gift to her [despite the heartbreak],' Irving Fineman wrote, 'was his awakening of her womanhood. Out of her love for him had grown an awareness of the mystery of sex, of which she had been as ignorant as a girl of sixteen... she had given him her first love, and coming so late in life, it was a love chastened and strengthened by a rich experience of sorrow, a manifold experience of circumstance and action.'[17]

During that fall of 1908, Henrietta befriended Alice Seligsberg who played an important role in helping Henrietta to forge through what she referred to as the "shock" of her life, the 'dark chronicle of a broken heart.'

Broken and disillusioned on the future of her life, Henrietta suffered a nervous breakdown. Eventually, through the support of Seligsberg and other friends and associates, she began to live again, and returned to work throwing herself into the editing and writing with all the strength she could muster.

'I will not make mention of him,' Henrietta promised herself, 'nor speak any more of his name.'[18]

Strangely, the loss of such a deeply, sought-after love had awakened Henrietta, and would eventually direct her life toward her true purpose; and there were those two epiphanies that would serve as guideposts along her earlier years.

The first, occurred in 1881 when Henrietta traveled with her father to Europe where they visited family. In Poland, Papa would take her to a special place.

As she walked up the hill in Josefov, Poland that morning with her father toward Alt-Neu Shul, the oldest active synagogue in Europe, Henrietta noticed that 'even the ancient clock on its tower still turned with Hebraic stubbornness counterclockwise.'[19] They neared the ancient

building, and glancing over the stone fence, she witnessed—and was immediately ashamed—at how the women were forced to worship. The women sat in a narrow garden outside the synagogue, while a single woman stood on a chair peering into a small round window, and serving as their personal minister, told the women what was happening. Henrietta was amazed, a quiet resentment rising up in her at the indifference. It all gave her doubt on why she had spent her life, to this point, absorbing the Jewish learning her father insisted that she acquire. But like Papa, Henrietta had learned to apply reason toward a problem. 'Pity and sympathy filled out my whole heart,' she would write. 'There was no room left for anger.'

Later, during an evening walk among the stone ruins of an aged-old castle atop the tree-covered Schlossberg, as Henrietta glanced down on the Danube River, her concern for the future of Jewish women finally dissipated: 'battlemented ruins speaking of powerful nations that had come, lived a strong conquering active life, and disappeared from the world's theater, leaving scarcely "footprints on the sands of time," while Israel still survives and is successful enough in world matters to rouse the envy of the people among which it abides.'

The second epiphany happened years later, an event that couldn't replace the first outside Prague, but did redirect her vision once again, that of administering to women's spiritual needs. During her emotional breakdown after Ginzberg had married another, friends and Szold's mother, Sophie, watched helplessly as Szold sank deeper into a depression. By the summer of 1909, Sophie had scheduled a trip for she and her daughter, a much-needed six-month vacation to Europe and then Palestine. The Jewish Publication Society surprised her with a five-hundred-dollar stipend, so that the two could expand their journey to include Palestine.

After several weeks traveling through the Holy Land, Henrietta wrote Alice Seligsburg describing the sights she and her mother had witnessed since arriving. She also, with those words, had unknowingly foretold her destiny on the soil: 'How much I shall have to tell you when I return,' she wrote, 'of the misery, of the beauty, the interest, the problems of the Holy City. If I were twenty years younger, I would feel that my field is here.'[20]

Then one morning, in Jaffa, they were invited to visit a Jewish girls' school. As they walked past children playing in the sand, what first appeared as a dark wreath about their eyes, to Henrietta's horror, were thick patches of flies, an early sign of trachoma, a bacterial infection that affects the eyes.

At the front door, they were met by Dr. Touroff, and given a nice tour of the school. But the contrast of the children's health struck a chord in

Henrietta later related upon her return to New York: 'As we walked to the school, we saw a horrible sight; children with a wreath of flies around their eyes. My mother was horrified. We entered the school and inside there was not a child whose eyes were afflicted.'[21] Not a single case of trachoma, as they had witnessed on the streets.

Henrietta and Sophie departed the school, after the situation was explained as to why the children in the school were healthier: 'we have a physician who visits us twice a week and a nurse who comes daily, and we take care of the eyes.' They walked in silence only a few yards, when her mother suddenly stopped. She turned to her daughter, her face changed, at once shaken, but also determined. 'This is what your group ought to do,' Sophie said referring to a Bible study group Henrietta had joined in New York several years before. Her voice shook lie dry leaves in a wind. 'What is the use of reading papers and arranging festivals? You should do practical work in Palestine.'[22]

Henrietta understood the meaning of her mother's sad words, though it would be a while before she understood that the intricacy of that one brief moment on the Jaffa streets, would influence the remainder of her days.

She returned to New York and told her study group about the horrible conditions in Safed, Tiberius, and Jerusalem, pointing out that the 'primary factor affecting the health of the Jewish community, was the dire state of hygiene.' She stressed the scope of the social-educationalhealth problem and underscored the need for an immediate and comprehensive public health program.'[23]

Ten days later, on 24 February 1912, thirty-eight women met in the vestry rooms of Temple Emmanuel. They selected the name Hadassah— the Hebrew name for Queen Esther, the hero of the Purim story—and Henrietta was elected president. The motto was suggested by Israel Friedlander, 'The Healing of the Daughter of my People,' *Arukhat Bat-Ammi.*

Again, Henrietta insisted that the group should devote itself to the practical purposes of healing in Palestine …

… and, in that moment, fate and meaning were cast into Henrietta's life.

<p style="text-align:center">***</p>

It has been noted by those familiar with her life, that remarkably, Henrietta's major achievements came for her after that time when she had decided to make *aliyah* (to ascend) to that barren land called Palestine, described by

Israel Zangwill, noted novelist and playwright as 'a wilderness . . . a stony desolation, a deserted home . . . a land gone to run; a land without a people, waiting for a people without a land.'[24] With such descriptions, it seemed unlikely that anyone would desire to live in such a forsaken land. Henrietta, however, believed differently. She had been there, eleven years before in 1909, had witnessed the slopes of Mount Zion, the biblical paths of 'ancient Jerusalem winding through groves of olive and lemon trees, gatherings of oleander bushes, the tresses of fresh grapevines.'

Henrietta had gazed upon a place much different than the one Zangwill had described, a glorious land with a future as prophetic as its olden past, and she understood the importance much as had the British who arrived as the empire's ill-destined British Mandate unfolded in 1920, lasting only the fragile timespan of twenty-eight years. Lord Curzon, a British statesman who possessed the ability to shape words toward the highly dramatic, said of Palestine: [It is] 'the holiest space of ground on the face of the globe; the land of the scriptures, and the land of the crusader, the land to which all of our faces are turned when we are finally laid in our graves in the churchyard.'[25] Henrietta, determined to not be discouraged by Zangwill's harsh reports, nor to be enlightened with glowing English quotes, simply believed in her own heart, that despite what was written, Palestine was the Holy Land of the Jews. This deep conviction drove her ever harder toward her purpose, that of establishing medical and social services, almost nonexistent in the early times of that century, for all peoples of Palestine, both Jew and Arab. Henrietta would witness two world wars: first, the Great War that forever changed the map of the Middle East where once a triumphant British General named Allenby walked victoriously (rather than ride his horse), with a self-imposed humility beneath the Jaffa Gate in December 1917 into a freshly captured Jerusalem; the more recent war in the 1940s would reveal an evilness that threatened not only everything that Henrietta had accomplished until then in Palestine, but also the absolute presence of civility in the world. It was during this war that Henrietta directed *Youth Aliyah*, a department within the Jewish Agency that would rescue thousands of Jewish youths from behind the descending curtain of Hitler's Germany. She, as would others, began to understand that what lay ahead for the European Jew was dark and foreboding—that their very survival would depend on unusual courage and fortune.

That Henrietta had the energy to travel throughout Palestine inspecting settlements for the children coming to Palestine to live (in the 1920s and 1930s travel was harsh and perilous along winding, dirt roads and the constant threat of ambush) at her late age, amazed her staff. When asked

as to how she could accomplish such travels, Henrietta would proudly announce that her morning regime of calisthenics and stretching exercises had much to do with her resilience. Norman Bentwich, the attorney-general in Palestine, described accompanying Henrietta through the country, who was by then eighty-three:

> 'A day with Miss Szold was an experience of physical and intellectual vitality. We would start early from Jerusalem, drive a hundred miles, stopping on the way at a village center to talk with a director here or a group of instructors there. At our destination we would have a meeting with a group of youths and discuss their problems. She would talk with them individually, and to the children together, in an exact Hebrew. Then on to another village; during the drive she would seem to be asleep and lost to the world. But when we arrived, she would wake and switch on the self-dynamo, and again settle all the problems. So, to a third village, which we would reach after sunset, stumbling through the courtyard in the blackout. Again, she would meet the community, adults and youths, in the dining room; again speeches, and a conference, or, if it were the end of a year's apprenticeship, an entertainment. To round off the day we would drive to Haifa or Tel Aviv, and arrive near midnight, with orders to be ready on the morrow at 7 A.M.'[26]

Even with blessed health, Henrietta struggled to work through weeks of sickness, attending endless departmental budget meetings, and addressing mountains of correspondence. 'When I came to Palestine,' she once admitted, 'I acted as though I were an expert on medical affairs. Fate made me pretend to be an expert on educational affairs in 1927.'

It was also a time when she dreamed, reflecting of retiring to America, to be with her sisters, to live out a life of quietness and rest. 'And now, in 1931,' she wrote. 'Having passed the Psalmist's terms of years, I dare go into another field in which to expertise is imperative. But what am I to do if experts refuse to tackle the job and tackled it must be? The situation is becoming daily more chaotic.'[27]

One reviewer of *Summoned to Jerusalem: The Life of Henrietta Szold* written by Joan Dash in 1979 stated: 'There is something slightly unbelievable about the life of Henrietta Szold. She was a woman who's potential and brilliance were unquestioned by everyone except herself, whose Jewish learning was probably unmatched by any other American Jewish woman of her day.'[28] Eighteen years before, Irving Fineman had

written his biography of Henrietta, *Woman of Valor: The Life of Henrietta Szold 1980-1945*. 'In the two years the writer [Fineman, writing in third-person] has been engaged in learning the life of Henrietta Szold, he has experienced a strengthening, a reinforcement of his own spirit. It is his hope that he has succeeded in instilling in this book enough of the essence of that impassioned soul—its strength as well as its sweetness—to influence similarly the spirits of its readers. . . for revealing not only her success but her suffering, without which that success would be insignificant.'[29]

With her achievements came recognition that reached, by the late 1930s and the 1940s, near-hero status throughout Palestine. Her passion for writing drifted into the background, and so, writing would never be her occupation, sacrificed so that crucial medical and educational undertakings—and the rescue of the Jewish children from Germany—could be addressed. Bentwich, who made his first visit to Palestine in 1908 a year before Henrietta arrived, and later became a life-long friend, explained: 'She had the instincts of a writer and a scholar, but even stronger than them was her will to help any suffering part of her people.'[30] For this gray-haired, smallish woman, drawn to the pressing needs of the Holy Land after she and her mother witnessed the unforgiving poverty and sickness while on a trip there in 1909, writing would, instead evolve as that record of her life; not as an autobiography as she was so often encouraged to write, but through her letters.

Still, there were those moments when Henrietta entertained lingering feelings about writing . . . once, in 1924, as she lay bedridden with body aches and a headache while suffering from the sting of the sand-fly, she took the opportunity to read *The Forsyth Saga* by the English author John Galsworthy. The words that she read again stirred her ancient urgings to write . . . that same desire that always brought her back to her youth . . . so, 'I think I might have become a writer,' she confessed.[31]

Despite all of Henrietta's accomplishments, her dedication to a holy land, though a land at times as foreign to her as another distant planet; and, her love for a people who were also, at times, tersely fragmented in their purpose, she was aware at an early age of her true identity. It was a self-character of which she would write of, fondly referring to it throughout life. Her depth and energy and her knowledge were shaped in her father's study. It was a simple truth for this rabbi's child: 'I am my father's daughter,' she would say.[32]

It was from his teachings and encouragement towards his older daughter, that Henrietta grew strongly and deeply in religious belief and observance. 'There was a wholeness and a completeness about her as a

Jewess, which is not often encountered in modern life' wrote friend Tamar de Sola Pool, President of Hadassah from 1939 to 1943. 'Ritual, prayer, learning, and ethical teachings were integrated in the unity of Judaism as faith, aspiration, and practice.'[33] Secularism that surrounded her, never influenced Henrietta's religious practice; she regularly attended Sabbath services and was one of the founders of the Yeshurun Congregation in Jerusalem, considered the foundation of the American synagogue. Her father had taught her that Judaism was not only a faith, or a creed, but a way of life. 'Spirituality can never be a rule of life,' she wrote. 'It is only the attribute of a life lived according to the positive behests of religion.'[34]

The Hebrew language was also dear to her heart, because she considered it crucial to the future of Israel's literature. Once it was assured that her work would take place in Palestine, Henrietta turned to learning Hebrew, not only as a language to speak, but to express thoughts. 'I made my first impromptu speech in Hebrew,' she proudly recorded in September 1921 her first full year in Palestine, 'rather haltingly, but I managed to get a few ideas into Hebrew form.'[35]

Still, despite the passion that she had for Palestine, by 1929 Henrietta believed that her usefulness had, perhaps, run its course. Perhaps, she had grown too old to fight all the problems confronting her, often within fifteen-hour work days. In a way, her mood reflected the desolation that had fallen upon the world—Arab riots had spread across the land, and a world-wide economic crash had delivered despair. The *Yishuv*, the Jewish community in Palestine, suffered an internal crisis. The Zionist Organization, involved in grandiose schemes for development, had overreached its finances and was bankrupt. As relationships with the British mandatory government became tense, the Jewish Agency was formed to conduct all Jewish affairs with the British government. Three separate school systems, all vastly underfunded, made Henrietta bitter about such matters that should have priority beyond political gains and ideologies. The last straw for her was when the World Zionist Organization asked her to accept a position as a representative. Her duty to Palestine was, despite personal misgivings, to accept. Within months Henrietta realized that she had made a mistake. It all finally appeared as a political post, and some her strongest critics, non-Zionists in America, rebelled against her and demanded her resignation, which she did, after strongly confronting her critics.

Discouraged and dejected, an opportunity to escape presented itself.

In October 1930, Hadassah extended an invitation for Henrietta to travel to New York where her seventieth birthday would be celebrated. The

homage lavished upon her was, at first 'a balm to her spirit.' However, soon she grew weary of the planned itinerary. Suddenly, amidst all of those events, Henrietta felt unneeded, by either Hadassah or the Zionist Organization of America. Even the Hadassah Medical Organization operated in Palestine in the capable hands of Dr. Chaim Yassky. 'I haven't done an honest hour's worth of work or thinking since I arrived here,' Henrietta reflected; 'it's dinners and banquets and luncheons and teas and meetings and messages and gossiping until I feel like a bubble filled, not even with gas, but with the "inspirational" fluid I am expected to give out all the time. The worst of such a regime is that it unfits one for the real things.'[36]

It did seem that the moment had arrived in her life for the writing of memoirs, the rocking chair on late afternoon, and she did love her sisters very much, but, sadly, the America Henrietta remembered, was no longer there, perhaps changed forever by the Depression. 'There was a garishness, a stridency,' she wrote. 'Radios blared, and most of what they blared was jazz. Skinny girls with dresses that ended above their knees and circles of rouge on their cheeks smoked in public and drank too much and used slang and worse. Gangsters were heroes.'[37]

Finally, she admitted that she questioned whether, or not, to live in this America.

In January 1931, Nathan Straus, with whom Henrietta had worked with upon settling in Palestine, died in New York. She was asked by Hadassah to write an article in memoriam of the American businessman. Henrietta remembered him as 'impetuous and strong-willed,' a philanthropist who had provided funds in 1915 for the first Hadassah nurse to set up a medical clinic and who had given two-thirds of his fortune to Palestine. As she wrote the article, her thoughts again turned toward the land where she had invested sweat and tears for over a decade.

'Where one so manifold in deeds and obviously so complex yet so positive in sentiments and convictions passes beyond our physical vision, it is a duty to wrest from his record the secret of his vivid personality for our guidance. What is the ultimate meaning of the values that invest his acts and grow out of his character roots?' Henrietta wrote on 11 January 1931. 'For our consolation as well, we crave to know the lesson. Death having rounded out life, the sting of separation is blunted, in a measure at least, if we possess the sweet or strong secret of the completed, precious life.'[38]

Soon, there grew a measure of understanding within her, a despairing thought of unfulfillment, that things in Palestine weren't quite finished.

Henrietta's decision of whether to remain with her sisters, or to return to Palestine, came to her in a cable from the Jewish Agency.

By May 1931, Henrietta was on board the SS *Saturnia* returning to Palestine. The cable had arrived only several weeks before, delivered to Bertha's home during the celebration of the Passover *Seder*, announcing that the Labor Party, her bitterest critics, has nominated her to the National Council of the General Assembly of the *Keneset*, the *Vaad Leumi*. What had once seemed a rejection of her, was now a pleasant surprise. 'In Palestine,' she said, 'they seem to think I can do a definite piece of organization work. So, I go back.'[39] Expectedly, the sisters were disappointed when Henrietta informed them that she was once again leaving.

Henrietta patiently explained that that distant place was where her true heart lived; that her people of Palestine needed her, and as though through the dreams and visions of an ancient prophet, she could sense the approaching peril. There was beating within her, that urgency of someone needing her, wanting her, desperately to come and fix what was wrong with the world. In an attempt to explain to her sisters Bertha and Adele, she simply told them, '... my maternal heritage seems to be asserting itself as against the paternal strain...'[40] The summons was simply too strong for Henrietta to ignore.

On 24 October 1933, Henrietta, reflecting on those days, explained what had prompted her to return back to Palestine in a letter to Dr. Solomon Solis Cohen. 'Last spring, I determined to cut loose from Palestine and return to America for my remaining years, to be coddled by my sisters,' she wrote while sailing to Marseille. 'Hitler disposed otherwise ..., there was a menacing sense of the dark war-forebodings in Europe...'[41]

So, at the age of seventy-three, Henrietta now had one more cause.

Though she shone in many fields— editor, teacher and administrator— she would always be quick to explain how she regarded the cause which demanded all of her creative powers, the directing of Youth Aliyah, '[was] the best thing we Jews are doing. I have never been concerned with anything in public work which as impressively made me feel,' she admitted, 'that I was an instrument in the hands of a Higher Power.'[42]

'Save the Children,' she told anyone who would listen at those times when she spoke of her worthy crusade that stirred her beyond her years. Those who listened, and knew her, were certain that she would be strong-hearted, and determined and durable through it all.

A cause that began with a woman, a rabbi's wife, a Zionist and a poet, living in the sinister heart of Nazism. Berlin.

2

Berlin

'Germany [is] silent, nervous, suppressed; it speaks in whispers.'
-W.E.B. Dubois, *Travels in the Reich: 1933-1945*

For American journalist Dorothy Thompson upon her return to Germany in the 1930s after three years in America, the transformation of that gay and cultured nation where she had lived the decade before—a delightful, swirling time filled with rowdy, crowded dinner parties hosted at her Berlin flat overlooking the 'bosky glades of the Tiergarten,' and late-night cocktail parties rubbing elbows with both famous and obscure writers and artists— was nothing less than shocking. It all gave her stunning pause. How could this have happened, Thompson had to ask herself? Openly staged incidents of brutality, hatred and antisemitism on the once tranquil streets, as ordinary Germans walked by unnoticing. Within a span of several days, she had come to realize that the reports, at first widely doubted, proved true. The year before, in America, reading newspapers or listening to radio reports on lazy, late afternoons on the porch of Twin Farms, her home in the Vermont countryside, for Thompson those problems of another world seemed so distant, and almost impossible. However, her curiosity had heated up amidst the turmoil of a troubled domestic life with her husband, the angular, fuming novelist Sinclair Lewis.

After all, Thompson had interviewed Hitler in 1931, convinced at that time that she was to meet the new leader of Germany. Instead, she was unimpressed by the man she described as 'formless, almost faceless, a man whose countenance is a caricature, a man whose framework seems cartilaginous, without bones,' she wrote. 'He is inconsequent and voluble, ill-poised, insecure. He is the prototype of the Little Man.'[43]

She realized later that she had terribly underestimated the power that Hitler, 'her awkward Austrian,' would hold over the German people.

Now, she had returned to Europe to see for herself these rumors of Hitler's rise, of the growing violence on the streets. Doubting warnings from friends and associates, the famous journalist, who by 1939 would be recognized by *Time* magazine as the second most influential woman in

America to only first lady Eleanor Roosevelt, witnessed and was shaken as members of the Nationalist Socialist party strutted down the narrow streets; her 'wavy-haired buggerboys,' as she referred to the Brownshirts. It was, at that moment, when Thompson admitted to herself that she would be a witness to the unfolding of an approaching disorder. 'It seems to me,' she wrote later, 'that every conversation I had in Germany [upon her return] with anyone under the age of thirty ended with the phrase: "*Es kann nicht weister. Es muss etwas geschehen.*" It can't go on. Something must happen. Nearly every one of the generations coming of age believes this.'[44]

Disturbed, but armed with journalistic curiosity, Thompson struck out into the German countryside, finding the roads crowded with bicycles, automobiles, motorcycles—strangely almost all driven by a new generation. 'I was in a procession of young men,' she remembered. 'I had the feeling that there were only young men in Germany, thousands and thousands of young men, all very strong and healthy, and all working furiously to get somewhere.' Thompson soon found that most Germans she approached on her travels were unwilling to discuss the happenings. Finally, she came across a Catholic priest who was willing to talk.

'The Nazi revolution is the greatest blow to all Christianity,' he admitted to Thompson. 'In the Nazi outlook nationalism is elevated to a mystic religion, and the state claims not only the bodies of the people but the souls.' Thompson asked his opinion on who would win the fight unfolding around him. 'They are getting the children,' the priest said quietly. 'That is their program—to get the children.'[45]

Even with Nazi beliefs and plans for the future Germany now brazenly out in the open, there were those who simply refused to believe where Germany and Europe were heading. Looking back years later, much of what unfolded was, in fact, written and described by foreign journalists, providing details of the slippery slope traveled. Sadly, few listened. There were two types of individuals living in Germany in the 1930s: those who grasped the perilous undercurrent of the Nazis, sensed the danger, and others who were simply spellbound by what they witnessed. Martha Todd, at twenty-four, the young and impressionable daughter of the American ambassador, William E. Todd in Berlin, was one of those fascinated with the ideal of National Socialism, a belief that she would later abandon for communism. However, in December 1933, she still innocently wondered of marvelous things young Germans could accomplish. In a letter to writer Thornton Wilder, she wrote with tolerance, 'The youth are bright faced and hopeful, they sing to the noble ghost of *Horst Wessel* with shining eyes and unerring tongues. Wholesome and beautiful lads these Germans, good,

sincere, healthy, mystic brutal, fine, hopeful, capable of death and love, deep, rich wondrous and strange beings—these youths of modern *Hakenkreuz* Germany.'[46]

William L. Shirer, war correspondent and CBS radio news reporter, would later also write of his experiences in Nazi Germany, in *The Rise and Fall of the Third Reich*. Arriving the next year after Thompson's return to Germany, he witnessed Adolf Hitler for the first time at a Nuremberg rally: 'Like a Roman Emperor, Hitler rode into this medieval town at sundown today past solid phalanxes of wildly cheering Nazis who packed the narrow streets... the streets, hardly wider than alleys are a sea of brown and black uniforms,' Shirer wrote in his diary, the spectacle mystifying him, 'for the life of me, I could not quite comprehend what hidden springs he undoubtedly unloosed in the hysterical mob which was greeting him so wildly.'[47]

A year later, Sir Philip Gibbs, novelist and British correspondent, observed, 'It was impossible not to be impressed by the splendor of that German youth,' he wrote. 'There was something stirring in the sight of this army of young men,' a scene that assured Gibbs that Europe would soon be embroiled in war. 'This pride and discipline of youth could be so easily used by evil minds for sinister purpose, later on.'[48]

The Nazi regime blanketed German society with such gripping fear that no one on the Berlin streets could actually remember when daily life was any different than the questioning days of 1932 and into 1933. 'One can evade a danger that one recognizes,' historian Friedrich Zipfel wrote in reflection, 'but a police working in the dark becomes uncanny. Nowhere does one feel safe from it. While not omnipresent, it could appear, search, arrest. The worried citizen no longer knows whom he ought to trust.'[49]

Several months later, on a night in March 1933, Dorothy Thompson stood on her Hotel Adlon room balcony and stared down the Unter den Linden, from where she had once, in the late 1920s, watched children peacefully playing in the Tiergarten. The view she gazed upon this night, however, was chilling and unsettling: 'I saw them,' Thompson wrote of violent men prowling the Berlin streets, 'in my mind's eye, the machine guns that would soon be in their hands, the planes that would fly over their heads, the tanks that would rumble and roll with their thread.' Dire warnings alarmed in her mind and she wrote: 'Post-war Europe was finished ... and pre-war Europe had begun ... the boiling kettle had exploded.'[50]

Six months later, by the fall of 1933, there was an incident that blatantly underscored the swift, ruthless changes within Germany, especially toward foreign journalists. It involved American journalist Edgar Mowrer. Born in

Bloomington, Illinois and a graduate of the University of Michigan, Mowrer had established his journalist reputation when he traveled to France in 1914 and wrote of events in the First World War, including the Battle of Caporetto, an Italian defeat. He moved to Berlin in the late 1923 with his wife Lilian, who, during her first days in the nation's capital, was initially unimpressed with Germany, but later grew to view the country in a different vein, ('a woman could do what she liked in Weimar Germany.') The Mowrers came to connect with many of Berlin's elite including George Grosz and Albert Einstein. However, Mowrer was headed for trouble, when he was awarded the Pulitzer Prize for Correspondence for his description of Hitler's rise to power. His dispatches for the *Chicago Daily News* from Germany had caught the attention of Nazi officials. When his best-selling book, *Germany Puts the Clock Back,* was published, his journalist friends warned him that he was now living within a sphere of danger, and that he should consider leaving. At first, he refused, vowing to report on the Nazi Party rally in Nuremberg before leaving. However, when American diplomats reported that neither his nor his family's safety could be guaranteed, Mowrer relented. He did however, before agreeing to leave Germany behind, obtained the release of a Jewish correspondent for the Austrian *Neuve Freie Presse*, Paul Golmann, being held by the Gestapo.

A Nazi rally in Weimar, 1932.

On 1 September 1933, the first day of the Nuremberg rally, Mowrer was approached at the train station by a Nazi official, who as Mowrer was aware, was in charge of making certain he departed Berlin. He sarcastically asked Mowrer when was he returning to Germany. 'Why,' Mowrer told him, 'When I can come back with about two million of my countrymen.'[51]

Later that afternoon, as the train slowly departed the station through a curtain of shadowy light rain, Lilian, 'watched him climb into the train, and wondered if he would really get across the frontier safely.'

The next day, she began packing the apartment for an anticipated move to Paris. As a Nazi control officer 'prowled' about the house, Lilian wrapped each of the three thousand books shelved in their library in paper before putting them in moving cases, and sadly reflected on how much Germany had changed since they had arrived in 1927.

While living in Germany ('they were so wonderfully hospitable, those Weimar Republicans…') she had written articles for *Town and Country*, had appeared in a German film, *Liebeswalzer* (The Love Waltz) and had met Marlene Dietrich while the popular movie star was filming *The Blue Angel*. Reflecting back on the many friends and associates who she had come to know during her Berlin years, Lilian would detail her sorrow of leaving them behind in her book written four years later, *Journalist's Wife*. She also confessed that the Germany from where they were departing was a much different place than the one in which they had arrived a decade ago … 'Nowhere have I had such lovely friends as in Germany,' she wrote in 1937. 'Looking back on it all is like seeing someone you love go mad—and do horrible things.'[52]

3

The Beginning of a Cause

A year previous, before the Mowrer's departure from Berlin, on a cold afternoon in February 1932, a group of a half dozen boys came to visit a woman living in an apartment near Berlin's Alexanderplatz.

A knock on the door stirred Recha Freier from her work, that of research on Jewish folklore. When she opened the door, a sixteen-year-old boy stood there, ashen and slender. After politely introducing himself as Nathan Höxter, son of the late Rabbi Höxter, he told her that they were members of the *Brit Ha-Olim*, a group of Zionists. Remembering back on that day, Freier admitted that she had no idea why the boys presented themselves at her home, that is not until the young man began to explain the reason for being there.

'There they stood, thin, excited, gloomy, despair on their pale faces. They told me that they had been sacked from their jobs for no other reason than they were Jews,' she remembered. 'They were looking for a way out... ' Then, they told her of their plans to get to Western Germany, perhaps to find jobs in the coal-mines, '... [or] perhaps I had other advice for them?'[53]

Telling the boys to call back on her the next day, Freier promised that she'd look into the matter, and went back to her study and sat at her desk. However, instead of returning to her research work, she found that the boys' visit had caused her to reflect back on a childhood moment that always reminded her of how so many people in the world looked upon the Jews.

Recha Schweitzer was born in Norden, in Prussia, on 29 October 1892 to parents Bertha and Menashe Schweitzer. Raised in a richly Orthodox family, young Recha was taught that knowledge was truly power in life. Her mother taught French and English and her father taught numerous subjects at a Jewish primary school.

It was on a Sabbath afternoon as she and her family walked through Norden, a small town in northeast Germany, when they noticed a paper fluttering in the wind, displayed on a gate. Recha was too young to know what it read, but she noticed that the adults were terribly upset: 'We stop to read it. I am only four and cannot understand but I hear what the others are saying. They say the sign reads "Entrance Forbidden to Dogs and Jews."'[54]

It was an experience that would stay with Recha throughout her life, reawakened that February afternoon by the boys' visit. Soon, the family would move to another town, and she would find herself in another, awkward situation, that of being the only Jewish girl in the class.

In 1919 she married Orthodox Rabbi Dr. Moritz Freier, a man well-known within the Jewish neighborhood; Recha was now the mother of three sons, and a woman of many talents, a social activist, poet, musician, a teacher, and writer of children's fairy tales. With her husband's

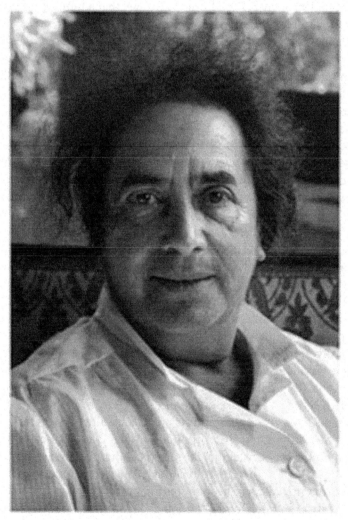

Recha Freier. David B. Green, *Jewish World*, January 30, 2013.

appointment as rabbi, which included living in several cities in Germany and Sofia, Bulgaria, Zionism, her main focus, had to take second place as she excelled in language studies, and by the 1920s her attention turned studying, and lecturing on Jewish folklore.

Described by friends as '[having] a prophetic vision and a fiery temperament, she was known as an enthusiastic worker for Palestine, a friend of the young, and an invincible fighter for any cause which she espoused.'[55] Because she had faced antisemitism from the other children, because she wouldn't write on the Sabbath, Recha embraced and accepted Zionism, and strongly believed at an early age, that a return to their Land, was the only stable future for the Jewish people.

It was because of those boys' awareness of Freier's study lessons on Zionism that February afternoon, and her desire to create a solution concerning the problems distressing the young German Jews, that she found herself now facing that question.

She couldn't have been happier.

'That visit disturbed my peace of mind,' she later confessed. 'The right to work, that is the right to exist, have been taken from these boys and this—because they were Jews. Yet they possessed the full right to live,' she believed, and found herself suddenly struck with a realization that, 'the utter senselessness of Jewish life in the Diaspora stood palpably before my eyes.'[56]

The next morning, Freier, small, fierce, and dark-eyed, acted upon what she called 'the push of reality,' and went to the Jewish Labour Exchange in Berlin, where she was informed that the situation the boys had discussed with her could easily be explained by the sweeping unemployment in the nation. True that was the cause, she reasoned, but when she pushed for solutions for the Jewish children, she was met with shrugs of the shoulder, and instructed to patiently wait, that the matter should take care of itself.

That night, when she arrived back home, Freier retreated to her study where she was alone with her troubled thoughts; two different perceptions soon stirred within. The image of those forlorn boys ached at her heart, the thought that they were cast out simply as Jews, brought up a rage of desperation. Then, the other impulse, one of an almost 'joyous inner voice' that told her, at long last, her prophetic thoughts ever since Hitler had appeared on the scene, were quickly approaching. Her dream drew close. 'I realized,' she determined, 'that this movement grew from the facts of my own past, and that fate had been preparing me for many years.'[57]

Suddenly she understood—her long sought-after desire was about to be realized.

'How I always dreamed of an exodus of Jewish youth to Palestine! But this was only a dream that was never practical,' she would later admit in her diary. 'Maybe, just maybe, now is the time. How helpless that boy made me feel. And how joyous, too. This certainly must be the hour. I must dream no longer. I must make reality my partner. Palestine is their home. They must go to it. It is my home, too.'[58]

The challenge would be overwhelming. 'In 1933, about 525,000 people, or less than 1 percent of the German population, were registered as Jews. Seventy percent lived in large cities with populations over 100,000.'[59] At that time, there was no way for Freier to anticipate the drastic shift in the Jewish population in Germany—by September 1944, fewer than 15,000 remained. Freier was also aware that she needed assistance in making it happen. Searching for answers, she reached out to Enzo Sereni, a Zionist, born in Italy and living in Palestine, who was visiting Germany and representing the *kibbutz* movement. After explaining to Sereni of her plans, it was obvious that he understood exactly what Freier was attempting to do by addressing the German situation—and Sereni told her that he was certain that she was poised to drastically change the German Zionist movement.

The meeting with Sereni inspired Freier. For this woman who believed that God had given her purpose, now there was no lingering doubt, and she was suddenly aware 'that it must be, that it will be and that I will perform it.'[60]

For those who knew her, to lend toward dramatic phrase was a common trait for Freier.

'She seemed utterly disorganized and full of unbelievably impractical ideas … although she was a mother … I am not sure whether she could have fried an egg or made tea,' Karl Stern wrote of her later. A German-Canadian neurologist and psychiatrist, Stern would leave Nazi Germany in 1936 as the Jewish situation deteriorated. 'If she did, she might have kept her hat on, even an overcoat—and it would most likely be a man's coat… Since she thought and lived on a plane of practical impossibilities, she actually carried things out which no practical person could have achieved.'[61]

Several days later, Höxter returned to Freier's apartment along with his friends. She told them of her plan, that they shouldn't stay in Germany, 'that Eretz Israel is your home. You must go there. You can work in a kibbutz. And if you so decide, I shall help you.'[62]

It was suggested that Freier should write to Henrietta Szold, director of the Social Department of the *Vaad Leumi* in Jerusalem. Encouraged, she truly felt it was a first good step, and would lead to assistance from Palestine. It turned out to be a disappointment.

'I wrote to Miss Szold about the problem that had arisen in Germany and my plan for its solution,' Freier wrote in *Let the Children Come*. 'After some delay I received her reply—a negative one.' This was unexpected for Freier. However, her memories of those awful experiences in Norton, and the faces of those young men who came to her apartment, pushed her forward. She would find a way to convince Szold of her concerns that she had spelled out in her response: 'Miss Szold pointed out the existing difficulties with children already in Palestine. There were neglected, retarded and mentally defective cases, which could not be dealt with because of lack of funds,' Recha recalled. 'She insisted that no children be brought over, as new difficulties were liable to be created through them.'[63]

Szold's response reflected her dire predicament in Jerusalem—one of which Freier could not have been aware—with more problems and less monies than she would have imagined since returning to Palestine. Szold's first impulse upon receiving the letter was that the plan seemed shameful to her. For the children to travel to Palestine without their parents, was perhaps the harshest part of this plan. And, she related her feelings in the frankest words, which was, of course, Szold's way.

There were the rumors that Henrietta Szold had decided to return to America and live out the last of her days with her sisters. There were many, working closely with her, who didn't take such gossip seriously. That it was just another rumor of her leaving Palestine—she had announced retirement before—had made it clear just how much she missed America, only to return to Palestine.

There were also many friends who assured Recha, despite Szold's first negative response to Recha's letter, that Henrietta Szold would never abandon a cause such as rescuing the children from Germany, once she realized the deadly results if the Jewish Agency didn't react.

'This letter of Miss Szold's was not only sent to me. A copy of it was sent to the Zionist Organization in Berlin,' a point that disturbed Freier, and for the first time since the youths appeared at her apartment door, caused her to fall into despair. There, it was duplicated and further copies were despatched to all the branches of the Zionist Organization throughout Germany ...' nowhere had the idea found a positive response... 'my plan had fallen through; of what use was it to support a lost cause?'[64]

In June 1932, even though Freier had failed to gather either financial or moral support for her project, a meeting took place that began, at long last, to move events forward. 'I got a telegram from Dr. Siegfried Lehman, the founder and director of the Ben Shemen children's village,' she recalled. 'He informed me of his impending visit to Berlin and asked me not to come

to a final decision about the group till he had seen it.'[65] At last, she had found an ally who believed in her idea.

Lehman arrived in Berlin to discover about forty youths present at Freier's home. The young people stood excitedly in a circle around Lehmann as he explained that he would afford twelve travel permits, providing that they devoted themselves to study farming once they arrived. Freier quickly agreed, and over forty teenagers applied for the twelve permits. One troubling aspect of the journey was that Freier had planned on her children arriving at *Kibbutz Ein Harod* and not a children's village such as *Ben Shemen*. But how could she refuse such an offer? Lehman's plan, at least, would have twelve German Jews arriving in Palestine, justifying her idea.

Financing was the first issue, and that was largely addressed by the *Koenigsberg* Zionist Women who sponsored travel costs and training for five. Leaving seven tickets remaining, one of Freier's friends pawned her jewelry, to cover the 4,000 marks asked for by *Ben Shemen*.

Akiba Vanchotzker, a teacher at *Ben Shemen*, selected the teenagers. Wilfrid Israel, an Anglo-German businessman and philanthropist, described as 'gentle, courageous, intensely secretive ... dedicated to the service of others,'[66] opened up his store, the Israel Department Store, to the youth so that they could purchase any travel items and equipment required. Israel would play an active role in the flight of Jews from 1930s Germany, and into the 1940s. On 1 June 1943, a Luftwaffe fighter would shoot down his civilian passenger plane *en route* from Lisbon to Bristol.

With the parents' consent and signatures, the group was now scheduled to leave Germany the second week of October. As events unfolded over the next months, among the Jewish community in Germany, Freier would become known as 'the dreaming woman.' It was a title that she relished. 'I happen to come from the world of fairy tales,' she admitted. 'There, as you know, everything is anonymous. So, I would like to remain anonymous, too. It's the youth, not me, that want help. I only want to turn dreams and fairy tales into reality.'[67]

On the evening of Wednesday 12 October 1932, Nathan Höxter and his group arrived at Anhalter Station in Berlin. The big clock in the hall of the station told them that the time for their departure was near. A large crowd of adults was there to meet them, as were several Zionist youth groups, standing on the platform, singing Hebrew songs. At one point,

Wilfrid Israel leaned close to Recha and whispered, 'This is an historic moment.'

The group would eventually land on 2 December in Jaffa, an ancient city, once used by Kings David and Solomon as the port receiving imported timbers to build the Jewish temples; it was a place of old, narrow streets and courtyards, often precarious passageways winding through brown, honey-coned buildings. It was the city in which many who made aliyah ('to ascend') arrived. One such witness was David Ben-Gurion, arriving twenty-six years before in 1906, who was destined to become the first prime minister of the new land of Israel. 'The spirit of my childhood and my dreams had triumphed and was joyous!' Ben-Gurion wrote in his diary. 'I was in the Land of Israel, in a Jewish village ... the howling of jackals in the vineyards; the braying of donkeys in the stables... the murmur of the distant sea; the darkening shadows of the groves; the enchantment of stars in the deep blue; the faraway skies, drowsily bright—everything intoxicated me.'[68]

Could this first group of children realize, was there a thought in their minds after they had traveled so far, that in their weariness, that they represented the vanguard of thousands of children who would make their way to Palestine? Theirs was an account of rescue before and during the Second World War; of Youth Aliyah, or as it came to be known in Germany—*Jugendaliyah*.

Franz Ollendorf and his wife Ruth, officials of the Youth Aliyah School in Berlin, were witnesses to the affair unfolding at the station. Franz, 'we see them once more in our mind's eyes,' would reflect on how the anxious children awaited their turn to go to Palestine, replicate that of all the students, and how they represented the character of German Jewry of that period merely from the outward appearance and behavior of the children in the class: 'Next to the hungry and ragged ghetto children sat the smartly dressed son of a banker from Grunewald. His trousers were creased, he had a silk handkerchief in his pocket and wore a gold tiepin... sitting next to the village lad from Hessen who was as restless as quicksilver,' Ollendorf wrote,

'The pale, thin boy wearing the uniform of a porter was always looking about him with his youthful, sparkling eyes. He worked every afternoon at the Aid Committee for Jewish Youth, and on Sabbath his voice—clear as a bell—was heard in the synagogue choir. Betty worked every afternoon, serving at her parents' shop near the Stettin railway station. Dora, whose eyes were tired from night work, helped her mother in her business sewing corsets.' Henry was busy thinking of the barrow with which he had to cart coal from the cellar to the customers—work which usually lasted until

midnight. 'Yesterday we took Paul out of the furnished room he had rented after he was sent away from the orphanage. His father had died, and yesterday his mother married a Persian.'[69]

A tapestry of childhood, as Ollendorf remembered. Children staying. Children leaving; however, the ones left behind continued in the school with them, as long as there existed the slightest hope of them traveling to Palestine with the Youth Aliyah workings. 'Some were with us for two full years.'

Then, suddenly, the station seemed to come alive with excitement. Events moved quickly now. The order came: 'Take your seats.' Doors were slammed. One late traveler was dashing forward," Ollendorf later wrote. 'I went from window to window, shaking hands... "Stand clear;" the stationmaster raised his flag. The windows full of faces glided past. Handkerchiefs were waved. A trembling voice from afar— "*Shalom*, see you again soon." For a moment I close my eyes, and as soon as I open them again, I see only empty rails. On the bridge beyond, and elevated train with red carriages passes and brings me back to reality.'

Cheering broke out throughout the crowd as the train left.

'The work had begun; no one could interfere with it anymore,' Recha wrote confidently after that afternoon at the Berlin train station. 'It would progress and develop and all those children standing there around me, full of hope, excitement and enthusiasm, would reach their goal.

'The platform seemed to tremble under my feet ...

'The parents wept.'[70]

4

A Summons

'When the moon is full in Jerusalem the sky is starless and the cypress trees are silver. When the moon is a salmon-colored sliver cutting the horizon, the sky is splashed thick with stars. This is not a phenomenon. It must be so elsewhere. Except that there is a calm intensity about Jerusalem which precludes elsewhere. There must be old stone walls elsewhere. And resigned olive trees. And unresigned cypress trees. And church spires. And mosque domes.

And crazy winding lanes. But these things are not Jerusalem...

... Jerusalem is a woman who sits among bleak hills combing her hair and smiling.'

-Dorothy Ruth Kahn, *Spring Up, O Well*, page 148.

In March, 1931, after an eighteen-day journey, the SS *Saturnia* brought Henrietta Szold back once again to Palestine, that land where, by now in her late years, it was destined that she would live out the remainder of her life. Szold, during the journey, reflected of how now she was such a different person than she was in 1909, as she traveled Palestine accompanied by her mother. The journey then had been to escape personal loss, a tragedy of the heart of which her mother had hoped distance could soften. Szold now returned with purpose, after all dark clouds stirred over Europe, enlightening an awareness that the dangers and perils of the future would be a long time in being resolved.

She was seventy, not quite five feet tall, believed in being plain looking, having always been plain, always refusing to change; and, once considered overweight, she was much slimmer than she had once been; she felt more attractive, as many agreed. She continued to walk at a faster pace than some 'older' people, and often slowed to accommodate them. And now, of course, she returned, not for those often-dreamed days of being pampered by her sisters, late evenings spent on Adele's porch in a rocking chair (she was well aware that returning to Palestine now had all but dissolved that life); for Palestine was a vastly different place also, than that land of a decade ago. 'Miss Szold, like the prophets of old, well knew her Palestine and her Jews,

a contentious and stiff-necked people,' Fineman wrote, 'as Moses had learned long ago; but they needed and wanted her. And this, at seventy, was still the elixir of life for Henrietta Szold, the woman: to be needed and wanted.'[71]

On that March afternoon, Szold's ship landed at Jaffa harbor and was met by friends and associates; later, when they arrived at the Eden hotel, she found the lobby crowded with well-wishers. Soon, she discovered that even her most personal habits—eating habits, no less—became public notices, thanks to a hotel waiter. 'She takes no more on her plate than she can finish, and when 'she asked for four prunes she never means five.'[72] She was prompt of schedule and expected that of everyone who worked around her. Her morning bus left Jaffa Road at 7:45, never earlier, never later, and for those on the early morning streets, to see her was a daily occurrence, the 'gnome like little woman of seventy wearing gloves, carrying a heavy briefcase, who would not take a taxi or auto when she could take a bus.'[73]

While in America, Szold, startled at her election to the Jewish National Council, had no idea who had supported her election, until arriving back in Palestine. In fact, Szold had little idea of what to expect when she returned, or was really certain of her decision. Weeks before she had written, 'My mind is a blank on my future...'[74] Surprisingly, she learned that her election had been assured by the Mapai, the Workers Party of the Land of Israel. 'They gave up one of the seats to which they were entitled,' Szold wrote to her sisters from Jerusalem in June 1931, 'in order that I might be assured a place. Their intention was that I should be the seventh member of the Executive, the member holding the balance.'[75]

Then, it became apparent that when she was appointed head of the education department, the purpose was obvious in that she would be used to raise much-needed funds. The financial depression had dampened the ability to raise monies, but she had also been elected to divert the opposition of the education department to the JNC from Zionist Executive control.

For numerous reasons Szold's election was opposed by many Mapai leaders, despite the possibility of the JNC being used within the *Yishuv*. However, one leader who supported Szold was David Ben-Gurion, he understood the strengths that she brought forward, outside of the relationship she held with the mandatory government [she knew how] 'to speak to them in their own language'; 'There are few among us who are suited to such constructive organizational work. Miss Szold is suited,' Ben-Gurion assured the members during a central committee meeting in March 1931. He then continued explaining that such an appointment would

strengthen his party's situation. 'To gather around the workers all who might be close to them. Although Szold is not a socialist, she is one of those decent Zionists,' he stated, 'who are fast disappearing. She is a woman and she is an American, and by bringing Szold in, we are bringing her closer to us, along with an important circle of Americans, who hear baseless things about us, and whom she will bring closer to us.'[76]

Back in Palestine and in her new routine, Szold did realize that she was older and had to make her world move more slowly, more cautiously; though not happy with such self-confession, she immediately sought out, working at task within the JNC, that which proved her greatest strength—habit and hard work.

'The demands upon me are as exacting as ever, and this year I am getting no funds with which to assuage and help,' she wrote weeks after her return. 'I think I am more callous or more experienced. No single individual can make a dent in the welter of conditions. So, I don't go to the office at seven as I used to, but at nine,' she admitted. 'I leave the office when all other well-regulated humans leave it; and I listen to woes and shake my head sadly, and I refuse. The two hours gained in the morning I devote to reading, systematic reading. And I sleep more, I even take a nap during the day.'[77] She also regularly scheduled throughout the day performing her gymnastics, and then a Hebrew lesson.

Soon, the work load and the long hours, once again, began to take their toll on her. 'In my work, the plot thickens.'[78] For Szold, reading and her garden was her only escape. The garden, so much so, that she wrote to her sister, Bertha, at great length about it, her shelter from those situations to which she had returned—no funds, no organization at the local communities—until she felt like 'a squirrel in one of those barbarous cages.'

> I have been enjoying my garden, consisting of pink hydrangea and a pot of varied cacti. It is queer about the hydrangea, a plant I've never had any fondness for. I classified it in my mind (or heart) with the old-time dahlia. Someone gave me the plant, with not a vestige of a bud on it, and I was speculating how decently to disembarrass myself of it when, lo and behold! I found myself getting very fond of it. Why? Because it's a toper. It claimed my attention morning and evening. If I didn't water it abundantly—more generously than the Jerusalem water supply permits—it drooped so pathetically that I had to devote myself to it. The result: six great blooms such as they print in the seed catalogues, and more coming. And the cactus also had bloomed gloriously. You see, I am getting to be as domesticated as Adele's cats.[79]

That Szold welcomed the solitude found in her garden, would not have surprised those who worked with her because they knew her secret. Though she was a widely known figure, and later, rising to the level of a national heroine, Szold would ever remain distant. And, that was the way she truly liked such things: 'She wasn't at home with the people,' a fellow worker in the thirties recorded. 'I don't care who tells you that she was … She spoke Hebrew but never with ease, never with ease… She had surrounded herself with the things that were home … home meaning America. She was quite a bit of a botanist, but tending to all these little plants was to remind her, always to remind her.'[80]

It wasn't as if she would ever admit that she worked hard to fit in, it just happened. Still friends and acquaintances, 'everyone,' tourists from America, nurses from the Rothchild Hospital came to her apartment for tea. 'It was the most interesting afternoon when one went to see her,' a nurse remembered. 'She spoke of literature, of anything under the sun, and with such understanding—and she was a very charming hostess, she'd go out of her way to make you comfortable, you felt uncomfortable because of it."[81]

It was during a late afternoon when Szold peered out the window beyond the deep, wide window sills lined with her row of flowers to be carefully watered every day. Beyond she overlooked Jerusalem's Old City, 'walled-in towers and spires and cupolas,'[82] intermixed with the new sprawling structures of whitish gild-stone, as decreed by Ronald Storrs, an official in the British Foreign and Colonial office.

Finding this view from her hotel so stunning, Szold truly believed that anyone gazing upon ancient Jerusalem for the first time, "should see the Old City first from the terrace of the hotel because it will be too excruciatingly lovely—to be all real,' Szold's good friend and journalist Dorothy Kahn Bar-Adon (she was then known as Dorothy Ruth Kahn) poetically wrote during her first visit to Jerusalem several years after Szold's return. A year into the Second World War, Szold would become godmother to her son, Doron. 'Then pass through Jaffa Gate into David Street and drench yourself in the reality of it,' the journalist would write, ' in the sound and colour and movement which is the flesh and blood of the Old City… and the Arab vendor has studded big flat white cheeses with red roses, donkeys and tumbling children and overladen porters and bearded rabbis and white-turbaned Muslim sheikhs… and the blind coffee grinder who for thirty years has stood just so in this little booth draining his life into this single circular movement.'[83]

Finally, Szold turned from the window, after one last glance up to Mount Scopus from where the Roman emperor Titus had prepared the

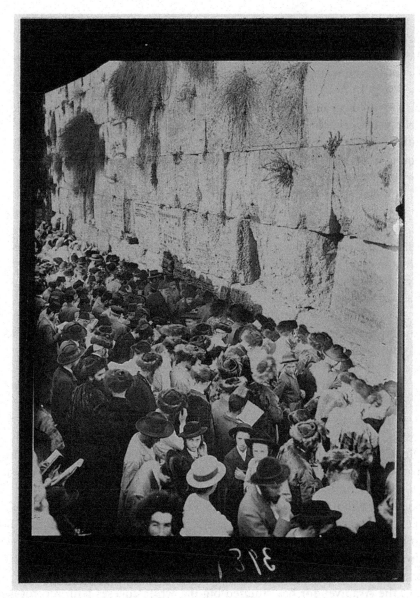

Atonement Day Crowd at the Wailing Wall, circa 1933.

destruction of the Holy City in 70 A.D. And, in that brief moment, she understood, giving one pause, as she retreated into her apartment. It was now in this time, at that moment when she returned to Palestine, that there were the still moments of peace before the storm.

It was a simple room that Szold entered from the balcony, with a bed (draped with a coverlet and cushions bought by friends), all presenting the appearance of a studio couch, a wash stand (hidden by a screen so that she could hang stockings and underwear at night), and a Morris chair, considered dreadful to those who forced the issue. It was in the public salon downstairs, where she met frequent guests.

Not at all, Szold often questioned, what she would have considered appropriate to spend her later years. But, as she often did, in making the best of a situation, she spent ten dollars on a set of bookshelves. In July, she would write home from Jerusalem, 'my room and my bookcase continue a delight, and for the last two weeks (her own books- 'what a silly business I have made of it all').[84]

With her return to Palestine, her reinvolvement in the workings of the agency and her responsibilities, she was well aware of the task laid out before her. As a matter of fact, since arriving in 1920, and from that moment until now, there never seemed to be enough time in the day. Now, in these days of the early 1930s, with the dark rumblings from Europe, it still seemed nothing had ever changed. 'I have been back in Palestine eighteen days, as many days exactly as the passage across two oceans last,' Szold wrote to a sister on 5 June 1931, 'and I am only now finding a quiet moment in which to tell you that I have arrived."[85]

Yes, she was back in Palestine, that mystical and beaconing land. And, from time to time, as on a late afternoon gazing over Jerusalem, she reflected on those days on another time when she came.

<p style="text-align:center">***</p>

How long ago it seemed, how vibrantly innocent those days in the spring of 1920 as Szold came to Palestine, determined to lead the Holy Land out of the dark ages, at least concerning the construction of hospitals and clinics for all Palestinians. She had witnessed the shocking lack of medical services in 1909 as she and her mother traveled throughout the land. Such sickness and illness among her people, especially the children.

When she first arrived in 1920, Szold was provided a place to stay until she was able to settle into a place of her own. It was in the northwestern part of the city, conveniently located nearby to the offices of the Medical Unit and the Zionist Commission, located on the Street of Prophets (*Ha-Neveem Street*) a beautiful place, 'an Arab house set in a garden, with two steep staircases inside and high-ceilinged squarish rooms and a few large pieces of furniture brought from Europe.'[86]

The arrangement was quite convenient because it was the home of Dr. Helena Kagan, supervisor of the Medical Unit, who was away in Europe when Szold was greeted by her mother and settled into the two rooms prepared for her, 'even mosquito netting over the windows and a little maid with a room of her own.' It was a convenient affair because it gave Szold a place to settle, at least for a short while, because when Kagan returned from her trip, it quickly became apparent to both that they would never get along. Szold found this young woman, tall, thin, and intense and nothing like her gentle mother, who Szold had quickly grown fond of as she cooked and gossiped with her. Alice Seligsberg, a close personal friend to Szold who was involved in the founding of Hadassah in 1913, and Dr. Kagan got along. However, despite common dreams involving the growing health services, she and Szold never did. This would present a problem because Seligsberg had announced that she was leaving later in the year for America.

Seligsberg's friendship had come to mean something very special to Szold. Her friend who had helped her so much through the darkest day of her life when she was abandoned by Ginzberg, was now leaving and would turn over the head position of the Orphans Committee, formed to aid Jewish war victims. She was also a board member of the Institute for the Blind in Jerusalem, along with many other duties, which led Szold to remember the advice she had given Seligsberg when convincing her to join Hadassah in 1912. 'I will not take up much of your time.' Unmarried in her late forties, Seligsberg was 'gentle, pretty, of dedicated refinement, with a hunger for the spiritual,' as described by Joan Dash in *Summoned to Jerusalem*. She had looked to Szold 'as a wiser, stronger figure, as Szold looked to her as 'spontaneous,' writing to her friend in the early days of the century, 'you are so earnest and single-minded,' Szold confessed, 'so stimulating to me, so whole a personality, that I recognize unity in all you do and say.'[87] Szold would also remember a stirring letter her friend had written as the Palestine advisor to Junior Hadassah: '[We] must say that we think of tasks not merely as medical enterprises or children's services, but as educational projects in the highest sense for Palestine as a whole ...' she wrote in a letter. '...Our ultimate task-the Zionist hope-however, is the upbuilding of the Jewish Homeland as a socially just and creative community, creative in every domain, in science, in art, in religion, a community in which every person may develop to the utmost of his power.'[88]

Despite their vast differences in personality, and it was obvious as to why the doctor was drawn to Seligsberg, Kagan did realize that Szold was

truthful and inspiring: 'awe-inspiring and very single-minded... I told her she was hard sometimes, yet she was so modest. She was extraordinary. She wasn't a usual person. She wasn't easy.'[89]

There were also other rude realizations when Szold arrived, other than her clashes with Kagan. That a new world entered was never as one would imagine, some insights, drawn after several months, not foreseen. 'The new people—a war-created generation—who are coming here are wonderful,' she would write a year after arriving in Jerusalem. 'But I cannot, cannot accept them. I want to—and I cannot.' Szold had inherited from her father a love of order, a strictness of schedule and purpose, and those who she dealt with in this new land simply didn't. These "new people" were the East European pioneers—the *halutzim*—who arrived equipped with their socialism and their principles of labor and a Jewish return to the soil. 'Disorder nauseates me. And they are systemless.... Yet they are heroic, not I,' she admitted. 'If indeed I am fine and aristocratic as you say I am, why do I not embrace them?'[90]

Despite the realizations, and the problems, and the homesickness, Szold was determined to make good on her promise to see this through.

Alice Seligsberg's replacement finally arrived from America, and shortly after Seligsberg departed Palestine. A great friend had left her and Szold couldn't hide her feelings, the homesickness and loneliness. 'I miss her terribly,' Szold wrote to her sisters several weeks later. 'I feel very far away from you all and I can't deny that I am distinctly homesick.'[91] Sophia Berger was that replacement, thirty-eight-years old, and considered by those who knew her as remarkable, despite strange habits and peculiarities; she was thrifty; she saved string; she was sociable and gossipy, 'a mine of information, much of it incorrect;'[92] and she had a certain superiority. An English friend remembered her as 'the ugliest woman I ever clapped eyes on; she grew uglier with time.'[93]

Despite her apparent sour appearance, Sophia Berger would prove the stabilizing force that Szold needed, informing her new friend that she would find 'an establishment' and while Szold managed the business of the Unit, she would manage the household affairs. The two became immediate friends and a photograph was mailed with a letter to family within the week after Berger's arrival showing the women, the ruins of a stone wall as their background, frowning beneath a beaming, hot noon day sun. On the back of the photograph was an inscription: 'Henrietta Szold and Sophia Berger picnicking at Ramallah, 1920.'

It was summer when she and Sophia let a small, stone house near the Jerusalem outskirts surrounded by both European and Arab neighbors.

From the window, beyond a modest, stone garden one could see the Mount of Olives, and in the distance the British Military Cemetery where Szold had witnessed Winston Churchill speak briefly on a Sunday the year after she had arrived. It was as if every foot of Jersualem held a visual enchantment for someone who had been raised in Baltimore. 'Old men sprawled in the sun by the Western Wall, dazed and motionless, babies lay torpid in their mothers' arms, and from the Arab cafes gramophones shrilled monotonous Oriental chants, hypnotic, piercing.'[94]

The house was heated by a 'smelly kerosene stove', which caused Szold great concern for the winter months. Pleasantly, however, she found the house, even during the 'searing heat of the Palestinian summer' as agreeably cool and shady.

The garden gave Szold a different perspective on life at once and her feelings toward being homesick without anyone to share that agony. But soon, because Berger loved to be with people, Szold found herself surrounded by visitors at her home; Saturday afternoon teas with friends, or Saturday morning Sabbath prayers. Norman Bentwich and his two sisters, Alex Dushkin, and poet and good friend to Szold, Jessie Sampter, soon made up the inner circle. She remembered that it was those simple things in life, much as it was during her childhood on Lombard Street. How she walked in the garden with a copy of *Gray's Botany* ('...I knew how charming our house set in its dear garden ...'). However, her new Palestine home, presented the same wonders, wonderful window plants planted by the Arab proprietor; 'and through the leaves, touching them with delicious gleams of color, streams the sunshine ... You see how I always get back to the sun. Can't help it. It is the dominant fact in Palestine. In the interval between the first rains and those bound to come some time or other soon, we are having golden days. What's the use—I can't describe them.'

Szold had been so busy and preoccupied back then, with the task before her that it was the first week of December before she wrote her sisters. Instead of describing the overwhelming business of organizing medical services, or the constant budget struggles, Szold wrote simply of an important event, for a woman—an unassuming hair wash— 'This morning I stayed away from the office—my first indulgence due to Dr. Rubinow's return [when Dr. Arieh Rubinow returned to Jerusalem with his family, Szold handed back to him the directorship of the American Zionist Medical Unit]. For what? Oh!' she wrote. 'You know what one does when one has had no time for femininities for months and months. First of all, a hair wash, under the douches [shower-baths] which I have learned to love in spite of the cold, the bitter cold, on the top of the mountain called

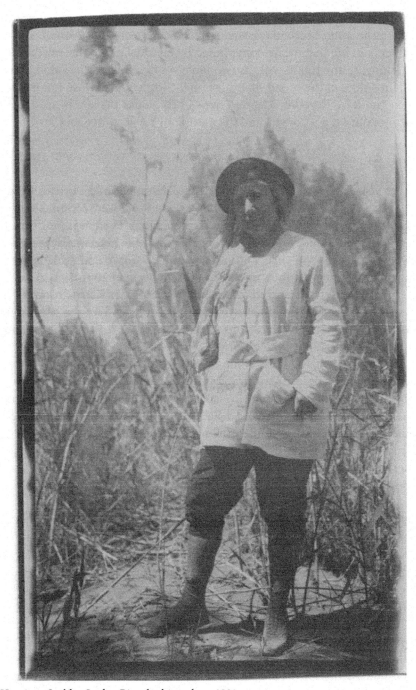

Henrietta Szold at Jordan River bathing place, 1921.

Jerusalem.' At last, it all meant that Szold was settled in her life in Palestine, despite the long, hectic days; that she could reflect on the small, silent moments in life that meant something. 'It was a delight to dry my hair in my sunny, sunny room, with its two large south windows. I could hardly remain sitting in the broad shaft of sunlight while it dried—so hot it was, when you have the contrasts, one enjoys here. Once the sun is up, genial warmth; once it goes down, and the minute its down, bitter cold.'[95]

<center>***</center>

Eleven years later, in late 1931, the world and Palestine and Henrietta Szold, had moved through many changes. Berger and Szold were roommates for three years, and then Szold had moved into a hotel. There was new threat arising in the distance—that always seemed to be the case, menaces to the Jewish land, Arab violence, and old age quickly approaching. However, some habits remained the same from those days in 1920 to 1931. Friday afternoons were still reserved for writing letters to her sisters, completed by sundown because Szold never worked or wrote on Saturday. And, she was always seeking out news from America, because America, home and family, were constantly on her mind.

She thought of 702 West Lombard Street in Baltimore, because it was there among this beautiful, warm family life where Henrietta and her five sisters flourished, surrounded by a house full of Jewish tradition and learning. Two sisters—Estella and Rebecca died in early infancy. Rachel, Sadie, Bertha, Johanna, and Adele followed Henrietta. It was at home where Henrietta learned German and Hebrew, and read the Jewish sacred texts, where she adopted the intellectual interests of her father, ancient and modern history, poetry, and philosophy.

Of remembering that from Papa, she learned books and history, and that at the age of twelve she was already editing proofs in a new prayer book that Papa was writing, in German no less. Of his warm and welcoming study with row upon row of books in Hebrew, Latin, Greek, French, and English. The cushioned rocking chair in front of the gas fire where he read. It was from him that she inherited a warm personality that drew people to her, gathered them close, listening, and eager to follow.

From her mother Szold inherited her sense of the practical, a daily urgency for organization in both the large and the smallest details. 'I think my whole intellectual make-up is my mother's,' Szold would say, 'because I am practical, my mind runs to details and I have a very strong sense of duty.'[96] All things taught and learned within the large, cool kitchen and the

garden filled with grapevines, and flower blossoms—one of her tasks was to always have fresh flowers gathered from the garden and placed throughout the house—and a fig tree where Henrietta would take her leave in the shade, and read.

In August 1905, years before she and her sister would find themselves separated by that vast ocean between America and Palestine, she had written a letter to Bertha, and shared her close feelings of their childhood times together: 'I find my mind dwelling on the old peaceful, harmonious days on Lombard Street. Was it really so harmonious, that life there in the back garden . . .? Take such an isolated feature as Friday afternoons. Do you remember the peace and clean-washed quiet that settled upon the house between three and four?'[97]

Reflections of her father's study, her mother's garden, the younger sisters disturbing her writing as she sat at her desk beneath the upstairs window, was always close at hand. Even years later, into the 1940s—the war, the constant danger for the European Jews—all of which gave her pause in realizing that her dreams of America, and her return to that land, would probably not be realized. There was still too much to do.

'It is Lombard Street,' she finally wrote from Jerusalem, 'that makes for sympathy and understanding; the rest may do its worst or best—it won't eliminate that.'[98]

5

Judische Jugendhilfe

In the autumn of 1932, amidst a swirling storm of legal persecution and violent acts against Jews in Europe, there arose, shaped through the fear of safety, a wave of immigration, mostly from Germany and Poland. There was, now openly in plain view for anyone to notice, an uneasiness for the European Jew. One German Jewish woman, as Szold discovered one day, was Mrs. Warburg who was linked to Szold's past. She was the granddaughter of a rabbi who had been responsible, in 1859, in securing Rabbi Szold the appointment to Oheb Shalom in Baltimore— 'and now the paths of their offspring had met in the Land of Israel, in this "gathering of the exiles."'[99] This was looked upon as 'forced' migration. However, between the two World Wars, over five thousand American Jewish women, both single and married with families, migrated to Palestine. They came freely.

The *Yishuv*, the Jewish community of Palestine, was rapidly growing, as the dream of a self-governing state appeared more so of a reality each day. Szold took notice of both thoughts.

Asked to present the valedictory address at a sports meeting in Tel Aviv, presided over by Mayor Dizengoff, Szold took the opportunity to present the story of Israel's restoration in a unique way: 'The distinctive task that sets it apart from and above every other *Yishuv* in the world is creation. Creation for finite man can be only a process of combining existing materials and elements into new forms...' Szold told the large gathering. 'In Palestine the eternal people search its storehouses for what is known to be there and for what has sunk into oblivion of disuse. The hand, the eye, the whole body, the mind, the soul are trained anew to restore atrophied possession to use. That is the essence of consciousness, of creation.' Szold recalled for them that 'the soul that would be strong and sane and noble must be houses in a body that is vigorous and healthy and well-proportioned and upstanding ... normal humanity is not a disembodied spirit but an aspiring spirit encased in solid flesh and vivified by fast-coursing blood.' Then, she assured them that their commission was 'the task worthy of the unshackled to find the way of Jewish life in the Jewish land that shall be irradiated with the beauty of holiness...' Szold assured

them '... The hallowed land is spread out before you in its bridal charm. It invites you to go forth and view it...Drink in its inspiration.' At the end, her words were as if she were sending them out as the Jew worthy of living must make himself a complete man, forgetting no part of his people's heritage... 'Carry these sights and sounds and new memories back with you to your homes here and in the Diaspora,' she urged, '... with the mandate of my generation to yours, of age to youth, of age that has completed its work and is ready to pass the torch of Judaism on to youth with willing hands...'[100]

<p style="text-align:center">***</p>

It is one of those oddities of past occurrences, an unexpected alignment of dates in history, that occasionally mystifies us; in that darkness and light, that the Society of Youth Aliyah would be established on the same day that the National Socialists, the Nazis, were sworn into office.

'On 30th January 1933, the first official meeting took place at the office of Dr. Hugo Fuerth,' Freier would write. 'At first the name of our society was discussed... later on, the constitution of our society was discussed, and the first paragraph read: "Aim of the Society: the vocational training of unemployed Jewish youths in Germany and their settlement in Palestine."

'When we left the notary's office after the first constitutional session and turned into Unter den Linden, we witnessed a torchlight procession. [Then it struck her...] On the very day the Nazis took office, 30th January 1933, we established the Society for Youth Aliyah.'[101]

Amazingly, with the shift in power, and Hitler's pointed and open and hateful discourse, there were many, even within the Jewish community, who continued to disconnect from facts through those days, refusing to admit an approaching madness. Journalist Lilian Mowrer had written about such denial several years before in her autobiography *Journalist's Wife*: 'that blindness to facts—what [Karl] Tschuppik, the Austrian author, calls the German sixth sense, "the sense of unreality..."'[102]

There were those, however, who did sense the shifting, sinister atmosphere in Germany, who anticipated the quickening of the hatred and violence against the Jews, now that Hitler was in power. George Lubinski, who directed the *Zentralausschuss's* department for social work and occupational retraining, at once recognized the significance of Palestine for this Jewish young generation. '[Only those young Jews] who found the way to the land of Israel, or were educated in and promoted the spirit of Zionism or at least the spirit of upbuilding Palestine, had found meaning in their

lives.'[103] Lubinski would leave Germany for Palestine in November 1938 after the eruption of deadly pogroms.

Hitler had eaten a late supper with his inner circle the night of the 30 January—Hess, Göring, Goebbels, Röhm, and Frank. It was a private small room. 'This evening marks the end of the so-called "Red Berlin" referring to Communism. During the meal the conversation shifted between several subjects that came to the celebrating Hitler—the death of communism, and eventually how Hindenburg now trusted Hitler: 'The Old Gentleman liked it very much,' Hitler told the table, 'When I said to him today that I would serve him as Chancellor as loyally as in the days as a soldier when he was my hero.'

Later that night, Joseph Goebbels, Reich Minister of Propaganda, wrote in his diary: 'It is almost like a dream … a fairy tale… The new Reich has been born. Fourteen years of work have been crowned with victory. The German revolution has begun!' Goebbels stopped writing and reflected on 'the prophetic words written by a Jew less than a century earlier, Heinrich Heine, German poet, writer and literary critic, 'German thunder is truly German; it takes its time. But it will come, and when it crashes it will crash as nothing in history crashed before. The hour will come… A drama will be performed which will make the French Revolution seem like a pretty idyll … Never doubt it, the hour will come.'[104]

'The Third Reich, born on 30 January 1933, Hitler would proclaim at Nuremberg on 5 September 1934, promising that "it would endure for a thousand years," then in the days after, in Nazi parlance, was often referred to as the "Thousand-Year Reich." Instead, it lasted twelve years and four months, but in that flicker of time, as history goes, it caused an eruption on this earth more violent and shattering than any previously experienced…'[105]

It was in those days that the newspapers in Palestine took notice and began reporting the happenings of Hitler's ascent. On 31 January 1933, the day after Hitler became chancellor, *Haaretz*, the liberal daily, printed an article decrying the 'hugely negative historical event.'[106] Just over a week later, it printed a headline warning, 'BLACK DAYS IN GERMANY.'[107]

However, newspapers in Palestine, apparently wishing for the best concerning the Fuhrer, and as did the British press, attempted to calm its

readers. *Haaretz* encouragingly wrote a month later, in early March, 'One must suppose that Hitlerism will now renounce terrorist methods: government brings responsibility.'[108] *Doar Hayom*, a right-wing publication, agreed. 'There can be no doubt that Hitler the chancellor will be different from the Hitler of the public rallies.'[109]

As the months passed, and actions against Jewish citizenship and the freedom they once enjoyed in German culture, were disturbingly affected by Hitler's decrees, most, finally, admitted the truth. It was a hateful regime who was now unchecked toward their purpose. Shifting from reassuring, *Haaretz*, in mid-March wrote a defiant editorial, '... all the Hitlers in the world cannot eliminate the names of Kant, Goethe, and Schiller from German history.

6

A Swastika over Jerusalem

Jerusalem: the face visible yet hidden, the
Sap and the blood of all that makes us live or renounce
Life. The spark flashing in the darkness, the murmur rustling
Through shouts of happiness and joy. A name, a secret.
For the exiled, a prayer. For all others, a promise. Jerusalem:
Seventeen times destroyed yet never erased. The symbol of
Survival. Jerusalem: the city which miraculously
Transforms man into pilgrim; no one can enter it
And go away unchanged.

-Elie Wiesel, *A Beggar in Jerusalem*, p. 11

On a spring morning in mid-March 1933, citizens of Jerusalem awoke to a sight that chilled the hearts of the Palestinian Jews. Flying in the morning breeze above the German consulate roof, a romantic, small stone house located on Prophets Street surrounded by pine trees, waved a red flag bearing a black swastika over a vast white circle. Earlier in the week, President Paul von Hindenburg had ordered German embassies throughout the world to fly the National Socialist flag alongside the German Republic flag. In Jerusalem, it was German consul Dr. Heinrich Wolff, who ordered the flag supplied by a local Nazi Party member, despite that his wife was a Jew.

Members of the *Betar* youth movement, a right-wing Zionist organization, succeeded removing the symbol representing the oppression spreading throughout Germany.

After the first flag was removed by the Zionist, a second swastika flag, hand-embroidered by orphaned Arab children and presented to Wolff by Frau Maria Schneller, director of the Schneller (Syrian) orphanage, was raised above the consulate.

There were requests and efforts between the *Yishuv* and the British governed Palestine under the British Mandate, to remove the flag. However, Britain held diplomatic relations with Nazi Germany, and until such relations were terminated, German consulates were to remain located in

Palestine—and to fly the flags of their choice. The Swastika, despite the troubling meaning for the Jews in Jerusalem, would fly without restriction.

And, it remained for the first six years of the birth of the Third Reich, until the German invasion of Poland in September 1939, commencing the beginning of the Second World War.[110]

The Jewish community in Palestine would live under the very threat symbolized by that flag, until German General Erin Rommel's famed, and once-regarded as undefeatable, Afrika Korp was defeated at El Alamein on 4 November 1942 in the desert sands near the Egyptian western frontier.

<p style="text-align:center">***</p>

In April 1933, Recha Freier arrived in Jerusalem to call on Szold at her office in the Vaad Leumi. 'I fixed my departure for Palestine for the beginning of May 1933,'Freier later wrote from Berlin. 'I intended to carry on the struggle for immigration permits in Palestine itself.' After reaching Marseilles, 'encircled by silent, dappled mountains,' and after a few days' voyage 'I saw the sun rise above the shores of Palestine and a little later my feet touched her soil.'[111]

Also, in the spring of 1933, Szold's sister Bertha had arrived, and Szold spent a good bit of her time taking her sister on enjoyable journeys around the countryside; to Meron, the village of the Kabballists, and to Mount Scopus where the two sat in the amphitheater as the high school children sang "Judah, the Maccabee" in Hebrew. They visited Petra, the dead city carved out in the pink desert rock, and even Szold admitted that she witnessed sights for the first time because she had been so busy working. She relished Bertha being there, it was a welcome break, and at least for a while, she even considered, once again, packing for home.

However, Bertha finally left alone without her.

With her sister gone, Szold returned to her work, and finally scheduled to meet with Freier. The woman from Berlin immediately impressed Szold who later wrote, that she had received that afternoon, 'A high-spirited, energetic woman who stared at you with intense black eyes.' Szold, well aware of her guest's following among the German Zionist, knew also that Freier defined the Jugendhilfe organization, and was nothing less than a hero for the group of children who were waiting to leave for Ain Harod. Freier had also found supporters once arriving in Palestine. 'In Jerusalem I met with Dr. Arthur Ruppin, one of the founders of the city of Tel Aviv, and Dr. Joseph Lurie,' Freier would later write, 'who were both interested, sympathetic, anxious that the plan should be put into effect.' Unexpectedly,

upon arriving at Szold's office, after Freirer meet her, '…and told her about the formation of the Youth Aliyah organization in Berlin, the desire of the youth to come to Palestine… my visits to the settlements in Palestine [and] their wish to take the youth groups…Miss Szold again turned down my request.'[112]

Szold quickly solidified her position, repeating her initial reasons for turning Freier down upon receiving her letter over a year ago. Szold still felt that the wants of Oriental children in Palestine were far greater than the needs of bourgeois children in Germany; and, that, with her knowledge of the texture of Palestinian life, she was content in believing the German children were better in Germany with families. Also, unknown to Freier when she had received her letter from Berlin, Szold had consulted with several of her friends about how to respond to this suggested scheme. Dr. Arthur Biram, principal of the Reali School in Haifa, and Dr. Ernest Simon, a teacher, both thought it imprudent to bring the children to Palestine without the means of supporting them or allow them to study.[113]

'Mrs. Freier replied that she didn't come from social work [as Szold had suggested]. She didn't understand social work. She understood Germany, the needs of the German Jewish youngster,' wrote Joan Dash, 'but social work—she was in quite another world.' There the discussion ended. Mrs. Freier came away from the interview with the conviction that … 'Miss Szold was rigid, unfeeling and determined to ride roughshod over all who opposed her.'[114]

Freier departed Palestine without accomplishing her goal, that of convincing Szold of the benefits and the potential of Youth Aliyah. 'The hour of my return journey was approaching,' she said shortly after her meeting. She had made many friends, most of who desired to see Youth Aliyah work to the advantage of the children. They had assured her that an organization could be created in Palestine, responsible for the project, including securing immigration certificates, heading up the training of arriving groups. Journalists soon came to her cause, and wrote supporting editorials: 'I advise establishing an organization, journalist Yosef Aharonovitz wrote in the May 4 issue of the Palestine Hebrew daily *Davar*, 'which will focus all its efforts to rescue the Jewish children of Germany and transfer to the Land of Israel. By Jewish children in Germany, I refer to children from the ages six-seven to fifteen-sixteen. It will be possible,' Aharonovitz concluded, 'to obtain great sympathy throughout the world for this project … I believe with complete faith that the rescue of German Jewry from a national historical perspective—is first of all and most importantly, the rescue of the children of German Jewry.'[115] The public

support and those of officials she met, prepared Freier to leave for Berlin, with at least some hope in her heart. But the most encouraging response was a last-minute conversation with Dr. Ruppin: 'My conviction was based above all on the promises that Dr. Arthur Ruppin had given me,' she remembered. 'He asked me to wait for a time in patience and confidence.'[116]

∗∗∗

The cause still had little appeal to Szold. To her analytical mind, organization of any project was the priority for success, and that made the immigration of upper-class German Jews to a primitive, in many ways, Palestine simply not feasible; it was not the place for social experiments, Szold believed that; The Holy Land remained—existing in a perilous transition that had breathed for ages beyond the clock of ancient days— British rule, Arab violence, the gathering threat to Europe's Jews—awaiting all peoples. True, Jewish farmers were the main target of Arab political violence, but in July 1932, a senior British official was the target of assassination for the first time. He escaped, but his wife was murdered. In October 1933, violence would erupt across Palestine as over 30,000 Jews had entered the country by the end of the year. Thirty people died in the uprising; one policeman and a six-year-old boy, and two hundred wounded. Christian Arab educator Khalil al-Sakakini wrote to his son, Sari: 'Demonstrations everywhere, attacks on police and railway stations, hundreds of dead and wounded ... the hospitals are overflowing and tempers are hot with anger. What tomorrow may bring, God, only knows.'[117]

The British were caught in the middle. C. G. Eastwood, Private Secretary to the high commissioner, Arthur Wauchope, wrote to his wife that he 'was fond of Jerusalem and the inhabitants thereof.' He was sad to leave both, and he understood that the country itself was 'so unhappy,' and that he was sad to leave his work. 'What a country,' he ended, 'more hatred to the square mile than in any other country in the world.'[118]

Frankly, the Palestine of Henrietta Szold, in so many ways, remained locked in time, echoing with the footsteps of Titus's Romans, [the] dream-like Crusaders and Ottomans. 'Historically the occupier of Palestine had always met disaster beginning with the Jews themselves,' historian Barbara Tuchman concluded. 'The country's political geography has conquered its rulers. But now that the original occupant has returned, perhaps the curse will run its course, and the most famous land in history may someday find peace.'[119]

Szold well understood the draw and desire of Zionism; why, she herself had forsaken life in her beloved America, suffered with the constant ache of homesickness even after all of these years. There was, Szold would admit, beyond the primitive, beyond the dangers, beyond the constant demand on one's life, a draw to this holy place.

'The land of Jacob's might and Ishmael's wandering power, of David's lyre and Isaiah's strain, of Abraham's faith and Immanuel's love,' reflected English born Zionist Israel Cohen, '—where God's mysterious ways with man began and where in the fullness of time they are to be accomplished— it also has claims on England's watchful vigilance and sympathizing care and already invokes her guardian Aegis.'[120]

And what of the historical significance, Szold would ponder. Was not out of the rise of Hitler, at least something good, the regathering of Jews to the land; and had it not been that way of all of time? A mixture of peoples drawn here for no other reason than to be?

'On the southern slopes of Mount Zion, alongside the ruins of biblical Jerusalem, lies a small Protestant cemetery,' wrote Israeli archeologist Gabriel Barkai. 'The path to it wends through pines and cypresses, olive and lemon trees, oleander bushes in pink and white, leading to a black iron gate around which curls an elegant grapevine. Perhaps a thousand graves are scattered over the terraced hill; ancient stones peer out from among red anemones. Not far away, on the top of the mountain, is a site Jews revere as the grave of King David as well as a room in which Catholics say the Last Supper was held; in a nearby basement chamber, they believe, eternal sleep fell over Mary, mother of Jesus. The Muslims have also sanctified several tombs on the mountain.

'Bishop Samuel Gobat consecrated the cemetery in the 1840s to serve a small community of men and women who loved Jerusalem. Few had been born in the city; the great majority came as foreigners, from almost everywhere between America and New Zealand. Engraved on their headstones are epitaphs in English and German, Hebrew, Arabic, and ancient Greek; one headstone is Polish.'[121]

The enormity of the land's history and appeal did give Szold pause.

<p style="text-align:center">✳✳✳</p>

Still, Szold had held fast to her belief. And, Freier had departed Jerusalem, disappointed.

However, that moment when events began moving forward, awaited Freier, once she arrived back in Germany. 'When I got back to Berlin in

July 1933, she wrote, 'I was surprised to see that things had changed completely. Chaim Arlosoroff, on his way from London to Palestine, had stopped in Berlin and had supported my plan.' Arlosoroff, head of the Jewish Agency's political department, connected with Chaim Weizmann, and a Zionist who Szold held in high esteem, had visited Berlin in May, so he had missed meeting Freier. He had spent the time to evaluate the situation there: 'I was constantly besieged by acquaintances, relatives, and friends, wanting help to immigrate to Palestine.' He estimated that the Palestine Office had received over 40,000 Jews who were seeking assistance in immigrating to Palestine with their children.

The primary purpose of his travels was to deal with the Nazis in that they would allow Jews to 'transfer to Palestine values up to 5,000 pounds.' He was so impressed with Youth Aliyah that, while still in Germany, he arranged a meeting with the British high commissioner in Palestine. Upon his return, he took Arthur Wauchope to visit the Ben Shemen Youth Village so that he could personally understand the quality of education offered. Wauchope was impressed. Then Arlosoroff published positive articles on *Jugendhilfe* and Freier's plan to transport the children to Palestine. It was obvious to Freier that once someone of Arlosoroff's position saw promise in her organization, well, that changed everything. 'The former opponents of Youth Aliyah had suddenly established a Department for Children and Youth Aliyah in the Palestinian Office of the Zionist Organization in Germany.' In what, at first, appeared to be a big step forward, Freier realized that the office in Palestine was of little value, because it didn't have the potential to attract 'the dynamic movement which had arisen amongst youth itself.' Still, Freier's organization was now recognized as a legitimate group dedicated to save Jewish children from Hitler's madness. She wrote, '"Youth Aliyah," formerly a ridiculous term that had always been thought of as a dream of mine had now become a term in common use, and that, in turn, was like a dream to me.'[122]

Once Arlosoroff returned to Palestine, he was soon attacked in the revisionist press that his offer to the Nazis appeared that he was in negotiations to do business with Hitler. In the later 1920s and in the 1930s, the Revisionists were known as the main Zionist opposition party to Weizmann's political principles, and to the measures and policy held by the World Zionist Organization and *Eretz Israel's* Jewish leadership. Szold watched with interest, however because of his apparent impression with Freier's Youth Aliyah. Arlosoroff had brought trouble to the political climate in Palestine. Russian-born and educated in Germany, the 'young, highly gifted believer in Britain and Arab-Jewish reconciliation,' looming target for the revisionists.

One Friday afternoon, after dinner at a Tel Aviv hotel, Arlosoroff and his wife went for a walk along a deserted beach. Two strangers walked up to them, began firing, and Arlosoroff was shot to death. It was reported that before he died, he said that the shooter was not a Jew. Officials attempted to link it to the Revisionists, and in the months following, the Yishuv became involved in a shameful trial, dividing the Jewish community.

Several days later, at a memorial service Szold had the opportunity to speak of reading a publication her had written before she had met him, of words that expressed, 'a constructive Zionist springing not out of negative phenomena such as anti-Semitic manifestations, but out of the reassertions of the positive values of a living progressive Judaism… [and that] 'the realization of the ideal of Jewish nationhood on Jewish soil was linked up with the solution of the Arab question.'

t was ten years after reading such a moving statement before Szold would actually meet Arlosoroff at a Zionist Congress. As expected, she found the man presented himself like his written words, cool, clearheaded voice of the man with its basic conviction and passion— 'here was a man whom one sought out for the discussion of problems.'[123]

Szold, at the time of his murder, found herself disturbed in Zionism beyond any thought she could imagine. 'All the visions she had brought with her to the Holy Land,' Dash wrote in *Summoned to Jerusalem*, 'the dream of the revival of Jewish law reinterpreted to fit the modern world, the dream of prophetic Judaism uniting and revitalizing the Semitic peoples of the Middle East—had been hidden away in the corners of her mind, dimmed treasures she hardly dared show to anyone … this wretched murder of a brilliant young man and the lies that followed. It erased everything else.'[124]

The subject of Arlosoroff, and the funeral in Tel Aviv of Hayim Nahman Bialik, poet, idealist and prophet, dominated conversation with the Yishuv. It ruled Szold's thoughts also, depressed her more than any other happening in Palestine; She found that it was the only subject of which she wanted to write home. 'The Jewish ethic had disappeared from our scene,' she believed in a letter, '… Today it is a week since the tragedy occurred. It seems a year.'[125]

Ten days later, unable to get beyond Arlosoroff's death, Szold turned to writing her friend Alice Seligsberg, concerning her deepest hope that she was terribly wrong, and that others would finally be able to 'combat' her pessimistic outlook.

'The Arlosoroff trial and the Nahalal bomb-outrage trial [bombing of a home that killed a man and his nine-year-old son] are revealing depth after depth of depraved revolutionary tendencies among the Jewish as well

as the Moslem youth,' Szold wrote to Seligsberg from Jersualem on 30 September 1933.

> In both camps terroristic movements have been laid bare. You can imagine how startling some of the revelations are …
>
> … there must be some very incisive self-criticism, then some hard intensive work, detailed work, that will require so much thinking and acting that our teachers of youth will have no leisure for politics and professional grumbling… the elders will have to forgo their favorite sport of discussion.
>
> Finally, she confessed to her friend, 'I hope I am wrong, and their optimistic cheerful interpretation of Jewish life is right … then the "saving remnant" in Jewry which has never failed us in our long history will assert itself, and a purer Judaism will emerge. You see, I refuse to be a consistent pessimist.'[126]

Several weeks later, friend Justice Brandeis, wrote recommending Szold chastise the people for the wrongdoings, acting within the role of a prophet. 'I can see myself doing nothing but what I have been doing all along,' she wrote back, 'keeping steadily at the tasks my life here has set me and performing them as best I can…'[127]

Hard work was her remedy for all difficulties and apprehensions, it seemed. Soon, she would find well-being in the authority of a new duty, for Arlosoroff's murder had changed the situation completely concerning Youth Aliyah. Eventually, Szold was approached to take over Arlosoroff's plan to emigrate German Jewish children to Palestine, a plan that appeared similar to Freier's design, which Szold had refused to be involved twice before.

This time, she accepted.

In both Berlin and Palestine, the pace of events quickened, and plans began to come together for the operation of those plans. To those who took notice, it appeared that Szold's presence had created an urgency toward the children trapped in Berlin. The start of war, or at Hitler's request that borders were to be closed, most Zionists realized, would rapidly doom the children's fate. A generation of Jewry would be lost forever. In Berlin, Freier finalized plans as the opportunity to transport the children arose—the children would be gathered in groups, they would be taught Hebrew—then, both parents and children would be prepared to be away from each other. Some parents were

financially able to provide supplies and to cover the cost of transportation; for many, the costs would be covered by funds raised by committees and private groups. A *madrih,* a reliable young man or woman, would be provided for each group as the leader and teacher.

In Palestine, the priority was to convince the British Mandatory Government to issue entry permits; secondly, funds would have to be available and find acceptable places for the children to live. In August Szold requested 500 certificates, issued by the Mandate's immigration department, dispensed from September 1933 to April 1934. The children, from fourteen to seventeen, would be located in private homes and *kibbutzim,* and at the end of two years would remain in the country as immigrants. Szold was aware of what she was asking of the British government, that these children who remained would not affect the overall immigration quota as it was set. However, she was confident that that would be the case because High Commissioner Sir Arthur Wauchope himself had endorsed Arlosoroff's plan after visiting Ben Shemen.

By late summer, Szold traveled throughout Palestine searching for settlements where she would decide if they were suitable or not. Szold had been honest when writing her sisters about why she had changed her mind about accepting such a task, in that Arlosoroff's murder had affected her deeply, and to continue his ideals would be a tribute to this man who she had admired. Szold was satisfied, at least at the moment, that perhaps her hesitation to take on such a task, was diminishing. After all, events were falling into place.

In the following days, Szold learned that she was scheduled to attend a conference in London to discuss the German-Jewish situation. Her main purpose, she thought, would be to plead for funds to save the children.

<p style="text-align:center">*** </p>

That summer of 1933, Szold received a letter from friend Stephen Wise introducing an American journalist who planned to emigrate to Palestine. 'To Henrietta Szold, Jerusalem 2 June 1933. The bearer of this line is Miss Dorothy Kahn, a young journalist of real promise who resides in Atlantic City, New Jersey... May I present her to you?' asked Wise. 'I would like her to write a real story about you and about your great work. Nothing in all Palestine is more interesting than your contribution to it. If she were very wise, she would make you talk and talk and talk, and then write out the story of one of the greatest and noblest of Palestine's pioneers. That's exactly what Louise and I think of you, dear Lady,' Wise offered.

'I suppose you know that I have been rather busy dealing with the German-Jewish problems. The thing we are trying to do is to keep Palestine in the center of the whole picture, otherwise the whole thing will degenerate into nothing more than another inglorious Jewish *Schnorrerei* (begging.)'[128]

Born in Philadelphia, Kahn lived most of her early life in the seaside resort of Atlantic City, New Jersey, when her father suddenly died when she was sixteen. To assist in supporting the family, she went to work as a staff reporter for *The Atlantic City Press*. Her editors liked her writing, placed her stories on the front page, and assigned her to international interest stories, though most national and international news was copy by the Associated Press, and interviewing visitors to Atlantic City.

Kahn's interest turned toward Palestine when the 1929 violent riots erupted and two events threatened Jewish immigration and settling of the land: The Hope-Simpson report endorsed limiting Jewish immigration to Palestine; and, the British White Paper, on 30 October, restricted Jews from acquiring additional lands.

Kahn's article dated 6 November 1930 was printed on page two of *The Atlantic City Press* headlined, 'Resort Jews Resent British Palestine Edict: Pass Resolutions Condemning Act.'

It was then, in the researching of that article, when Kahn resolved that Palestine was where she should live and write; of that moment when the Jewish homeland drew closer to reality; she felt that she could be a part of that dream.

Rabbi Stephen Wise provided Kahn with letters of introduction to people he believed could assist her in developing her new writing career. Two such letters would prove to be important and worthwhile—first, to Gershon Agronsky, founder of *The Palestine Post*, and secondly to Henrietta Szold. Kahn and Szold would eventually establish a close friendship as Kahn accompanied her on visits to villages where the German-Jewish youth lived, and Szold would appear in numerous columns written for *The Palestine Post*. Szold and Kahn became good friends, Szold would admire her writing, and later, in 1940, Szold would become godmother to Kahn's son, Doron.

And so it was that in 1933, as Henrietta Szold prepared to travel to Europe, that Kahn departed New York for Palestine.

Henry W. Nevinson, British war correspondent, later wrote the introduction to Kahn's book *Spring Up, Oh Well* (referring to the well in Beersheba detailed the verses in Numbers 21:16-18). He described his disappointment of Kahn arriving in the Holy Land at Tel Aviv. 'It was, I think, unfortunate that she landed at Jaffa and at once proceeded to its great northern suburb, Tel Aviv, where on the thickly pressed sands of the desert

coast, the Jews have founded their growing city,' he lamented. 'Here all is new and all is Jewish. Only Jews live here, and the only language spoken or written is Hebrew… there is nothing to remind one of Palestine's ancient history.'

Despite Nevinson's disappointing verse, Kahn, on that bright morning of promise, wrote of her arriving in that land, words written with vivid brevity, words of bewilderment of the beauty and the mystery, and the conflict of the peoples, Jewish and Arab, writing prolifically, continually from that first day Kahn arrived, until her death in 1950. Her words would reflect that of so many other arriving…

> So here we were—all of us—huddled in the prow of the small Mediterranean vessel.
>
> Hour had piled on hour. Waiting had piled on waiting. Dawn came. More waiting was piled on more waiting with tensity bordering on passion. And when the dawn intermingled with the waiting it seemed as though something must crack. Crack with the force of Rabbi Shapiro's prayers—Miriam and Zvi's songs—Judge Adler's silence—Dr. Shulmans tears—Abraham Fine's bravado. Suddenly dawn widened into morning. Suddenly the sea narrowed into the coastline of Palestine. Suddenly the praying, the singing, the silence, the weeping, the bravado, widened into one force. A force of human emotion that was terrific.
>
> And then the spell was broken. The waiting split into smithereens. We climbed into small boats. Wondering if we would have to be inoculated. Hazarded guesses about the duty on cigarettes. Fretted over mislaid cameras. Scribbled addresses on our cuffs …
>
> '… another boatload of Jews reaching the Promised Land.[129]

Journalist, Kahn, as many others who befriended and worked with Szold found, would fall under her spell, fulfill Wise's wishes and write about Szold. 'To describe the response of the people of the countryside… is not easy,' Kahn would write of Szold later in life. 'To witness it is a deeply touching experience, of which one can say very little. She [Szold] walks among the simple people, the nearest approach to a prophet that modern Palestine has seen. Schoolchildren wait shyly at gates with bunches of roses; housewives offer apple strudel baked with the first apples. No problem of theirs is too large or too small for her. She discusses with them. She laughs with them. She cries with them. And she scolds them. She is of them, and yet her visits are in the nature of a triumphal procession.'[130]

7

The Nightmare Years.

'What is more tragic than a child that grows up with tight lips, with secretly clenched fists, with a tormented disturbed soul?... From such a fate we must strive with every ounce of our spiritual energy to protect those Jewish children whose parents desire them to have a different home. Those who help now to take German children out of their oppressive surroundings and to plant them into a life that is more free and happy are not only helping the children alone, are not merely diminishing the personal sufferings of individuals, but are helping to diminish hatred itself, which is now, in a thousand different ways, darkening our European earth.'

-Stefan Zweig (Austrian novelist), November 1933

By late August 1933, Youth Aliyah, for the first time of its existence, was a budget item within the Jewish Agency; 18,876 Pounds Sterling—a meager sum considering it funded such a dramatic undertaking, that of rescuing the Jewish children. Szold, with her organizational skills, had precisely, and hurriedly 'made Youth Aliyah a Movement,' forging an alliance between children, who were not yet used to the idea of leaving home on their own and going to Palestine, with that of the pioneers of Israel, as numerous settlements opened up to receive the young.

It still remained for Szold's confidence to be fully forged on her action of reversing her decision of handling the affairs of the Jewish children in Germany. Earlier that summer she had written of her concerns: 'What keeps me worried is the children,' she admitted. 'They are already beginning to come, and with their parents—who cannot come away without risking the loss of every penny they own.' When she questioned herself, it was not the doubts of providing places for 3000 to 4000 children. It wasn't the funds that bothered her, but 'I am thinking of the forces of organization at our disposal.'[131]

In letters written home, she again explained that it was the murder of Arlosoroff that had inwardly convinced her to carry on his work. And, besides, she was aware that the children were already coming to Palestine

with fathers and mothers. Ninety-five hundred in 1932; over 30,000 the next year. 'That summer such an influx of refugees jammed Tel Aviv that whole families slept on the beach for want of rooms, and the illegals, who were not numerous in spite of Arab claims, included hundreds of youngsters of their own.'[132]

Despite her growing skepticism, and her natural distrusting of disorganized, chaotic programs, Szold was certain, even with the flaws she had immediately recognized, that this uncontrollable immigration process would provide a 'legal and constructive process to the emigration of the children.'[133] At least now, Szold was at last committed to make the best of a situation of which she still doubted its outcome.

There was a situation, a growing concern in Szold's mind, once she recognized its presence concerning the people coming into Palestine and, astoundingly, their discussions of one day returning to Germany. It was hard to understand how people longed for those times and places, the comforts of their everyday life, long taken away by a totalitarian government.

There was a great gap, emotional and social-economic, she recognized, between the German and the East European Jew. 'The latter is the disciple of Russia, the former its opponent, conscious and unconscious. So much for the young,' Szold wrote. 'Those who have passed the forty-year milestone are bound to suffer. They long for the fleshpots of their German Egypt' ... and this was the point that astounded Szold, try as she would to comprehend the inability of those people to truly understand, that they that home would still be home and they tried, with full hearts, to believe, as they waltzed into the gathering chaos. 'They would return—they say so themselves,' Szold heard them admit, 'in a jiffy if the Hitler regime were ended. And many of them believe it will end soon. The wish is father to the thought.

'And if it were to end, they forget that a whole generation, now sitting on the school benches in Germany, has had its mind poisoned forever and aye. I ought not fail to say that it's only the non-Zionists who believe Hitler's reign will be brief and who speak of the return of Germany,' Szold wondered in her written words. 'The Zionists among them have an entirely different attitude. The privations (I don't know what they are) of Palestinian life don't affect them. In other words, their philosophy is practical.'[134]

And with that realization of their thoughts, Szold's own thoughts turned to how she would find the thoughts of the German citizenry once she traveled to Berlin. Deeply inside was a concern, an apprehension she was preparing herself for what she was to witness first hand; she was certain

that the city that she had loved and cherished with friends and relatives, could not be the city she would walk down the streets of within the month. Hopefully, though, she hoped that the hearts and minds of the German people had not changed.

Journalist Dorothy Kahn, much as Szold when she arrived in Palestine in 1920, also attempted to understand the peoples of Palestine, that tapestry of unalike stained fabric stitched together. Kahn found that books written around the Holy Land seemed to be imposing, of necessity, dealing as they did with the sweeping picture of Christianity, Islam, and Judaism.

She expressed, with vivid words sought out, and wrote of what the immigrant, new to Palestine would find. She was certain that this land would appear nothing less than a mystery attempting to be understood.

'I have been in Palestine only two years.

'I know little of Christianity. But once, in the early morning hours,' Kahn wrote, 'when the deep stillness of Jerusalem was a living thing, I heard the sound of a church bell from nowhere and return again!

'I know little of Islam. But once, while sitting before a tent, I saw a caravan of camels etched against the crimson fringes of a setting desert sun and I heard my Moslem host praise Allah!

'I know little of Judaism,' Kahn admitted. 'But once a bearded man with eternity in his eyes and a prayer shawl under his arm brushed past me in the stepped street of the Wailing Wall.

'I know little of Zionism. The history, the politics, the number of factories, schools and institutions which the Jews have established in Palestine, I leave to one who can darken the canvas with a bolder brush. But once I saw the face of a *Chalutz* (pioneer) consumed by a prophetic fire when he pronounced "Moledet" (homeland) on the desolate hill of Tel Chai. And once I thought I heard, under the staccato tapping of a rivet in Tel Aviv, the ecstatic gasp of conception and the agonizing groan of birth.

'I know little of Zionism,' she wrote, 'but I saw a Chalutz. I heard a rivet.

'And thus, I caught sight of the sea!'[135]

On the first day of September 1933, Szold took time to write out events in a letter: 'I can't say it's been a dull week. Plenty of work, as usual, several trips to Tel Aviv, and an accumulation of reports from Germany on the throttling process.' She went on to explain the thoughts of the German immigrants concerning returning to their home. 'Some of the sanguine Germans who have come here cherish the hope that the Hitler regime must

come to an end soon. They don't seem to realize that the mischief has been done for a generation—perhaps forever.'[136]

For many immigrants, the situation had grown more desperate.

In that letter, Szold detailed how German immigrants making their way eastward over land, as many as two hundred nightly, came across the northern border under the cover of darkness. 'Many of them are caught without visas in the countries through which they pass and are forced to return to their hell,' Szold wrote that week detailing the tribulations of illegals attempting to reach Palestine. 'And those who escape into Palestine—there is no telling what their fate will be if by frequent chance these "illegals" are skinned and fleeced at the border by those who are making it a business to help them across—it's fiendish!'[137]

Despite her words of despair, Szold and Youth Aliyah had achieved what she considered as considerable accomplishments: during that September week over three hundred were settled at work near the villages, despite funding issues. On that issue of monies, progress was made also—'after three months' constant pegging away at the demonstration, in proving to the rest of the committee that certain sums must be allocated to social service—philanthropy, they call it contemptuously—for the care of children, for the sick (especially the mentally disordered!), the aged, and to release [craft] instruments and tools from the customs.'[138]

However, events were moving forward for the German children, even though for Szold, who was impatient toward achieving the goals laid out before her, it was much too slow. How much time did they have to get the children out before Hitler slammed the door shut?

At the World Zionist Congress in Prague, Dr. Chaim Weizmann and Dr. Arthur Ruppin were designated to chair the newly formed Central Bureau for the Settlement of German Jews in Palestine. The Palestine government immediately issued 500 immigration certificates for children between the ages of fifteen and seventeen.

Szold was scheduled for the October conference in London on the German Jewish situation where she was confident that she could present a vivid account of the situation faced in Palestine every day. It would, however, prove to be a great disappointment to her. From London, she would travel to Berlin, to witness for herself events unfolding, to feel and experience what the parents were dealing with as to the aspect of sending their children away from home, and at least to safety.

'Well, a New Year is approaching,' Szold wrote hopefully, 'and we shall follow our habit and wish each other happiness,' she wrote as the eve of the Jewish New Year, *Erev Rosh Hashanah*, approached. 'I suppose habit is the

best safeguard against cynicism and despair,' she admitted. 'But whether it conduces to improvement, that's another question.'[139]

<center>***</center>

Before traveling to London to attend the conference, Szold traveled to Haifa to visit with a woman 'who stood at the very head of all social-pedagogic work in Berlin.' In a letter written from Jerusalem on 20 September 1933, Szold reflected on the overwhelming depth that meeting had on her, 'I didn't know that it was possible to sink to lower depths of dejection than Hitler had dropped on me.'

Instead of spending her normal Friday afternoons writing to her sisters, she met with Mrs. Siddy Wronsky, the city of Berlin archivist, and founder of a library of over 55,000 books of which she collected all volumes. At fifty her accomplishments were remarkable, and she remained the editor of several sociological journals, and a much sought-after lecturer of national stature, though had 'little money of her own' and she spoke 'dreadful English.'

'I heard her personal experiences,' Szold wrote, 'she told them in the most objective, unemotional way conceivable. The greatest stress, if stress there was anywhere, she put on the demonstrations of sympathy and disgust by her associates and subordinates.' Surprisingly to Szold, she spoke of no atrocities. Instead, 'it was a tale of spiritual suffering, of relinquishment of all cherished values, the passion of the German Jew, in the same sense which the nuns of Dames de Sion speak of the passion of their Saviour—also a Jew, as was the founder of their church, Father Ratisbonne.'

As Hitler became emboldened with his feverish oratories, events in Palestine occurred more quickly, and German immigration was continuously expanding, producing enormous housing problems, even as whole families lived on the beach because there wasn't a vacant room to be found. Groups of boys and girls waited in Germany as Szold had interviews with the Director of Immigration and with the High Commissioner, providing them with letters and sheaves of details.

As Szold prepared to travel to Berlin, she had yet to receive a reply. 'I shall not repine when the end of the drives comes,' she admitted in a letter, 'it's been hard drudgery.' The heavy weight of the children's transfer to safety hung insecurely in the balance, causing Szold during moments of exhaustion and frustration to question her decision to remain in Palestine and take up this cause. For whatever else it accomplished with its conversation of doom, the Haifa meeting that Friday had changed Szold's mind.

'But when I heard Mrs. Wronsky's description of the Hitler system, placidly philosophic and analytic though it was, I could not but feel that I had acted rightly in staying here.' Still, in her heart she had wished, somehow to accept that going to America would have been the right thing. Wronsky's lecture had moved something close to her heart. Events she would witness several weeks later in Berlin, would reinforce her decision.

'Here I am writing on *Erev Rosh Hashanah*, the eve of the Jewish New Year, all alone,' she wrote. 'It is true I am writing in my room heavily fragrant with roses, lilies, and carnations sent to me by all sorts of people. But ...'[140]

Before departing Jerusalem, Szold wrote a letter to editor and book publisher Thomas Seltzer on 1 October 1933. 'The times are too serious for one to be writing pleasant nothings. Every letter ought to be a self-revelation to one's own inner self ... I am busy, heart-breakingly busy. This German Jewish business is devastating,' she admitted. 'Zionism apparently justified itself by having Palestine in readiness, with doors at least ajar, to receive the German refugees. But Palestine is so small, and the means are so limited, and the need so cruelly great.'[141]

As her departure neared, the next week on 9 October, Szold wrote to her friend Mrs. Rose Jacobs. Another crucial matter occupied her thoughts:

> The Arab community is agitated over the volume of immigration. An incident happened a few days ago that stirred me more deeply than the announced demonstration [the Moslem Supreme Council had arranged a protest on Friday of that week]. The counsel for the defense in the Nahalal bomb case pleaded for mercy for his convicted [Arab] clients on the grounds that they were led on to their misdeed [the bombing of a house had murdered a father and his nine-year-old son] by the false policy of the government. The judge meted out no rebuke, and I understand that the pleas for clemency has been granted the holiday season has been exquisitely beautiful. Nature takes no note of man's degeneration.[142]

<div align="center">＊＊＊</div>

By October Szold was in London attending the conference discussing the situation of the German Jewish landscape. However, her main purpose was to approach the Central British Fund for German Jewry, to obtain funds for Youth Aliyah. Szold, respected in the Jewish community, had a reception in her honor at the stylish Palace Hotel on Kingston Road, which included a dinner hosted by Chaim Weizmann.

One evening, however, she overheard Mrs. Weizmann and two distinguished English Zionists discussing the youth transfer in a surprisingly light-hearted manner, seemingly unaware that Miss Szold could hear them, 'as if sending German children into Palestine was no more complicated than packing them off to boarding school. One had only to assemble the young people in Berlin and ship them to Yishuv, where all would become happy farmers and laborers. They were eager for it. Everyone said they were.'

It was conversation that deeply concerned Szold in that Zionist leaders should have been aware of the human, religious, and political realities of the circumstances. It did occur to her that German Zionist leaders might be equally ignorant. Taking aside an official of the London office, Arthur Ruppin, Szold shared the disturbing words that she had overheard. 'I heard such and such a conversation,' she told him. 'I am afraid this thing is going to be pretty messy.' So upset was Szold that she was willing to shorten attending the conference and depart immediately to Germany. Did he think that she should follow up on her Berlin trip and 'sound out the Jugendhilfe?' Ruppin, in fact, encouraged it.[143]

Szold, the next day, set sail for Germany aboard the SS *Naldera*.

8

In the Haunt of Jackals

'It will be called the Land of Nothing… [and] the ruins will become a haunt of Jackals…'

-Isaiah 34: 12,13

As Szold stepped off the train, the drastic changes to the Berlin she once cherished, shocked her. Gone, at once, was the civilized Berlin, the 'pleasant civilized capital of the country of Lessing, Goethe and Schiller. It was a fearful and dreadful place blatantly placarded with brutish hatefulness. The once *gemütlich* Germans were unrecognizable,' she lamented. 'Their decent orderliness and self-control were vanished like a cast-off garment. It was as if their malevolent ruler with the long forelock and little mustache had blown off the foam of civilization from their culture and given them to drink the dark intoxicating underlying draught of barbarism.'[144]

What Szold witnessed that day dispelled any hopeful impression that this was a fleeting sickness. She knew at that moment for certain, that German immigrants attempting to settle into Palestine, would never have the opportunity to return to their homes. Hitler and every dark instinct and thought that followed him, would last for a long time.

'I was in Berlin on the Friday of Hitler's pre-election address [the campaign of 12 November 1933 was the referendum endorsing the Nazi regime],' Szold would reflect later upon her return to Palestine on board the SS *Naldera* … 'and heard part of it over the radio, standing among hotel personnel.'[145] That morning in the lobby, only moments before, Beethoven music played foreshadowing the Führer's speech as the common citizens moved through their day. Housewives strolling down the streets, shopping bags swinging at their sides like precious toys; men dressed in workingman's heavy jackets or businessmen in pinch-waisted overcoats on their way to an office, morning newspaper in hand.

Polite and orderly Szold noted; even the ranks of chambermaids, errand boys and porters behaved ever so politely. Then, there was a great stirring of activity, a hurried orchestrated effort to assemble everyone in the lobby before a large loudspeaker, just at that moment as the Führer's high-pitched

voice broke in as the music faded. 'I did not listen in long, because the apparatus was unclear,' Szold explained. 'The passage that caused much excitement was the one in which he referred to the emigrants who had left and were leaving the Third Reich as gypsies—*Zigeuner*. The interpretation is that he referred to all fugitives—Jews, liberals, pacificists, and socialists.' Szold studied those standing silently before the loudspeaker, listening, and the transformation they had instantly gone through. They were the very maids and valets and porters who moments ago were polite and smiling and gentle in that courteous way one presented one's self—in another time. Now, just moments later, she noticed the tightness of their faces, the long, unblinking stare of worshipping eyes. And, Szold understood. They, indeed, did believe. 'The audience in his hall, by means of *Zwischenrufe*, referred it expressly to the Jews alone. They cried: "The Jews, the Jews!"'[146]

Out on the streets, Szold was unhappily impressed with just how much the nation's heart had changed. The landscape that she gazed upon that November afternoon surprised her; why these were the same streets, shops, restaurants, the very people, of the dauntless nation considered as perhaps the center of European civilization. Now, posters announcing hatred for fellow citizens hung throughout. Street pillars, hotels, restaurants, plastered across the windows of Jewish shops. 'The Jews of the world want to destroy Germany. German people Resist! Don't buy from Jews!'

When Szold later wrote of her experience, she doubted the reader would believe her, that a nation could change into a place, unrecognizable. 'The city is placarded with every sort of propaganda poster that imagination can devise,' she wrote. 'In the hotels, in the restaurants, in the synagogues, in the office buildings, on the streets, poster after poster. A favorite one consisted of Lloyd George's recent sympathetic utterance. What cannot be described in the atmosphere, the *Stimmung*, and apparently it is a depressed *Stimmung* that holds not Jewish Berlin alone in its clutches,' Szold discerned regrettably. 'The streets of Berlin are dead, empty. The shops are empty (but so are they in London and Paris!).'[147]

In the fall of 1933, there were now two lands traveling in parallel through time and into a history which would, eventually, judge them drastically different—Germany and Palestine. Populated with characters who would, also, be drawn out much differently because of their objectives. Adolf Hitler. Adolf Eichmann. Their solution grew within the grasp of mass murders and elimination of the Jews, and perhaps their greatest enemy— the children because of the blood that ran through their veins. Henrietta Szold. Youth Aliyah. Portraying a vast difference than that purpose of the Nazis, that of saving every child that they could from the German fires. It

was 1933 and there were distinct differences that Szold witnessed then. That was the beginning, and she was aware that each year would present more horror and death for the Jew.

The evidence of such was already before her. The sights and sounds on the streets, an absolute and obvious obedience as the German people stood at attention, listening to every word of Herr Hitler's messianic word, that proved to be quite enough for Szold to ever doubt only the worst for the German people and their destiny. A certainty that threw an intensifying fear for the Jewess that day. 'The worst manifestation is the startled look people cast around when they have been betrayed into uttering a free and critical word, to assure themselves that none but the interlocutor [speaker] hear it.'[148]

<p style="text-align:center">***</p>

That startling transition that surprised Szold with its rapidity that day she stepped off the train, was an undercurrent of National Socialism. It had crept into power silently, until the most experienced foreign correspondents recognized that any chance to turn the clock back now to some resemblance of civility, had vanished. 'What, up to election Sunday on March 5, I called terror,' wrote Victor Klemperer, a Jewish professor of Romance languages in Dresden. He lived throughout the war in Dresden with his wife, Eva and kept a secret diary published after the war. 'Now the business of 1918 is being exactly repeated, only under a different sign, under the swastika,' he wrote of recalling the events of January 30, when Hitler became Chancellor. 'Again, it's astonishing how easily everything collapses.'

One such writer who understood the undercurrent of darkness was Christopher Isherwood, who was twenty-five years old when he came to Berlin as teacher of English and enjoyed the nightlife. The first hint of trouble was his description of the newspapers and nothing more than 'new rules, new punishments, and lists of people who have been "kept in." ... this morning, Göring had invented three fresh varieties of high treason.

'Every evening, I sit in the big half-empty artists' café by the Memorial Church, where the Jews and left-wing intellectuals bend their heads together over the marble tables, speaking in low, scared voices,' he wrote of those days just weeks before Szold arrived. 'Many of them know that they will certainly be arrested—if not to-day, then to-morrow or next week. So, they are polite and mild with each other, and raise their hats and enquire after their colleagues' families. Notorious literary tiffs of several years' standing are forgotten.'[149]

Six years later, in 1939, he would vividly describe the scenes he witnessed in his autobiography *Goodbye to Berlin*, scenes comparable to those that Szold wrote of later with words of great concern.

'This morning, as I was walking down the Bülowstrasse, the Nazis were raiding the house of a small liberal pacifist publisher', Isherwood wrote, noting how the brownshirts and police became more emboldened against any opponent, clearly in plain view. 'They had brought a lorry and were piling it with the publisher's books. The driver of the lorry mockingly read out the titles of the books to the crowd: "*Nie Wieder Krieg!*" he shouted, holding up one of them by the corner of the cover, disgustingly, as though it were a nasty kind of reptile. Everybody roared with laughter. "No more war!" echoed a fat, well-dressed woman, with a scornful, savage laugh. "What an idea!"'

In April Isherwood traveled to London and returned to Berlin to organize his personal business to leave Germany for good. He had seen enough. He had been gone eight months before Szold arrived in November to visit *Jugendhilfe* officials, as Germany continued to waltz, eyes open, into the abyss of dying light.

Isherwood later reflected on the beginning of his last day in Berlin: 'To-day the sun is brilliantly shining; it is quite mild and warm. I go out for my last morning walk, without an overcoat or hat', he wrote. 'The sun shines, and Hitler is master of the city... No. Even now I can't altogether believe that any of this had really happened...'[150]

Author Lilian Mowrer, who had moved to Berlin in the mid-1920s with her husband, journalist Edgar, remembered the first time she witnessed Germany's new generation. Until then Hitler was simply an item, a man who had been sent to prison instigating a riot; Germany was a peaceful place, tranquil, that Lilian had fallen in love with; until that day—at the revived Wagner Festival at Bayreuth— 'we did have a little glimpse of these super-patriots.

'When we arrived in the beautiful little Residenzstadt with its fountains and castles, the town seemed full of young men, wearing windjackets belted with leather and carrying small canes. "There they are," said Edgar, "the swastika lads—the new "race" party that is behind every *Putsch*..."

'... they looked harmless enough', Lilian admitted, 'with their bright blue eyes and cropped hair'.[151]

Szold visited the *Jugendhilfe* offices the second day of her Berlin stay and was informed that the structure had been reorganized during the summer

months. The new organization was named the *Arbeitsgemeinschaft fur Kinder und Jugendaliyah,* a name Szold considered laughable, and was changed to a more 'simple and inspired choice' in Palestine as *Youth Aliyah.*

She met with numbers of concerned citizens, often throughout long days: officials representing the Jewish communities as well as the Jewish Youth Aid; Wilfred Israel and Dr. Ascher, directors of the Palestine Office in Germany. She also comforted many frightened parents who explained of their children's anguish, and asked her how they could arrange transferring them to Palestine for a chance at a safe life.

It was in these meetings that Szold's concerns from her earlier London conference discussions were confirmed.

There had been, to her consternation, apparently little thought by the German Zionists toward what these children would experience when shipped to a strange land, and the question was never asked, what tests and trials they would face? Palestine, life in the *kibbutzim* was to prove tough, exhausting in a place where the climate was much hotter and the land rugged. There would certainly be sickness and loneliness and self-doubt among the children. After all, Szold had personally witnessed how the land had defeated the *Chalutzim* from eastern Europe. It had broken their spirits so badly that they retreated into larger cities, or had abandoned Palestine all together.

'Who would care for the failures, physical or mental among the children? And with what funds?' asked writer Joan Dash, 'and what was being done to minimize failing by learning more about Palestine and understanding life in the kibbutzim, by inspecting individual settlements to see how one differed from another, which were primitive, which more advanced?'[152]

These concerns greatly bothered Szold, so she sent the *Jugendhilfe* a series of lengthy questionnaires in an attempt to expose these serious problems. The questionnaires went mostly unanswered, convincing Szold that she, at least, now knew the truth. These German Zionists, though with honorable intentions to rescue the Jewish children, lacked any idea of life in Palestine, or had no detailed organization to their actions, and apparently had no desire to correct either situation.

She had traveled to Germany, after all, to establish a working relationship between the Yishuv and the Jews in Germany. On that purpose, she remained focused and began working on ideas, and believed that, before departing, she had at least accomplished a foundation. 'I found much confused organisation, no understanding of Palestinian conditions...' Szold

wrote. 'I don't flatter myself that I straightened out the whole tangle, but I think the path is somewhat levelled.'[153]

These worries are recorded in Szold's letters, however, a comprehensive history of Youth Aliyah during those early days wasn't, however, thoroughly recorded. What is apparent is that during Szold's week-long stay in Berlin, these educational schemes were designed by both Szold and the *Jugendhilfe*. 'It was an amazing vision, amazing as an ad hoc creation, hardly less so if it had been mulled over and revised for months,' Joan Dash wrote in *Summoned*. 'Perhaps no more powerful tool has ever been devised for the passage of a band of young people from one culture to another.'[154]

Finally, Szold realized that they had designed a training program to establish several guidelines: First, each Zionist group was to gather candidates for immigration, and second, after a six-week training period, a committee would decide on the most fit and best qualified candidates. Then Szold focused on how to construct the school in Palestine. She came up with two parts: a farm labor, workshops, and in the fields of the kibbutz; then the children would attend classes in which they would study Hebrew, Jewish history and literature along with geography, botany, physics, and chemistry. A well-rounded curriculum, she felt. At the last, Szold added what she considered an important factor as part of the children's orientation to this strange, new Palestine—that of periodic exploration of the land.

As Szold made plans for the youth escaping to Palestine, so did Hitler and his political machine create strategies to indoctrinate the German youth. Changes to personal freedoms and thought transitioned rapidly. Personal lives were destroyed with the new decrees.

'... I remember Hitler came to Leipzig. I was a little kid there and there was a big square, I think it was called the Augustus Platz.' The young boy remembering those days was William Benson, born in Leipzig in 1924, the son of a successful businessman. In 1937 he would leave Germany with his family to Italy where he fought with partisans during the war. 'There was Hitler and he was preaching there. I could not understand a word he was saying because he spoke a very bad German. You know, he'd scream. So, I saw people with tears coming down their faces... and I couldn't understand why.

'... I had an album with all the Nazi pictures of them marching with the banners... [and] as a matter of fact, the German Jews during the early years of Hitler were petitioning Hitler to form a Jewish Brigade,' Benson

remembered. 'Some of those German Jews were more German than Jews. They had medals and they were really gung-ho—real, real Germans, especially the rich ones—because Hitler was against communism. Anybody with money would say, "Oh, good, Hitler. He's a good guy to have around."'[155]

Also, in 1933, began the wholesale discharge of 'non-Aryan' teachers and administrators, of which the great majority were women. 'When I arrived at the school building, the principal stopped me, and asked me to come to his room… he had orders to ask me not to go into my classroom. I probably knew, he said, that I was not permitted to teach anymore at a German school,' Hanna Bergas wrote of a morning in April 1933. 'I collected myself [and] my belongings … There was nobody to say goodbye to, because everybody else had gone to the classroom. In the afternoon, colleagues, pupils, their mothers came, some in a sad mood, others angry with their country, lovely bouquets of flowers… in the evening, the little house was full of fragrance and colors, like a funeral, I thought; and indeed, this was the funeral of my time teaching at a German public school.'[156]

<center>✳✳✳</center>

Szold departed Berlin on 19 November sailing eastward on the *S.S. Naldera*.

'My visit to Germany was entirely in the interest of the children,' she wrote shortly after, if only there were funds. 'In Paris I went to see Dr. Bernard Kahn. He insists that the Joint Distribution Committee has practically nothing to give until its next drive comes off which cannot be soon.'[157]

For, Szold, her sense of duty had proven once again to be correct. 'There is no hope,' she wrote after her visit, 'as many fondly believe, that the Nazi terror is, or can be made, a passing phenomenon. Hitler and his hordes have come to bid a while in this torn, agitated world of ours. It will be cause for gratitude if they do not ignite another world war.'[158]

<center>✳✳✳</center>

When Szold arrived back in Jerusalem, she was informed that chief of the Jewish Agency's newly created German Bureau, her friend Arthur Ruppin, had designated her as director of Youth Aliyah. Ruppin, born in poverty in Rawicz in the German Empire (today Poland), and despite him having to work to help support a family, completed his studies in law and economics. Ruppin moved to Palestine in 1908 and opened the Palestine Office of the Zionist Organization in Jaffa. Because he became the chief Zionist land

agent, Ruppin was influential in determining the character of Jewish settlements in Palestine. He would eventually head the Jewish Agency between 1933 and 1935.

Szold first met Ruppin in the fall of 1909 as she and her mother toured Palestine. At Jaffa, in their hotel by the sea, they met a number of important people engaged in Zionist activity. Ruffin, then involved in land development and labor organization, was well aware of Szold's work in New York at the Jewish Seminary Society, and they had a lengthy discussion.

Jaffa, Szold and her mother discovered was 'another miserable place, the streets unpaved and filled with heaps of rubbish, an unpleasant smell hanging over the town.' And, it was where Arthur Ruppin had contracted typhoid months before.

'He was taken to a hospital kept open for a few months each year by Rothchild money; when the money ran out, the hospital shut down. It was open when Ruppin took sick,' Szold wrote. 'He was put in a room without a door, water utensils or linen. Cats wandered in and out all through the night, waking him with their noises, staring at him with phosphorescent eyes form the top of his coverlet. When he needed a bath, the water was carried up in tins from an outdoor well.'[159]

Years later, Ruppin watched as Szold came to Palestine and through Hadassah began to develop worthwhile medical facilities and rural clinics. It was his first meeting with Szold on the balcony of the Jaffa hotel overlooking the ocean, however, that had convinced him that one day he would take advantage of her skills and fortitude. By late 1933, Ruppin had convinced himself of the importance and urgency of the Youth Aliyah scheme, and that without its success, many more of the children would face tyranny and death. 'He told her she was the only figure in Palestine capable of dealing with all political parties, as the leader of Youth Aliyah must.' She was, Ruppin admitted, 'the only non-political person of stature in the country.'

Szold refused, explaining her strong doubts that the scheme would succeed, and informed Ruppin that she wasn't taking 'on a task that might last several years.' That dream of returning to her sisters in America was on her heart again, and many nights, as she looked out of her Eden hotel window and studied the gray-sketched outlines of Jerusalem, she would share with those close to her, 'she meant to sit on Bertha's front porch in a rocking chair and crack Indian nuts.'

But Ruppin would not give up, and told her, referring to her being the deciding factor of the survival of the German-Jewish children. 'Either with you, or not at all.'[160] Finally, in her heart, Szold knew that she couldn't resist,

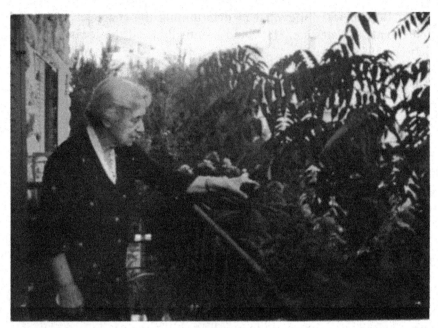

Henrietta Szold in her garden, Jerusalem, 1942.

not Ruppin's argument that it would all depend on her. At the age of seventy-three she had another purpose in Palestine, one that dwelled closely to her spirit—it all became alive to her—that purpose and how it lived in a simple statement, a self-prophecy she had made years before; it was true now, more than ever with the children trapped in Germany. 'I should have,' she had admitted, 'had children. Many children.'[161]

With new conviction, Szold began work in a small room in the Jewish Agency, along with her secretary Emma Ehrlich, a single filing cabinet containing all the documents pertaining to the German children.

Though she would claim a disappointment that her task was nothing more than piles and piles of paperwork, she would later admit to sister, Adele, that she needed the cause, to justify her life. 'I do all connected with it [the awesome task] in fear and trembling.'[162]

A month later, in December 1933, she would write from Jerusalem:

My new job, the organization of the transfer of the children from Germany to Palestine, is growing under my hands from day to day. It deals with children— [but] it is not child's play. The responsibility is great. If and when I carry it through, I think I should let my active

life come to the end with it. Not that I feel too tired to contemplate more. But I should make room for the younger, better trained forces that are coming into the country.[163]

It was decided to go ahead with the first group to come to Palestine, a first try to find out the problems that would present themselves. There would be sixty-three boys and girls between the age of fifteen and seventeen. A young man, Hanoch Rheinhold, would lead them to their new home, Ain Harod, a colony in northern Palestine near Mount Gilboa. However, quickly it was realized that extra barracks would be needed before the children arrived.

Szold, instead of sending someone, traveled there to personally supervise the building of the additional facilities. 'It's a serious experiment,' she admitted. 'My sense of responsibility toward it grows every minute.'[164] And there were those occasions when she wasn't satisfied with the work, Szold would charge forward, and 'In her gray woolen suit and her small felt hat set squarely on her smooth-brushed gray hair and held in place by the black elastic under the bun in back, she stood over the workers until they had it done.'[165]

She realized that the moment was pivotal—the first group would be sailing to them within weeks, and there were so many affairs to make certain were in order. Years later, as the Second World War raged, she would look back, certain of decisions made on the part of the children.

'Women are the natural protectors of childhood,' she proclaimed. 'They are the guardians of the generations. If Nazi brutality is not swiftly deprived of its child victims by removing all endangered children from Nazi-occupied territories to all countries whose portals will be open to them, what will be the aspect of the next generation? Is not the plea to women to organize a movement to "Save the Child for Civilization" the plea for a supreme peace effort? ...'[166]

PART TWO

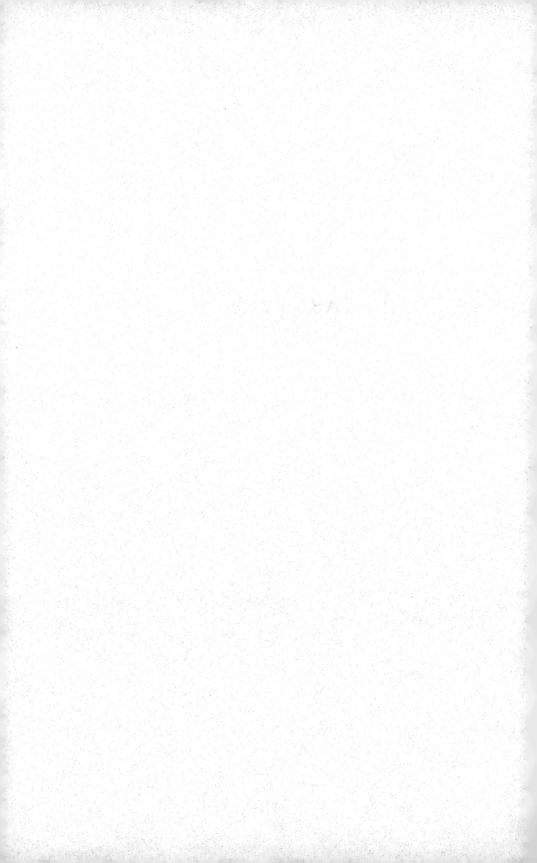

9

Escape to Palestine

On Monday 19 February 1934, on a dark day filled with hard rain and high winds, the first boatload of children from Germany, traveling on the steamship *Martha Washington* of the Lloyd Triestine Line, landed at Haifa harbor. The weather along the Palestinian coast had turned so badly that the children's landing, originally scheduled to anchor in Jaffa, had been moved to Haifa. 'The vessel came in under a heavily shrouded sky, driven by a gale, with the rain pelting down steadily...' wrote Szold, '[but] the merciless wet could not dampen the enthusiasm of the young travelers nor the joy of their grandparents, brothers, sisters, aunts and friends on hand to meet them.'[167]

From Jerusalem the day before departing to meet the children, Szold had poured out her feelings of doubts and apprehension of the whole affair to Rose Jacobs: 'Day after tomorrow, the first detachment, a group of forty-four of "my" children, arrive from Germany,' Szold wrote the Hadassah president. 'I go to Haifa to meet them, have them examined medically, and get their possessions out of the customs. Then I accompany them to Ain Harod, to see them installed there. I want to see them tucked away in their beds. I feel weighed down by the responsibility of this children's immigration. It's a terrible experiment. What next?'

And, once again, to a dear friend Szold wondered aloud of America and her sisters.

'I had thought in the remote days of my youth that one attained to serenity and wisdom with old age. What do I find in my old age? Vagueness, eternal wonder at the meaning of things, inadequacy to the daily tasks, anything but tranquility.'[168]

That Monday morning, the director of the Haifa Branch of the Immigration Department for the Jewish Agency, was officially in charge of the children at the dock. Assisted by volunteers, everything from quarantine to customs to their first meal on Palestinian soil moved quickly.

The young people, accompanied by their *madrich*, their youth leader, marched down the walkway dressed in clothes that struck the Yishuv as strangely odd— 'well-made corduroys for boys and girls alike, the clothing in which people of leisure visited the countryside.'[169]

Waiting for the children, these new pioneers, among the wharf burdened with cellos, mandolins, rucksacks, and even the unusual sight of bicycles and flagpoles, stood Henrietta Szold. She was accompanied by Aharon Zisling, a member of Kibbutz Ein Harold, their new home.

A month later, a group of girls would arrive, and be sent to their new home, the horticultural school at Talpiot, headed by Rahel Yanait Ben-Zvi, wife of Itzhak Ben-Zvi, who would become the second president of the new nation, Israel.

For the Zionists welcoming them, it would later be a strange feeling, the difference between those arriving now, and those coming later; the start of the war would change everything, creating confusion and chaos as refugees fled, went into hiding, or were confined to ghettos.

For those children coming to Palestine before the Second World War, they left behind parents who, reluctantly, sent them still believing that Germany would, when more rational leaders arose, return to some sense of ordinary. 'These children held to several characteristics, which children who came later have—for those who came before September 1939, they had left behind a "home address" 'a house or an apartment somewhere in Berlin, Frankfurt, or Leipzig.' To arrive in Palestine also meant to give up another comfort which these earlier children had to sacrifice. In their German homes, had not had to share a bedroom, where as pioneers on the Palestinian front, they lived within close surroundings.

News editor of *The Jerusalem Post*, Arie Rath remembered of that day when he arrived in Palestine from Vienna later in 1938:

> Here we were, fifty youngsters, looking for some kind of warmth and shelter, forced to cling together, but at the same time looking upon the others as "the group" … which constantly infringed on our [basic] privacies. All private property was forbidden; pocket money we brought from home, farewell gifts of candy we hoarded all through the trip to remember home, international postal coupons our parents had given us to be able to write home as often as possible, and even the few precious books we had managed to pack away… we were told to share and did not know how, because to us sharing [these things] meant cutting our ties with home.[170]

Despite these differences, large or small homes, or later "home addresses" as Jews were relocated, dispersed to ghettos or holding centers throughout Germany, they had, as author Chasya Pincus wrote in *Come from the Four Winds*, 'shared a similar pattern of life—their fathers were storekeepers or

doctors, clerks or bankers; some of their parents had come to Germany from Eastern Europe during the years following World War 1, while others looked back proudly on generations spent on German soil. But all these youngsters had in common the influence of the rich culture of Germany. In Palestine they experienced the first shock of their lives, not only due to their physical uprooting from the home environment but also to their sudden alienation from the culture they had regarded as their own.

'Outwardly, yes, we wanted to be like the Russian-born pioneers on the kibbutz—to work [like] they did, to dress like they did, to dance the *hora* with the same zest,' an early Youth Aliyah graduate, psychologist Lotte Gelbart, reminisces. 'We even forced ourselves to enjoy eating the sharp, bitter olives that were absolutely foreign to our taste. But inwardly, we were determined to preserve a measure of ourselves and our own culture,' he wrote. 'We refused to admit that we were homesick ... but after a long, exhausting day's work in the fields, our group would gather to listen to the music of Bach and Beethoven, and talk about Schiller and Goethe and all the other writers...'[171]

David Ben-Gurion, of the Jewish Agency, was well aware of the children and Szold's efforts. He also understood that Hitler's rise to power was an influential weapon for Zionism. 'We want Hitler to be destroyed,' he said, 'but as long as he exists, we are interested in exploiting that for the good of Palestine.'[172]

In 1934, with a Jewish nation now a realistic dream, Ben-Gurion spoke of four million Jews in Palestine; two years later, he spoke of a more optimistic number of eight million 'at the least.' The Youth Aliyah project, assured of success because Szold managed it, fit into his vision. Later, in December 1938 after *Kristallnacht* (the Night of Broken Glass): 'If I knew that it was possible to save all the children in Germany by transporting them to England, but only half of them by transporting them to Palestine, I would choose the second—because we face not only the reckoning of those children, but the historical reckoning of the Jewish people.'[173] Once he realized that such a statement could have been misconstrued, Ben-Gurion openly appended his thoughts: 'Like every Jew, I am interested in saving every Jew wherever possible, but nothing takes precedence over the saving the Hebrew nation in its land.'[174] Journalist Dorothy Kahn would later write that she saw, 'the children from Germany as "Hitler's gift to Palestine," who would bridge the gap from past to future.'[175]

At the Haifa harbor that February day, Szold patiently waited for the children. And then met each personally, knew their names, then stayed with them as they made their way through customs and medical exams, as Szold

watched the emotional, brief reunions with relatives who had arrived previously.

'Szold knew that her life was no longer a patchwork, 'wrote Irving Fineman. 'There on the dock at Haifa, in her seventy-third year, her life achieved a coherence, a value, and a significance beyond anything she could have hoped or planned,' Fineman knew. 'It was as if all the channels of her so varied lifelong activities, and all of her Jewish inheritance, everything she had got from Papa and Momma and had herself learned, merged there at the foot of that gangway for the sake of those children who were coming to her, to be healed and taught and cared for, and given a goodly life in the Land of Israel.' It was, Fineman grasped, reflecting of that crucial moment, the heaviness of a purpose for Szold, '[that] Even her failure to marry and have children of her own was like a part of a predestined plan whose climax was enacted there on the dock in a driving winter rain.'[176]

Long ago, she had written: 'I should have had children, many children.' Now, her wish was coming true 'as we read her letters and shadow her, through the months following, setting a stunning arrangement in motion; following the children through the horrid weather 'of a Palestinian winter,' commanding every need and comfort for the children's needs and comforts.'

Across the way at the working-men's kitchen facing the Haifa docks, the children and Szold sat at a long table waiting to eat. Suddenly, the children burst out singing Hebrew songs learned in their *Hechalutz* training. At that dramatic moment, they were no longer emotionless statistics on paper, but the children 'became as truly her own as troubled outcast of the Palestinian towns.'[177]

After dinner they set out to the train station, which took them through the Emek Jezreel and the plush Harold Valley, soaked from heavy rains. Later, they reached Ain Harod where they were met by every kibbutz resident waiting for them beneath stirring palms and palmettos.

'All the way up to the settlement, the troop was met by members of the *Kevutzah* streaming down to catch a first glimpse of the new contingent,' Szold wrote on 25 February, 1934. '... In front of the dining room, the veranda of which was crowded with the rest of the residents, the ubiquitous photographer snapped the scene.'[178]

The children were settled in their surroundings, made comfortable in their rooms, while in the storeroom they placed their personal belongings, and then given a tour of the grounds, all conducted under the patient, watchful glance of Szold.

Then came the official welcoming ceremony with speeches, singing and music and hora dancing. All which Szold found as 'a religious poem.'[179] She

found it all inspiring for the hard work that she was aware lay ahead for her. As long as Hitler reigned, as long as Europe lived in darkness, Szold knew that she would be at the harbor many times to watch children come. And then, there was a deep satisfaction within, that she had done the best she could in preparing these children: 'these tender creatures, sometimes too frail to survive the rigors of the trying life to which their young bodies and spirits were subjected...'[180]

However, after the next two days conducting one more personal inspection of the barracks, showers, and toilets before departing Ain Harod, Szold looked upon images that greatly moved her—in the rooms the children had, with care, hung photographs and posters and, along one wall near the bed—books neatly lined the crude bookshelves.

It was then that Szold knew she had prepared them well for the days ahead.

<center>✳✳✳</center>

Within a month after the first group's arrival, sister Adele Seltzer who had closely followed events in Palestine, wrote admiringly to Szold from Danbury, Connecticut. It was this approval from a dear sister that satisfied Szold as much as any recognition could have: 'The work you are doing for the German refugees surely is not so immeasurably finer than what you have done for health and education and all the rest. Perhaps it is more spectacular. America seems to be thrilled by it.' Adele went on telling how people who knew Szold had always spoken to her of wonderful happenings, but now, her sister insisted that strangers told her of how they were aware of Szold's marvelous successes with the immigrant children. She wrote:

> As I read you poetic letters of the arrival of the German children, of their bursting into song, of their crying *entzuckend*—' "delightful"— of the simple life into which they are to be fitted, I am actually filled with a glow. But then—the other side of the coin. Not the wayward youth you mention, but England, perfidious Albion, treacherous, arrogant, imperialistic England. Do you purposely never mention the political situation—the rising nationalism of the Arabs, the restriction of immigration, the deceitful lion—or isn't the future menace to your Jewish "homeland' as grim as it seems to me?[181]

<center>✳✳✳</center>

Within Palestine, Szold's efforts were being significantly noticed and applauded, despite reservations, and in some cases fear, of the German influx that was increasing in flow each week. She had responded to Adele's letter that yes, the condition was awful and growing more so each day it seemed; It was a double-edged sword of concern in that the Arab nationalism was swelling, and the English effort and promise of a Jewish homeland, was dreadfully wavering. Among the Jews, there were political quarrels and continuous labor disputes: 'Our political divisions here are deplorable.'[182]

Once again, Dorothy Kahn felt that she should express publicly the purpose of Youth Aliyah, without reservation of the dreams of the German immigrates. Especially one group 'This is one group among these immigrants who raise no questions. The children. Scarcely are they in Palestine than they are of it. For them there are no ghosts, no echoes, no bitterness, no loyalties to the old, no criticism of the new', Kahn assured her readers in *Spring Up, O Well*. 'One day they are crying because their playmates cannot understand what they say. Inside of a few months they are jabbering away like natives. They shed their tailored Eton jackets for loose blouses. They do not find it over-strange to be in a land where the Bible is one's history and geography book.'

And, then of course there was Henrietta Szold and her organization Youth Aliyah, who Kahn wrote about. 'Children of the Hitler Exodus,' as

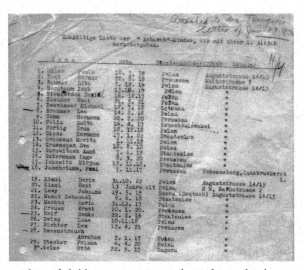

One of the many lists of children to receive travel certificates for their immigration to Palestine, January 1934.

she had described them. 'Another group is the youth. They have been settled in the *kvuzoth* by Miss Henrietta Szold who, at the age of seventy-two, undertook her task as foster-mother of the refugee youth. Miss Szold will tell you that not only are these children rooted in Palestine, they are literally rooted in the soil of Palestine. And they are rooted in the new communal life of Palestine. One need not weigh or measure their gifts,' Kahn assured the reader. 'They bring strong arms and bright eyes and singing lips. They have felt the hot sun of the Emek beating down on their heads. They have felt the rain-soaked soil under their feet. With sun and rain, with fire and with water, they have been forged into Palestine.'[183]

Several months later, as a sultry summer descended upon Jerusalem, Szold took an unusual night off from the arduous workload placed on her, and attended a concert held on Mount Scopus. As Szold was shown to her seat in the amphitheater, her mind flooded of thoughts of what had been accomplished with the children thus far; and what unknown future lay ahead for them. Germany, that once cultured, civilized nation had, by the summer of 1934, decided to let Herr Hitler rule despite obvious hints of the darkness shadowing over the nation. She had witnessed it during her visit the previous late fall—yes, all the signs of collapse were there, out in the open if anyone cared to admit it, though there were many who still refused—and despite those signs, she had hoped in some way that his path to total power could have been avoided. Now, there was no denying it, nor any chance of returning to any sense of normalcy, or respect.

Reflecting on the night Szold was attending, as she also had anticipated the event for weeks, Dorothy Kahn wrote:

> I have sat in the open-air theatre to hear Hebrew operettas. And one full moon night I heard Bach. And on the tenth anniversary of the opening of the university, the students marched in singing and carrying banners. Hundreds of Jews were crowded into the rock-hewn benches rejoicing because a Hebrew seat of learning has arisen again in Jerusalem. You can't take that for granted. Throughout history seats of learning have arisen and others have arisen and others. Arisen, arisen, and fallen. You can take that for granted. It is history. It is nature. It is birth and death. But to rise again? It is a version of the myth of resurrection. Facing, touching, feeling of the resurrection? You cannot take that for granted.[184]

However, on this night, despite the immensity pressing on her mind, Szold was determined to have, at least, one night of peace, and so the concert settled her, and for that brief moment, took her from those countless problems awaiting her in the following days.

'It was a full moon,' Szold later confessed to her sister… 'the night was magically beautiful, and the moonlight on the Moab hills bathed them in an atmosphere and colors that have no name.' The moment gave Szold stunning pause—such men of noble music on such a beautiful night, and in Palestine, no less, that newborn homeland—what would they possibly think of Germany now? 'The program was exquisite dance music …' she admired, 'Bach, Handel, and Glück, through Beethoven and Mozart, down to Strauss. The orchestra entirely strings … a huge audience that sat spellbound.'[185]

The moment had given her time to reflect back to Ain Harod, the children excitedly speaking German, echoing yelps of happiness in German, and she had carefully spoken to them about this. That despite conditions forcing them from their homeland, that had forced them from their warm, comfortable, loving homes, that despite all that which had drastically transformed their lives, they should not abandon their heritage, that dear part of their past. 'That past can never be destroyed without doing damage to the self,' she told them. 'Because it was in itself so precious.'[186]

For Szold, those memories, those experiences, personified all the tranquility of her childhood; the books in her father's study, the warmth of her mother's kitchen, the love of her sisters, letters written to aunts, cousins, grandmother in old German script as her mother watched over her shoulder. No, Szold promised herself that night beneath the stars and moon of a new and glowing Palestine, she could not let these children leave their precious yesteryear.

'We brought with us Kafka; I had in my group two or three very intelligent, intellectual kids—existentialists,' *madrich* Hanoch Rinott remembered in an interview with author Joan Dash in Jerusalem, 1975. 'There was this empathy, this understanding. I accepted her as a mother figure very willingly; there was very much of a natural authority built into her composed of age, appearance, prestige… but you see, Miss Szold took a particular interest in us, in our group. More than others, she was *interested* in us.'[187]

In early October 1934, Szold was asked to lay the cornerstone of the new Rothchild-Hadassah University Hospital adjacent to the decade-old

Hebrew University, with a ceremony to be held several weeks later. Szold had, in fact, spoken to the first class in November 1921, to the first graduating class of Rothchild Hospital, 'a beautiful two-story building of rose-colored granite, with one lavatory, no bathrooms, no running water, no lighting or heating system, poor plumbing.'[188] How things had changed.

Chosen to design the hospital was an exiled German architect, Eric Mendelsohn who wore thick glasses and had only one weak eye, cancer had cost him the other eye; complete blindness confronted him daily, a trying illness for an architect. Accepting the task, the sights that he gazed upon when he first arrived in Palestine, appalled him. "He was ashamed by the ugliness of the Jewish settlements, the boxy apartment buildings, the slab like synagogues that sprung up haphazardly throughout the land. The absence of planning galled him.'

Along with his wife, Luise— 'an elegant, pampered European cellist who believed herself of Jewish descent'—they moved into a rustic Jerusalem windmill, heated with portable kerosene stoves and food was kept cold in a zinc-lined box. As her husband became obsessed with his hospital project, she shopped in stores in the Old City. And, she quickly learned to avoid the fashionable beauty parlors where one could become the subject of gossip.

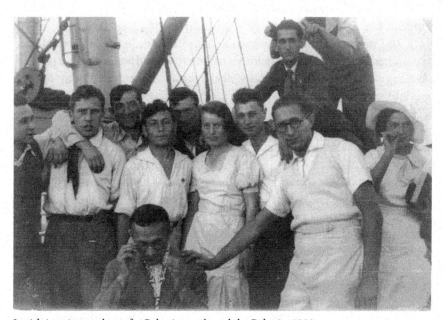

Jewish immigrants leave for Palestine on board the Polonia, 1933.

Instead, Luise frequented the Arab-run concerns void of anyone who spoke her language, or running water. Much as Szold remembered fondly of those days in the stone house on the hill outside Jerusalem drying her hair in the dazzling sunlight, Luise recalled that 'she enjoyed the way a small boy in a caftan climbed up on a stool and washed her long dark hair with a watering can.'

Despite the disappointing beginning, Mendelsohn was determined to build a hospital to be poised atop Mount Scopus, dreaming of the simple lines of Escorial and Assisi. His creation, already dwelling within his precise mind, would have to be created on a location he would never have created—a narrow one-mile-long ridge, standing over 150 feet above Jerusalem. A deep descent on the east side fell toward the Dead Sea, 'to the west a slope into the Kidron Valley facing the site of the Temple upon which Moslems had built the golden Dome of the Rock.'

Mendelsohn dreamed: 'I want to create monumental austerity even though it will disappoint the layman who expects British baronial splendor or America's imposing verticals... this,' he demanded, 'must be built for the ages.'[189]

<p style="text-align:center">✳✳✳</p>

For Palestine, the steady apathetic thinking, in the fall of 1934, hid no true dangers. For Szold, who ignored such indifference, her days were full of work and problems, though life would soon change, with the arrival of a man in her life. A man, sent from Germany to Palestine for the purpose of assisting Szold within the daily whirlwind, those hectic day-to-day operations of Youth Aliyah.

Hans Beyth's arrival would present Szold with that profile of strong man—there had been those men in her life before, after all—who would listen, a man who would truly understand her regrets, and he would patiently listen just as her Papa had in her early years.

However, Beyth would also bring, as Szold had totally missed in the beginning, during those first long days as they traveled through Palestine, also, the opportunity to relive that part of her life when it seemed that everything of value to her—simply vanished within a single callous act from the only man she had ever truly loved, those many years ago.

For this man, Beyth, became a good friend, a good listener, and even though she hardly spoke to him about her past love, still his strong presence surfaced those hurts from the New York years. Thoughts and bitterness that had done its part to stay hidden away, Palestine after all, was her distraction

from reality in so many ways. And, now, she once again glanced back, and doubted how she could have been so fooled about love.

Later, the danger in the years ahead was shadowed and silent; there would come the rise of Arab violence, just over a year away, beginning to show its ugly face, gradually, and if the *Yishuv* had taken the time to recognize it—the start of the Second World War—and even a more imminent danger—a German general named Erwin Rommel, a military strategist of the highest order within the Nazi ranks, victorious and a threat to Palestine, as he seemed unbeatable, immortal even to the opposing British troops, winning battle after battle on the sands of north Africa.

And, still, there remained Germany's descent into darkness.

William L. Shirer, reporting from Germany and witness to the unfolding tragedy there, later admitted to his 'own naivety in regard to Hitler's designs,' after nine months in the Third Reich, it was, always he admitted, greater than he could have realized. Some forty-five years later, he reread a lengthy entry he had made in his Berlin diary, after the Führer's peace speech. 'It shows I was terribly taken in, as much as *The Times of London*, for whose growing appeasement of the Nazi dictator I would feel a growing contempt over the ensuing years.'

Shirer had arrived at just that right moment for a journalist and historian, arriving in the summer of 1934 as Hitler, now emboldened, charged forward with his agenda. Shirer would remain in Nazi Germany until December 1940 reporting on Hitler's rise to power and the beginning of the Second World War. Later, he would write of his experiences in *The Rise and Fall of the Third Reich*. However, in the beginning, on 25 August 1934, Shirer arrived in his new position as reporter for the Berlin bureau of the Universal Service, one of William Randolph Heart's two wire services. His first contact with the new government was an eye-opening inauspicious beginning.

'Our introduction to Hitler's Third Reich this evening was probably typical,' Shirer recorded in his diary. 'Taking the day train from Paris so as to see a little of the country, we arrived at Friedrichstrasse Bahnhof at about ten this evening. The first persons to greet us on the platform were two agents of the secret police. I had expected to meet the secret police sooner or later, but not quite so soon,' he wrote. 'Two plain-clothes men grabbed me as I stepped off the train, led me a little away, and asked me if I were Herr So-and So—I could not for the life of me catch the name.' Shirer told him no. One of them asked again and again and finally he showed him his passport. 'He scanned it for a few minutes, finally looked at me suspiciously, and said: "So…You are not Her So-and-So, then. You are Herr Shirer."

"None other," I replied, "as you can see by the passport." He gave me one more suspicious glance, winked at his fellow dick, saluted stiffly, and made off. Tess and I walked over to the Hotel Continental and engaged an enormous room. Tomorrow begins a new chapter for me. I thought of a bad pun: "I'm going from bad to Hearst".

Within a week in Germany, Shirer sensed the change, felt the dark undercurrent of the new regime. During the first week of September, he wrote: 'In the throes of a severe case of depression, I miss the old Berlin of the Republic, the care-free, emancipated, civilized air, the snub-nosed young women with short-bobbed hair and the young men with either cropped or long hair—it made no difference—who sat up all night with you and discussed anything with intelligence and passion,' Shirer reminisced, obvious that Germany would never be the same. 'The constant *Heil Hitler's*, clicking of heels, and brown-shirted storm troopers or black-coated S.S. guards marching up and down the street grate me, though the old-timers say there are not nearly so many brownshirts about since the purge.'[190]

Journalist Shirer was living in the midst of anarchic change, and now understood.

Szold, was still a year away from her second visit to Berlin...

10

A Man Arrives…

'Smells on David Street in Jerusalem are as mixed up as the people, the animals, the stalls and the sounds. There are odors emanating from sizzling kebab [meat cooked over flames], damp sheep entrails, nargilehs [hookahs], and the very pink roses being arranged into small bunches by a peasant woman on a step. And yet, at one particular spot, there is an odor that never fails to disentangle itself from the others with the distinction of time-honored aristocracy. It is the odor of coffee, rich and fresh and tempting. So, follow it to its source and discover Ahmed Ali, the blind coffee grinder who, for thirty-years, had been discovered on and off by all habitués of the Old City.'

-Dorothy Kahn, *Writing Palestine 1933-1950*, p. 180

Szold, now operated in that moment, 'that noble and beautiful moment,' as one biographer noted, shrewdly steering, day-by-day, Youth Aliyah through a maze of problems. Mainly financially—the monies to handle the transportation and locations for the children was staggering—but also attempting to stay one step ahead of the Nazis, and anticipate how they would react to those schemes designed to rescue the children. At that same time, it was also when that woman in her seventies, often still at her desk past midnight, would take a long time, and peer out over the Old City, the dancing lights and a distant flash of lightning over the mountains, and pondered … then, she would pause, and return to her work. Time was valuable for the children.

Life now wore at her. 'In her seventies [she] had become two people… an old woman yearning for home and family… and at the time she was a shrewd and toughened veteran.'[191] Concerning the *Jugendhilfe*, she found the disorganization (at least by her standards, and what she expected) unbearable. Numerous times she had threatened to resign. For those in the Youth Aliyah Berlin office, they realized that without Henrietta Szold, their office would accomplish so much less, or that perhaps that even the rescues would cease. When her opposition within the organization

faltered, she demanded, and received centralization of the operation—all communications between Germany and Palestine would come across her desk.

And, what was often the situation, with *Vaad Leumi* there was always the constant conflict, Szold considered the members as though 'they were living in the Middle Ages.' In turn, they, behind her back, referred to her as 'the old girl.'

That spring, in a violent act, Revisionist boys and girls tossed heavy stones through the new *Vaad Leumi* building. A demonstration between two political parties grew into a small riot, and over a hundred were wounded, 'and along with all of this,' Szold wrote there was the 'constant thrum-thrum of the Arlosoroff murder trial dragging its slow length along.' Disgusted, she would finally write home, 'I feel like screaming at the top of my voice all the time … I can't bear to set foot in Tel Aviv, the hundred per cent Jewish city, the hundred per cent garish… Am I old and cynical and hopeless? The German children's work gives me satisfaction until suddenly I realize that I am bringing them into a community that no longer is connected in my mind with anything reminiscent of Messianism. However, they all go to the country districts, and after all there one finds idealism.'[192]

In late 1934, and into the following spring of 1935, two events would give Szold a reprieve from weariness and antipathy.

In October 1934, there was the honor bestowed on Henrietta Szold that she would lay the cornerstone of the new Rothschild-Hadassah University Hospital on Mount Scopus. And, she would address the occasion, a broadcast heard in New York at the Hadassah convention. That lifted her spirits. Then, in that faithful next spring, help would arrive for Szold—a man, a former German banker, Hans Beyth.

The broadcast took place on Tuesday 16 October 1934 at four o'clock in the afternoon broadcast from the turret office of the Hebrew University, which through the windows, one could glance along a panoramic spectacle of Ancient Jerusalem. 'It was a wonderful panorama,' reporter Barbara Board later wrote in her book *Newsgirl in Palestine in* 1937 of these scenes when she first arrived. 'Before me lay Jerusalem, its myriad housetops glowing in the bright sunshine. On my right,' Board remembered, 'Mount Scopus with the Hebrew University gleaming white against the clear blue sky. Behind the Hills of Moab, a pale pinkish-mauve, slipping down into the Dead Sea.'[193]

Her friend and president of the university, Judah Magnes, opened the ceremony.

Later Szold would share her thoughts of that day: 'of course, one cannot help being impressed with one's own funeral,' her 'morbid metaphor as she glanced at the cemetery on Mount of Olives. 'That's what it was, to the "Mother of Hadassah," and the "Founder of Hadassah," and the "Inspiration of Hadassah." What were my thoughts? Should I confess them, such an estimate of honors accorded her would hardly have been appropriate for the ears of the dignified audience on Mount Scopus...'[194]

It was nine o'clock in the morning in Washington where fifteen hundred Hadassah members, many who had skipped breakfast to secure a seat close to the loudspeakers in the grand ballroom of the Wardman Park Hotel, had assembled. Draped across the meeting room was a banner: 'We Will Build.'

The broadcast would be the first live transmission originating from the Middle East, relayed through Cairo and London, and then from the National Broadcasting Company Manhattan studios, coast to coast, and finally to the anxiously awaiting Hadassah audience. 'The government radio station, which operated out of the Palace Hotel in Jerusalem beginning in 1936, broadcast in English, Arabic, and Hebrew. Initially the station was called the 'Voice of Palestine Eretz Israel,' but the Arabs protested, and its name was eventually changed to the Voice of Jerusalem. In fact, the announcers had not even used the full Hebrew name, only the initials EI, pronouncing them as one word. The Jewish community had considered this a great affront.'[195]

From the beginning there were problems, as with any new venture such as this broadcast. For several days, the Palestine Broadcasting System sound engineers fought through echo problems in the vast room, and even more troublesome, field mice, finding their way into the room, and chewing at tangles of wires spread out across the floor.

Just after nine o'clock Washington D.C. time, Rose Jacobs walked to the NBC microphones and read a cable describing the Mt. Scopus ceremonies that had taken place earlier in the day. Moments later Hadassah heard the first exciting words breaking through the brittle static, from Magnes's assistant Julian Meltzer: 'This is Jerusalem calling from the Hebrew University on Mt. Scopus.'

Then the voice of Nahum Sokolow, Zionist leader and a pioneer of Hebrew journalism, was heard next: "World Jewry celebrates...' Static crackled over the line, blanking out words, clearing for a moment as Magnes stepped back to the microphone: '... it is but a few minutes' walk to the laboratories of the Hebrew University...'

The focus, however, was on Henrietta Szold, who spoke next. It was her time and she took full advantage of it with exciting and encouraging words,

stirring the Hadassah delegates even through the poor electrostatic reception. Szold then spoke, asking 'for the rearing of a temple of healing and learning, on the spot from where Titus hurled his firebrands into the temple area;' and in sight of distant Mount Nebo where Moses, the great teacher, had gazed hopefully upon this land.'

Earlier, in front of an audience of physicians and Zionists and British dignitaries, she had delivered a summary of the history of Hadassah beginning when Israel Friedlander gave them their motto "the healing of the daughter of my people." 'The Jewish soul stands in need of the healing which wells up for it from the soil that produced prophets—in the life of the spirit,' she said, 'there is no ending that is not a beginning...

'We celebrate today the culmination of an idea,' she said, 'the healing of my people ...'[196] It was, after all, the early days of radio broadcast, especially such an international venture, but all was forgiven—Szold's voice had been heard from Jerusalem.

The reporter covering the event for "Hadassah Newsletter" wrote: 'The words are not clear. But that does not matter. Hadassah's founder is speaking to thousands of her colleagues and it was enough to hear her voice. On the platform and scattered throughout the hall are some who toiled with Miss Szold in the early days. Before them, in these seconds, must have flashed a quick kaleidoscope of those pioneer days,' the reporter noted. 'They could not restrain their tears. The audience is tense, electric, trying to catch every syllable. And when the 20-minute broadcast is ended the whole assembly rises to its feet, applauds, and cheers and breaks into singing *Hatikva*. Women weep for joy and kiss and embrace one another.'[197]

As chairman of the ceremonies, Szold was leading Hadassah into a new era; the Rothchild-Hadassah University Hospital and the Medical School would become the largest medical institution in the Near East. And, Hadassah formally voted to join the American Jewish Physicians Committee when the construction began, and had moved from 'an age of pioneering into an age of sophistication and voted itself a physical permanence in Palestine.'[198]

On 19 October 1934, several days later, Szold wrote, her pride and satisfaction shining through in the letter to her sisters that she had 'survived' her own Hebrew speech and all the rest of it connected with the cornerstone-laying of the Hadassah-University Hospital on Mount Scopus. She confessed:

> It was really a very dignified and impressive ceremonial. What were my thoughts? Should I confess to them-to the cynical ones? I couldn't

ward off, first, the thought that in spite of all the respect and even homage shown me—and I don't doubt its sincerity—I have so little power. I can't get a thing done because I can't get co-operation. Then came the thought of the price I should have to pay. I knew the price—that the next day and thereafter the seekers after place and the unemployed would come or would write and tell me, as I had so much influence, wouldn't I secure for them what they wanted or needed, since I could do it by simply uttering a word. And they did come the very next day! But something else crept into my mind. I went whizzing through the Shenandoah Valley, the apple country, and across the Atlantic Ocean, to and through Charleston, and I gloried in that other time, nearly four years ago now, when I was threatened with a similar funeral. I had made my escape with you in Adele's little Ford. Even the skidding after John Brown's monument danced through my mind. That one time at least I cheated an audience.

I suppose you read that we, the speakers, broadcast to the Hadassah Convention at Washington. I confess I got a thrill out of that. But even that was enveloped in a funereal atmosphere—the solemn silence enjoined upon the participants, the hangings and floor-coverings that shrouded the room, the cryptic technical words that passed between, "Hello, New York," and "Hello, London," and doubtless "Hello, Jerusalem," and the expectancy until the red light flashed up to announce that the connection between the two distant continents had been established—it was awesome.[199]

Sister Adele wrote back to her from Connecticut several weeks later: 'Like Bertha I listened, or tried to listen, to your voice from Mt. Scopus, along with Mr. and Mrs. Warburg in their home. In spite of their $2,500 instrument the static was awful. You just went boom, boom, boom. Some words from the next speaker came through. Then, for that child of luck, Judah Leon Magnes, the static cleared away completely, and his tones rang as mellifluous as from the pulpit of Temple Emanu-El.'[200]

After the cornerstone ceremony, Szold continued the long days of work and travel amidst the gathering of a terrible Palestine winter. 'In all fourteen winters I have spent in Palestine,' she would later write Mrs. Rose Jacobs, 'I haven't ever experienced such constant rain.'[201] On 8 December she had

visited *Kibbutz Kinneret* (*HaShomer Ha-Zair*) a left-wing settlement of the Palestine labor movement. Thirteen days later, she celebrated her birthday. A week later, Szold sat at her desk in her Hotel Eden apartment and described both events in a letter to nephew, Benjamin Levin: 'My birthday caused others a great deal more excitement than it would have caused me, 'if I didn't now have to write dozens of letters of acknowledgment of cables, letters, flowers, and other gifts. Last Friday a stream of visitors began to pour in and it continued to pour until Saturday night, and dribbled all week, 'she wrote. 'I must reveal the cause of all this public attention. I myself could not explain why on my seventy-fourth birthday, not the number of years usually marked by wide celebration there should come, beginning with the first day of December, cable after cable. Late in the month the explanation came in a Release to the Press by Hadassah in America. They were having a Membership Campaign for 7400 members, 100 for each one of my years. I was convenient propaganda material! I wish I could make Hadassah write my "thank you" letters.'

Szold then wrote of her visit to the settlement two weeks before, admitting that much work had taken place to prepare for the German young people. In fact, she was encouraged that she found the Kibbutz 'in a much better state of preparedness.' She wrote, 'This time I went up with a group of sixty-two children from Germany. In the evening of the day of arrival there was a great reception. At Deganiah A, to which the residents of all the settlements in the region came, there was feasting and singing and dancing, and of course speechmaking.'[202]

One of the speakers was Yisrael Galili, a Ukrainian Jew who would become head of the Haganah, which later became the Israel Defense Force. His speech, where he compared Youth Aliyah to the Children's Crusade, and the preparedness for the children, gave Szold hope. At last, beyond all the political and financial problems, she sensed an organization that had come together.

Szold was very proud of a curriculum, worked on continually for months, and had been developed for the education of the children. After four hours of field labor and workshops, the farmers were to be instructed in Hebrew, Bible history, geography, and science. 'The aim is to inure young Jews of urban tradition and centuries-long removal from the plough and the saw to the labor which lies at the foundation of the social structure,' Szold explained. 'Our students must be next door neighbors to ploughing and harvesting, to cow and horse stable, to chicken-run and barn, to kitchen and laundry, to tractor and scythe. They must learn to handle tools for building and repairs.'[203]

Szold traveled to Tel Aviv, on 31 January 1935, to speak to a large group of recently-arrived German women, whom Szold pleasantly found to be intelligent, and searching for information about their new home. The subjects were the organization of the *Knesset Israel* and the union of the Jewish communities to Palestine. Those who had planned the meeting, found that the women spoke only German and would have to wait on the arrival of *Judische Runschau*, a Jewish review, to understand. But Szold spoke fluent German and answered many of their questions. The one consequence of the successful trip was the weather, a bad storm during their trip to Tel Aviv, and a worse storm on their return to Jerusalem. 'The wind blew me away and knocked me down, none too softly,' Szold admitted. 'I wish I might have had a photograph of myself flying through the air.'[204]

It seemed that Szold was always on the road, the constant travel wearing her down, but despite the long hours and the awful Palestinian weather, she was constantly on the move. 'I was again out of town for three days, this time to welcome twenty-six new arrivals of the Youth Immigration,' She wrote on 22 February:

> I accompanied the sixteen who were destined for *Mishmar Ha-Emek*, and spent the night there, sleeping in a barracks which serves as the "hotel" of the place. The room is furnished with all one needs, including running (or rather trickling) water. There was a welcoming with speeches, nuts and fruits—good speeches at that—and of course the *Horah*, the inevitable. Mishmar Ha-Emek is the best-ordered *Kvutzah* I know, and their attitude towards life and particularly education is most satisfactory. But such mud and such incessant rain!'[205]

Amidst the constant flow of American tourists and old friends into Jerusalem who were interested in meeting Szold, there was an urgency within the Jewish Agency for Szold to travel to Germany, Poland, and Holland on behalf of Youth Aliyah. There would also be a conference in Amsterdam, the purpose by European groups to raise monies for the Youth Aliyah. 'I always find it hard to mobilize myself,' she admitted. 'I foresee, however, that I shall not be able to resist—the pressure promises to be great.'

Dr. L. Hess, a dentist, and his wife were some of the first to arrive in Jerusalem that winter. Being from Baltimore, Szold's hometown, she and Dr. Hess quickly developed a conversation of 'the good old times' in that

Maryland city. 'I was amazed myself—as he was—at the memories and names I pulled out of the storehouse where they had been gathering dust these many years.'

An old friend of more than sixty years, Dr. Harry Friedenwald, a Baltimore ophthalmologist, requested that Szold have dinner with him one afternoon at the Hotel Eden, where they were staying. The two friends enjoyed discussing those years in America, however it was his daughter, Mrs. Julia Strauss, president of the Baltimore Chapter of Hadassah, who appeared to enjoy the event to the fullest described in a letter to her husband: 'It made the trip additionally stimulating to be privileged daily to enjoy the society of Miss Henrietta,' Strauss wrote in her diary, 'to drink of her deep wisdom and to wonder at her selfless devotion to her two jobs which keep her actively engaged from 7:30 every day, all day and almost every evening, excepting *Shabbat*. She is a marvel, she would be remarkable were she my age, but I can never understand how she is equal to it at 74 1/2 years of age—a most extraordinary personality!'[206]

By the spring of 1935 Szold found herself again working at a furious pace 'gasping, hope against hope that if I sleep less, I'll catch up to myself.'[207] Really, she had no one to blame but herself, with her insisting that she personally conducts all business, and instructed her secretaries to never refuse anyone access to her. Sleep now became a necessary commodity. The last week of April she was still wearing her winter clothes. On a street in Jerusalem one stormy day, she was swept off her feet by a gust of wind, her umbrella torn out of her hand, and she fell to the ground. Gathering her umbrella, she was quickly at her feet and dashing down the street.

'Last week the hurry and scurry of Palestinian life got the better of me...' Szold confessed in an April 1935 letter to Mrs. Rose Jacobs. 'To all this there has been the bass-drum accompaniment of so-called peace talk around Germany's "unilateral" action in disposing of the Versailles treaty.

"I must find time to get my passport into shape! There's bound to be war," she admitted. 'And if there is, what will be the fate of, for instance, this hardly built-up "homeland" of the Jew? It will be scattered bloodily to the winds—that's my opinion. That will be only one of the many still remaining values to be shattered and dissipated.'[208]

It became obvious to anyone who dwelled on the matter, that Youth Aliyah's growth demanded additional staff and new offices, if the organization was to avoid being swamped beneath a sea of paperwork, letters from despondent parents in Germany, and the constant request for

travel certificates. By May, Szold would be relocated into a larger office closely to the agency's expanding offices, the view out the window reminding her of Maryland wildflowers. 'Over the fence of the little garden of my Youth Aliyah office a honeysuckle vine drapes itself, 'Szold wrote her sisters. 'I have been bringing bunches of the blooms home with me and making myself homesick as I draw in the fragrance that fills my room.'[209]

A flurry of secretaries, Hebrew and German were hired all young, most married. They were relentless personnel and all curiously attractive, and were soon nicknamed the "American beauties," except that only one— Emma Ehrlich—was American. As Szold's personal assistant and close friend, she would prove invaluable in those perilous years, of war and death in Europe, that lay ahead.

'That a beautiful, dark-haired young American with no particular education, no interest in intellectual affairs, no striking characteristics beyond her fantastic devotion, should attach herself to a woman of Miss Szold's stature was not surprising,' Joan Dash wrote.[210] It was soon apparent in the office that Emma adored Miss Szold the way 'a nun adores a mother superior. She stationed herself between Miss Szold and the other secretaries like a protective barrier, for which they often resented her.'[211]

Despite the resentment toward Emma's protection, the other secretaries still viewed Szold as tender and clear-eyed. 'As she grew older, she became more beautiful, I'm convinced of it,' a secretary remembered. 'The wisdom showed out of her eyes somehow. She loved me in the end, I know she did, although she was cool at first. She was suspicious, she was suspicious of any stranger; it took years until she trusted someone.'[212]

However, it was Emma Ehrlich, who would become her longtime secretary, who understood Szold, a woman who prided herself on her strength and fitness, spending the early hours of every morning doing gymnastics and grooming her long, silken hair: 'For her, beauty begins with order, and it is her aesthetic sense which makes her so systematic. Everything around her is perfectly arranged; she can put her hand on any of her belongings in the dark,' Ehrlich explained in an interview years later, explaining that Szold's concern with her appearance was not vanity but a simple response to the fact that a public woman had to mind her appearance; for Szold, beauty of self and surroundings were synonymous. 'The same system and order which are an integral part of her public work are also part of her personal program, each item having its assigned time and place. The careful ordering of her life in mechanical things, she thinks,

saves her time, keeps her in good condition, and leaves her mind free for the important problems of the day.'[213]

<p align="center">***</p>

Hans Beyth was Nordic-looking, tall, broad with a handsome presence and wearing a smart suit, that May morning when he walked into the office dominated by women. Szold, at first impression, didn't know what to make of him, until she found his manner as 'warm and direct.' And, with that, she sensed, as she often did with her strength of discernment, that he was truly a 'kind, affectionate man, someone who would not judge.' Later, one secretary would explain, 'he was an artist to handle people, and especially women.'

A German-Jewish banker, born in Bleicherode, Germany, Beyth became a Zionist in his youth. After Hitler came to power in 1933, he worked as a volunteer for the administration of the *Jüdische Jugendhilfe* in assisting Jewish youth to immigration to Palestine. Though his first passion was banking, a business where he had all his friends, he was glad to come to Palestine, and work with Henrietta Szold. 'On the one side he had all these friends,' Lotte Beyth, who would later marry', Beyth remembered, 'these chalutzim, and on the other side he had also Aryan friends, and all the high society life of Berlin in the years after the war [First World War] when everyone started to make money.'[214]

When Beyth arrived on that spring day he was adventurous, unattached, in his early thirties and grateful to work alongside Szold, which fit into his plan—he would contribute to help Youth Aliyah to be as successful in their rescue project as it could be—success measured by how many children they could get out of Germany, then he would move on to something else.

Inspite of his carefully thought-out plans, instead, Beyth would remain with Youth Aliyah until his death in 1947.

In those spring days of 1935, a 'pleasant relationship' quickly blossomed between Beyth and Szold. 'He treated Miss Szold, of whom he obviously stood in great awe, with the utmost deference, yet with a courtly protective attentiveness which would warm the heart of any woman,' wrote Fineman in *Woman of Valor*. 'From their first meeting a pleasant relation soon grew that quickly grew into a staunch friendship on which she could rely, as she had been relying on Emma's these many years …

'Now she often worked for hours at her desk, flanked by these two devoted companions; and when Emma bullied her in her daughterly way,

Beyth would nudge Emma to remind her to be considerate of his *"guter Kamerad"* as he called Miss Szold.'[215] Beyth, mainly sent to Jerusalem to assist in financial matters, eventually joined in other departments, easily grasped the situation, relieving Szold of many arduous items.

'People were drawn to her—there was a certain warmth of personality she had got from her father, although there were still times when people irked her so that she stormed and raged as Mamma used to do. Then Emma Ehrlich would stand by while she vented her anger, until Emma would say, "Now you're going to be nice," and she would be.'[216]

As people approached her during those busy days, Szold warmed up to them, and many times before they left, they wanted to work for her. Her sister Bertha wrote of Szold's spirituality which overrode any of her other virtues— [it was] the 'steady blue flame, the holy eternal light' within her— that cast a spell on all who came into contact with her;'[217] ... and anyone who did come near felt the sensation of 'entering a cathedral' perceiving that the frail, delicate woman possessed within 'the strength of armies...'[218] Rose Jacobs, when she became President of Hadassah, allowed Henrietta Szold's name to remain on the letterhead. Her steadfast conviction toward Youth Aliyah, the *Yishuv*, toward the Jewish Homeland, drew people to her. Szold referred to this belief in an address conducted in Tel Aviv: 'The distinctive task that sets it apart from and above every other *Yishuv* in the world is creation. Creation for finite man can be only a process of combining existing materials and elements into new forms ...' Szold spoke, visualizing Israel's restoration in works of an art work ... 'In Palestine the eternal people ... searches its storehouses for what is known to be there and for what has sunk into the oblivion of disuse. The hand, the eye, the whole body, the mind, the soul are trained anew to restore atrophied possessions to use ... the hallowed ground is spread out before you in its bridal charm. It invites you to go forth and view it ... Drink in its inspiration,' she urged. 'Learn from its beauty as well as from its ruggedness and its resistance, that the Jew worthy of living upon it must make himself a complete man, forgetting no part of his people's heritage and also rejecting nothing that is human...' her final words were spoken as though, in the back of her thoughts she was once again, dreaming of retiring to America and given the opportunity, at last, "to clearing out those boxes she had stored in Bertha's cellar, and the overflow in Adele's barn in Connecticut 'With the mandate of my generation to yours, of age to youth, of age that has completed its work and is ready to pass the torch of Judaism on to youth with willing hands...'[219]

By the first of May, Szold was again on the road. She wrote Mrs. Rose Jacobs from Jerusalem on 3 May 1935: 'Next week I again go off on a

German-children investigating and visiting tour in the Emek ["Valley of Ghost," a German colony out of Jerusalem in the biblical valley of Rephaim] I shall spend a few days at a gathering of the teachers and leaders of all the German youth groups in the country, at which pedagogic and organization questions are to be discussed,' she wrote. 'At this moment the chief point under discussion is the possibility, from the political and financial point of view, of extending the movement to embrace youth groups in other countries, Poland foremost among them,' she told Mrs. Jacobs.

'It is interesting that a movement started by children—the initiator was the *Judische Jugendhilfe*, a federation of Jewish, chiefly Zionist, youth organizations in Germany—gives promise of developing into a Jewish world movement for youth. It is something to be attached to such a movement when one is seventy-four, isn't it?' Szold asked. 'But one pays for the honor. It demands every scintilla of time and strength and involves one in endless minute details of organization.'[220]

On 31 May, after over three weeks of traveling Palestine with Beyth as her companion, Szold sent another letter, expressing her own amazement that she had kept up such a frantic schedule.

> It is really next to incredible that a person of my age can keep going at such a pace. But it must be admitted that I am absolutely juiceless. Life rides by me at full speed. Nothing makes any impression, certainly my memory retains no impressions. Such an old age! And when I was a little girl, I expected a serene old age, such as it seemed to my unsophisticated years the Quakers among whom I then lived were enjoying. But now I am sure that their demure gray Shaker bonnets hid turmoil.[221]

Later in the spring and summer, Szold and Beyth visited youth settlements throughout Palestine gathering information that she would present later in Lucerne to the Zionist congress. As was her routine, for every purpose and action that consumed her life, operated within a strict routine, Szold visited these youth settlements twice a week.

Beyth drove her now, her constant companion, and beneath a dazzling summer sun, as the hot *hamsin* stirred, they spoke in German to one another because Beyth hadn't learned to speak Hebrew well yet. Gradually, with their long days together, his gentlemanly protectiveness expanded over her. 'When the car stopped, he helped her out, when they walked across rocks, he held her arm in a firm grip, almost lifting her along, his head bent down to listen while she spoke.'[222]

"'Achtung, Achtung! Careful now...'"[223] when they approached a slippery area.

So, that summer they struck out into the Palestine countryside 'into a land of noble beings' and away from a place of arrogant, prideful problems. Besides, the number of children were growing, Hitler's hateful speeches now encouraged that they come, hurriedly, and it was up to her and her new associate to be certain the children had a place to arrive.

Once they were back in Jerusalem, on many nights Beyth and Emma worked with Szold, often past midnight at the Eden Hotel. But, no matter how late the work, Szold expected everyone to be at the office at the appointed time the next morning. Szold, also, desired to be loved from those around her, but sometimes those that worked with her, found it very hard to return such affection. 'Nobody could say my child is ill, or I can't. There was no reason,' Lotte Beyth remembered. Husbands weren't quite as understanding on such matters, often showing up at the hotel and waiting downstairs for their wives. 'And Miss Szold would shift uneasily in her chair, bang on the desk and say, "I don't like husbands!"'[224]

Beyth, at those moments of outward frustration, would calm her by taking her hand.

Emma quieted her in a different fashion, with calm conversation. And, in Miss Szold's eyes, she could do no wrong. 'Emma was brave, intelligent, honest, indispensable, as Alice Seligsberg was, or Julia Dushkin,' observed writer Joan Dash. 'But that Miss Szold should attach herself to Emma was a source of amazement to all who knew them.'[225]

By the last week of July, Szold consented to demands that she travel to Europe and then Berlin. Her itinerary was finalized by the first of August— she would attend the Zionist congress in Lucerne, then a short trip to Amsterdam, a month-long stay in Berlin, and finally to Vienna where she would enjoy a well-desired two-week holiday in Vienna. She was scheduled to depart Palestine on 14 August.

As in the past, Szold would miss Jerusalem, she always missed Jerusalem when she traveled, even on those occasions when she returned to America. One imagines that her thoughts turned to the hills and the streets that held such ancient beauty and wonder. Austen St. Barbe Harrison, who was noted by local architectural historians as 'the representative builder of the British Mandate for his work in the 1920s, wrote longingly when he left Jerusalem: 'descend [ing] the stepped suk which leads from the citadel of Jerusalem to the Great Mosque and stand [ing] for the first time on the threshold of the Haram ash Sherif' as 'one of those experiences that a man of sensibility treasures all the days of his life

... [the contrast between] religious calm and the secular bustle [all around] as well as the beauty of the Dome of the Rock and the 'thought provoked by passive contemplation of this historic and holy ground [was] ... so absorbing that he is likely to be reduced to awed silence.'"[226]

One aspect of Szold's world was that, in the past she would have been concerned about leaving the Youth Aliyah office for such a period. This time, she would leave in confidence. Emma's husband, Louis, would assist in making certain personal issues would not get in the way of 3necessary work. As would Beyth's wife, Lotte. Yes, the office would be in good hands, and she was well aware that she would receive correspondence from Beyth letting her know the goings on of Youth Aliyah. Reports addressed to '*Meine sehr liebe Miss Szold.*'

11

Journey into Darkness

'We will have to move through a very deep valley, I believe much deeper than we can sense now, before we will be able to ascend the other side again.'

-Dietrich Bonhoeffer, German Lutheran pastor, and anti-Nazi dissident

The Palestine that Szold departed in August was undergoing dramatic changes. Each day German refugees arrived as the number grew drastically, much to the dismay of Arab leaders. Each day, more terrible, tragic news was received, prophesying the dark future unfolding for European Jews. And, in that same moment, life, in many ways, stood still.

Szold's publicized second visit to Berlin created a stir of interest in Palestine, and a heightening of concern within the *Yishuv*—and an urgency of the German Jews. "My husband had always dreamed of coming to Palestine,' one woman told writer Dorothy Kahn. 'He only needed a push. Hitler gave him the push.'

Jessie Sampter, Zionist educator and thinker, and personal friend of Henrietta Szold, realized that Szold's involvement with Youth Aliyah, and specifically her second visit to Berlin, was timely; this 'unparalleled tragedy of the German Jews' hastened her resolution to respond with her influential weapon—the pen:

> It makes Palestine even more vital as a haven for these refugees who are passionately fond of German culture. Already German children are sent to Palestine and saved from humiliation and death. In Rehoboth, there is no family with its German refugees. In fact, it is the only way to bear these awful times, if you are able to do something to help.[227]

However, Kahn heard every day on the streets comments which confounded her, that is, until she finally sorted out the truth for those who had arrived safely in Palestine, but in their way of thinking had never really

accepted that truth. ' "The Germans" includes also those who never were Zionists and who are not Zionists now,' Kahn finally admitted. 'Perhaps they are foolhardy. At all events they will not submit. They were Germans. They are Germans and they intend to remain German.'

One night while walking through the streets of Jerusalem, Kahn was in discussion with a friend. 'I remember walking ... with Adolph whose faith, although I might question the wisdom of it, was pathetic and in some way wonderful... "Germany is ill now. Hitler is a mad doctor. But Germany is so ill that she believes him. Germany is the same at heart as she ever was. How can I stop loving Germany?" He asked Kahn. "When Germany is well again, I shall go back. I shall be made welcome. It is my country. I have never felt myself a Jew. Can I change my heart because of a political movement? Only now Germany is ill. She will be strong again. I shall go back."

'I told Adolph cruel truths. I said that he had never been a German and had never stopped being a Jew. I tried to speak of pride—the pride of men—the pride of a nation,' she wrote. 'I spoke of building and new growth and new hope and new life. We walked through the streets of Jerusalem and yet I could not bring Jerusalem to him...'[228]

But as only Szold would, in the midst of the busy arranging of the trip, she indeed took to the road visiting the German children in their homes. 'The week previous to this one of preparation for the journey, I spent in visiting all the groups in their new habitations—nearly 600 children,' she wrote on 15 August 1935 off Cyprus on her way to Lucerne. 'Everywhere I was met with individual problems, the problems of the adolescent, until I felt that the undertaking was a failure. But when I summarized the complaints, I found that all together—health, sex, activity, educations, parents (the last cause is the most persnickety)—amounted to less than five percent of the whole number enrolled,' she wrote. 'And when I summarized the advantages and the achievements, I was—I write the word even now so threadbare—thrilled. I keep on saying that this is the most worthwhile undertaking I have ever been connected with; and after my grand tour, I am convinced that I am right in my appraisal.

'The achievements lie on both sides—for the main beneficiaries, the youth, and incidentally for the *kvuzoth*,' Szold wrote. 'The latter must bring themselves up to a better mark in sanitation and in developing educational systems for the youth of the country. I wish I were younger—my broken back after getting through with packing up the contents of my room warns me of my age.'[229]

In Lucerne, Szold prepared to present the Zionist Congress her first formal statement concerning her work with Youth Aliyah, as she stood that

evening at a podium adorned with roses and petal leaves strewn on the aisle. Dr. Chaim Weizmann, presiding as president of the congress, introduced her, 'this is the first time that a Zionist leader's path is strewn with rose.'[230]

By August, over a thousand Jewish children had immigrated from a darkening Germany and settled in twenty-three colonies throughout Palestine. It was announced that the new colony of graduates from *Ain Harod*, the first colony, would be renamed *Kfar Szold*. To her surprise, she was greeted with poignant applause, and those young people in attendance spoke openly to her, 'Your indefatigability, your devotion to the work and your power to build new Jewish lives will inspire us in the performance of own duties.'

Then, after a long pause, Szold began: 'Were I not close to seventy-five, I would yet dare to make promises, and say that I shall do everything to make your words true. Now I can only thank God that ... I was privileged to help to some extent. ... the dear God has dealt well with me.'[231]

A despiser of long-winded, pompous speeches, Szold had carefully planned its briefness, but more importantly, it included a peace offering to Recha Freier. In fact, the speech was rewritten after Szold had received a letter from Freier, in which the rabbi's wife had sharply reminded Szold that the beginning of Youth Aliyah wasn't when she was appointed in Jerusalem as head of the department within the Jewish Agency, but in Berlin at Freier's apartment that dark, cold February day—and if not then—on that Wednesday afternoon in October when the first group of children departed Berlin for *Ben Shemen*. And afternoon, as Freier would later write, when 'the platform seemed to tremble under my feet.'

Recognizing Freier's grievance as genuine, Szold wrote back promising her that her first act on her part was to place words of recognition in the speech; and in future speeches and reports. Szold, true to her word, referred faithfully to Freier's 'inspiration,' though Freier would later admit that Szold's actions placed little healing salve on her 'piercing pain.' Szold opened her Lucerne report, referring to Freier: '... a word of thanks, especially to the initiator of this movement, Mrs. Recha Freier. It was she who had this brilliant idea and made it reality.'[232]

In Lucerne, Szold also had looked forward to once again seeing her old friend Rose Jacobs, president of Hadassah, and Tamar de Sola Pool, president of the New York chapter. It was there where Szold learned that within the hallways of hotels, lobbies, hotel rooms, and cafes, that was where the actual business of a Zionist congress unfolded.

And, so it was that the matter of which Szold wanted to speak to Rose Jacobs and Tamar de Sola Pool, was discussed along the banks of Lake

Lucerne. When the two Hadassah leaders informed Szold that their organization wanted to support Youth Aliyah, Szold insisted that, instead, Hadassah should focus on the new research hospital. Pool insisted that she believed Hadassah could raise $100,000 in twenty-four months. It was monies much needed, and though Szold honestly didn't believe that much money could be raised—and, besides if it could—her concern was, as she told her friends, 'What she did not need was the firm managerial hand from New York running Youth Aliyah in Palestine.' Still, Szold was always seeking the means to raise supportive funds, and so 'when Hadassah offered to enter into partnership with Youth Aliyah, the news came to her like a transfusion.'[233] For Szold, the provision that could form the partnership was that it would be understood that Szold would 'brook no interference from America or from Hadassah representatives in Palestine or Germany.'[234]

Jacobs agreed, only money, no policy making or directives, she promised Szold, and that she would visit Palestine once the conference was over, and look into other projects which would draw Hadassah's interest.

Unimpressed with the business surrounding the conference, Szold wrote to Benjamin and Sarah Levin on 29 August:

> It is amazing how successful a Zionist Congress is in preventing you from doing anything, even from doing the business of the Congress. At the same time, one's sense of duty keeps one chained down; and with the Lake of Lucerne and Pilatus and the William Tell country and the Rhône Glacier calling out to you to come and see, you stay put and enjoy none of the beauties that beckon and tempt. I wonder whether the news of the honor done to me has penetrated to you. My German associates have announced the foundation of a settlement to be named after me. It is thrilling, but the surprise nearly paralyzed me. Now I've got accustomed to the idea, and all I can think of is how they are going to adapt my awkward name to a Jewish Palestinian village.'[235]

The settlement for young Germans was located in southern Judea, named *Kfar Szold*-Szold Village.

Szold left Lucerne for Amsterdam with Emma Ehrlich, and then to Berlin.

Rose Jacobs, as promised, departed for Palestine. Publicly, Jacobs would let the Hadassah organization know of promises made in the November 1935 issue of *The Hadassah Newsletter*: "... the saving of European Jewish

youth is the crying need of the hour. Hadassah is that channel through which can be made effective the appeal for the rescue of our youth..."[236]

Amsterdam. For Szold and Emma, the first Youth Aliyah Conference, as productive as it was in that the representatives expanded, as expected, such efforts of rescue beyond the boundaries of Germany into Poland first. Expected to follow were France, Carpathian Russia, Lithuania, where danger was certain to follow Jewish children. Szold, at last, spelled out her plan for expansion, and asked for monies.

However, Berlin was always on her mind. In a way, Szold looked forward to it, there was much to do, organization, encouragement, the very things as to why she had been urged to visit Hitler's capital; and then, in an inward, secret moment, she awfully dreaded going, aware that witnessing what she had read about, this great nation dissolving into a curtain of treachery, would be a saddening vision.

In October, once Amsterdam and Berlin were behind her, she was in Vienna for a much-deserved holiday. Szold would write her family, revealing her soul:

> I have lived a century since I last wrote. Where was my last news from? From Amsterdam? Amsterdam was interesting and stimulating—I refer to the Conference. But when such a thing as Berlin lies between Amsterdam and Vienna, nothing counts. I don't think I shall ever be able to describe what Berlin was and means. To be there is living history in a stirring time, at once depressing and elevating. The Jews, whom Jeremiah and myself criticize unmercifully, are a wonderful people—even the German Jews.[237]

From Palestine, writer Dorothy Kahn watched from a distance. Berlin, by now, was considered to be on another planet, unlinked to civilization, unfamiliar. Nonetheless Henrietta Szold was there, 'immersed in misery and sorrow'[238] venturing, with clarity and wisdom and courage, into the midst of Nazi shadows. 'What will Palestine do for the German refugee? What will the German refugee do for Palestine? As far as the adult refugee is concerned, it is too soon to judge for we are still in the midst of the drama,' wrote Kahn in a personal diary. 'Almost daily, new boatloads of

these uprooted men and women land in Jaffa or Haifa. There are those who come strong in courage and hope; there are those who come leaden-eyed like mere bodies, their souls still lingering in the Germany that they and their fathers have known and loved...'[239]

The loudspeaker on the train taking Szold and Emma toward Berlin, that second week of September 1935, just as they approached the border, announced that Germany was celebrating the Nuremberg Laws; 'All Jews were excluded from German citizenship, and prohibited from marital and extramarital relations with non-Jews; Jews were forbidden to employ Gentile domestics, women under forty-five in Jewish homes, or to hoist the German flag. A Jew was now defined as a person with at least one Jewish grandparent.'

Szold listened in hushed silence, staring straight ahead, until the broadcast ended. As the train finally crossed the border into the Germany, she leaned to Emma and whispered, but 'this is the land of Schiller and Goethe.'[240]

The train pulled into the station almost at that moment that Hitler was delivering his Nuremberg speech. 'I entered Berlin at the very moment,' she wrote later in October en route back to Palestine, 'almost, at which Hitler was delivering his speech at Nuremberg, in which the new legislation was announced. More or less, the Nazi intentions were known before. But with the saving grace of humanity, one hopes up to the last moment that the worst will not supervene.'[241]

The scene that the two women descended from the train into—was shocking, still unimaginable from what Szold had witnessed just two years ago—how could it happen so quickly? Now, she looked at it with open eyes. Signs and placards: *JUDE, VERECKE!* "Jews, Perish!"; *'DIE JUDEN SIND UNSER UNGLÜCK!'* "The Jews are Our Misfortune!" *'MÄDCHEN UND FRAUEN, DIE JUDEN SIND EURE VERDERBER!'*— "Girls and Women, the Jews Are Your Corrupters!"[242]

As discouraging as it all was, when Szold arrived later at a meeting hall, over eight hundred men and women from various Jewish groups waited for her to speak of the solution determining the destiny of their children. Even the little ones knew the great lady standing before them. The reception was overwhelming. 'There would be much to write, particularly about my experiences in Berlin,' she later told her nephew, Benjamin Szold Levin. 'To be there was living history, the sort of history one reads about but does not envisage as a present possibility.' She told him of her plans to arrive back in Palestine by 15 October: 'I am afraid to think of the sea of work into which I shall have to plunge after my prolonged absence.'[243]

Szold, looking out over that meeting, was heartbroken at the mask of desperation on the faces, the sudden, vile misfortune of not knowing what their future would be, not now in these times, not where a country they had loved, had simply vanished.

What could she possibly say to them to reassure them, to calm their fears for their children? She spoke in her flawless German, which connected her to the crowd, and shortly Szold felt that each one of them trusted her. She spoke, reassuringly, telling the parents that she received daily, letters from the children asking when their parents could come to Palestine to meet them. 'Will you let me, Miss Szold, go out of the *kibbutz*, back to the city, in order that I may earn money, and I am hard-hearted and my answer is, it will be a long time before you can bring your parents here and I cannot let you go out into the city where you would learn nothing, earn a pittance and not be adjusted to the land to which we have brought you…After two years you may begin to think of rescuing your parents.'[244]

This discussion of the children, who would soon be living far away, of reassuring the parents and letting them be aware that their children had not forgotten them, was exactly what they needed to hear. Their questions were not pertaining to Zionism, Palestine or Youth Aliyah; they only wanted to know of their children. 'Many had photographs that they held up. How was the broken leg, the poor study habits, the dental problems of the boy or girl in the picture? …' Szold reassured them again and again.

Then, quite suddenly, a noise, the tramping of feet, out on the rainswept, cobblestone street, the sound of marching Nazi storm troopers returning from a nearby demonstration. Their voices echoed the words to the *Horst Wessel* song: '… *Wenn das Judenblut vom Messer spritzt…*'— "When Jewish blood spurts from the knife…' Szold heard them shout, *"Jude, verrecke!"*— 'Death to the Jew!' Without a pause she finished her speech and called for more questions.

It was during one of the Berlin meetings where Szold was introduced to Eva Stern, chief of the *Arbeitsgemeinschaft* (the joint action committee, Working Group for Children and Youth Aliyah). Stern, of course, was glad to meet Szold, however, 'she sensed an idealism that might never come to terms with the existence of evil, as well as a sense of honor that could make it impossible to cheat and deceive in a time when lives might depend on it.'[245] Stern is often missing from the histories of Youth Aliyah, though she was aware, quite early in her life, that the purpose of the organization, was 'this calling.'

Born in Breslau in 1904 into a German-Jewish family, Eva's father, Wilhelm was a professor of psychology. Her brother, Günther, was married

to the philosopher and writer Hannah Arendt, who was the secretary general for Youth Aliyah's Paris office.

During the First World War her father refused to accept baptism, which would have furthered his career. The family moved to Hamburg, and there Stern enrolled in the Jewish Girls Lyceum, chosen by her parents for its reputation as a progressive educational institution, and directed by liberal poet Ya'akov Löwenberg. Her father requested the school to excuse his daughter from learning Hebrew. Still, her introduction to Jewish life and culture, at age fourteen, drew her to join the *Jüng-jödishcher Wanderbund*, an organization that later became the Zionist group *Brith Haolim*.

After graduating with a certification as a physical education instructor, Stern worked in Hamburg, which brought her not only with young eastern European Jews but with Siegfried Lehmann from Ben Shemen. He asked Stern to live and work at his young village in 1928. She was thrilled with the opportunity, and often quoted that she 'was the only German Jewess at Ben Shemen.' However, at this point in her young life, as is often the case, a failure is what moved her to her purpose in life. Stern could not adjust to the hot climate of Ben Shemen, a common reaction to European emigres, and returned to Germany settling in Berlin.

Her experience of working with Lehmann at the youth village which presented her with firsthand knowledge of Palestine, and her enthusiasm for the Zionist cause, made her valuable to the activists organizing youth immigration. She joined the staff in 1933. 'In accordance with the *Arbeitsgemeinschaft's* mission in 1933, Stern appealed to the wider Jewish public to support Youth Aliyah, handling publicity and fundraising.'[246]

Because the Nazis, during those early years of the 1930s encouraged the emigration of Jews from Germany, Stern's work was accepted and she was allowed to travel to other European countries to promote Youth Aliyah. Slowly, the Gestapo toleration for such activities by Jews narrowed. By December 1937, the world of Eva Stern and Youth Aliyah, had turned violently dangerous. One night, she would be summoned to Nazi headquarters, quite abruptly. Stern would find herself face-to-face with Adolf Eichmann.

Understanding that Szold would soon return to the safety of Palestine, Stern had asked herself many times, where would she stay and live within the Jewish life of reality in Germany. To be fair, Stern wasn't that aware of the hours and dedication Szold poured into the children, inspecting their new homes, making certain that they saw her periodically, dancing, lecturing, and speaking German to the children. Censorship conducted by the Nazis would continue to control the

children's lives as long as they remained in Germany, their projects and meetings and the letters they wrote. Refugees would arrive in Palestine and relate stories; horrors growing daily that would, sadly, sound almost too tragic to accept as true.

'Stern was young… just past twenty. They sensed the future in a very terrible way,' reflected Franz Ollendorff, an Israeli engineer who moved to Jerusalem in 1934 after being dismissed from his Berlin teaching position. 'The man who became principal of the *Jugendhilfe* boarding school had a child come to him one day from one of the villages who told him both his parents had been gunned down by the Nazis. Forever after witnessing his parent's murder, the principal remembered it was that moment when he first caught the smell of death.'[247]

At last, Stern determined that she had guessed correctly. 'She [Szold] lacked the capacity the imagine horrors; she saw only that the Jews in Germany lived "in a stirring time, at once depressing and elevated," '… all the young would leave and the old would stay on in their thousands, silent and proud and sad among the joyful Germans.'[248]

Stern would, after Szold's last visit in 1937, witness and resign herself to the innocence of Youth Aliyah toward the maelstrom unfolding in Germany, disappearing into a cloud of urgency. But in the present day, she urged German-Jews to consider the days that lay ahead for Jewish Youth to either remain in Germany, or for that child would to be cast upon the land of Palestine.

There were problems, terribly complex issues, when one discussed with parents the program to send their children far away, to a land unknown to them except for its ancient reputation. The vein of rich foundation of what family meant ran deeply in the Jewish (and the German) community, that focus of life created an emotional obstacle between the parents and Youth Aliyah. The other aspect of Jewish life, that disruption of Nazism and the emotional jolt it produced, profoundly affected all Jews.

Just over a month after Szold departed Berlin, in December 1935, a leader in the Jewish women's movement, Dora Edinger, wrote a distressing letter: 'It is hard to bear, even though I had long anticipated it rationally. Again, and again, it is something entirely different to know something and experience it' … it was urged that Jewish women maintain the home and family… 'that all hardships be met as duties … with calm and presence of mind.'[249] Now, the burden of confronting the tyranny, mostly burdened the women. Erna Becker-Kohen wrote in her diary, of her thoughts of worry about both herself and her mother, 'I can't burden my husband… with my family problems.'[250]

Jewish women living in Germany, because they didn't necessarily view themselves as essential to the community, were considered more disposed to emigrate. For a woman to leave her country, she was also leaving friends. A woman leaving in 1936, wrote of her leaving a friend: 'Female friendships...There is something sisterly... Part from a friend! Last hour together. Suitcases...are packed, the furniture stored, the apartment... stands empty and ...appears almost hostile... Will we elderly people ever see each other again? Will friendship last...?... A personal story from an individual fate but also a community fate for us Jews; for who does not feel... this tear, this shock... during separation, emigration, departure! *Partir c'est mourir un eau!* ["To part, is to die a little."] '[251]

Then, there were those who believed that the National Socialist firestorm would dissipate beneath the uprising of rational minds; that Hitler was no more than a clown to be controlled by trustful politicians until his days were finished. Within the Bernheim family, Hanna's sister had taken no chances, emigrating to France. In the 1930s, during a visit to the south German town, she was asked why Hanna and the rest of the family had remained. 'First of all, it is so awfully hard for our old, sick father to be left by all his four children,' Hanna rationalized. 'Second there are so many dissatisfied people in all classes, professions and trades. Third there was the Roehm Purge and an army shake up. And that makes me believe that people are right who told us "Wait for one year longer and the Nazi government will be blown up!"'[252]

While in Berlin, warnings had been whispered to Szold for her to be careful, to not speak words or comments that could be regarded as offensive to the German government. Spies were everywhere, they cautioned her, and any such anti-Nazi comments could halt future emigration to Palestine. Szold wrote:

> I knew that in Berlin all sorts of preparations had been made to press the most out of my visit for the good of the propaganda for the Youth Immigration, and I could not bear the thought of the public demonstrations which had been intended for the previous week and were now going to be kept to the letter, though the dreaded blow had fallen. The Jewish organizations went through with the program with grim determination. They used each of my public appearances as an occasion to assert their undaunted courage in the face of the degradation inflicted upon them ...[253]

'The horrors of that hell in which she spent a month,' Fineman explained, 'were mitigated for Henrietta Szold by the dignity, the indomitable courage

of her people, their steadfast refusal to revile their persecutors and their determination to put all their energies into constructive efforts to save and preserve their youth. In the midst of the Holocaust, they had the grace even to "entertain" their honored visitor. They gave her teas and dinners, sent her flowers and sweets ...'[254]

Throughout the German rural area Szold was given a tour, by the *Jugendhilfe* leaders, of preparation camps, through villages where children were starving because the Nazi regime had prohibited the sale of food to Jews. 'With my own eyes,' she wrote later, 'as I passed through villages, one after the other, on my way from Berlin to two youth camps, one in the Mark [of] Brandenburg, the other in Silesia, at which our young people are trained for immigration into Palestine, I saw huge signs stretched across the main road with the legend: *'Juden nicht erwünscht'*— "Jews not wanted."'[255]

Once Szold had departed Berlin, writer Dorothy Kahn drew her conclusions of the promise recorded in her 1935 manuscript written in Palestine: 'But in the children of these refugees there is no element of chance, no gamble. We need not wait for time to deliver up the answer of what they will give to Palestine or of what Palestine will give to them. The answer streams from the lips of every German child whom one hears babbling Hebrew in the streets of the cities and the roads of the colonies... ' Kahn explained. 'But in the colonies, one is conscious of a change more vital than the mere change of language. For here the victims of Hitler's spleen are being bound to the soil of Palestine as though they themselves were the young orange saplings that they are skillfully grafting.

'...And so, it is from one end of the land to another, these children, Hitler's gift to Palestine, are bridging the gap from the hopeless past to the hopeful future.'[256]

By 1937, the conflict, this perpetual struggle between this darkness and this light, became tersely fixated on the fortunes, the futures of the German, Jew and non-Jew, children.

The most innocent of all caught up in the maddening chaos, were the children of Jewish heritage, selected as the enemy of the Nazi regime simply because of the blood flowing through their veins; the children who would either, eventually, die in Germany, or escape to a life in Palestine. Then, there were the children of Germany who were not Jewish; children of German hierarchy and those of men who lived in villages and small cities and had fought for the fatherland in the Great War; those who had sacrificed much, never really believing that Hitler would come to power. Or, when he did, that he simply couldn't remain as the irrational,

maddening leader. Two groups of children were the struggle; different backgrounds, with destinies, of which no one would have believed such distinctions drawn, just a brief decade ago.

'We have begun, above all, with the youth,' Hitler had spoken in May Day speech in Berlin, 1927 as National Socialism gained momentum into German society. 'There are old idiots out of whom nothing can be made any more. [This was greeted with laughter] We take their children away from them. We bring them up to be a new kind of German.

'When a child is seven it does not yet have any feeling about its birth and origin. One child is like another. At that age we take them and form them into a community until they are eighteen. But we don't let them go then. They enter the party, the S.A. and S.S. and other formations, or they march directly into the factories, the Labor Front, the Labor Service, and they go into the army for two years.'[257]

Sir Philip Gibbs, British correspondent and novelist, witnessed, in early 1934, Hitler's end result of beginning the Nazi cause with the youth. Asked whether Europe would go to war, and after observing the SA marches, and the stirring rallies of the *Hitlerjugend*, Gibbs wrote his alarming answer: 'It was impossible not to be impressed by the splendour of that German youth … There was something stirring in the sight of this army of young men … this pride and discipline of youth could be so easily used by evil minds for sinister purpose, later on.'

And so, the die was cast, the moment cruelly defined as the struggle over the Jewish children in Germany approached, for there would never be a future for them in Hitler's world. There would never be a status in the promised, glorious destiny of the Third Reich. To the last Jewish child, there belonged, by the 1930s, only a destiny of mass graves, camps, crematoriums and cherry-brick chimneys protruding from distant, isolated leaf-covered forest floors. Szold and Youth Aliyah wanted them as pioneers in the ancient land; the Nazis wanted them as gray, bellowing smoke, ascending death, lost in the skies over Poland.

One never knows, but wonders, that by 1935 just how much Szold believed of the danger. Yet her words have a prophetic power to them as she wrote of ghettos. Evidence, testimonies from witnesses, wouldn't come to light what was unfolding in the death camps and the murders until late 1942, but still, at times she spoke as a prophet of either wonderful destinies, or death in Europe… 'Wherever I came they told me—and I have no reason to doubt their sincerity—that my presence, the presence of an outsider interested in their affairs, had fortified them to bear the new trials imposed upon them,' Szold wrote en route to Alexandria on 10 October 1935.

And I myself, when the time came to leave, felt that I was abandoning a dear sick child, mortally ill, who needed my ministrations. I still feel regretful. Will you think me sentimental? You would not, if you had been in the Berlin atmosphere a half-hour, in which no three Jews can gather together and not speak of the nasty, black thing. That is one of the accursed aspects of the situation—one cannot escape it. The whole of life is permeated with it, negatively and positively. Jews keep away from the theater and the concert and the lecture hall and the opera and the cafés and the restaurants—they refrain from a thousand normal activities. They might as well be in a ghetto—indeed, they would be better off behind the ghetto walls.[258]

12

'Winds of Violence'

'Here in Palestine, it is a daily occurrence, my meeting people whose families were known to me and by me more or less intimately in the Old Shalom days. The two ends of my life are joining themselves into a circle.'[259]

-Szold, 22 November 1935, Jerusalem

By December, Szold had departed Berlin and sailed for New York where her sister, Adele Seltzer, met her and secretly motored her away to Baltimore. They stayed at the home of her sister, Bertha Levin at 2104 Chelsea Terrace. During that time, Szold did allow an interview with a local *Baltimore Sun* reporter, who later reported, 'that Miss Szold looked fifteen years younger than she was … walked with a buoyant step, and displayed frequent flashes of humor.'

Not usually smitten with such comments, she paused and shared a personal moment from her days in Baltimore: 'It was exactly fifty-two years ago that I received the first Russian immigrants to reach here down at a local pier.'[260] She was referring to Russian immigrates for whom Szold created a night school in Baltimore, so that they could learn American history and English.

Szold's 75th birthday celebration was planned at Baltimore's Chizuk Amuno Synagogue. Julia Strauss, president of the local Hadassah, presided over the program. Dr. Harry Friedenwald delivered the main address, after Szold's career was discussed by Mrs. Emil Crockin, the first president of Baltimore Hadassah.

Friedenwald's address told of Szold's early life, one spent with her family where he often visited. He concluded with glowing words in describing his dear friend: 'What less than Isha Gedolah, a great woman, shall we call her?' Friedenwald asked. 'Who has provided, not for one nor for a hundred, but for a thousand youths, and who is restoring them to a new life of hope and dignity… May we not say to her as Mordecai spoke to Esther, "And who knoweth whether thou are not come to royal estate for such a time as this?"'[261]

Szold, who didn't speak during the celebration, later wrote her friend thanking him: 'I am relieved that I was not present when you spoke this,' she admitted, 'it would have been beyond my powers of self-control to listen without betraying emotion that is not for the public eye.'[262]

Over the next days, praise came to her from many admirers, in so many places. 'I have full sympathy with Hadassah in their natural desire to celebrate Miss Szold's 75th birthday,' wrote General Sir Arthur Wauchope, British High Commissioner for Palestine, in a letter to Mrs. Tamar de Sola Pool. 'All who know Miss Szold's achievement in Palestine in the cause of promoting health and happiness know its value. All who know Miss Szold trust she may live for many years and be able to continue that good work.'[263]

Then, still glowing with the attention lavished upon her during her birthday, Szold followed with a thank-you letter to Tamar de Sola Pool, president of Hadassah. 'It was a fairy tale and you were one of the fairy godmothers.'[264]

Yet, despite all the attention, the dearest part of America were those days that she spent with her sisters. In Baltimore, she was wonderfully entertained with a lengthy, private reunion with not only her sisters, with Bertha's children but also 'with friends, old, old, friends, white-haired women she had gone to school with—girls from the Western Female High School and "young ladies" from the Baltimore Woman's Literary Club... as 'they forgot their white hair and their wrinkles, as she forgot hers, when they looked into one another's eyes.'[265] Memories that she had carried with her to Palestine in 1920, 'the warmth and easiness of Lombard Street, that sweet childhood that so often filled her mind and heart.'

Then it was off to New York, arriving on a cold, wet night after traveling by ship to Hoboken.

In the damp drizzle, Rose Jacobs and a Hadassah delegation, accompanied by reporters and newsreel cameramen, were there to greet her. The reporters were anxious to interview this famous woman, the 'Mother of the Yishuv.' She chose her words carefully when asked to speak, for she and everyone in Youth Aliyah, were aware that their continued operations in Germany depended wholly on the Nazis allowing them to do so. Any word suggesting propaganda against the Nazi regime, would damage their rescue effort. She looked into the camera, beneath floodlights, and spoke of Palestine, 'I come on behalf of German Jewish children,' she said, 'who are leaving their homes and coming to Palestine to be educated.'

Szold's words had purpose, because she knew that the newsreel would be distributed throughout the nation; so, what Americans heard would make them aware of what was happening concerning Youth Aliyah, and perhaps they could draw similarities between the American and Zionist dreams.

'We have already brought out of Germany into Palestine one thousand boys and girls, between the ages of fifteen and seventeen,' she told them, 'From a land in which they could not attend school, to a land where they have fine educational opportunities; from a land in which they cannot pursue trades, into a land where they are taught trades; from a land in which they are repressed, into a land in which they are given opportunities to self-expression and full cooperation,' Szold told them. 'Palestine is in that respect comparable to America, to the United States. As in the United States, our young people look forward to a life of usefulness. They arrive not knowing the language—they learn the language; ... they devote themselves to... study. They go forward to a life of opportunity ... They are prepared to become good, useful citizens.'[266]

Careful words describing children leaving for Palestine, to become new pioneers. 'And then her picture was shown on the movie news, 'a Hadassah leader remembered, 'and there she was with her wonderful eyes, her wonderful voice, coming over for two full minutes.'[267] That brief moment made Szold so familiar to moviegoers that a salesgirl recognized Szold as she bought a new dress to wear at fund-raising functions, gatherings organized by Zionist and non-Zionists from actor Eddie Cantor to first lady Eleanor Roosevelt.

Szold was driven to New York's City Hall, where she was greeted by Mayor La Guardia, small in stature, as was the short Szold, and half-Italian, half-Jewish. A soaring Rabbi Stephen Wise, loomed over the two as La Guardia presented Szold the keys to the city, then spoke from his heart about what she, and her dedication, meant to the American Jewish community. 'If I, the child of immigrant parents, am today Mayor of New York, giving you the freedom of the city, it is because of you,' he said. 'Half a century ago you initiated that instrument of American democracy, the evening school for the immigrant...'[268]

Mrs. Felix Warburg, who had served as the first honorary chairman of Youth Aliyah held a breakfast meeting in her home, attended by people throughout the nation. Szold's speech was set for ten minutes, which infuriated her—she had traveled all the way from Palestine, and had purchased a new dress at Franklin Simon, a department store in Manhattan—and all she was going to have was ten minutes to speak?

Fortunately, Rose Jacobs negotiated for an additional twenty minutes. As was often the case since Lucerne, Szold opened her speech paying tribute to Recha Freier: 'How did this whole system originate? It originated in the mind and heart of a woman with lustrous eyes and most attractive features and manner,' Szold said, 'a God-created propagandist, Recha Freier.'[269]

At the turn of the century, on the old Baltimore streets, Szold had once raised $141 for her Russian night school. In those last days of 1935, Hadassah, now 100,000 members strong, pledged $30,000 to Youth Aliyah for two years. The final total for her visit to America would be $100,000.

Content and rejuvenated with the visit of sisters, old friends, and Hadassah companions, in early February, Szold headed for Palestine.

<p style="text-align:center">***</p>

Sailing on the SS *Lafayette*, Szold spent her time on the desk catching up on answering birthday greetings, numbering in the hundreds, and reading news of her trip. An exciting bit of news was that Hadassah was planting a forest in her name on Mount Scopus. 'You have bound me, not to stone, mortar, some human institution in Palestine, but indissolubly to the land itself,' Szold wrote them. '... in my name you are restoring a piece of the land to fertility and beauty. I have thus been made part and parcel, as it were, of the land of our heroes and prophets and of our holiest aspirations... you have incorporated me into something fundamental, something which in human parlance may be called eternal.'[270]

She arrived in Palestine safely, after crossing the Mediterranean on board the SS *Tel Aviv*, while observing the officers' 'brave attempt at disciplining a heterogeneous group of Jews above and below decks.' She had, sadly, arrived back in time to experience the foulest of the spring Arab riots. Irving Fineman, in *Woman of Valor*, described the atmosphere in Palestine as she returned, 'this one [the riots] had been preceded by months of blatant anti-Jewish expressions and demonstrations, learned and borrowed from the Nazis.'

This was instigated by efforts within the Zionist organization to increase efforts, really since 1929, to purchase land in Palestine. 'In the summer of 1934, the Zionists began organized efforts to land immigrants without permits on the shores of Palestine. Both the labor movement and the Revisionists brought ships to bring the illegal immigrants. The Revisionists complained about discrimination in the Jewish Agency; the labor movement gave expression to their patriotic impatience; and both were spurred on by the competition between them. The illegal immigration,

ha'apala in Hebrew, embarrassed the Jewish Agency, as it ran counter to cooperation with the British. In response the authorities deducted a certain number of legal permits to account for the illegal immigrants. In other words, a Jew who entered the country without a permit came at the expense of another Jew. By the end of Wauchope's term, the number of Jews who had arrived this way was less than two thousand.'[271]

The Arab press labeled Jews as a menace to all mankind. In Safed during late March, Arab leaders gathered to plan the uprising as Arab parades resembling something out of Nazi Germany with brown-clad 'storm-troopers' marched down Palestinian streets yelling, 'Heil Hitler!'

On 19 April, the fires of hate swept, burning openly when the violence reached Jaffa. Soon the whole country was in flames as five British battalions were transferred in from Egypt, followed shortly after with three more units.

Barbara Board, a young journalist from England, sent by the *Daily Sketch* to report on the Palestine situation, arrived in time to witness the riots and violence. '... Apart from the people who come out to Palestine on duty, or business,' Board wrote, 'most visitors make the journey for sacred or sentimental reasons, and their interest is in the past, rather than in the present.

'But the present in Palestine is an intense and vivid reality. The Jews are making a new nation here. The Arabs are fighting to push the Jews out. Everywhere life is real, everywhere there is a vigorous conflict and striving.'[272]

Reporter Dorothy Kahn, wrote an account of 22 April from Tel Aviv of a funeral, one of many throughout Palestine in those days. On a Sunday morning nine defenseless Jews had been slaughtered on the streets. Kahn reported:

> The cortege passed slowly from Hadassah Hospital to the Municipality on Bialik Street. The bodies were carried in simple orthodox manner, on wooden stretchers. The white shrouds were tightly tied around the necks and ankles of the corpses. No one, not even the families, dare glimpse these bodies mutilated until the flesh hung in ribbons. One white shroud followed another down Allenby Road. Only nine in all. But the procession of sacrifices seemed endless... there might have been ninety or nine hundred, so long did it seem in passing.[273]

Despite the escalating violence, through the next three months—March, April, and May—Szold became a 'wandering Jewess,' going to see numerous

settlements where she trained the children through stages of their development from six months of age on up.

She was in Ain Harod when she received the sad news that over five hundred orange trees had been set afire at Mishmar HaEmek, 'the beautiful woodland, the pride of the settlement, has been set fire to eight times,' she wrote. 'The other night the match was applied to ten different places ... the other day 150 olive trees of seven years' growth were cut down—in this treeless country.'[274]

Soon, as the violence deepened into a frenzy, she found herself existing in an unwelcome position, locked away in Jerusalem, cut off from the youth settlements, isolated from 'her children,' by a vast expanse of hill country where her security to travel could not be guaranteed. Still, she worked long hours, sleeping little, four, no more than five hours a night. "All the rest of the time, all my waking hours, I am strenuously at work," she wrote a sister. 'I never, never relax ... I am inhuman.'[275]

Strangely, she found herself filled with sympathy for the Arab *fellahin* [peasant], caught in the middle of the violence, much as the Jews found themselves, refusing to act out any part of the violence, and in turn found themselves 'starving, their shops shut down, their villages lifeless.'

In a letter to Harry Friedenwald, Szold would explain that what disturbed her most in 'Zionist relationships with the Arab world was ... [the] overly nationalistic pattern the *Yishuv* had imposed upon itself. 'I have always held that Arab-Jewish relationships should have been the central point of our Zionist thinking in Palestine,' she wrote. 'It has not been so. We are reaping the harvest of our neglect. At least during the catastrophe our people behaved with marvelous dignity and self-restraint.'[276]

By summer, Szold refused to accept isolation from the children. Despite the continuing bloody fighting in the remote areas, she simply determined to travel again—and soon discovered that convoy travel was terribly slow. However, as the summer dragged on and violence worsened, especially attacks along the roadways, the British banned travel without military escorts. Two stories, concerning Szold, became legend of those times:

Early one morning, Szold headed for Tel Aviv, her procession escorted by an armored car bristling with British troops. Szold wrote of the experience in a letter to a relative sent from Jerusalem on 31 July 1936: 'A few hours ago I returned from a visit to Tel Aviv, the first I have made, I think, in two months. It was a humiliating experience. The arrangement now is to travel only in convoys under military escort,' she wrote. 'Our convoy consisted of three omnibusfuls of passengers, in each omnibus a British soldier occupying the front seat opposite to the chauffeur, and a

cartful of soldiers besides, provided with a machine gun and accompanied by a second cart equipped with signaling-apparatus.

'Our soldier was a dear young lad, with a delightful English, half-Irish accent, a fresh complexion, who kept assuring us: "See, the danger is past," until he warned us that a danger spot in the hills was coming or pointed out the places at which he was engaged in some action. For you must know, if your papers haven't told you about it, that we are now having daily pitched battles in all the hill country.

'It's sickening,' Szold confessed, how sickening I didn't know in fact until I was actually being "protected" by this young slip of a boy, sitting opposite me, his rifle in his hands, in position for instantaneous action when the moment of danger announced itself. I went down yesterday and came back today unharmed, except for the scar to my spirit, inflicted by the consciousness that a young life might have been the ransom for mine.'[277]

The other incident happened upon her return, when Szold's convoy stopped as a large crowd blocked the road. Szold asked who was the funeral for? And, she was told a sad story. 'A professor of Arabic at the Hebrew University was studying at his desk at home when a shot passed through iron shutters on his front window and struck him in the head as his manuscript drifted to the floor. Szold knew him, remembered him as a mild-mannered man, of Arab culture, and, ironically, a firm supporter of Arab-Jewish compromise.'[278]

Several weeks later, there was an attempt to set fire to the Baby Home in Jerusalem. Szold appealed in the name of the Jewish women to the 'Arab mothers and women of Palestine... to influence your husbands and your sons to desist from courses of action... which we believe to be as abhorrent to you as they are to us. In the name of our common motherhood and womanhood...'[279]

Even with this brutal flash of violence consuming Palestine, Szold held firmly to 'her forty-seven-year conviction that Palestine must be not merely the refuge of the Jews from anti-Semitism but the refuge of Judaism—the place where Jewish law and ethics would be reestablished as the Jewish rule and way of life.'

In the midst of the whirlwind of seemingly endless violence, Szold wrote, 'the Jews ... go right on.'[280]

On 7 July 1937, the British Peel Commission proposed dividing Palestine into three states: a Jewish state, an Arab state, and a British Zone around Jerusalem. Surprisingly, Zionist leaders accepted the offer; Arab leaders in Palestine rejected the plan. Szold opposed the offer 'because of the social-ethical dangers' she thought were inherent in a two-state solution.

During the last week of August amidst rumors that the strike could be ending, there was hope 'that the reign of violence is then to be called off.' However, only a week later, violence was unleased. Szold wrote on 4 September: 'The same story still—murder, sniping, ambushing, bombing, indiscriminate shooting, lying, slandering, and so-called negotiating with all the forms of diplomacy.' Everyone continued to live in fear. In that same letter written the first week of September, Szold recounted an incident of the inner fear mounted on everyone who lived in Palestine: 'Here is an illustration of our terror!' She explained. 'In the bus in which I traveled to Tel Aviv last Tuesday there was a single Arab. In the valley we stopped to wait for a part of the military convoy. A number of persons took the opportunity to descend and stretch their legs. So did the Arab. When we were ready to start, all the Jews returned—not so the Arab. Great excitement, and a search of the bus to make sure he had not left his visiting-card behind in the form of a bomb under his seat,' she wrote. 'One Jewish passenger happened to know the Arab and to know that he was an employee of the government in the Water Department, and that when he left the bus, he had walked across the fields to one of the pumping stations. A sigh of relief!

'That is the way we live. And yet, we eat, we drink, we build homes, we work our heads off over Youth Aliyah and social service and all the rest of it.

Don't worry! Unless an international war breaks out!'[281]

It all ran together now, the suffocating violence, as the present reminded her of the first time, she had witnessed such vehemence, in 1921: 'On May 5, the settlement of Petah Tikvah was attacked by thousands of armed fellaheen from surrounding Arab villages. The colony of Kfar Saba was destroyed; Rehovot and Hederah were ravaged. Gardens and orchards and vineyards, the work of years, were ruined; houses and barns burned down; equipment and cattle carried off...'[282] Later in May 1921, Szold had been in Palestine not quite a year yet. She had spent several pleasant days in Rehovot, where she was prompted to write her niece Bertha's daughter, Sarah Levin, comparing the place she had left behind, to this new land '... your description of a precipitate Maryland spring made me very homesick...'[283]

Traveling back to Jerusalem with a group, Szold stopped in Jaffa at a Hungarian place for a late lunch, the only place in all Palestine which made *matzoh-klös* like her mother had cooked. While waiting she visited a friend, passing the May Day parade. Returning later, Szold sat for dinner with her group and was informed that police had stopped the parade because of possible violence. While eating they heard shots and by two o'clock the car

had not returned to pick them up. When a man went out to check on things, didn't return, Szold walked out and saw a riot stirring. Szold hurried to the hospital to see if she could be of assistance. 'Outside was a line of waiting stretchers bearing dead and wounded; inside eighteen wounded were being treated; the wounds were from bullets, knives, clubs; the operating room was jammed...

'Szold hurriedly helped as much as she could, taking care of arrivals, and the crowd of relatives seeking their lost one. The small hospital became a bloody shambles, the floors strewn with wounded, the yard with the dead, mostly Jews and a few Arabs.'[284]

One night after she had returned to Jerusalem, an Arab neighbor showed up at her door giving her a bouquet of flowers and, 'for want of any other means of expressing its significance, sadly repeated the words, "Jaffa, Jaffa"'

That was an act of violence, the riot, and an act of kindness the flowers; that was then and the same actions happened now. Death and peace existing together in a troubled land.

'At night the city is still and dark,' wrote Dorothy Kahn.

In the summer Szold sailed for Zurich to attend the Zionist Congress. En route to Trieste she wrote on 23 July after rumors of refusal by the Arabs: '... at least it gives assurance of serious consideration of a serious subject. I doubt whether in the end it will bring the sort of solution I dream of— conciliation between Arab and Jew in Palestine. At least we shall not be hurried into an ill-considered action.'[285]

Nothing ever came from the partition proposal.

<p style="text-align:center">***</p>

Strangely, Berlin was at peace, in contrast to the violence erupting across Palestine, but it was a peace planned and with purpose. For in the Berlin of that summer in 1936, a plan of deception so intricate, so vast was unfolding, that the possibility of achieving its goal, was impressive even to the Nazi hierarchy.

Hitler, in fact, had inherited the 1936 Olympic Games in Berlin, at first denounced by the Fuhrer as 'an invention of Jews and freemasons. Once, he had even considered cancelling the games, then reconsidered, persuaded by the German Olympic Committee, that he could develop the event into 'political value.'

'The proper solution of the problem,' he considered later, 'demanded thinking on a grand scale.' Hitler considered that he was the only one who

could achieve such a feat, especially with the potential of such splendor and grandeur of a new Olympic stadium, replacing the 1916 stadium, which had not been used when the games were cancelled because of the First World War. Located west of Berlin, in the Grunewald woods, the structure was considered too small.

So, a complete, new and shining showcase of Germany's rebirth and Nazi superiority, would be constructed. 'They've built a magnificent sportfield,' Shirer wrote in a July 27 entry in his *Berlin Diary*, 'with a stadium for a hundred thousand, a swimming stadium for ten thousand, and so forth.'[286] The problem for the Nazis by 1936, with the world coming to their doorstep, was to hide the antisemitism which was now a way of life for Germans. So, great effort was spent to 'sanitize' such happenings in Germany. Signs declaring 'Jews Out!' and 'Jews Not Wanted Here! were removed throughout cities and villages.

'*Die Stürmer*,' Julius Streicher's newspaper disappeared. Anti-Semitic articles and opinions in other newspapers were quietened. Books, once banned, were lined along bookshop shelves. Jewish shops, once forbidden to fly Nazi flags, were provided Olympic flags to display. Helene Meyer, a half-Jewish athlete, who had won a gold medal at the 1928 Olympics, and Gretel Bergmann, a Jewish high jumper, were both on the German team. The deception was so completely thought out and complete, so successful, that journalists and foreign visitors were taken in.[287] As were many Jews who had remained in Germany.

As the games neared, Berliners flowed out into the streets, proud and admiring. On the last day of July 1936, a Friday, young Marianne Gärtner walked along as Berlin 'seemed to click its heels and salute its guests … happy crowds sauntered along the broad boulevards where generous flower displays lent grey, stuccoed facades and monumental Third Reich edifices a cheerful touch,' she wrote. 'There was a holiday about the city, a festive mood which not even the sight of massed uniforms could dispel… For two weeks, the world had come to Berlin; for two weeks the world seemed to have shrunk to a few square kilometres.'[288]

'I'm afraid the Nazis have succeeded with their propaganda,' Shirer recorded on 16 August. 'First, the Nazis have run the games on a lavish scale never before experienced, and this had appealed to the athletes. Second, the Nazis have put up a very good front for the general visitors, especially the big businessmen,' Shirer late wrote. 'Ralph Barnes and I were asked in to meet some of the American ones a few years ago. They said frankly they were favourably impressed by the Nazi "set-up." They had talked with Göring, they said, and he had told them that we American correspondents

were unfair to the Nazis ... and he assured us there was no truth in what you fellows write about persecution of religion here.'[289]

At exactly three o'clock, beneath an overcast sky and gray drizzle, 'Hitler's cavalcade, five big, black Mercedes tourers, left the old chancellery building on Voss-Strasse, drove north up Wilhelmstrasse to the Unter den Linden and turned left to cross Pariserplatz and pass through the centre of the Brandenburg Gate,' one witness recorded. 'Hitler stood upright beside the driver of the leading car, gripping the windshield with his left hand while he saluted the hysterical crowds with his right arm held almost horizontally before him ... at the same time, the runner carrying the Olympic torch set off from the Lustgarten, followed by twelve others wearing white or black strip. In strict V-formation like migrating geese, they ran steadily across the broad bridge over the Spree and then along the Unter den Linden... moments later, 'the great Olympic bell with its inscription *"Ich rufe die gend der Welt"* (I summon the youth of the world), began to toll...'[290]

American writer Thomas Wolfe thought of Germany as his spiritual homeland 'one of the most beautiful and enchanting countries in the world,' continually visiting, as it hauntingly drew him, five times between 1926 and 1935; ending with a final month-long visit in that summer of the Olympic Games. Condensed into a novella, *I Have a Thing to Tell You*, in 1937, his words describe his goodbyes to friends, his disillusionments, and the lasting understanding of what was actually happening in Germany revealed by an event along the Belgian frontier— 'an unheard of event that has occurred— ' *"einesich ereignete unerhörte Begenbenheit."*

'To that old master,' Wolfe wrote, 'now, to wizard Faust, old father of the ancient and swarm-haunted mind of man, to that old German land with all the measure of its truth, its glory, beauty, magic and its ruin—to that dark land, to that old ancient earth that I have loved so long—I said farewell.

'I have a thing to tell you:

'Something has spoken to me in the night, burning the tapers of the waning year; something has spoken in the night; and told me I shall die, I know not where. Losing the earth, we know for greater knowing, losing the life we have for greater life, and leaving friends we loved for greater loving, men find a land more kind than home, more large than earth,' Wolfe wrote.

'Whereon the pillars of this earth are founded, toward which the spirits of the nations draw, toward which the conscience of the world is tending— a wind is rising, and the rivers flow.[291]

Yes, Wolfe was leaving that dark, wicked land; its soul lost. But, into that dreadful place, Henrietta Szold would travel for what would be her last

time—perhaps not the wisest of decisions—but, she was prepared with purpose, and that was to fight the darkness; to encourage both parents and children—that yes, with their continuing, sometimes fearless, sometimes trembling commitment, Youth Aliyah would save many.

As the clock began to run out on rescue from Europe.

13

Berlin, 1937. 'Save the Young'

'As a counterpart to Jerusalem, the power center of the Third Reich is an unholy city.'[292]

-Norwegian author, Theo Findahl

'In Palestine a far-flung network of undertaking and institutions was wrought... In America...a spiritual sisterhood arose to direct the execution of the purpose in Palestine by feeding the fires of the ideal behind the purpose, the restoration of Israel to nationhood...

-Henrietta Szold, broadcast address, February 1937

In the summer of 1937, Szold arrived at the Zionist Congress in Zurich carrying the speech she had been working on since listening to the broadcast of the Royal Commission recommendation. However, Rabbi David de Sola Pool was roundly booed as he spoke words that reflected what Szold believed. Afterwards, when the Agency council convened, Dr Judah Magnes was also booed down after recommending new negotiations with the Arabs suggesting an undivided Palestine.

Szold's speech included much the same message:

The British Government failed, also we failed; and unless we snatch our last opportunity to retrieve ourselves, we shall stand before the tribunal of history as failures ... What I see before us if we accept the *Judenstaat* of the Royal Commission is a repetition of the past. 'We entered the land by means of the sword, the *Judenstaat* of the Royal Commission will compel us to keep the sword in our hands day after day, year after year... I am not pleading for justice to the Arabs alone, I am pleading for justice to ourselves, to our principles, the sacred principles for which our martyrs gave their blood... I too, believe that the land will be ours, but this is not the way to win it. The way to win it is not by might and not by cunning but by the spirit of the Lord, which is the way of conciliation. This *Judenstaat* that is offered to us means war...[293]

In the end, Szold, troubled by the negative reactions she heard, withdrew her speech. She would follow with a letter to Magnes weeks later:

> I cannot stand up against official action, because I can protest against it only with my instinctive feelings... I bump up against my intellectual limitations... I am a moral coward in view of my intellectual limitations. Suppose I were, with a word of mine, to destroy such good as may, after all, be tucked away in the folds of the negotiations I abhor and do not understand! In other words, I cannot follow your example—standing calm and unassailable before a [jeering] audience, with only one voice demanding that you be listened to. There's my confession and my torture.[294]

As much as Szold participated in confrontation on many occasions, especially concerning problems and issues within Youth Aliyah, Szold tended to fade from confrontation in public. She especially feared speaking her personal truths, and that others would be the wiser regarding the issues being debated. That was what she so admired about Magnes—his truth and his calmness under fire and his courage. Even at seventy-seven she still didn't possess that strength; but one day she would, she would stand with Magnes and state her facts, unwavering before the fire.

She wrote again on 10 October 1937, confessing her fears to Magnes and his wife, 'I am still quailing when I remember—and I remember often—the nastiness of the sights and sounds of the evening when I was present... I cannot follow your example—standing calm and unassailable before a jeering audience... there's my confession and my torture.'

In Zurich, Arthur Ruppin reported on the second Youth Aliyah World Congress entitled "The Importance of Youth Aliyah for the Rebuilding of Palestine:" 'Youth Aliyah is only five years old,' Ruppin said. 'In 1932, Mrs. Recha Freier came over as the pioneer of this idea in Palestine. Like every new project, at the beginning it did not find the response it deserved. However, Mrs. Freier did succeed in putting her idea into practice in the same year by sending a group of 12 youths to Ben Shemen...

'On behalf of Youth Aliyah, the greatest struggle I had in our country was with my esteemed friend, Miss Henrietta Szold and we said: "either with you or not at all." With a very heavy heart Miss Szold agreed to take over this task.'[295]

Mrs. Marian Greenberg, the first chairman of Youth Aliyah, from 1936 to1941, reported on the meeting and assured those attending of Szold's strengths that she brought to such an undertaking as the rescues: 'Although

Miss Szold occasionally referred to Youth Aliyah as a Homeric episode,' Greenberg wrote, 'she was wont to dwell upon its human side. Although her passing closed a canto of epic sweep and introduced a still more heroic epoch, she gave little attention to grandiose concepts. Her chief joy was in the simple things: the natural museum at Beth Gordon, a history lesson in a settlement school, the new kibbutz—*Kfar Szold*—founded in August 1937 by German and Palestinian *halutzim* in her honor.

'Above all she gloried in Youth Aliyah's graduates— "the human and citizenship material shaping itself to the uses of the new Palestine." And among the graduates, perhaps, she regarded the pioneers who founded Alonim [a kibbutz in northern Iseal] as her very own. We take leave of Henrietta Szold by recalling her message to them: "Appropriate words do not come to my pen, nor could they come to my tongue. If I could be with you, I might be able, by hand grip, or by a smile, or a tear, to give expression to the feelings buried in my heart. Your coming to Eretz Israel opened up avenues of action and comradeship and endowed me with spiritual riches such as I had not dreamed I was destined to enjoy in my old age."'[296]

Despite glowing speeches and reassurances of funding for this undertaking, Szold was disappointed in the meeting. In a letter written in Trieste in late August, Szold reflected on her dissatisfaction: '

> Emotionally the Zionist Congress was devastating. I felt shattered by it. But it was to be followed by worse—the meeting of the Council of the Jewish Agency. That I know only from hearsay, for during its sessions I was away in Germany, taking part in the farewell "party" arranged for the one hundred and twelve young people for whom, after a considerable interval, we succeeded in securing certificates. In all I was away from Zurich only seventy-two hours, thirty-four of them being spent on a railroad.
>
> Either I was so played out by the Congress happenings, or, indeed, the emotional strain produced by what I saw and heard in Germany was so inordinately great that my powers of resistance proved inadequate. At all events, those three days will be unforgettable for their misery. What I saw in Germany two years ago was a grueling experience; what I saw this time cannot be described in language at my command.[297]

Even before the congress had ended, Szold departed for Berlin. Even a woman such as Henrietta Szold wasn't prepared for what she witnessed.

Years later, in 1960, Tamar de Sola Pool would write about meeting Szold when she returned to Palestine from Berlin; her face reflected the abrupt, obvious change in her: 'During the last journey, by special permit of the Gestapo, she went to Germany for a weekend…Those who saw her off at the railroad station [on her last trip in 1937] said good-bye to a sprightly quick-stepping figure, but when she returned, her friends were shocked to see the bent and shrunken figure looking her seventy-seven years,' her friend wrote. 'There was no need for words to tell the harrowing experience—the meeting in the synagogue with the Gestapo on watch, desperate parents hanging on her words, some pleading for rescue of their children, some wanting a living word from little ones they were never to see again. When she had finished speaking [to a Jewish audience in Germany] and answering all the questions, the congregation, emotionally all but spent, rose and sang under the eyes of the Gestapo *"Hatikvah,"* the hymn of the Zionist movement and now Israel's national anthem.'[298]

Szold, in turn, finally wrote to her sisters of her chilling experience during that short visit: 'What I saw in Germany two years ago was a grueling experience; what I saw this time cannot be described in language at my command.'[299]

The experience for Szold had been nothing less than alarming, despite her preparing herself for such, in that she found a different Germany in such a short time later; 'the older Jews resigned to a fearful fate—they would rot or die there in Germany.' A gathering composed of parents of children who would be leaving in a few days, as the children themselves stood closely, and parents who had already sent their children to Palestine, listened as she tried to reassure them. Parents, who had already sent their children, crowded around her with their pictures and questions, and 'she was able to tell them of over seven hundred who had finished their courses and were well established as farmers and artisans all over the land, some of them organized in labor groups of their own, working eight hours a day and continuing their education in evening classes,' Fineman wrote. 'They were working hard, mostly with their hands, building houses and roads, planting, picking and packing the fruit and the produce of the land, but they were intelligent and civilized as well as hardy young men and women, a new kind of Jew—neither the unearthly *luftmensch*, the impractical intellectual, nor the *am ha-aretz*, the ignorant man of the earth of the Diaspora.'[300]

Families of rich and cultivated Jews in Berlin had hosted Szold and Emma on their last visit just two years before, however, this time, they stayed at a hotel, 'for it was unwise to compromise people, either by living

with them or talking to them or even asking the time. There were other changes. In order to hold an informal meeting, two Jews would enter a house; when they left two others went in. Some people put a pillow over the telephone because they believed the Gestapo had a way of listening to them through the telephone even when it was not in use.

'They were afraid,' Szold saw. 'Furtive, scarred, in the grip of a strange passivity. Unlike the small-town Jews, they were not shot or beaten up, and some of their neighbors even continued to greet them.'[301]

Szold also witnessed that 'the heart had gone out of Berlin Jewry. To Miss Szold they looked like living corpses capable of no emotion but fear. And they were increasingly reluctant to send their children to Palestine; they had lost interest in Palestine,' one writer reflected. 'The Youth Aliyah fund-raising office was to close down at the end of the year because of that lack of interest. Sensing some great catastrophe, shapeless and unimaginable, the Jews of Berlin clutched their children to them.'[302]

The Nazi government, would impose a huge collective fine on the Jewish community one year later, meaning that the Jews had to pay their way out of Germany. These laws trapped many Germans who had decided it was time to live, instead, finding that they had waited too long... as described in Ann Lewis's memoirs: [By then] the sum my parents received

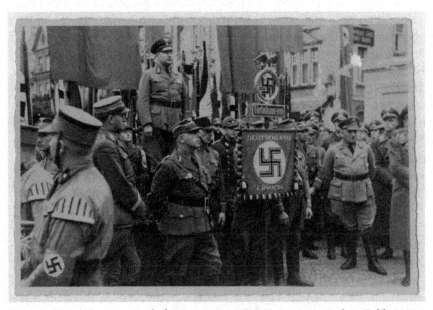

Nazis carrying a Germany Awake banner at a May Day Nazi party parade in Fulda 1937.

in sterling was less than a quarter of what it would have been at the official rate. When the transfer to their English bank had been completed, their 27,000 marks had become only 450 instead of the 2,160 which they would have obtained if their funds had been exchanged at what was then the normal rate.'[303]

A large hall had been rented by the *Jugendhilfe,* and they had asked Szold to speak again to 'invigorate the Zionist community. 'The parents came, those with certificates assuring that their children could travel, and those with children already settled in Palestine; they all crowded around, yelling out questions, showing her pictures,' Fineman described in *Woman of Valor*; 'many expressed their happiness that their children were safe in Palestine, but some had brought petitions and thrust them at her.' Suddenly, all the experiences, all the sensations of the past thirty-six hours washed over her; and there was a despair that even she had not expected—'the furtiveness, the passivity, the vision of Germany as a prison in which the Jews would rot—flew at her in a single moment. It took the form of an unaccountable fear; she was afraid of being torn to pieces.'

Then, there was the understanding of Germans who had been abroad and returned to their country, only to see the enveloping darkness, its distinct impression on Szold, sent a warning to them also. As an 'outsider,' glancing in, they saw the danger as it lingered. The daughter of Bella Fromm, Jewish reporter, traveled to Berlin from America to witness the 1936 Olympic games. 'It was breathtakingly wonderful to have my girl again,' Fromm wrote on 18 August 1936. 'But she has changed. She looks well, and her eye is clear and cynical. Returning, innocently, "Gonny" was suddenly, emotionally overwhelmed at what she saw, and obviously disillusioned, confessing: 'I could not breathe here anymore.'[304]

'It was 1937 and my parents wanted me back home for my summer vacation,' wrote a Jewish teenager, sent away a year before by his parents. 'This decision shows the supreme test for my parents ... had in their government, despite what they saw happening around them. It showed how they had somehow accepted and adjusted themselves to the new conditions. Evidently they felt little risk in having their child return to a land ... about to explode.'[305]

From Berlin, Szold returned to Zurich, and on to Palestine, and then, eventually, to raise money in America...

As the Zurich Congress finished, there was a meeting of Youth Aliyah workers, including Eva Stern. Despite a distant relationship since Eva had doubted how much Palestine understood about happenings in Berlin—a conclusion Eva had made during Szold's last visit in 1935—the two women

had drawn closer. Szold constantly worried over the young woman. She told her that she wished Eva would come to Palestine. Eva told her the work wasn't completed yet in Berlin. Confessing that 'things were getting very difficult' … increased harassment, the Gestapo raiding the Youth Aliyah office and, in one instance, stole monies.

Szold knew her young friend was playing with fire; but she said nothing else.

Szold would return to Palestine and Eva to Berlin, a decision that almost cost Stern her life.

After her last visit to Berlin, during those hectic days of travel, Szold reflected and recorded, in the most dramatic words of what she witnessed in a letter from Trieste on 27 August 1937: 'The Jews in Germany are living corpses. They are capable of only one emotion—fear…

'… their one cry is "Save the Young."'[306]

PART THREE

14

Two Men from Berlin Board a Steamship, September 1937

Now, in those years after her last visit in Berlin, the entirety, the concentration of those efforts of Youth Aliyah took on a higher-pitched resolve. It was obvious to Szold, that the German effort to persecute the Jews, would not disappear, but would rise to a higher level of zeal and hatred. Spilling over into the Middle East.

'We know that within weeks of Hitler's coming to power in 1933, the Grand Mufti of Jerusalem got in touch with the German consul general in Jerusalem, Doctor Henrich Wolff, and offered his services,' noted historian Bernard Lewis.[307] It was there, the Mufti spoke approvingly of the Nazi's Jewish policies, particularly of the anti-Jewish boycott in Germany.

'In the first few months of World War Two, shops in the towns of Syria would frequently show posters with Arabic signs: "In heaven God is your ruler, on earth Hitler." In the streets of Aleppo, Homs, and Damascus a popular verse in a local dialect said: 'No more "monsieur; no more mister— God in heaven, on earth Hitler.'[308]

On the morning of 26 September 1937 two men boarded a Romanian steamship, the *Romania*, at the port of Constanza, bound for Istanbul. Three days later, the ship departed taking the men, Two Nazi SS officers—*SS-Hauptscharfuehrer* (Master Sergeant) Adolf Eichmann and his boss, *SS-Oberscharfueher* Herbert Hagen to their destination—Palestine.

'Dressed in a starched silver-gray uniform,' Eichmann, 'of thin frame, light brown hair and impassive gray-blue eyes, thin-lipped mouth, despite his slight stoop as he walked,'[309] portrayed the cold and calculating figure of a man Hitler would demand of one, who, with the dispatch of an accountant working with columns of financial numbers, could effectively dispatch, extinguish the lives of millions of Jews until the war finally ended.

He would become the dominant and central figure in the mass murders—by then promoted to *Oberstleutnant* (Lieutenant Colonel) Eichmann—reporting to Heydrich and Himmler as chief of the Jewish Affairs Bureau of the SS, managers of what would later be the structure of The Final Solution. Eichmann's cold heart possessed such zeal and bitterness toward the Jew, that he committed himself to learn both Hebrew and Yiddish so that he could better deal effectively with the Jewish problem. His fanaticism toward the Jews ran so deeply that 'when even one threatened to escape him, as in the case of Jenni Cozzi, Jewish widow of an Italian officer, he fanatically and successfully resisted her release from Riga concentration camp against the reiterated demands of the Italian Embassy, the Italian Fascist party, and even his own Foreign Office.'[310]

English historian Hugh Trevor-Roper would be an observer at Eichmann's trial in Jerusalem later in the early 1960s, capturing the essence of the man: 'It [the Final Solution] needed something like a genius,' he later wrote, 'for a mere SS Lieutenant-Colonel to organize in the middle of the war… and in fierce competition for the essential resources, the transport, concentration and murder of millions of people.'[311]

His would be a life consumed of staggering ascent, to the level of 'the banality of evil'[312] giving pause to one who considered his uneventful early life, that of a German-Austrian, an unremarkable school career, and as a traveling salesman before joining the Nazi Party, and soon after, the SS in 1932.

The trip to Palestine in September 1937, coordinated by Walter Schellenberg's SD section of foreign intelligence, had by the time of their departure, taken on a crusade-like purpose—beginning with a meeting coordinated with Haj Amin al-Husseini, the Grand Mufti of Jerusalem and the Emir Abdullah of Jordan.

With Schellenberg involved, there arose an argument of who would travel with Eichmann. Hagen, finally used his seniority to establish himself as that companion. Eichmann posed as a journalist for the Berlin *Tagblatt*, dressed in 'a dark suit and a light travel coat. The younger Hagen would act as his 'student.'[313] No one, during the trip, should be given a reason to believe that they were connected with SD, SS, or Gestapo, or for them to carry identification cards that would suggest their true purpose.

They reached Haifa on the afternoon of 2 October at 6 p.m., where plans quickly fell apart. The British, suspecting unknown purposes, restricted their stay to a brief forty-eight hours. A meeting with the mufti, instead turned into a meeting with one of his representatives, a journalist from Jerusalem.

As they later departed on the morning of 19 October from Alexandria, on board an Italian steamer the *Palestina*, Eichmann had mixed emotions concerning the results of their trip. He had discovered that the Egyptians and Arabs, in general, disliked the Jews, but they weren't people who leaned towards embracing National Socialism. There was, however, a group of 'ordinary Arabs' who honored and respected Hitler, just not National Socialism.

The trip was without merit, however, for Eichmann had, during that short time, emerged as an expert on the Jews and Jewish immigration.

What wasn't known to many in the Nazi hierarchy was that Hitler had plans to conquer Palestine once British forces were either captured or forced to evacuate the Egyptian campaign and the Middle East in general. The Holocaust, only vaguely planned for Europe at the moment, would then expand into Palestine, complete with death camps.

'Germany stood for uncompromising war against the Jews,' Hitler had assured the Mufti at a Berlin meeting. 'That naturally included active opposition to the Jewish national homeland in Palestine, which was nothing other than a center, in the form of a state, for the exercise of destructive influence by Jewish interest.'[314]

By the autumn of 1941, Hitler's generals will present the fuehrer three options: Firstly, Nazi forces would invade from the Caucas. The second plan was the 'liberation' of Palestine, which could happen as the German army advanced through Turkey and Syria. The third plan detailed defeating the British in the north African desert on to the Suez Canal, which appealed more to the Fuhrer's liking and a more likely possibility, so much so that Hitler spoke of it confidentially and directly with the mufti: 'when we shall have arrived … then the time of the liberation of the Arabs will have arrived. And you can rely on my word.'[315]

Hitler's confidence in his plans would destroy any advancement toward a Jewish homeland, and the dismantling of medical facilities, and schools (for Jews and Arabs) that Szold, the Zionists, and Hadassah had worked so hard for over the years. All that time spent by Szold, would simply waste away into images of death camps and mass murders on the plains, in the deserts, in the holy shadows of the mountains of Palestine.

Soon, these plans of conquest would be known to all—including Szold and the Zionists.

It involved perhaps Hitler's most brilliant military strategist commanding an experienced, battle-hardened German army, smashing their way through British-occupied Egypt to the Suez Canal and then into the land of the Jews, General Irwin Rommel and his famed Afrika Korp.

Representing a present danger to Palestine, at least, for several years into the war.

<p style="text-align:center">***</p>

By February 1938 Szold returned to Palestine after attending the Hadassah twenty-fifth annual convention in Atlantic City. She had taken the opportunity to portray the hardship of working days of the young men and women who had been rescued from Germany. She described the harsh conditions in which their work was conducted, often in dangerous areas of the country because attacks and violence continued.

Then she offered good news of ongoing progress on the new hospital on Mount Scopus and the new Nurses' Training School, she described as, 'faith in progress, in the perfectibility of life and the bearers of life,' she spoke, confessing, 'in human virtue, in the values of idealism and aspiration. Such faith is the guarantee of continued achievement.'[316]

Before leaving America, Szold wrote of her experience in a letter dated 29 October 1937 from Atlantic City:

> The Hadassah Convention is a spectacular demonstration. I have been enfolded in affection on all sides. For me the climax came today, when Hadassah voted $25,000 as a memorial to Felix Warburg, to be incorporated into my Children's Central Fund. Besides, I am to get my birthday gift of $5000 for the placement of children. Handsome, isn't it? Worthwhile coming five or six thousand miles. And Hadassah is a marvelous, flexible, well-oiled machine. I am sorry I could not get here sooner, to see the country in its early October glory, the sight I always long for.[317]

On board the S.S. *Manhattan* on 10 January 1938 Szold wrote to her nephew, Benjamin Levin, explaining how hard it was for her to say goodbye to Adele, Bertha, and the family and her concerns of developments in Palestine: 'Altogether the parting was hard, harder than ever before, at least for me. I suppose my depression in the matter of our political situation reflects itself in personal affairs too,' she wrote. 'I cannot understand the Zionists who are rejoicing over the prospect of a statelet to be launched at a time of international conflicts and menace. The outlook is particularly dark in the Mediterranean basin. I suppose the young must be depended upon to meet this emergency.'[318]

<p style="text-align:center">***</p>

At last, she sailed for Palestine on the SS *Galilea*, concerned of what she would face during a continuing storm of Arab violence, upheaval, and the work that remained for Youth Aliyah, and at the same time, struggling against a ticking clock out in the distance, as she was sadly aware, displayed how time was running out for many of the children in Germany.

During the trip back she wrote to Thomas Seltzer— "'a little Jew," who was very little indeed, not quite five feet tall, slight, frail, and addicted to tea and cigarettes.'[319] Seltzer, sister Adele's husband, was the editor of the left-wing *Masses*, publisher of foreign literature gathered among avant-garde writers and artists in Greenwich Village. On 28 January detailing her apprehensions: 'I am literally afraid of what will meet me in Palestine. The economic conditions prevailing there are the worst we have known since the beginning of our adventure,' she admitted. '… Personally, a mountain of accumulated problems awaits me …' and then as she often did, Szold returned to that dream of returning to her sisters, that safe and warm place that remained in her heart and mind: '… Isn't it clear that it would be easier to remain in America, to return to America? But one has a conscience.

'When my mood is apprehensive to the point of pain, there arises before my eyes your little white house set in green shaded by elms, and its warm cozy interior, and my conscience almost vanishes,' she confided. 'They were idyllic weeks in Connecticut.'[320]

True to her concerns, Szold returned to a country aflame with violence, 'perhaps the most murderous week since the beginning of the disturbances all but two years ago.'[321] Palestine existed under British martial law as a new High Commissioner attempted to restore order. Jerusalem resembled a vast camp with steel-helmeted British troops patrolling streets cluttered with muddles of barbed wire. In the settlements outside the cities, the older Youth Aliyah children stood guard at the kibbutz perimeters.

By March, news of Hitler's annexation of Austria, and the unexpected announcement of the Mandatory Government's announcement, on 10 March, of 'unrestricted certificates for Youth Aliyah [from April to September 1938], Szold appealed to Hadassah, informing them that youth immigration was restricted 'by our own limitations; available places and available funds.'[322]

'We could hardly believe our Senses … Unrestricted!" Szold exclaimed. '… If we collect enough money, we can empty Germany, the old Reich, and the Province of the East, of all young people under seventeen.'[323] The next day Hitler ordered his army into Austria.

Hadassah answered her plea, raising large funds and as a result during the next six months, over a thousand children from Germany, Poland,

Czechoslovakia, Hungary and Yugoslavia made their way to Palestine. Then, she turned her attention to Austria, writing on the eighteenth, six days after the German army marched into Vienna: 'Good Purim! I cannot say that my feelings are festive. Perhaps, nevertheless, they are in accord with the spirit of Haman's and Amalek's evaluation in Jewish tradition. I can't think of anything but Hitler's hellish efficiency in the matter of Austria. As a matter of fact, I am depressed by what has happened, not first and foremost by reason of the fate of the Jews, but by what it forebodes for humanity,' she admitted. 'Is it possible to avoid the bloodiest war of history after what this week brought the world? And Czechoslovakia cannot but be the next victim. The whole world stands glaring at Germany, and not one power can raise a finger in protest or for help.'[324]

In Austria, there existed no Youth Aliyah structure. Szold prepared to go herself, to set up an organization to take advantage of the new immigration law. 'We have already begun discussing preparations for the incorporation of the Austria-German boys and girls in our Youth Aliyah rescue work.' However, on 14 March she received a cable from the London office warning her to abandon such plans. It seemed that Adolf Eichmann had personally gotten involved with the Austria situation sending definite warnings on specific matters, as the telegram from London explained. '... one such matter was any visit by you to Austria. You are definitely warned by Eichmann not to attempt to set foot in Austria. You were mentioned by name by him. Furthermore: you are begged by Dr. Loewenherz (an officer of the Zionist organization in Vienna) to heed this warning ... At the moment Mrs. Loewenherz is kept as hostage.'[325]

Eichmann, however, wasn't finished with his campaign of intimidation. One morning, he walked into the *Jugendhilfe* Berlin office and questioned Eva Stern, 'why don't you send many more of these children to Palestine?' Stern informed him that British procedure demanded that evidence of money for their support had to be verified before children would be allowed to go. 'So, we collect first the money,' Stern explained, that there was no Zionist money remaining in Germany, a situation that demanded funds be collected from other countries.

'But when you leave Germany,' Eichmann said, 'you spread stories about us.'

'No, we do not spread stories,' Stern assured him.

'He shouted at me; he said you have to cease with your work, he wanted my passport but I didn't give it to him,' Stern wrote Szold within days suggesting that her office, for safety, had to be moved to London. Szold agreed, suggesting that Stern first go to Poland where no Youth Aliyah

existed, but thousands of children, living in filthy ghettos, begged to get out.[326]

Once she had completed her work in Poland, Stern moved to London and opened the Youth Aliyah office and took over operations of the *Arbeitsgemeinschaft* Berlin office, that of fundraising and publicity. Her husband, Dolph Michaelis, until the beginning of the Second World War, directed the Intria Company that absorbed funds from Germany to Palestine within an agreement known as *Ha'avara agreement*.

Life for the *Jugendhilfe* in Berlin became even more dangerous after Stern departed. Many of those had the opportunity to go to Palestine; most declined as did the director of the organization and Recha Freier. Freier's son left for England and her husband and two younger sons followed shortly thereafter. It would be only through an act of fate that Freier circumvented the attention of Eichmann. Others weren't as fortunate.

The last director of Jugendhilfe was shot. The last Berlin director of *Arbeitsgemeinschaft*, and her assistant, would die in Auschwitz.

On the last Sunday in March, Szold traveled to Haifa in a taxi. Twenty minutes from their destination, a tire blew out, taking over a half hour to repair. Once Szold's taxi continued the journey, armed bands attacked two taxis on the point where Szold's vehicle left. One was driven by an Arab. All the passengers were wounded, and the chauffeur died from his wounds.

'It's gruesome. And there seems to be no end to it—or to the funds with which the gunmen are supplied... I am writing this at the end of what has been perhaps the most murderous week since the beginning of the disturbances all but two years ago,' Szold told him. 'I have lost count of the victims, young men, old men, women, and children, with practically not a word of condemnation of the outrages in the Arab press ... And all this is happening in a country poignantly beautiful and peaceful-looking,' she wrote from Jerusalem on 1 April. 'Such a bloom, such verdure, such blue skies (but not zephyr winds; winter refuses to depart from the temperature), such rich promises of crops, with oranges gleaming from the trees, in heaps under the trees and on the roadside waiting to be carried to the packing-houses, from the lorries filled to the brim.'

In a way, Szold could never understand the violence that consumed Palestine '... in the grip of guerrilla warfare [Palestine] is still looked upon as a haven of refuge for the hounded Jew of Central Europe,' from that first time she witnessed a riot, until this summer of 1938. But no matter the fact

that she didn't grasp the anger of the Arabs, Szold knew only one method—
to move forward, pursue defined goals—rescue the children.

In the same letter, she found the method to close with a positive avenue:
'Today cables came from Hadassah: Eddie Cantor collected $32,000 for the
Austrian Youth Aliyah. Meantime it seems certain that we shall have to
tackle Rumania, too. There should be many Eddie Cantors unless the
Hitlers and the Francos can be made innocuous.'[327]

Szold received three postcards by the first week of April from relatives
in Vienna—'The Austrian situation is overwhelming me ... Practically daily
I get a letter from one of our relatives in Vienna—some of them want
certificates, some inquire whether I can secure affidavits for them for
America.' As she read the postcards, she could see the urge to not write
exactly what one was thinking. 'What the Germans learnt in the Reich in
the course of five years they have applied with Satanic efficiency in Vienna
in the course of as many days,' Szold recorded. 'I have been told by a
Palestinian just returned from Europe, where he visited a number of places,
that everywhere the Jews "sit in darkness" wondering what will be their fate;
and the others are ready to embrace Hitler-Napoleon when he comes, as
they think he is bound to come.'[328]

<p style="text-align:center">***</p>

Writer Dorothy Kahn was annoyed.

To Jews remaining in Europe and the Americas, Zionists were labeled
as "idealists," devoted to forming a perfect society within the boundaries
of a Jewish homeland. Kahn strongly rejected that idea—in the midst of the
violent riots—Zionism was, in clear fact, the building of a home for Jews
guarded from anti-Semitic persecution, its purpose to attain cultural
authority, along with political and economic influence.

After receiving a letter from an American friend voicing a strong
opinion: 'The difference between you Jews in Palestine and us Jews in
America is that you are idealists—you live for an ideal—we are just plain
human beings, selfish and concerned only with the little spot on which we
stand ... the sentence annoyed me ...'[329]

<p style="text-align:center">***</p>

In the Jaffa marketplace, three weeks later, on a peaceful Friday, a bomb
exploded killing a number of people— 'nevertheless, we are having
"disturbances"—not a war—in Palestine!'

That same afternoon, Szold's associate Hans Beyth met a friend who had just arrived in Jerusalem and soon every taxi carrying Jews was stoned and shot at. Beyth's friend escaped injury, but he was covered in blood, the blood of the woman sitting next to him. And she, this bleeding woman, had just escaped to Palestine… 'and promptly she dropped from the frying-pan of the Nazis into the fire of the Arabs.'

And Szold did continue to fight. 'It is no use warning me not to overwork,' wrote Szold to a sister on 27 August, 'it's no use telling anybody in Palestine to take care. One has to grit one's teeth and take a chance.'[330] The unrestricted immigration regulations were continually being changed, and there were the shifting intentions of the American government, 'we have had reason to realize that warnings given us by our friends are well founded.'[331] And, at this point, the Jewish Agency began looking closer into the workings of Youth Aliyah with its approval for "unrestricted" immigration. Szold, immediately pushed back once she sensed the agency pulling closer. She didn't trust them, and their relationship had never been cordial; in her mind, Szold didn't seem to care if the relationship became even more strained. One last matter wore on her nerves—the Evian conference, where President Roosevelt had invited 'representatives of thirty-two countries to discuss the destiny of thousands of Jewish refugees—had failed. The British government had set too many preconditions, the major obstacle being that Palestine could not take in refugees. Palestine would not have a representative at the conference. By June Hadassah had all but given up on the conference, as Stern pushed back against even attending, Hadassah then asked Szold to go, but she was engaged in several battles in Jerusalem. 'Do you wonder that… we view the Evian Conference with distrust?" Szold asked in a letter to her sisters. 'It was a fine gesture. Doubtless Roosevelt was honest in his intentions…No country is going to open its doors to receive the unwanted.'[332]

The failure of the conference created more pressure on Szold in the summer of 1938. The Jewish Agency pushed Szold, who was armed with her 'unlimited' certificates. Poland, Romania, Czechoslovakia and Hungary sought any assistance. And Hadassah 'wanted German children brought to America to present their case to the public.' Szold's composure began to wear thin, 'What am I doing here! What for? … I don't want to die in this place.'[333]

The New York Times, by summer, wrote of their findings that the segregation of Jews in Austrian public schools was wide-ranging: 'The youngsters are not spared; infants of the kindergarten can no longer play in public parks. On the school door the legend is painted: "Cursed be the Jew."'[334]

Several months after the annexation of Austria, Szold found herself apprehensive about the possibility of a Youth Aliyah organization in Austria. 'The Jewish Community is still kept incommunicable,' she wrote. 'Not even Berlin may make contacts with stricken Vienna. We want to send someone from here and I had thought of going; but the Gestapo decided otherwise. It found worthwhile to forbid my coming.'[335]

Survival and escape took on a life of its own, however, in Austria. The first group of children departed Austria in August, 970 reached Palestine before the war began.

Beyth married during this time, keeping it away from Szold until the wedding day. Little changed after marriage, however, for he still traveled with Szold to visit the youth camps, a situation his wife accepted. 'And you see my husband didn't like to take me when he went away with her. He would always say he has to look out for Miss Szold, and if I am with them, she will be … she doesn't feel so well. She could have said, "take your wife with you if you are two days in the whole week away," but she never said it.' Beyth even missed the birth of his first child when he was escorting Szold in Tiberius. 'I think there she felt a little bit guilty that he was not at home.[336]

In mid-July a bomb exploded in a vegetable market in Jerusalem's Old City. Among the many killed and wounded were ten of the Arab peasant women who came to the market to sell produce. 'The events of the week are too ghastly to write about,' Szold protested on 29 July. 'I am suffering in particular because my most knowing friends are of the firm opinion that the bomb-makers and throwers are Jews. If that is true, something subversive is going to happen to my Zionism.'[337]

Later that summer, the long hours, the exhausting schedule, the heavy workload finally wore down Szold's aging body. She became seriously ill and was admitted to the new Hadassah Hospital on Mount Scopus. The doctors told her that she had 'a tired heart, the more technical term was 'a cardiacvascular disturbance.' The worst news she could receive was that she must rest, two weeks in a private sanitorium; to withdraw from the daily activities of her beloved Youth Aliyah she considered inacceptable; Her patience was challenged even further when she was told that, once she was allowed to return to work, fifteen-hour days were forbidden, reduced to a more acceptable six-hour days, and then for only six days a week.

Within several weeks, Szold had been relocated to her room at the Eden Hotel, surrounded by her flowers 'the air of my room is fragrant with the perfume of orange blossoms. I wonder how orange trees stand it.' Lotte Steigbügl, one of the secretaries, came to read German books to her, which appeared to satisfy her for the moment, but gradually Szold convinced Lotte

to bring 'business letters, reports and bulletins,' so that the daily affairs of the office blended in with the writings of Schiller.

In early autumn, Szold was back at work, and with the assistance of Beyth and Emma, her workload was reduced to just twelve hours a day, as she was confident that her health, was completely restored. With that confidence, though was her realization that time had, perhaps, caught up with her. '… the warning administered to me was impressive, and I find I must heed it. I cannot work as I used to. I must give myself more sleep; and I do, with the result that I fall behind more and more each day in my work. I cannot keep up with the procession. The march is too rapid,' she confessed in a letter to Mrs. David B. Greenberg from Jerusalem on 11 October. 'As it is, I am actually at work twelve hours daily. To do what is required calls for at least eighteen, and at that I should not be responding to the demand for personal contacts, not to mention articles, etc., that should be written and visits that should be paid to institutions—*kvuzot*, social service bureaus, and all the rest. As you see, it is not a question of more secretarial help. I have no doubt that others could work faster than I do.'[338]

Autumn was also the season for violence to escalate in Germany, the time for what became known as *Kristallnacht*, the Night of Broken Glass. Violence erupted across the nation against the Jews their businesses and synagogues. Over 20,000 Jews were arrested, 800 Jewish shops burned and broken, and over 100 synagogues destroyed. Within the darkness of that night, the world changed for German-Jews. What had once been isolated events, hatred toward the Jews was now open and blatantly public, and dangerously wide spread. Men and women, who had once hoped that Hitler would go away, and that their children would be able to live a good life in the good nation of Germany, now understood. The worst was yet to come.

In Jerusalem, Szold watched and read of those events, and her heart ached. War was now a certainty. She knew that, for those adults who had held back, the time had come to admit their failures—the requests for the children to come, now, would, in all probability, flood in and overwhelm the Youth Aliyah office. And, with the world shifted drastically for those German Jews, Szold was aware that the future of the last days of her long life—had changed, forever.

By October, she was back in America for another Hadassah Convention, as war dwelled on Szold's mind, and the continuing violence in Palestine. She wrote a letter to her sisters on 21 October:

> This week taught me what I could never make myself understand when I read history or a description of a war in the daily papers. I

have not been able to imagine how ordinary people went on living in Spain throughout the frightful upheavals in city after city. This week I have been living in a beleaguered city with airplanes whizzing and buzzing through the air, and the reverberations of shots assailing my ears. And what did I and thousands of others in the city do? We picked up the circulars dropped by the planes, we read almost with equanimity that the military commander whose troops had taken possession of the Old City advised us not to leave our houses, we gobbled up all the details of the beleaguerment of the Old City by the soldiery—and we went about our business.

In January, the 'indefatigable traveler' sailed once more for Palestine. 'In these last four years,' Marvin Lowenthal wrote, 'her gait had begun to slacken—she is calling twelve hours a day's work—but she still marches sturdily along a highway into which all the familiar roads have converged.'[339]

Szold's good friend Jessie Sampter 'had been a pacifist all of her life—except for a short while when she and some "millions of other dupes," to quote herself, had been deluded by President Wilson's message about the "war to end all wars." The violence and retaliations occurring daily—'it is the greatest danger, that the Jews will not continue their discipline of non-reprisal,' she had written on 15 March 1937—in Palestine drove her to a deep depression as she had fallen to illness, an attack of pneumonia where she was treated at the hospital in Petah Tikvah. She and Dorothy Kahn had developed a wonderful relationship among two writers. As Sampter became ill again, this time with malaria, it was Kahn who wrote of her last days ... 'three years ago, when I was living in Jerusalem, I wrote Jessie a note "I know your name. I should like to know you...' Now it was March 1938, Sampter was ill again at Givat Brenner, and Kahn traveled to see her: 'For a while, our walks in the garden continued. Then, she was confined to the terrace. And finally, as her life was visibly fading, she was confined to her room. But restriction of movement could never touch the inner flame ... from behind the walls of her room, whether she could walk up and down the tree-lined paths or whether she was compelled to remain in her small bed—she reached out toward the world from which she was physically cut off...'[340]

Reports of Sampter's waning health reached Szold in Jerusalem, causing her great grief. It was during this time that she also became haunted with the likelihood of war. However, it was her deep wishes within the last years that honestly troubled her. She ended a later letter, willingly declaring, while admitting to her sisters that the dream that she had held for so long—to

return to America—was quickly being erased with the weight and consequence of her reason for her existence in Palestine. 'If war breaks out, I am afraid I shall not get back to America,' she wrote. 'Your analysis of my attitude about leaving my responsibilities is correct. In any case, however, I am working unceasingly toward the end of relieving myself of public responsibilities. I keep saying that I always knew it was hard to get a job, but I never knew it was so hard to get out of a job as I am finding it.[341]

Jerusalem, during the mid-1930s, appeared to have more than its fair proportion of women journalists. It was in Palestine, along with Nazi Germany where Shirer remained until the fall of 1937, where news reporters sensed a unique unfolding of history. Because of the darkening nature of life in Germany—Dorothy Thompson had been expelled in August 1934, Edgar Mowrer left under pressure from the Nazis, and William Shirer departed in late 1937—many journalists turned to the Middle East. In Palestine, unusually, there were a large number of women.

One predominant writer was Mrs. Gershan Agronsky, wife of the editor of *The Palestine Post*, a capable journalist herself; there was Miss Dorothy Kahn, employed also by *The Palestine Post* (later *The Jerusalem Post*) who wrote with eloquence in her book, *Spring Up, O Well*. Most of them were Jewish, well versed in Hebrew, German and English, and one could meet most of them any evening in the Vienna Café—a real European café.

And then, there was Barbara Board; British, young, adventurous and considered controversial. Tall, thin, and beautiful, she had been sent to Palestine by the national *Daily Sketch* bylined as 'our Jerusalem correspondent' to cover the Royal Peel Commission in November 1936 to investigate the origins of the Arab unrest in Palestine.

That may have been the stated reason, but for Board, Palestine and the people came to mean so much more for her, as she wrote with both flowing words and brilliant descriptions. Board explained her own personal reasons in the first pages of her book, *Newsgirl in Palestine*, published in 1937 after she had left Palestine for Egypt. 'This book is a record of things that I have seen and heard as a newsgirl in the Holy Land,' she opened. 'Apart from the people who come out to Palestine on duty, or business, most visitors make the journey for sacred or sentimental reasons, and their interest is in the past, rather than in the present...

'... But the present in Palestine is an intense and vivid reality,' Board wrote. 'The Jews are making a new nation here. The Arabs are fighting to

push the Jews out. Everywhere life is real, everywhere there is vigorous conflict and striving.'[342]

<p style="text-align:center">***</p>

Since arriving in Palestine, Board had watched, with great interest, the work of Henrietta Szold, her influence on the people; of Hadassah, and their sincere dedication to the causes of the people, Jew and Arab. Then, one day, she had the opportunity to interview 'the greatest Jewess of our century,' Board wrote. 'A white-haired old lady of seventy-seven, lives in Palestine. She is Henrietta Szold, and she is the fairy-godmother of *Eretz Israel*.'[343]

Board had learned that Szold was one of those people who spoke very little, in spite of the fact that she had so much to say. She would speak freely 'about things that do not matter,' and, for that reason, Board had gathered her information about Szold from other sources. Until that day that she was scheduled, she felt truly privileged, to sit down for a fifteen-minute interview with the famous lady.

'As I walked into her office at the Jewish Agency in Jerusalem, I could feel her personality as a definite presence in the room,' Board recalled. 'She fixed me with her lovely brown eyes and walked forward to shake hands, a diminutive woman, old in years and yet not old in spirit. Her forehead was high and her hair, which was white, had been bobbed and cut short.'

Board's first question was about Hadassah. Szold's eyes changed as she recalled a meeting in New York that seemed now, a lifetime ago. 'We started here in Jerusalem twenty-six years ago—we did not discriminate between Arab and Jew. There were forty-four pioneers—physicians, nurses, bacteriologists, sanitary engineers,' Szold said. 'It was hard to begin with—but we preserved.' That statement opened her up, and she began a long list of accomplishments over the years, crediting Hadassah instead of herself at each achievement, speaking as "We" and never "I."

Szold spoke on, discussed Hadassah work during the war with the Red Cross, and spoke until she had brought Board, and herself, to the present day, all the while 'clasping and unclasping her nervous fingers as she spoke.' Board remembered: 'I looked at her gleaming eyes, at the wrinkles beneath them. I admired her smooth forehead—so smooth for a woman of her age—and her small, smooth, but pale lips.'

Szold paused; something had come to her.

'We are building a large hospital on Mount Scopus—you know about it?' Then, she went into a summary of what this hospital offered for Palestine, the carrying on of medical research work connected with the

University; the gradual transfer of local hospitals to the communities themselves.

'Am I interested in politics?' Szold responded to Board's question.

'I think we should sit down to one problem, finding out how to live on good terms with the Arab. I have always held that view, I hold it as strongly as ever. I think it is Palestine's chief problem,' she said. 'If we don't solve that problem, I shall feel we are not worthy of our National Home. But I do feel that the British Government should help us to live on good terms with our neighbours, and I have the conviction that if it had wanted to it could have.'

However, it felt reasonable that their final moments of the interview would be concerning what Board understood, from those who worked close to Szold, of her greatest achievement in her celebrated life.

'You want to know about the German immigrants I meet as they land in Palestine? Szold asked. 'The Youth Aliyah? There is nothing to tell. I always make a point of meeting these young immigrants when they arrive, accompany them to their destination and spend a day or two with them.'

What an amazing story to write about, Board realized, and she thought that only Szold could have given such 'a bald, bare description of a great work ... I thought of the tales I had heard of Henrietta Szold tramping through rain and mud to reach some child newly arrived in Palestine— some child who was home-sick and unhappy—and how she has comforted and mothered it. I thought of her fairy-God-mother work at the Haifa port—where she meets the immigrants in the large customs shed and lets them feel that they have one real friend already in Palestine,' Board wrote. 'I thought of the days when she is feeling tired and worn out with work, when she has given advice in her office and talked to a continuous stream of visitors all day—and how, if someone should need her, no matter where in Palestine, she would be ready to go.'

The next morning after meeting with Szold, 'a cold but sunny morning,' Board visited several Jerusalem Hadassah institutions to complete her notes on Szold and Hadassah. Board was taken to a children's clinic. There were Yemenite mothers clutching their children; there were Orthodox Jewesses accompanying 'small boys with long ringlets and the big velvet hats edged with fur and little girls with white caps over their heads'; there were Greek and Armenian orphans; there were, to Board's surprise, Moslems ... 'I was told that in the 1936 strike it was more than their lives were worth to be caught attending a Jewish institution—but that these mothers still came, risking anything for the sake of their children.'

Leaving the clinic, Board was shown into a maternity home 'with forty new-born babes lying in cradles in rows around the wall ... two dark-haired

Jewish nurses were on duty.' They toured several other facilities, then to the Nathan Straus Health Centre, 'a fine building, large, roomy, and full of sunshine.'

What Board witnessed that morning, and thinking back on her interview with Szold the previous day, she then fully realized what Szold and Hadassah meant to Palestine, the women, and the children. 'I wondered if American Jewish women who contribute to Hadassah funds realise fully the amount of good, they are doing in Palestine,' Board recorded. 'The work is proceeding quietly and steadily to improve the lot of the people, and Hadassah is playing a very important part in endeavouring to improve public health conditions. In some ways it is ahead of the Government Departments run by the British Administration.'

Szold received word of Jessie Sampter's death on Friday 11 November 1938. The end came as 'a strangely happy end' as her lifelong friend, Mary Antin, wrote in a letter referring to Sampter's burst of writing, even as she was too weak to walk from her bed.

Sampter's funeral was on Sunday, at Givat Brenner as they brought her to the cemetery in a small black coffin decorated with white chrysanthemums. Szold's longtime friends gathered there remembered that it was the first time they had ever witnessed their iron-willed leader weep. 'A part of myself which was of the best, was gone,' Szold wrote. Szold, as her mentor, spoke of Sampter's lifelong 'search for the truth' and that Sampter's publications and her early School for Zionism (established at Szold's urging) made Sampter a treasured 'teacher as well as a friend.'[344]

Later that day, Szold, with an urgency inside that she must simply do something, knew where she should go to speak of her friend. 'She went to the *Beth Hatarbuth* and gathered around Youth Aliyah children dressed in their clean shirts and white blouses, she told them of the friend she, and all of them, had lost. She told them of the dramatic story of her life, and how she had freed herself from the bondage of her crippled body...' Julia Dushkin, wife of Dr. Alexander Dushkin, professor at Hebrew University wrote in *Hadassah Newsletter* of the funeral '... How she came to Palestine and to Labor Zionism in Givat Brenner; and how Zionism could best be served by following Jessie Sampter's footsteps—thus, Miss Szold, on the very day of Jessie Sampter's funeral—planted the first seeds of Jessie's life after death.'[345]

15

Adele and Bertha

In January 1939, Szold resigned from the *Vaad Leumi* so that she could focus her efforts on the ever-expanding Youth Aliyah. She wrote:

> Though I extricated myself from the *Vaad Leumi*, that is, the Social Service job, a day plus a week ago, the week was as full as usual. In the first place, I must clean up in the *Vaad Leumi*. I had fallen behind in my work rather considerably, and in the second place a number of really involved problems had arisen in connection with the refugees' plight.[346]

Later that month she dedicated a new Youth Aliyah facility, sponsored by Junior Hadassah at *Meier Shefaya*. 'The countryside revived by the winter rains was radiant with flowers—the fields with red and white anemones, the almond trees with clouds of pink blossoms, the hillsides with carpets of lavender … the children, gathered in the courtyard to greet her, sang the "*Hatikvah*" as the flag was raised; and a girl from Germany, sunburned and sturdy, stepped out and spoke; and Henrietta Szold heard a restatement of her own dauntless faith: "We all recall the burning of our threshing floor and the destruction of the wheat which was the fruit of our labor. But we remember, too, that we refused to be discouraged and began at once to plow and plant anew, 'Fineman wrote. 'We had faith that this time we would harvest what we had sowed…'" Children with her like-spirit, Szold was glad and was presented with roses and violets, as they spoke a prayer over her: 'May your days be long, for your task is great and many await salvation through you. Szold responded by reminding the children of the peoples to whom they owed a great debt, those in Palestine and Germany. And, she spoke of Recha Freier.[347]

Back in Jerusalem, Szold reflected on those first days of 1939, man's fear of war; 'her people bleeding from thousands of wounds, mankind bound and throttled.' And, so Szold turned to pencil and paper, her healing, a release of her soul 'it would have been less than human not to lament: I believe in lamenting, if only lamentation does not hinder action, if only acute fellow feeling does not hinder action,' Szold wrote. She reflected of a

day, 'standing alone, on Mount Haifa overlooking Haifa harbor, the Mount of the Prophet Elijah, and the scripture of a cloud appearing from the sea's horizon, "as small as a man's hand," a provider of rain among an awful drought and she thought of those who cared, and had moved toward the Jew to help during this present-day storm and 'of the almost divine self-restraint of the Jews in the face of savagery... Yes, the Jewish doctrine is true and right. Man is perfectible,' Szold wrote. 'Setbacks there have been; setbacks there will be. But what our prophets, our poets, our philosophers, what the good and the wise of all ages and peoples have preached, will emerge triumphantly ... man's humanity may sink out of sight for a span. It is bound to assert itself... This is my creed in these, dark, terrible days... It does not banish sorrow and pain, but it keeps ajar the door of hope...'

'Now she was certain that letting go many obligations cluttering her efforts of rescue, was a good decision. If all indications were true, as many now believed, war was close, the chaos of those who would find themselves in the way of conflict, then time for this rescue was narrowing. Who really knew the days remaining?' Fineman wrote. '... Also, my creed demands that I shall keep on steadily with the work that life has entrusted me and do it to the best of my ability. The sorrier the time, the more poignant the anguish, the keener the need, the greater the challenge to wrestle with fate.'[348]

The following months were days filled with tension and turmoil.

Eva Stern had written to Szold from London. Germans, who had once considered Hitler a clown or a passing whim, now, quite suddenly, realized that they must give up whatever possessions they owned, and get out. Szold's response was brief, her heart saddened.

∗∗∗

Henrietta's sisters had tempted their promise to visit her in Palestine with letters describing family picnics, trips to the country, and most importantly, America was a country protected from war by a large, vast ocean. So, when she received their letter that they would be coming in the spring, Szold began to prepare. She wanted to use every moment.[349]

Bertha Levin and Adele Seltzer, Szold's sisters, traveled in March 1939 aboard the *Ile de France* to Palestine. It was a visit that had been promised for a long time, as dedicated and busy as she was, Szold treasured the idea of taking some time away from the daily burden of Youth Aliyah, and enjoying a holiday with her sisters.

Bertha was a widow; Adele was married to Thomas Seltzer, a small book publisher who held more rights to D.H. Lawrence's first editions than

any other American publisher. But Seltzer was a poor businessman, and the childless couple was heading toward struggling to survive the economic depression smothering the world economy.

On 5 April, a Monday, the sisters arrived in Palestine. Benjamin Levin described the event to his sister, Mrs. Harriet Terrell, in a letter addressed to Baltimore: 'Of course the exciting event of the past week was meeting Mamma and Aunt Adele. At the last minute we learned that the *D'Artagnan* would dock at Tel Aviv and we went there Monday morning. Sarah and I had never been to the port before and for some time we wandered about the grounds of the adjacent Levant Fair before we found the right entrance,' he wrote. 'Finally, we reached the dock and through the gates we could see Aunt Henrietta and Emma Ehrlich... [later] all along the trip up to Jerusalem one of the striking things was the way in which Aunt Adele was impressed by what she saw. Tel Aviv in particular was a pleasant disappointment to her. She had been told that it was an ugly city, and she found it "jolly."'[350]

However, the sight of Adele shocked Szold; 'she looked ghastly thin, without appetite, her skin broken out in dark red hives. She suffered from enteritis [inflammation of the small intestine].' That initial shock aside, Szold was pleased that the three would be together and they could revisit Lombard Street and their 'beautiful past.'

A month before the sisters arrived, in mid-March, Hitler had invaded Czechoslovakia, and now with them in Palestine with Szold, the government had presented another White Paper, which abruptly cast aside any hopes of British protection creating a Jewish homeland.

Several days later, on 7 April, Adele sat down in her room at the Hotel Eden and wrote her first impressions to Thomas, her husband: 'I am already prepared to say that building of the Jewish Homeland is a remarkable, a fascinating, a thrilling adventure, perhaps even a glorious undertaking. But—my "but" is greater than ever,' she suggested, 'along with the upbuilding goes also the upbuilding in a magnified degree of nation ego, harmless enough, I suppose, for the Jews alone, but awful in its general effect where the same national egotism affects nation upon nation. If it weren't that what the Jews have done here is so interesting, the chauvinism would drive me straight back to our retreat in Easton...' Adele went on to review her sightseeing experience—the Wailing Wall, the Old City, the Arab and Jewish bazaars; and then there were the Arab and English guards posted throughout the streets, the constant passing of armored cars, and any walking freely throughout the city was burdened with barricades, searches, and curfews. One story that Adele related in her letter told of an

Englishman curator of the Rockefeller Museum, in what was considered a safe part of the city, was shot while parking his car in a garage. All, which led her to end her letter: 'The Arabs have, for the moment, concentrated their killings upon the English and their own countrymen who decently refuse to play with the gangsters. I just received a letter concluding: "Hope you keep well and don't get shot"—a comic commentary on the times. Another funny one I heard: A man preceded a statement with: "If peace should break out."'[351]

The chaotic world events unfolding daily were briefly skirted by the reunion of three sisters. They celebrated the Passover seder with Bertha's son Benjamin and his wife Sarah from *Kfar Syrkin*.

Over the following days, Szold, despite remaining in constant contact with business ongoings, paraded her sisters throughout the city. At the Youth Aliyah office, they met people who worked with Szold, people whose names were made familiar through their sister's letters. 'Bertha, with her ready laughter and easy, motherly manner, was everyone's favorite. Adele was something of a puzzle; quizzical, thoughtful, she looked them all over and kept her opinions to herself,' one writer reported. 'In Jerusalem she saw that her sister was a woman of importance; the stream of people that came and went from her office ranged from bearded rabbis to *Hashomer Hatzair* of the farthest left. They came with complaints or requests, financial, ideological; they came to do battle, and Henrietta gave as good as she got.'[352]

Szold showed them where the children were sent to be pioneers of Palestine, the *kibbutz* with wide lawns and large dining halls among tall trees. When the children recognized Szold, they came running to her, and the sisters were impressed of the showing of such love for their sister. 'What was most extraordinary was her reaction [she was thought to be rigid and stiff-necked] … she honestly enjoyed being with the children, and even danced with them as Adele and Bertha watched, even drawing comments from those in the community that Szold really didn't get along with.' Wrote pediatrician Helena Kagan of the scene with the children, 'I could not do what she did—to play with them like that. I gave my life to these children, but I could not play with them.'[353]

And, it was during this spring and summer that the once doubtful Adele witnessed the fullness of Szold's chaotic life in the Holy Land. It was then, when all doubts vanished of what her sister was truly accomplishing with the children (they did love her so much, one could see it in their faces) that Adele, an excellent writer, decided to gather materials on the trip, research on a biography of Henrietta Szold.

They visited Natanya, "the Jewish Riviera," where Adele wrote on 1 May 'while there we were driven to orange groves and to an interesting farm beyond a Jewish village, Hadera. At Kfar Syrkin we had a good opportunity to see the relation existing between the common British soldiers and the Jews. An excellent one. A very, very bad one between the soldiers and the Arabs.'[354] The next day, Bertha and Adele were impressed with the 'overwhelming' beauty of Nazareth, Cana, and Tiberius located on the shores of the Sea of Galilee. They returned to Jerusalem and then were soon off to Tel Aviv to visit several colonies.

Adele in a letter to Thomas on 13 May from Tel Aviv's Pension Moscowitz describing the experience of meeting Goldie Meyerson, later Golda Meir and the first woman prime minister of Israel: 'Today I had a most interesting conversation with Goldie Meyerson, a chief propagandist in the Histadrut. In a few days I will be ready to write my article on Palestine. Title: "The Great Will." Angle of approach: the noble structure that England is destroying. I have asked several of the more intelligent labor people here: "Supposing Palestine had been nothing but an aggregate of orange-growing colonies such as existed before the Balfour Declaration, what would England's attitude have been?' Adele asked. 'The answer was: "The opposite of what it has been." It is apparent that England has *not*, as we supposed, been afraid of an Arab movement. She has simply supported the rich class, the Arab leaders in their personal claims. Plutocrat allying with plutocrat.'[355]

Adele and Bertha enjoyed seeing the city and the land, but it was those times, on the Sabbath and at meals when Szold had the time away from her duties, that they spoke about their rich family life. Of Mamma and Papa and how their parents had traveled to America as a young married couple, stayed in Baltimore, though they once discussed considered leaving, and later took a house on Eutaw Street where Szold was born. Much had changed, and there was much to remember. Baltimore, then, was a place of 'town criers, and when people wore nightcaps and owned slaves.' Eventually, Szold talked about Papa and his library and so many books that as a child she despaired that she would never have time to read all of them.

There was, the unspoken that lingered. Adele was obviously more ill than she was letting her sisters know. Adele, in fact, had been diagnosed with amoebic dysentery, a finding that the doctors had been unable to control. Then, one morning Bertha came down for breakfast and collapsed. Just the last evening she had appeared healthy and good-natured, but now she was fading away, Szold feared, writing to her sister's family in Baltimore:

'For several days we were dazed—there seemed no hope. Since then, she has been recovering, though very, very slowly.'

Adele, worn out from fighting the illness upon her and the constant activities, returned to America in November, 'you are my home, Toby [Thomas, her husband]. I come to roost and rest with you,' accompanied with a suitcase filled with notes of a biography she was going to write about her sister.[356]

Bertha remained in the winter and was there when Szold celebrated her seventy-ninth birthday. She was amazed at how many coddled Szold with gifts and messages from all over Palestine and the world. Plants and flowers arrived several days before, and until several days later. Photographs taken when the children were younger, and had just arrived, concerned and yes, frightened of this new land. They sent money for Youth Aliyah, the organization that had given them their freedom.

'Together,' Szold addressed the ones who were present at the celebration, 'we will strive to achieve what at one and the same time is national and universal, symbolic and actual, antagonistic to strife and destruction, and constructive of what makes for progress, justice and peace.'[357]

When Bertha departed Palestine in February 1940, a harsh isolation arose in Szold. Letters in those days took weeks to arrive, and for Szold's to reach them as she bared her soul, and wrote of the wonderful times they had had on their visit. Still, Szold felt a world away; they were both gone and Szold slipped into a depression, that only faded with her return to the office as she worked furiously against the evil expanding in Germany, rescuing every child she could.

It saddened her that both sisters had fallen ill, and departed Palestine in bad health. Their laughter and conversation had softened her, and she remembered.

Just beyond the fruit garden, over a fence, grew a honeysuckle vine; its wandering fragrance took Szold back to thoughts of Lombard Street, of papers stacked away in those boxes in Adele's barn and Bertha's cellar, papers of secrets and memories. 'Perhaps I shall survive this terrible war and join you in America…I do not wish—I only hope.'[358]

<p style="text-align:center">***</p>

Still, Szold pushed forward.

Whatever the weather, she left Jerusalem in the mornings, accompanied by Hans Beyth and driver Oscar Eckhaus both armed with pistols, and traveled to Haifa. She was there to 'greet every group of incoming children

… she welcomed each one of them, sang and danced and talked with them, and saw to it that each of them had as good a life as was possible in the mad world they had not made.'[359]

In the United States, first lady Eleanor Roosevelt worked on behalf of refugees and all who stood in the path of Hitler's fury. Journalist Dorothy Thompson, who had been expelled from Nazi Germany in August 1934, and Nobel Prize-winning novelist Pearl Buck worked with Roosevelt in efforts surrounding the American Committee for Christian German Refugees and the Non-Sectarian Committee for German Refugee Children. Thompson was recognized for her contribution in a banquet hosted by among others, Albert Einstein. Roosevelt forwarded a message to Thompson, read at the dinner, thanking her for her 'courage and zeal.' Novelist Pearl Buck completed the night with a warning: 'In Germany the Jew is merely a symbol, and when he is gone the attack will continue against all who dissent.'[360]

<p style="text-align:center">***</p>

'In London, Eva Stern lived through those last days of August, close to the continent and in direct contact with British authorities, without whom nothing could be done.'[361]

Her office had become 'the nerve center of Youth Aliyah.'[362] Telephone calls, were conducted mostly with a business-like manner, some with a more frantic tone to the conversation, to Berlin, Prague, and Vienna. On 25 August, Stern was aware that there were thirty-one children in Germany waiting for transportation to England. Learning that British authorities would no longer take responsibility for Youth Aliyah movements into England, Stern phoned the Berlin office and instructed them to 'ignore official notices and rush the children out of the country.'

The next day, Germany closed its border to Holland and mobilized and requisitioned its railways. For four long days Stern watched several situations—Berlin at last had telephoned and stated that they were going to try to get the children to Holland. In Trieste, 400 children were delayed traveling because the Mediterranean was closed to shipping; Children in Prague were sent to the homes of Danish farmers. Children in Berlin were accepted by Norway and Sweden. At any certain moment, Stern directed telephone calls to eight countries. It was well understood that the gates of rescue were dramatically closing.

On 30 August, a Wednesday, Berlin phoned, informing Stern's office that transports were leaving that night for Holland, then England. By wire

Stern would be informed of the progress, unaware that communications from Berlin would soon be interrupted.

Thursday. 'Stern and her staff waited, hour by hour, for the wires from the transport leader, remaining in the office until midnight for word.' Finally, a call came in from Harwich, a North Sea port on the English coast, on Friday morning, informing London that the German children had arrived, they could hardly believe it. 'They set out immediately for Harwich. But that day London was a city in turmoil, for the evacuation had begun of close to a million children, their mothers and teachers, and warnings were posted that no one else could count on rail or bus accommodations. By a stroke of luck Stern and her party were able to squeeze into a train leaving for Harwich at ten.'

The London office celebrated, but only for a brief time. There were still 300 children holding Youth Aliyah certificates within Germany. What could be done for them? And if, as seemed likely, nothing at all could be done, how were Eva and her staff to accept this new reality? Encouraged that, against overwhelming odds and the certainty that war was approaching meaning closed borders, Stern sent a cable to Szold and Hadassah:

'REMAINING LONDON CONTINUING WORK...'

Fighting back tears on a late August night in 1939, Chaim Weizmann walked onto the stage at the Zionist Congress in Geneva. He paused, aware that he was bidding farewell to the 1,500 delegates who would be heading home to an unknown fate. 'It would need the eloquence of a Jeremiah to picture the horrors of this new destruction of our people,' Weizmann said. 'We have none to comfort us.'[363]

During the meeting, Hitler and Stalin had signed a pact, even as Hitler threatened Poland's sovereignty. Britain and France, as they had in March 1939 when Germany marched into the Czechoslovakia, a violation of the Munich agreement, simply blinked.

War edge closer.

'The most horrible feeling in Geneva was that not a sound came out of the magnificent League of Nations building looking at us,' President Judith Epstein, leading the Hadassah delegation remarked. 'I shall never forget the silence coming from those portals.'

'Most delegates were warned to leave Geneva immediately,' author Marlin Levin wrote. Harsh decisions had to be made, quickly. Were German Zionists to return home, or stay away and fight with resistance units that

were organizing? Polish delegates were ordered to travel through Hungary or Yugoslavia instead of directly through Germany. Palestinian Jews, instead, purposely traveled to Nazi Germany, with the purpose of establishing escape routes.

Before disbanding, though, the delegates finished one last piece of business—condemning the terms of the British White Paper. On the way out of the meeting room, Weizmann, on his way to England, clinched Menachem Ussishkin, a longtime friend. 'What kind of a world will it be when we meet again, Menachem?'

16

War, again—September 1939

'War is not Women's History.' Virginia Woolf

Towards late evening on a hazy, Mediterranean afternoon, along the coast north of Haifa, a sedan parked at the base of a barren hill. A woman, old and with careful steps, slowly made her way up the hill. Shortly, she was standing beneath a tree, a book in her hand. She sat on a rise in the ground and began reading.

'On the road to Haifa there was a tree, an ancient sycamore, there was no telling how old it was, its trunk a great twisted shell supporting gnarled, wide-reaching branches,' Fineman wrote in *Woman of Valor*. 'Whenever she [Szold] could she would break her journey there, get Oscar to stop the car and let her sit there for a little and rest in the leafy shade of that lone old tree, so serene, so noble, for all the storms that had beaten and bent its burdened trunk and branches. It was rooted there in the land; and so was she… And she felt as timeless.'[364]

At those times when Hans Beyth accompanied her, which was often now that she was growing frail and weak, and the danger of traveling, he would walk up the hill and tease her.

"Miss Szold, did you forget your morning exercises today? We must make up for that?" –and with a mighty leap, he jumped aloft and chinned a few times on a branch. Szold enjoyed the joke very much, and she answered: "You know full well that I've never in my life missed my five minutes of morning exercises, and I must warn you: Perhaps I can still chin without breathing as hard as you are doing just now! Hans Beyth was always, "Herr Beyth" to her.'[365]

Those were light moments; Szold always enjoyed a joke. But, later as war approached, the light of her world dimmed, quite suddenly, it seemed. Szold stopped more often when she was alone, as Oscar waited at the foot of the hill. He would wait for as long as she wanted to linger in the shade of the old tree. Then it became a place to ponder; to wonder of those days that lay ahead.

There was a man named Rommel wandering out in the desert of Egypt, apparently unstoppable by the British armies; Europe had fallen strangely

silent about European Jewry, and, she could sense the danger in that muted quiet. Hitler was poised to send the world into darkness, destruction, and death. Everyone knew. Her heart was often heavy when she came here, because Szold had long ago admitted that the day Herr Hitler started a war, the gates would close for freedom to the remaining Jewish children in Germany. They had done their best, Youth Aliyah, Freier, Stern, Szold realized that. But now, as war closed in, somehow it wasn't enough. One remaining Jewish child in the darkness was one too many.

Long ago, Szold had written, on the festival of *Tu Bishvat* (fifteenth of *Shvat*), titled "The New Year of Trees." She thought of it often, here, visiting, her old friend. '…trees are a symbol, as a sign for the whole of God's nature. The Jewish religion wants us to have our eyes wide open for all things in the world of man, the past and the present, the Jewish world and the non-Jewish world, but no less it wants us to give heed to what passes in the world of nature…' Szold wrote '… life is made up not only by the object seen… the most powerful forces are those that work unseen, with patience, with perseverance, and in silence…Let [us] apply [our] mind and study how the sap rises, brings life to the driest stick, clothing it with verdure and color, and [we] will at the same time learn that beside the life of material things… there is a hidden life, which we call the life spiritual, the Godly life, full of the beauty of holiness, a life of love, of charity, of hope, of faith in God, of noble self-sacrifice.'[366]

Words written over thirty years ago, yet, at this time, seemed as important as ever. On this evening under the old sycamore, Szold worried; she was aware that everything, everything they had worked for in this Holy Land, could be eradicated in one fateful, victorious swoop of a giant enemy army eastward.

Years after the establishment of Hadassah, Szold had written a letter to Mrs. Julius Rosenwald, wife of the American businessman and philanthropist, explaining what she considered 'the cause of Palestine' with 'the cause of the Jew and, most important of all, of Judaism.' Szold understood, then, that the Zionist enterprise in Palestine… 'the need of a center from which Jewish culture and inspiration will flow … in a happy, prosperous country, [who] will be free to draw spiritual nourishment from a center dominated wholly by Jewish traditions and the Jewish ideals of universal peace and universal brotherhood.'[367]

Dreams; all dreams throughout the years. And now—imaginings that could all be gone in an instant.

Eventually, Szold would walk back down the hill where Oscar patiently waited. He helped her into the sedan, and shortly after they had disappeared

over the next rise in the road, to that which was most important on Szold's mind—always, the children.

<center>***</center>

Journalist William Shirer was in Berlin on the first day of the war, and wrote of his emotions in his diary, 'It's a "counter-attack"! At dawn this morning Hitler moved against Poland," Shirer wrote. 'It's a flagrant, inexcusable, unprovoked act of aggression. But Hitler and the High Command call it a "counter-attack." A gray morning with overhanging clouds. The people in the street were apathetic when I drove to the *Rundfunk* for my first broadcast at eight fifteen a.m. Across from the Adlon the morning shift of workers was busy on the new I.G. Farben building just as if nothing had happened ... tomorrow Britain and France probably will come and you have your second World War...'[368]

In a Tel Aviv theater, during the first week of the war, Jaroslav Hašek's antiwar classic play, *The Good Soldier Schweik*, completed its 125th performance in front of another full house, considered a great success. However, a leading theater critic in the Hebrew press didn't appreciate the character— 'a defeatist and a deserter' not appropriate with war raging in Europe. Instead, he considered him 'despicable and dangerous,': "If, heaven forbid, the armies of the democratic nations contained many Schweiks, Hitler would have conquered the entire world by now.' How he wrote, that 'this ridiculous and primitive pacifist' was so popular when the war was of such consequence, the fate of nations and— 'our future, our existence as human beings and as Jews.'[369]

On 13 September, in the early hours of the morning, Jews of Polish nationality aged fifteen and sixty-five were arrested and handed over to the Gestapo. Then they were sent to the concentration camp at Buchenwald. Polish Jews in Berlin were forced to run to the Sachsenhausen camp near Oranienburg. Recha Freier wrote:

> After the first ten days telegram after telegram was delivered to the houses in the Jewish streets of North Berlin, sent by the commandant of the concentration camp, bearing the words: "Your husband, son— has died of heart failure, pneumonia: (later on also "inflammation of cellular tissues"). "The cremation has taken place at the expense of the Government. The urn containing the ashes can be obtained against payment of 3.75 marks at the Fuerstenberg Crematorium." Signed: "The Camp Commandant."'[370]

Despite the *Yishuv* being caught between the despair of a German victory, and their continuing dedication to oppose the British white paper, David Ben-Gurion, on 3 September, attempted to place their position in the proper perspective: 'We shall fight with Great Britain in this war as if there was no White Paper, and we shall fight the White Paper as if there was no war.'[371]

In May 1940, Hitler invaded Holland, Belgium, and France. By June, the German conquest was complete when France surrendered. 'I am particularly downhearted over the news from Paris,' Szold wrote on 14 June. 'What an array! Poland, Norway, Denmark, Belgium, Holland, France—all since September.' Since Adele and Bertha returned to America, Szold had moved into a new home, the Pension Romm, a two-story cottage made of pink Jerusalem stone, No. 11 Ramban Street. On 5 July, she wrote Bertha: 'I feel as though I were standing in a howling desert, vast stretched of desolation on all sides. From day to day, one opens the newspapers expectantly, only to be hurled into greater depths of despair. These days have convinced me that King Solomon wrote Ecclesiastes in his old age, the defeatist age. My refrain would be, instead of vanity, all is vanity—cruelty, all is cruelty.'[372]

'In spite of all my resolutions to "jump off the bandwagon," I am traveling on it faster than ever,' Szold admitted in a 14 June later in the letter. 'Emergency organization is the order of the day; and protest as I will, I am drawn into the hurly-burly. Italy's entry into the war was depressing, but not half as depressing as the peril of Paris.'

As was the case most times, Szold, in her search for peace away from world issues, turned to her garden, her beloved flowers and plants. 'I had a gardener—Perles, the grandson of our father's best friend! —re-pot my window plants. Most of them are now ranged on the table on my porch,' she wrote. 'The fuchsias bloomed, but wanly. There is too much sun, too little moisture for them; they are now standing under the table for protection. Mr. Perles insists upon my keeping the begonias and the amaryllis indoors. Do you remember the begonia that bloomed so incessantly? It is still blooming ... '

And, then words written of home, '...your enumeration of the spring blossoms in Eva Leah's woods made me homesick beyond words. But it was right for me to stay here! We who get together and discuss the news of the day—and how we discuss it! —are heartsick over France,' she admitted. 'I feel, foolishly I admit, that I am being treated badly in particular. It is the second time in my life that I am experiencing a German victory over France. I remember well the war of 1870 and the Commune in Paris...

'... Apart from the world situation, and my constant brooding over Adele's going from us, and over your having to settle so much of what by

right is my business, a huge unanswered personal correspondence stares me in the face and all my papers still lying on the shelves as your deposited them. Nor do I ever "catch up to myself" in my work—the old, old story.'[373]

With all the worrisome war news, the rescue of the children remained Szold's priority and she wrote on 9 August:

> We are still hammering away at the problem of bringing our young candidates from Denmark, Sweden, and Lithuania. There are about 600 of them.
>
> Besides there is a group of 120 we are endeavoring to save from among the group of unfortunates who have been waiting on vessels on the Danube at the Yugoslavia border since January to be brought here as *Ma'pilim*—illegal aliens. We have secured all the necessary funds for the transfer of the 720, and all the visas—Russia, Lithuania, Syria—except the Turkish. Now our hearts have stopped beating until the emissary sent Turkey for the purpose, cables the Agency the result of his diplomatic intervention. Nothing daunted, however, and in expectation of our third quota of certificates for the current period, we have begun preparations for Roumanian and Hungarian groups. "Hope springs eternal!"'[374]

<p style="text-align:center">✳✳✳</p>

In those first days of the war, Palestine turned quiet, subdued, even the Arab violence waned. Tourists no longer came to see the Holy Land, safety for their lives prevented that. As for the flow of immigrants, the flow reduced as 'the *Yishuv* turned in on itself.'

In that period later named the 'phony war,' when time seemed to stand still for the longest, and then, suddenly, defeats and tragedy exploded with rapidity. Great defeats fell on the French and British armies. In June, Italy would declare war and bombs would fall on the land of Palestine; In North Africa, Rommel seemed to gain momentum after being held at bay, for a brief time, by the British Expeditionary Force. Then, Rommel gave them a thorough wiping. By spring, there were rumors of British retreats from Egypt and Palestine. The *Yishuv*, suddenly exposed to extinction, released any misleading of tranquility, with the reality of invasion, vanished. 'There is no strength to face tomorrow,' Avraham Katznelson, a prominent Zionist political figure wrote in his diary.[375]

The world, then, stood up and took notice. In London, as Britain feared a German invasion, there were demands for the eleven battalions of British

troops in Palestine—twenty thousand soldiers—to be transported back to stiffened defenses along the channel. Churchill grew concerned that such an action would leave the Jews at the mercy of an Arab attack, and suggested that the Jews be armed so as to defend themselves. However, on 23 May 1940 Churchill was told that Secretary of State for the Colonies, Lord Lloyd, had 'strong objections,' and feared the 'worst possible repercussions on the Arab world.'[376]

Then, a group of fifty children arrived in Palestine, delivered out of the transit camps, creating excitement. Writer Joan Dash, took note of the event, and wrote about it in *Summoned*:

'They were sturdy, well-dressed, well-fed and bursting with vigor 'still... in their eyes were reflections of hate.' Miss Szold questioned them closely. What were the farmers like with whom they had lived? Cultivated people, she was told; each house had a library including scientific and historical books. Where did they go to school? In the high schools, with the Danish children. How did they get along with their host families? It was marvelous, they said. They had such beautiful manners, such nice eating habits. They talked with the children all the time about Zionism and its objectives.

"About Zionism? What did they know about Zionism? She asked. Nothing, and the children explained it all. The farmers argued with them. Why must they go to Palestine, they were asked. Weren't they receiving good care in Denmark? Hadn't they been shown every kindness and consideration?

"Szold told the madrich they must be encouraged to write about their reminiscences, for they were an important bit of history. There was goodness and decency in this world that had no room in it for Jews..."[377]

There was one other arrival that stirred the interest of the Yishuv in those days in 1941, more so than any other.

Recha Freier.[378]

She had desired to stay and work as long as she dared, but Freier began to feel the closeness of such men as Eichmann in Germany. The noose was tightening on everyone now that war had started. Accompanied by her eleven-year-old daughter she joined a group of smugglers, and followed them across the Yugoslavian border in Zagreb. Hearing of children in Vienna, she sent the smugglers into Austria. 'These children were brought in over the course of several months while winter came the mountain passes froze and the route outside grew increasingly uncertain, for the German conquest of Yugoslavia was expected at any moment.'[379]

Freier set up a school for the children in Zagreb, and during the night they hid out at the houses of private homes. Illegal immigrants also gathered

at the school, 'for they felt less forsaken in the neighborhood of the children.' Eventually Freier obtained visas from the British consulate and the Jewish Agency office located in Istanbul.

On 6 April 1941 the Germany army crossed over into Yugoslavia. Freier knew that was the day to attempt their flight to Palestine, through Belgrade and then Greece. Trouble arose just as they were preparing to leave; a young boy had contracted polio and was in the hospital. It meant, for the safety of the others, he would be left behind. 'Mrs. Freier refused to leave him behind even though the safety of the entire group might be compromised if he could not keep up. They would carry him—on their backs if need be.'[380]

Freier simply waited for the moment, then got the children out from under the Nazis, waiting months for them all to be gathered, and then delivering them to Palestine; such an heroic act for a woman whose appearance certainly didn't portray a hero. She was small, as small as Szold; 'she was cultivated, musical, poetic; she had a low, breathy voice and a tendency to shift abruptly from one mood to another.' The children accompanying her were safe. In Palestine, she would live with her son, Shalhevet.

Within several weeks, Freier attended a meeting of Youth Aliyah leaders. Szold was too sick to attend, so, at the end of a long conference table, Freier perched herself and chose the chair in which Szold always sat. 'Then she took over the meeting like a high wind, all force and direction, sweeping the others along with her without a pause for minutes, rules or orderly procedure. The event, Freier's ruling the meeting as she did, created much excitement,' remembered Ernest Simon in an interview. 'A graduate student of a professor of education at Hebrew University, Ernest Simon, telephoned the evening of the meeting, and suggested that he had the subject of his dissertation: Classicism versus Romanticism in Youth Aliyah—that is, Henrietta Szold versus Recha Freier.'[381]

Eventually, Freier reached out to Szold, and a meeting was arranged.[382] Freier brought a purpose to their meeting, 'during which Mrs. Freier meant to claim her rightful place in the organization she had brought to life... a position of substantial importance in the Jerusalem office, as she confessed to her son, Shalhevet, she still felt it was rightly hers.'

The meeting, however, didn't go well. When Szold pronounced an offer of 'an interim position,' with support by the bureau in the meanwhile, with nothing definite spoken for the future—Freier stood and walked out.

Dismayed at her actions, Szold wrote a letter to her, reminding herself that Freier's 'existence in Jerusalem was a source of pain—there were now

two women who desired the title "Mother of Youth Aliyah." She wrote to Freier on 27 April 1941: 'We believe that you have no basis to take such a position towards us and to refuse our proposition.' A sort of civil war broke out among the ranks, but it was conceded by all that Freier was not, and would never be, the organizer that Szold was.

However, it was Szold, that kind old woman, that, no matter the weather or the time of day, who continued to consistently traveled to Haifa to meet each group of children arriving. She enveloped their fate within her personal responsibility, and then turned hardened and business-like and negotiated with government agencies. She was able to reach out to Hadassah, and with that honesty in which Hadassah trusted her, obtained the release of monies when truly needed.

On the other hand, Szold even with her administrative skills, could never have created the romanticism—as had Freier in Berlin—surrounding the rescue of children away from the Nazis.

An incident, a celebration at the kibbutz *Kiryat Anavim*, finally allowed Freier to witness that the demanding, commanding woman she pictured, didn't really exist at all; but, instead, 'a human woman.' In the Judean hills six miles from Jerusalem, an oasis of green in an austere landscape, they sat at a table in the dining hall. A woman beside Szold cut a cake, inscribed "To Our Mother," placed in the middle of the table. She handed the piece with "Mother" written on it to Szold, who gulped it down. 'Yes, she took that piece and devoured it,' remembered a guest. 'You know she was a very delicate lady; she did not usually devour things. There was everything in that scene—there was most of all her shame, as it were, that she was not a mother. Mrs. Freier had four children of her own ... and Miss Szold who was not a mother at all, she ate up that cake.' Freier watched and then understood, with compassion, what everyone on Yishuv recognized— 'Mrs. Freier was the natural mother, (biological) the other (adoptive, never to give us the child she had saved) as Miss Szold. The child was Youth Aliyah.'[383]

In the end, the Yishuv, and even more deeply members and staff of Youth Aliyah, realized that they were two desperately different women, the complex organizer and the romantic. And, Freier stirred a compassion in each person involved. 'There are two sides to Youth Aliyah,' Freier wrote, admittedly, later in her 1950s account of her work in Germany, 'the one of light, the other of darkness ... I was fated to live and work on the other side, in darkness, affliction and suffering.'[384]

On 4 November 1940, Franklin Roosevelt was re-elected as president of the United States. Several days later, Szold recorded that the people in

Jerusalem were 'jubilant.' To overcome the quota established the year previously in April by the British High Commissioner 'on the grounds of economic and political necessity,' many Jews were attempting to escape Europe by illegal means. Benjamin Levin had written to his sister on the first day of November: 'During the months immediately preceding the war a swarm of refugees came into Palestine legally or illegally. So many came in that this year was in fact one of the banner years of Jewish immigration. Over 100 are now in Kfar Syrkin. They are camped in tents on a vacant lot. Finding work for them is one of the great problems of this locality. We have had several of them help us in work. They come from all countries in Eastern and Central Europe.' He described. 'One girl who helped Sarah [Bertha's daughter] with housework for a short time explained to us why most of them had practically nothing at all. The boat landed them on some desolate part of the coast where there was no dock of any sort. They had to walk a long way through water to get to land, and then they had to throw away most of what little they had brought with them.'[385]

By November 1940 the war and Szold's efforts were all consuming. On the 20th she wrote to Mrs. Rose Jacobs from Jerusalem:

> My working days are far shorter than they used to be. I can't any more extend them far into the night and until the morning after. And my Youth Aliyah and Kehillah obligations fill my working day, such as it is, to repleteness. Yet honesty compels me to confess that not lack of leisure alone is the explanation of my silence. There are so many reasons for not pouring out one's soul on paper these days, again for both external and internal considerations, that words of all kinds dry up on one's lips and in one's pen… on one happening I did long to speak to you—the passing of Alice. [Alice L. Seligsberg] I know you were prepared for her going, I also know what her going at the time meant to you and will always mean to you. To me it means parting with the purest, the truest, the most stimulating of friends—with a friend in the highest sense of the word … it is hard to realize that the force she had made of herself is no longer in action. Such realization neither life nor death has taught. This reflection puts meaning into so hackneyed a phrase as "may her memory be for a blessing."[386]

Within several days, a cable was delivered to the Youth Aliyah, addressed to Hans Beyth. Adele was dead. He went throughout the office discussing with each of who should deliver this news to Szold. After all, she was seventy-nine and how would she react to her dear sister's passing? Should

someone be in the room with him? Should they prepare for her to be overcome by shock and grief?

Finally, Beyth took it upon himself to tell her; as gently as he could manage, and then he came out of her office where the others waited—she had taken the news with remarkable quiet. 'Finally, someone said it must have been because she was so deeply religious. No other explanation seemed possible. Resigned to the will of God, she had stoically accepted her loss ... But Miss Szold accepted nothing. It was not calm, serenity, resignation, but her terrible fear of showing weakness, of revealing herself.'[387]

In the days that followed, Szold continued to fight through transportation problems and certificate restrictions.

> My spirit is sore, as must be the spirit of every thinking and feeling human being in this troubled world,' she shared on 23 August 1940. 'One plucks up courage for a moment on reading a Churchill speech. It's only a passing emotion at best. We haven't yet succeeded in bringing to Palestine a single child on the certificates of the present half-year. One obstacle after the other has interposed itself. At present it is Turkey's refusal to grant visas after we secured, with infinite trouble, visas from Russia, Lithuania, and Syria. We believe it is the only obstacle left.[388]

Then came the directive from the American government instructing American citizens that they should leave Palestine as soon as possible. It was indicated, at some point as Rommel roamed North Africa, that departing would soon become impossible. Szold considered leaving. The initial meeting of the Hadassah emergency council, headed by Magnes to act for Hadassah, was held in Szold's room at the pension. The discussion came up that she should leave when Mrs. Jacobs did. But though Szold hadn't told anyone, she had made her decision weeks before. 'I made my choice twenty years ago,' she told them.

It was not any easy decision for her. She felt worn out, 'played out, useless.' A wrenched leg muscle from a fall, and Szold spent several weeks in bed. Besides realizing that her fading health could cause her to rely more on others, she faced the salvation of the Jewish children trapped in Europe would be her monumental focus for many years, until the war was over. Sadly, from April through September 1940, not one Youth Aliyah child arrived in Palestine.

'We talk war all the time, we read war, we eat war, we work war,' Szold wrote to her sister, 'especially those who are in Youth Aliyah,' wondering

all the time whether the route that was open yesterday remains open today.'[389]

War came closer. Italy having entered the war in June, sent their bombers to Tel Aviv and Haifa causing destruction and death, Jerusalem practiced night blackout precautions, and social workers prepared for invasion.

If the British retreated out of Palestine, Zionists would adapt converting an area around Haifa into 'a kind of Tobruk,' referring to the Libyan coastal town where the British had held out against Rommel's forces. Jewish soldiers would meet on Mount Carmel outside Haifa, where the Yishuv would build fortifications and stand and fight to the death as had Jewish fighters at Masada in 70 A.D., against the Romans.

Youth Aliyah boys wanted to enlist, and Szold, in many cases refused their right to do so. She warned them of what they were deciding, though she understood the motive. Eventually, she addressed them with their issues, well aware that all Jews, the old and the young, knew that the time had come: '... for the last sacrifice, so that those who come after us may not be deprived of the highest purpose of life; and the young men are called upon to make the most complete sacrifice. From you it is asked to make the most complete sacrifice. From you it is asked that you give your life...' she told them. Szold assured them that she understood that their resolve to answer the call was proof of their conviction '... that if this precious heritage of humanity disappears, the death sentence is proclaimed against the Jews, body and soul ...

'... in many ways the land of the Bible in which we live is the last fortress of the Jewish people. There are Jews who believe that, if this fortress is captured today by our enemy, the whole Jewish people would be so injured by the loss that it could not recover.'

She finished by telling them that her belief, her faith was in the remnant of Israel, no matter how small; but that each 'must search himself deeply and form his own conviction.'[390]

This critical, eddying time drew Szold into thoughts of being isolated, of another world entirely from those of her childhood, her sisters. There was an enormous, wide sea out there separating Bertha from the threat of war in Palestine, and Szold needed to touch them, somehow. She returned to her habit, no matter the busyness of the day, or the problems confronting her, that she wrote to sister Bertha on Fridays before sunset.

In October, she recorded a message for the women of Hadassah at their convention: '... The contact of kindred spirits sustains vision and knits the sinews of conviction,' Szold began in her small voice. 'So, comrades in ideal

and endeavor, I reach out to you… across expanses of space, and also across the weeks and months, fraught with who what added burdens… I grasp your hand to steady myself… I have sore need of steadying myself…,' she told them in transparent words. 'Amid the smoke and din of titanic battle on land, on sea, and in the air, an urgent perspective disengages itself clearly to my eyes. The world will not again wear the aspect familiar before forces were unloosed intent on shattering cherished ideals. They will not, they shall not, achieve their sinister purpose. Even the grave reflection must be faced undaunted, that, in very task of striking down malignity, we ourselves must resort to measures hitherto alien in our world of ideas and ideals. We are resolved, cost what it may, to preserve the essence of our faith and our philosophy, while adjusting ourselves to new ways demanded by the time and their events… My voice and my words will be followed by the voices and the words of the youth whom you have plucked as brands from the burning, to become the builders of the future of Israel in the Land of Israel. You have prepared them as an advance guard marching into the new era… From them gather courage and hope.'[391]

<p align="center">***</p>

Eventually the shifting of the policies of the British Government in reducing immigration quotas and the threat to deport anyone entering Palestine without certification, led to ill feelings from the Jews. There were those in England who saw the tragedy in enforcing such guidelines during wartime. An eminent Labor member of Parliament, Colonel Josiah Wedgwood, argued that these Jewish refugees, though illegal in the eyes of British law, were eager to fight with them. Evidentially, over five thousand Jews would join the British forces ranks. Sadly, with the reduction of British allowances on immigration, as Jews escaped Nazi Germany having no choice but to attempt to steal into Palestine, such actions brought tragedy.

One such tragedy was the *Patria* incident occurring on 25 November 1940, a disaster which would haunt Szold and the Jewish Agency for years.

A misfortune that began as two steamers, *Milos* and *Pacific*, docked in Haifa, with 1,771 illegal refugees from Central Europe on board. British authorities announced on 20 November that all peoples on the ships would be deported and detained until the end of the war. Worse, they were informed that they would not be allowed after the war to enter Palestine. The passengers were then transferred onto the *Patria*, a 12,000-ton French liner, where the final destination would be the Mauritius, an island in the Indian Ocean, as they waited in Haifa harbor. On 25 November, another

ship, the *Atlantic*, transferred its 1,800 illegal immigrants to the *Patria*. Once about 260 people had been moved over, the *Patria* was rocked with a violent explosion and sank within fifteen minutes. Witnesses on the beach saw arms and legs and bodies floating toward the shore. 'Planes circled overhead; little tugboats plied the littered waters retrieving corpses with fishhooks. Some did make it ashore. Many were trapped inside the sinking *Patria*. Evidence was sketchy, the source never proven, but it was decided that the explosion 'had been a bungled act of sabotage,'[392] to prevent the refugees' deportation.

Over 260 refugees died in the sinking; 209 bodies were recovered.

As 'an exceptional act of mercy,' British officials allowed the Patria survivors to be interned at the Athlit detention camp. The number was deducted from the following legal immigration quota.[393] Sixteen hundred refugees, originating from Austria, Poland, and Czechoslovakia who had remained on the Atlantic, continued the deportation to Mauritius.

Five of Szold's children lost their lives in the explosion. Sadness was joined by anger as she divided her anger between the British and the miscalculation of the saboteurs.

Jewish shops, factories and schools were closed during the funeral, as the victims were buried in Haifa with solemn rites. 'The week has been filled with the Haifa catastrophe,' Szold described on 28 November. 'First, all thoughts were centered on provisions for the comfort of the deportees and then on clothing the naked. The collection of clothing, underwear and shoes in Jerusalem was a notable feat. It was the first task applied to our *She'at herum* organization devised for war emergency purposes, 'Szold wrote. 'It stood the test admirably. Within a few hours Jerusalem could send over 10,000 pieces of clothing and shoes to Haifa—4,000 by Hadassah, the rest by the volunteer collectors in the 14 districts into which the *Sherut-ha-Am* of the Social Service Department of the city (Kehillah) had divided Jerusalem. But the last message is that more is needed. Of our Youth Aliyah candidates—there were 77 on board—one lost his life and, it appears, four girls are missing. The report is that the wrecked boat still holds a number of victims.'[394]

However, there was soon good news—a large Youth Aliyah group was to depart Scandinavia. Good news that Szold was anxious to share: 'This week, too, has been consumed by the *Patria* incident,' she admitted on 6 December. 'Not that anything was achieved. But one was trying to achieve. Now we are living in hopes that at least the young people and the children will be permitted to leave the camps at Athlit and wherever they may be, and be taken care of by us. Places are ready for them.'[395]

Though, as much as Szold hoped that such a tragedy would change the hearts of politicians, of those in power who hadn't realized that the war had changed everything—hope, fears, destinies—it hadn't. The British Government policy held firm. On 8 December 1940, 1,584 despairing illegal immigrants, recent arrivals, were deported.

17

Tormented

'Inside, she was tormented and full of guilt. She blamed herself, always herself,' wrote author Joan Dash in her biography, *Summoned*. 'Still, those who worked around her followed her with nothing short of amazement. There were even those—people who didn't know her deeply—who considered that only a cold heart could get one through the daily problems of Youth Aliyah and the scores of people who brought their serious problems to her door. "I am so alone. There is no one who really and truly knows me," she mourned. 'Loneliness pressed in on her,' Dash wrote, 'guilt weighed her down… over and over the inner spirit seethed and the surface remained so calm, so controlled.'[396]

It was during those days that one of the Hebrew secretaries who admired Szold, a *chalutz*—a member of a group of Jewish immigrants to Palestine after 1917 who worked in agriculture or forestry—who had toiled as a master mason, worked in the late evenings with her. His name was Arieh Lifshutz and he had watched Miss Szold since coming to work for Youth Aliyah: 'You see the way she had of looking at me, the way of talking to me—I would say it was some light around her, in her eyes; not usual, not as others … You see she was an old woman very, very esthetic. She was looking at me if I was sitting opposite her to see what kind of tie, how I'm dressed. And she used to say: yes, I must go to the dressmaker…,' Lifshutz recollected. 'I didn't understand how she did not marry twice or three or four times.' However, there was something else, deep and almost a wandering spirituality that he looked upon: 'She had something inside her soul, a kind of tragedy. Sometimes when we were sitting one opposite the other, she became so sad. So sad, I could say the sadness of the whole world came on her shoulders, and her head sank. But in that moment, she saw that I see it, so suddenly she changed. "Yes?" she said. "So, what are we doing now? So, what is about this child, and what about this institution, and where are we going tomorrow, and what did you arrange about this problem?" and so on. "There is no depression in her and not a sign of weakness," she seemed to say.'[397]

And, that was the case after the *Patria* incident. Szold resumed working at a frantic pace. Accompanied by Beyth and working out of Tiberius,

during a three-day trip, she visited the *Emek-Ha-Yarden* settlements. As was her habit since arriving in Palestine in 1920, despair, loneliness, and even heartbreak was cured with a dose of hard work.

At *Ashdot Ya'acov*, Szold's photograph was taken with Yael Goldfarb, a Youth Aliyah graduate now in her third year. She deemed the trip a success, as the Ha-Yarden villages were thriving, mostly because of advances in the agricultural areas. Szold was reinvigorated, she was past the illness that had slowed her, past the missing of her sisters since their departure back to America—though, not completely—and had, to a degree, witnessed a trace of good come out of the *Patria* bombing. 'Within the next ten days we expect the arrival of Youth Aliyah candidates from Denmark and a small group of refugees from Constantinople,' she wrote on 14 December, 'We also have hopes of securing the release of over seventy from the Athlit camps.'[398]

Heading into December 1940, Szold began to dread her eightieth birthday, the celebrations, and the eulogies that would be burdened on her. 'I wonder whether I shall survive those eightieth-anniversary celebrations,' she wrote from Jerusalem, 'of which rumors reach me day after day.'[399] The 15 December 1940 edition of *The New York Times Magazine* published a tribute to her entitled: "Grand Old Lady of Palestine." 'For what she has contributed to mankind her name is blessed in various tongues the world around,' wrote Kathleen McLaughlin, the *Times* reporter. 'Since the days of her youth Miss Szold has launched social welfare activities in such profusion that her name ranks with that of Jane Addams of Hull House ... or Lilliam Wald of Henry Street.'[400]

'As for the future—one prepared for it as *ordentlich* [tidy, orderly] as possible,' Szold often advised others. So, she brought Emma Ehrlich into her bedroom one afternoon, and showed her where the shroud she had picked out for herself was stored away in the closet. 'She still did not like cemeteries, and especially the coffinless funerals they had there in Palestine, like the one she had seen the first day on the Mount of Olives. But there she was, rooted in the land...'[401]

'And no eulogies,' Szold insisted to her secretary.

Szold, well known as a perfectionist concerning detail, she even picked out her final resting place. Abed Sayd was an apprentice gravedigger in 1941 the day Szold came to the cemetery on the Mount of Olives. 'I was a boy, but I knew that she was the woman who built Hadassah Hospital,' Sayd said, who was eighty-six when he related the story to Barbara Sofer of *Hadassah Magazine* in 2012. 'He is tan ...,' Sofer wrote then of the old gravedigger, 'and muscular, though slightly bent, sitting on a stone terrace on the Mount

of Olives,' as he told of meeting "Miss Szold," as everyone referred to her. As he and Szold walked together in 1941, close to where she had picked out her grave, a small area of rosemary covered a nearby tombstone. 'Szold bent down and picked a few leaves of the green plant, inhaled and said, "I like this. Please plant it near my grave." Later, when he visited her in her office to finish the matter, 'she spoke nicely and gave me a glass of tea,' Sayd remembered. She asked him to take care of her place.

'I pledged to take care of the grave,' Sayad said, realizing how important it all was to her. 'She said she wanted to be buried here on the Mount of Olives across from the Old City … so that when the Messiah came, she would be the first to get up from her grave.'[402]

With the future taken care off, Szold could focus on the present days, days that frightened her when she dwelled on the destiny of so many European Jews. The time, of which she had so dreaded, the closing of the gates through where so many Jewish children had passed, to freedom—was gradually being slammed shut. Though the *Jugendhilfe*, occupying a floor of the Zionist offices at 10 Meinekestrasse, continued getting small numbers of children out. The future was now upon them, heavily with grave consequences… for by the late spring of 1941, where once Nazi policy encouraged Jews leaving, now all German-held territories closed their borders, trapping two million Jewish children inside a darkening Europe.

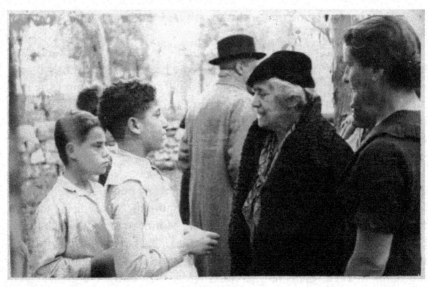

Henrietta Szold speaking with two boys, circa 1940.

And then it was her eightieth birthday, declared a national holiday for all of Youth Aliyah, and the celebration went on for a week. Representatives, from every youth group, traveled to *Ben Shemen* to honor Szold. On 21 December, there was a meeting in the dining hall, decorated with greenery from the garden. The children sat facing the stage where Szold sat on a low stool. It was the festival of lights, *Hanukkah*, a festival of liberation. She was to light the first *Hanukkah* candle, but couldn't reach it, so a tall young man helped her. Then the choir sang traditional *Hanukkah* songs.

Later in the afternoon, Szold addressed, by radio, the school children throughout Palestine. She told them:

> When I was as young as you who are now listening to my voice, the world existed without a telephone, without an automobile, without an airship, without a radio. Today, in my old age, when I have reached the years of strength, as King David called the age of eighty, a marvelous invention grants me the possibility of sending my voice to thousands of little children, big boys and girls, and youth scattered to all corners of this land.
>
> As you see, in my eighty years I have lived, many wonderful changes have taken place, but in one respect the world has not changed. Today, as long ago, good men and good women do noble acts; today, as long ago, wise men and wise women think great thoughts; today, as long ago, energetic men and energetic women work and achieve... The soul does not change; it only learns to use new and better ways of communicating with other souls... Youth and old age can meet as I am privileged to meet you today with my voice and my soul, and old age and youth can resolve together... to live nobly and wisely and energetically... as long as the breath of life is in us.
>
> This is my promise to you—this is the birthday gift I ask of you.[403]

Amidst the turmoil and tragedy, there were those other moments which brought happiness to Szold. The Hebrew University Library received on her birthday, her father's manuscripts, the academic *Commentary on the Book of Job*. In a letter dated 23 January 1941, she told nephew Benjamin, her father's namesake, of the event: 'From a certain point of view the crowning celebration was the one at the University last Friday morning. Dr. Magnes had invited me to be there at eleven o'clock with the case of mss.

[manuscripts] He sent a taxi for me. To my surprise I was ushered into a room in the Library in which were assembled all the professors and instructors in the Department of Jewish Studies.'

Then Dr. Magnes talked of her father, Dr. Benjamin Szold, and of the manuscript 'asking Szold to tell of the circumstances under which Dr. Szold had written the text.'[404]

Meanwhile, Hadassah had presented Szold a birthday gift of $25,000 for her to spend as she deemed appropriate. After pondering the problem, she found that the answer wasn't an easy one. 'One of my difficulties,' she wrote a sister from Jerusalem, 'is to decide whether I have the right to organize something which the community or Hadassah has to support and develop. The alternative seems to be to divide the handsome sum into small parts and help an infinity of lame ducks of institutions for the next year— a plan that does not satisfy me.'[405]

On 22 June 1941, while on a trip with Beyth, Szold heard that Hitler had invaded the Soviet Union. Drastic and surprising as the news was to the Zionists, in the coming months rumors would reach the *Yishuv* that would heighten fears and concerns among the Jews. There were reports of mass shootings, of wide craters filled with bodies of their people.

The invasion of Russia also presented the Zionists in Palestine with additional concerns. 'The British Minister Resident in the Middle East, Oliver Lyttelton, warned Churchill on July 21 that "if Russia collapses soon" the British might be driven out of Egypt altogether, and forced to fight a defensive battle in Palestine or even Syria.'[406]

Szold had other issues to deal with at the moment; yes, she pondered, worry about Hitler, but deal with the problems within reach. One such difficulty that she had not forgotten, so on 25 July she wrote of her apprehensions of the *Patria* survivors remaining confined at Athlit: 'Yesterday I paid a visit to the camp at Athlit. In recent weeks we were permitted to take out 115 children and young people and care for them through the Youth Aliyah,' Szold wrote and was glad of such actions. 'Now a number of additional children have been transferred from the second camp at Mazon, near Acco, to Athlit, and we are hoping something may be done to release them to us, too. Among the 96 now there, about 47 are of the age the Youth Aliyah can deal with. The rest are too young,' she admitted.

'I was permitted contact with the adults, too. Black despair and hopelessness! They have been deprived of liberty these eight months. While the conditions in the camp are not too bad, the monotony of their days and its lack of purpose and aim bring them to the very edge of insanity. *Hinaus,*

hinaus! [out!] they all cry, even the little boys and girls of six and seven, of course in imitation of their elders. What is heartrending is the cry of the members of the disrupted families; the father is at the other camp, the mother and children at Athlit; the father has been in the country several years, the wife and children in detention. They expect me to speak to the High Commissioner! Utterly useless, I am convinced.'[407]

By summer she had received the birthday present of $25,000 from Hadassah to use as she felt. Deciding that the funds would support three groups of urban children patterned on Youth Aliyah groups, she wrote on 15 August:

> I returned late last evening from a two days' trip to Haifa and the Emek region. My business was to inspect the two camps we have organized for the purpose of choosing sixty city children to whom we are to give an opportunity for agricultural education or adjustment parallel to the Youth Aliyah system. There will be three groups, twenty boys and girls in each. In large part they consist of children of the Eastern communities. I believe we have made a successful beginning of what promises to be a valuable contribution to educational development. We found the children at both places happy, primarily I think, because without let or hindrance they were eating their fill of good food.[408]

'For the rest, it is war, and Youth Aliyah, and Social Service without let-up,' Szold wrote on 26 September 1941 from Jerusalem. 'The start made in our new undertaking—three groups of boys and girls from the cities of Palestine, to the number of seventy-five, placed in three *kibbutzim* according to the Youth Aliyah system, approximately—has been auspicious. We had the candidates in two camps for observation for a little more than a month. The camps were a great success. I hope the results will be what we—enthusiasts as we are—expect. In that case Hadassah will continue to finance the undertaking'

She described next a project very dear to her, of not only the value and education it brought to the young women, but in honor of her dear friend, Alice Seligsberg, endowed with funds she had gathered—an institution, a school, second to none of its importance, a weapon against delinquency of girls: 'a veritable refuge for girls exposed to all sorts of dangers that are incidental to war,' Szold spoke, 'a spiritual possession which the pupils ... will carry with them into all the departments of their lives, into their homes, into the education of their children, into their pleasures. ... The

cultured woman is the better dressmaker, the better cook, the better companion..."[409]

'And have you heard of my success with Hadassah? I cannot recall whether I wrote you of the plan for a Girls' Trade School in Jerusalem which I submitted as a fitting Alice Seligsberg memorial? The idea is a Girls' Trade School with a four years' course in trades now open in Palestine to girls— sewing in all its branches, housekeeping (cooking, household economy, etc.) clerical course (secretarial, bookkeeping, etc.). The school is to serve the girls who have completed the eight elementary classes of the general school system, and there are to be evening courses for working girls.'[410]

Then, Szold received news that her good friend, Louis D. Brandeis had died. A justice of the United States Supreme Court and a leading Zionist, Brandeis often argued that 'to be good Americans, we must be better Jews, and to be better Jews, we must become Zionists.' It was a friendship that had taken deep root in the early 1900s. 'I was kept particularly busy the past week by newspapers and broadcasts in connection with the passing of Mr. Brandeis, 'Szold wrote of the sad occasion on 11 October. 'During the coming week, too, I shall have to prepare two tributes, one for the meeting of the Zionist Actions Committee, the second for a memorial meeting to be arranged by *Ein Ha-Shofet*. *Ein Ha-Shofet*, the kibbutz named for Mr. Brandeis, means "The Judge's Spring," and is located in the Manasseh Hills west of Megiddo.'[411]

At the service Szold told of a meeting in New York in 1914 when Brandeis was influenced to undertake the Zionist leadership: 'The spirit of a quiet, grave, yet dominating personality was infused into it. To be it, was like standing on a mountaintop with invigorating breezes blowing about one and vistas and perspectives of hope and achievement revealing themselves... to those who asked: "Where are the leaders to come from to fill the places left vacant?" Szold quoted Ecclesiastes: "One generation passeth and another generation cometh, but the earth abideth forever..." 'Leaders will continue to exist, rising from the masses or from the recesses from which Herzl and Brandeis emerged,' Szold assured the people gathered. 'Leadership will not be lacking.'[412]

News of the number of friends dying, saddened Szold. Menachem Ussishkin, a member of the Zionist Executive, had died only the day before Brandeis. And there was the loss of a friend of thirty-two years, Professor David Yellin. The personal tragedies, however, did not slow her pace, or the work tasks tackled. "I suppose old age is bound to have the effect of slowing down the processes of living and working, and doubtless it takes me longer than it used to, to do the day's work," she admitted in a 15 December letter.

"I am equally sure, however, that my day's stint goes on growing in content and extent—I simply cannot keep pace with what is expected of me."[413] Still newspapers provided evidence of the opposite—photographs showing her, youthfully, dancing the *Horah* with Youth Aliyah children.

For several weeks in the winter Szold fell very ill, a participant in a flu epidemic that fell upon half of the *Yishuv* during a notable snowfall. She spent time in bed writing long letters to Bertha as she asked about family treasures that her sister was going through:

> In spite of all my sympathy with our desire to clear things away and gain space I cannot repress the hope you are not destroying the letters you write about—those to Sadie [the sister who died in 1893]. Your description of them clutched me. Perhaps I shall survive this terrible war and join you in America. Sometimes that hope is strong enough to buoy me up. But I lay no injunctions upon you—I do not wish— I only hope.
>
> This is the third day of the passage of the year from old to new. And now, when at last my room is cleared of visitors and the flowers sent to me by friends are bestowed in waterfilled vases, I must light the candles and go off to synagogue. Perhaps just as well!
>
> 'What can one say that is not in every mind not utterly diseased? There can be only one wish—for peace, for cessation of the butchering of a generation—another generation—of young men. I confess that I have so far left behind my old attitude that I cannot myself with the wish for peace—I have learnt in the interval between the two wars that it must be a just peace, that is, a complete peace, a peace that solves the problem, if men are to live humanly, as becomes human beings ... I must stop. Love, love, love.[414]

During her sickness, Szold read *Gone with The Wind* noting that she found it 'homey—the language and atmosphere. Partly it transports me into the days of my contract with the Misses Adams [two sisters that ran a school where Szold taught].' And, with the Japanese bombing of Pearl Harbor, she realized that the world was at last lost, all its innocence and purity vanishing. America was in the war now, and 'it's a pity that the last refuge of one's soul is gone.'[415]

Szold, with her strong instincts, prepared herself and her world for the last days of old age. Bound in a 'specially constructed steel case,' her father's papers were now safely placed within the sanctity of the Hebrew University. She had ceremoniously presented Emma with the shroud that she was to

be buried in at her apartment one night. Her gravesite had been chosen on the Mount of Olives... 'Now she faced what were surely her last years on earth with folded hands.'

This realization changed her, perhaps more than she could have ever awaited. Szold softened, cared less about others' opinions, whereas before such ideas of shallow thought would have brought her to argue. She reflected, consoled herself of some matters of which she had never corrected or contained. Except for her temper, a disappointment that she had never tamed. 'I have always thought that with growing old I would become more rational, less bound to lose my temper,' she once told Ernst Simon, 'And nothing happens. All ages are difficult. Do you think eighty-one is an easy age?'[416]

Was it that Szold realized that she was still learning, and mostly from those younger who had been brought through the storm? The *madrihim*, teachers and leaders of thirty-five hundred children, she turned to 'for moral strength to persist unflinchingly. 'I turn to you whose source of strength is your daily contact with the youth which is in our charge. I envy you,' she confessed to them. 'Your duty lies defined before you. The darker the outlook, the more clearly you see your task—to teach, to train, to influence, to open up vistas into the past and into the future. It is for you to

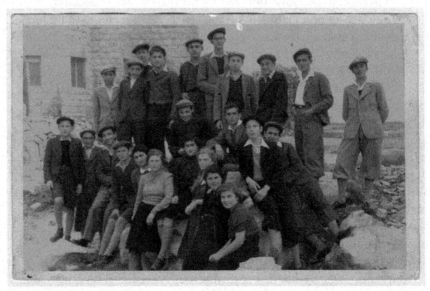

Recent Youth Aliyah immigrants to Palestine gather in front of the Horev boarding school, 1939-1941.

heal wounds inflicted by malign cruelty, to replace the wrenches of ties that bound a generation of children to fathers and mothers scattered to the furthest corners of the earth, to restore confidence in men and their works... to encourage aspiration and direct it into channels of actions towards culture and peace...'[417]

In those last days of 1941, as the world descended into the unknown, Szold blamed herself for so many things, the greatest that she wasn't there for her dear sister, Adele during her last days. 'I am so alone,' Szold had written. 'There is no one who really and truly knows me.'

Irving Fineman, in *Woman of Valor*, detailed those days as a poignant moment for Szold, of when she realized, with sinking certainty, that worldly events had trapped her with their actions: 'By the time Pearl Harbor and its consequences had made the possibility of her return "home" remote indeed,' he wrote, 'and she was like a stranded woman stubbornly engaged in properly raising her brood on an island surrounded by angry seas.

'Long ago, Goethe, the prophetic poet, in *Hermann und Dorothea*, which her father used to read to her, had described just such a world:

> *... all is in motion*
> *Now for a time on the earth, and everything seems to be failing;*
> *In the firmest of states the old fundamental laws are dissolving...*
> *All is in motion, as though the already shaped world into chaos*
> *Meant to resolve itself, backward into night...*[418]

Seeking a moment, a promising glimmer of hope against the imminent fateful future, Szold thought back on an event at a children's village, *Ben Shemen*, and it was a year ago, December 1940. Writer Dorothy Kahn would relate the story and remember also. 'Young men and women who were graduated from the Youth Aliyah, and boys and girls still in training, have gathered from all over the land to do honor to Miss Szold on her eightieth birthday. They represent the nearly eight thousand youngsters whom the Youth Aliyah had salvaged from the wreck of Europe.

It was at that moment that, 'A slip of a girl with blond bobbed hair'—wrote Dorothy Kahn—'rose to her feet. She was Margalit of Deganiah, who had come originally from Austria. Her family was dispersed "somewhere in Europe." In a few words she told of the change which Palestine had wrought in the lives of the youth. She told of the time that the youth had stood in the fields, sweat running from their brows. "And then the country seemed to say: Look at your land, love, it is yours."

Turning to Henrietta Szold she promised: "we will follow the road we have taken, forward and upward. And you will be with us on the road.'[419]

PART FOUR

18

Wearied Tasks

'Now I know the full power of evil. It makes ugliness seem beautiful
and goodness seem ugly.'

August Strindberg, "The Dance of Death"[420]

At the beginning of 1942, Szold, for the third time since the previous spring,
fell ill—a 'serious' bout of influenza complicated with a bout of bronchitis.
However, Dr. Magnes by 5 January, felt confident enough after visiting with
Szold that he cabled Hadassah that 'her condition was satisfactory.
Hadassah, in turn, forwarded the news to Bertha Levin in Baltimore.

'I believe I may say that I have recovered in all but strength,' Szold wrote
to Benjamin on 20 January. 'I think if the weather became milder, less
windy, that I could regularly perambulate on the street for a half hour daily,
I might gain more quickly. The day nurse left me only two days ago. Now I
need the sun without wind. I saw nothing of the snow which everybody
went crazy about. I was tucked away under the bed covers the whole time.'[421]

On 20 January 1942 in the Berlin suburb of Wannsee, a meeting of fifteen
Nazi leaders, took place in a conference room with wide, glass doors
looking out over a serene snow-laced garden. However, the subject of the
meeting in no way reflected the pastoral settings of the purpose of these
men. Adolf Eichmann, who had confronted Eva Stern, an incident that had
forced her to England, and who had personally suggested that Henrietta
Szold should never come to Austria, attended the meeting.

Henrich Himmler, within the initial hour of the meeting, first spoke
the term that would become infamous of the directive overshadowing the
destiny of European Jews. After noting to the conference that Hitler had
approved a new policy of deporting Jews to the east, Himmler assured them
it was a temporary measure, though it would provide, 'practical experience
that is of great significance for the coming "final solution" of the Jewish
question.'[422]

Particulars followed with a discussion in a business-like matter. One major decision was how many Jews would be killed immediately and how many would simply be worked to death as slave laborers. Several months later, in March, Joseph Goebbels, Hitler's Minister of Propaganda, would provide details in his diary, 'The Jews are now being pushed out of the General Government, beginning in Lublin, to the east,' he wrote. 'A pretty barbaric procedure being applied here ... in general one may conclude that sixty percent of them must be liquidated, while only forty percent can be put to work.'[423]

However, if there were any doubts of the endgame to Hitler's plan, that was openly exposed on 20 January 1942 as he reminded in a speech at the Sports Palace in Berlin, to those who heard his voice of prophecy, echoing from earlier days: 'We are ... clear that the war can only end either by the Aryan peoples being exterminated or by Jewry disappearing from the Europe ... This time the true old Jewish law "an eye for an eye, a tooth for a tooth" is being applied for the first time.'[424]

As the meeting ended late afternoon, as black sedans delivered the Nazi hierarchy back to Berlin, the dusk settled over the German landscape. Atrocities and mass murders were now, openly and officially, the order of the day.

<p style="text-align:center">***</p>

At Chelmno in northern Poland, a center was built to construct specially-designed vans, to accomplish one purpose. Murder Jews shipped from the ghettos. The concept of these killing vans was a simple matter—the Jews would be placed in an airtight van and piping from the exhaust fumes would be pumped inside. What at first seemed as an efficient way of killing, these vans, after those responsible realized the vast numbers who they were commanded to murder, would look to concentration camps with even better ways of killing.

However, at the beginning of 1942, this was the best weapon the Nazis had to unleash their coldblooded ways. Later, the van operators would detail how up to sixty Jews, 'often in a poor physical state, hungry, thirsty and weak ... were herded into the back of the vans, fully clothed ... "It did not seem as if the Jews knew that they were about to be gassed." 'When the doors were opened,' one German remembered, smoke poured out of the van. Once the smoke cleared, the Germans knew that their obscene work would begin—emptying the vehicle. 'It was frightful. You could see that they had fought terribly for their lives,' one wrote. 'Some of them were holding their noses. The dead had to be dragged apart.'

It was, at times, too much for the Germans who performed their murderous tasks in the Polish forest. Many drank and were often drunk when reporting for duty. As horrible as the recollections of removing the dead from the vans was, there was even a worse memory for one German.

'I can still today,' recalled Anton Lauer, a member of Police Reserve Battalion number 9, 'hear the Jews knocking and shouting, "Dear Germans, let us out."'[425]

'My duties overflow the limits of the hours of work, and my endurance is not what it was' Szold confessed on 17 April. 'I have long known that I should jump from the bandwagon—it moves too fast—but I can't find the proper moment for jumping down without, as it were, breaking my leg or breaking the backbone of whatever job I may be abandoning.'[426]

Within the next days, events would turn badly, convincing Szold that she couldn't turn away now. There were children, brought by Youth Aliyah to the Palestine coast, aboard the *Struma*, a ship carrying Roumanian illegal immigrants. But, for these refugees, time had run out.

Originally setting sail at Constantinople, the *Struma*, 'an ancient cattle ship,' was warned numerous times not to 'approach the shore of Palestine. On 24 February, while the Turkish government had refused visas for over 800 refugees, and the British government had accepted only fifty children to come ashore, it was towed into the Black Sea. There, it exploded and sank. Investigations could not expose the reason for the incident. Only one of the 800 survived.

The Jewish community was outraged.

Hadassah telegraphed Szold: 'APPALLED STRUMA DISASTER CABLE IMMEDIATELY IF CHILDREN PREVIOUSLY REMOVED.' It would be three weeks before Szold could bring herself to respond. Four days after the explosion, Szold wrote,

> I had a hard day yesterday. We all had a hard day on account of the *Struma* disaster. We of the Youth Aliyah had had high hopes of saving the children from suffering on that miserable ship. We could not save them from a horrible end. I suffered doubly and trebly because in fulfilment of a promise long ago given, I visited the passengers of the *Dorian* detained in Athlit.They were fasting to express their sympathy with the fate of fellow-suffers. I came back physically exhausted. Then, too, the children were my chief concern. There is

not much hope that even they will be liberated. Think of it! There are 19 little babies there born as it were in captivity![427]

Problems, beyond the *Struma* tragedy began to mount against Szold, with the coming of Passover, *Z'man herutenu*, but she somehow, found the energy and lingering strength to confront each difficulty: She wrote on 3 April:

> I should have been particularly attuned to the festival of the Redemption, because I had part in the release of thirty children from the Clearance Camp in Athlit, passengers of the S.S. *Darien*, on the way to Palestine these sixteen months: five of them on the high seas in a crazy craft and eleven months in the Camp. They were Tuesday forenoon by the High Commissioner who waived certain formalities in order that we might get them to their new homes for the Seder. In eighteen homes Mr. Beyth achieved the miracle. During the short time at our disposal, he took two trips from Jerusalem to Athlit and back, and got the whole of them to five institutions in good time; he returned to his own Seder rather late. A second exodus from slavery to freedom! I was excited and exhausted.[428]

Hadassah realizing the growing importance of their founder, Henrietta Szold, and wanting to present her with a surprise, offered to writer Marvin Lowenthal an assortment of her letters, and provided him with notes to write a commentary, so that he could write an autobiography of Szold.

On 19 April, a critique of Lowenthal's book, *Henrietta Szold: Life and Letters*, appeared in *The New York Times Book Review*, under the headline, 'Marvin Lowenthal's Life of the Dauntless Woman Whose Name is Linked with Palestine.' *The New York Herald Tribune* Books described the book as 'a discriminating biography of a memorable woman.'

The Enoch Pratt Free Library, in Baltimore, displayed the book in a large front window. '… I look forward to the book itself with trepidation, in spite of the series of letters I have had from friends praising the book extravagantly,' Szold wrote on 15 May after learning of the front window display in her hometown. 'I can understand Harry Friedenwald's judgment—his admiration of Marvin Lowenthal's literary craftsmanship. The book is to be brought to me by a member of the U.S. forces soon to come to Palestine.'[429]

In the summer of 1942, a copy of the book arrived and Szold read it, 'dashed through it from cover to cover, practically at one Sabbath sitting.'

A year earlier, she had read *I Have Considered the Days*, the memoir of Dr. Cyrus Adler, president of the Jewish Theological Seminary in New York who had died in 1940. 'In my opinion Cyrus Adler's reminiscences are as imperfect as my *Life and Letters*. However, it at least touches upon the core of one aspect of the life which he and I experiences.' She then went on to compliment his role 'he personally played no small role in this development (the consolidation of Jewish life in the United States)'

Szold found that there were writings of hers that had either been destroyed or that Bertha, to protect her personal, overwhelming grief at a time in her life, had filed away. Affairs which 'touched deep-lying springs,' she wrote to her cousin Miriam Schloessinger who had guided her dear friend during those days, as Szold referred to them—'A Dark Chronicle of a Broken Heart.'

She finally wrote Lowenthal in a letter dated 22 June: 'This afternoon Dr. Magnes brought me "the book" about which my sister had been writing to me and a score of friends, all in the same major key of admiration of what you had woven out of an endless skein of letters of mine... the volume lies before me on my desk, with its two gracious inscriptions, the one from you, and the other from my Hadassah associates, in the name of one hundred thousand women...'[430]

'All in all, I am still of the opinion that I am not a subject meet for a biography. I lived through great times—stirring transformations, social convulsions, scientific and technical achievements of the highest order happened during my more than fourscore years,' she wrote. 'Is there an echo of all this in my letters? Do they indicate that I responded to the events under my eyes by searchings of the heart, by revolt or assent, from which readers might learn how to battle with life? As a matter of fact, I may disclose to you that there was actually much more of a spiritual reverberation than the letters indicate. But the deeper reactions did not find their way into creative expression, creative subjectively and objectively,' she told Lowenthal. 'The book was conceived in the affection of my Hadassah co-workers, and they will read it with satisfaction because it is the portrait of the associate they knew. But the thinking of the great host of Hadassah members will not be leavened...'[431]

Szold wrote her friend Rose Jacobs, curious that, 'if the reading of the book will stimulate the great mass of Hadassah members to think and feel and order their lives consciously according to a principle derived from a description of my spiritual struggles.' To Tamar de Sola Pool, another friend, after admitting that she had appreciated the book, then insisted that

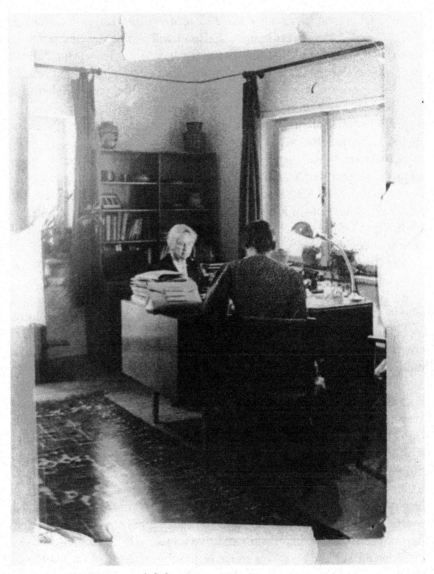

Henrietta Szold and Emma Ehrlich, 1942.

'biography should be more than chronicle. It should stimulate thought, influence action, lead to introspection and creation.'[432]

By June of 1942, two major issues pressed, with a desperate heaviness down on Palestine and the *Yishuv*. In the North Africa campaign raging, the Germans had captured Tobruk and 20,000 British soldiers. Now the

question haunting each Palestinian Jew was could Rommel be stopped and prevent the Germans from reaching their homeland? Many Jews, especially Zionists officials, Weizmann and his wife among them, carried cyanide pills.

Szold was urged to leave Palestine and go to America while there was still a way. She refused. 'The Nazis in North Africa were unreal to her, as perhaps all the Nazis had always been.'[433] Szold also witnessed the rise of a new form of terrorism, absurd in that it was aimed at fellow Jews, Jewish institutions, Jewish banks. 'The Jews would survive Hitler,' she truly believed, 'but how they would survive, what would be the state of their souls, the strength of the ethical ties that bound them to one another, to their prophetic past and the world at large, were more troubling questions.'[434]

So, instead of leaving Palestine, Szold steadfastly remained, and spoke out against the violence. 'These wards of our people, who ties to parents and home we severed, were brought here by us to be trained as citizens and builders of the new-old land sanctified by the words and the lives of legislators and prophets as well as by our fervent faith in an honorable future,' she reminded them. 'For their sake, for the sake of all our young men and women, whom we cherish, and the future we aspire to, I would adjure the leaders and the led to take solemn thought of what is happening under our eyes, and remove partisan strife and violence from our midst... liberty of conscience and freedom of speech threaten to slip from our guardianship. Our hallowed ethical standards are in danger of declining... these are evil things, of which our camp must be cleansed.'

Now, Szold appeared to be moving away from her argument of a binational state, which she had shared with many Zionists leaders, including Magnes. An Arab who worked with Magnes on an Arabic newspaper, had been murdered. Instead, Szold wrote that 'her faith in the values of inherent in negotiation as contrasted with decisions of the mighty, which eventuate in resort to force, if not at first, then at last.'[435] Szold, having reached King David's "age of strength," that of eighty, in turn assured herself during each visit to the children in their villages, that she would continue. That she had strength in the belief that she had held since the beginnings of Youth Aliyah: that the children, her children, must be raised surrounded by the ideals of civility, that of the history of the Jews, no matter the deteriorating fabric of a chaotic, mad world.

To the young soldiers, of which several thousand had joined the Jewish Brigade, pledging to fight alongside the British soldier, Szold told them, 'We are calling upon our young men to battle to the finish against totalitarianism with its iniquitous star-chamber practices,' she said. 'We lay

the task upon them to save from annihilation the precious bits of culture amassed since the remote days when our fathers were bidden to "proclaim liberty throughout the land unto all the inhabitants thereof." These young warrior-builders fulfilling our behest and the mothers of our future hosts of peace, freedom, and justice demand of us to be mindful of the teaching of our people's history: the Jew and his cause have persisted through the ages not by the might of the fist, not by the power of brute force, but by the spirit of divine law and love.'[436]

Then, by September, Szold and others walking the Jerusalem streets, noticed among these young warriors, American soldiers, a welcome and unexpected sight which prompted her to publish an article addressed to her fellow countrymen:

> Welcome to the defenders of the four freedoms who have come from the United States. ("I feel impelled to stretch out my hand to them and press theirs in fellowship and gratitude...") 'Only yesterday you sighted the Statue of Liberty which I have not seen for a number of years. You and I, we know, and we shall know as long as we breathe, that the inscription it bears expresses the soul of our America ... [now] you have come for the purpose of restoring liberty to the world... this is your consecration and your serious task, and eventually will be your order of merit.[437]

As the days hurriedly passed, the pressing issue of rescues, weighed more and more on her mind. Problems abounded on her, as if each tragedy, or possibility of tragedy was hers personally, not to be delegated. On 28 August, Szold wrote a letter describing that for the first time, she was made aware of a group of children being held in Iran at an abandoned Persian air base. They would come to be known as The Tehran Children: 'My work had been devoted to one thing—thinking out how we are going to meet the problem presented to us by a cable from Tehran which announces that five hundred chiefly parentless children have come across the Russo-Persian border, sick, starved, degenerate after endless wanderings. They are between the ages of five and ten, 'she explained. 'The first demand is certificates, the second, oodles of money. I am not altogether certain that the Youth Aliyah is the agency to deal with the present situation. And if it is, am I the person to preside over such an enlarged agency—enlarged not by reason of increased numbers, but by reason of increased and deepened scope.'[438]

Rumors of Jews being massacred finally confronted Palestine in August 1942. Despite the despairing news, Szold informed an associate that she

still truly believed, 'a great mass of child refugees' would arrive in Palestine after the war, 'and Youth Aliyah must be ready for them,' she said. 'They must plan ... nothing should be done rashly or superficially, for there was no hurry.'[439] Patience, purpose, and carefully organized process, Szold's strengths, had rescued over ten thousand already.

Later that month, reports of drastic changes within Germany schools came across Szold's desk. 'Teachers of history are instructed to stress the importance of race purity and the menace of Germany of Jewish influence in politics, religion, art, literature and morals,' Szold read. She was stunned—though by now, she realized that she shouldn't have been—of the attack on the children's spirits in the land of Goethe and Schiller and Lessing: 'Children studying ancient Rome are to be shown that it was the Jews, after their dispersion, who penetrated all quarters of the Roman Empire and caused its downfall,' she wrote. 'Medieval and modern history should be taught with special emphasis on the desperate struggles of the Spanish, Polish, and German peoples against Jewish domination ... even in elementary art instruction, children will be encouraged to develop their perception of racial differences by including caricatures of Jewish faces in their drawings, and kindergarten picture books will have pages designed to instill in the child sentiments regarding Jews similar to those regarding dangerous wild beasts...'[440]

On 18 November 1942, the truth as the Jewish Agency had believed for a while, was now not a rumor but fact. That day, a group of sixty-nine Palestinian Jews, "exchangees," arrived in Palestine, freed when a deal was reached to exchange them for German residents who wanted to leave Palestine.

Officials for the Jewish Agency began the process of interviewing the Jews, and were shocked with what they were told. It was the first-time eyewitnesses, interviewed face-to-face, confirmed such atrocities—the horrific life in the ghettos and the mass murders. Though they didn't witness themselves the camps and the gas chambers, they did receive first-hand accounts. A locomotive engineer, on his return from Russia, told how the Jews 'are being forced to enter special buildings and being destroyed by gas.'[441]

A report to the Polish government in exile in London told of how Dr. Avraham Stupp, a member of the *reprezentacja* of the Polish Jewish Association, began a meeting with the JAE telling them that 'somewhere in the environs of Treblinka and Malkin, as well as in Belsen, there are installations specially built [for cremating] the Jews in the places where they are being murdered en masse.'

The official announcement was released on 22 November, and then the next day in the United States. The *Yishuv* newspapers published the news of the methodical annihilation on the first pages. Strangely, most American newspapers placed the story inside; *The New York Times* story of the atrocities, headlined, "Slain Polish Jews Put at a Million," appeared on 26 November 1942 on page 16.[442]

David Ben-Gurion, the head of the Jewish Agency, upon hearing the full details, shortly offered his thoughts: 'We do not know exactly what goes on in the Nazi valley of death or how many Jews have already been slaughtered, murdered, burned, and buried alive and how many others are doomed to annihilation,' he wrote. 'Only from time to time does news of atrocities break through to us… the screams of women and children mutilated and crushed.'

He held to the belief that, once final victory was achieved, Europe would be found to be 'a vast Jewish cemetery in which the bones of our people are scattered … for but one sin … because the Jews have no state, no army, no independence, and no homeland.'[443]

With the news of the cruel murder of Europe's Jewry, the Jewish Agency requested assistance from the International Red Cross and American War Relief agencies in removing children to neutral countries, serving as temporary shelters for the refugees. Within the week, Szold issued 'A Call to Women' in the unbound countries from the platform of the Elected Assembly of the Jews in Palestine: '… the children held in the clutches of sadistic monsters in human shape,' was who Szold was now speaking for.

> They are being exterminated, piteously, of malice aforethought. They must be saved. We here have seen what promise the rescued youth holds out of becoming restorers of the breaches, of renewing the cultural values, destroyed in Berlin, Vienna, Prague, Warsaw, Cracow, and a score of other centers of learning…The women of the world cannot but recognize that the cause of the Jewish child is their cause. Perhaps if the world had not been silent and unconcerned when the torture of the German Jews was begun, there would not have been a second World War claiming its millions of precious young lives. The devilish work beginning with Jewish children may easily extend to the children of all races and nationalities… Is not the plea to women to organize a movement to "Save the Child for Civilization" the pleas for a supreme peace effort?[444]

During that fateful Autumn of 1942, Szold had a visit from a man of strong conviction, exactly what the world needed at that moment, as did she in

many ways, at that dreadful time. Though defeated handily by Franklin Roosevelt in the 1940 election—journalist Dorothy Thompson had remarked that if Willkie had made one more campaign speech, Roosevelt would have carried Canada—he offered his full support. He made two wartime foreign trips, considered 'dangerous missions' as the president's informal envoy. His purpose was to tour the war-torn areas and analyze the possibility of making the world a 'One World' to avoid further war and bloodshed.

On 11 September, Willkie arrived in Jerusalem. He spent a long, hard day meeting with High Commissioner Sir Harold MacMichael and U.S. Consul-General Lowell Pinkerton, Jewish officials including Moshe Shertok, head of the political department of the Jewish Agency, and assorted other Zionists and Arab leaders. Then he was introduced to Henrietta Szold in her home in the Pension Romm. She was preparing for the High Holy Day, on the eve of *Rosh Hashanah*, the Jewish New Year.

It was the late afternoon and Willkie immediately confessed that his conclusion was 'that the only solution to this tangled problem must be as drastic as Solomon's.'[445] Through the window lay the site of Solomon's ancient palace. 'Facing her across her desk in the late sunlight slanting down over golden Jerusalem, Willkie—that tough midwestern politician, his honest eyes sheltered beneath a wave of unruly hair—told her of, 'My confusion and my anxiety to find the answer.' Then he asked Szold if she believed trouble between the Jew and the Arab was a deliberate action by foreign powers to maintain control of this land.

'With a sad heart I must tell you it is true,' Szold confessed. 'Mr. Willkie, this problem had been with me for many years. I cannot live comfortably in America while it is unsolved. There is no other appropriate place in the world where the persecuted Jews of Europe can come. And no matter how much we may wish it, the persecution will not end in your lifetime or in mine. The Jews must have a national homeland,' she told him. 'I am an ardent Zionist, but I do not believe that there is a necessary antagonism between the hopes of the Jews and the rights of the Arabs. I am urging my fellow Jews here in Jerusalem to do those simple things that break down the prejudices, the differences between people. I urge each of them to make friends with a few Arabs to demonstrate by their way of life that we are not coming as conquerors or destroyers, but as a part of the traditional life of the country, for us a sentimental and religious homeland.'

The sun slipped below the Judean hills, as night fell on Jerusalem. After Szold had lit her mother's candlestick, she told Mr. Willkie that she was determined to continue to improve, beyond what had already been

accomplished, education and the work on the farm villages and the town's industries.... 'She told him stories of her indomitable children...'

Willkie finally confessed that 'it was probably unrealistic to believe that such a complex question as the Arab-Jewish one, founded in ancient history and religion, and involved as it was with high international policy and politics, could be solved by good will and simple honesty.'

As he rose to leave, he took Szold's hand.

His afternoon with Szold caused Willkie to rehash many theories he had heard about Palestine. During the busy day he had just spent meeting, baffled by the bitter charges he had listened to all day, he still doubted that Miss Szold's simple solution was a realistic one. 'But as I sat there that late afternoon,' he later wrote at the end of his journey, 'with the sun shining through the windows, lighting up that intelligent, sensitive face, I, at least for the moment, wondered if she in her mature, selfless wisdom might not know more than all the ambitious politicians.'[446]

Szold went to the synagogue to pray, during the solemn time of the Jewish New Year, 'for peace, for cessation of the butchering of another generation of young men,' realizing that 'I have so far left behind my old attitude that I cannot content myself with the wish for peace—I have learnt in the interval between the two wars that it must be a just peace, a peace that solves the problem, if men are to live humanly, as becomes human beings.'

For the moment, the peace that Szold envisioned, had no chance to transform the world. It was war that would decide the fate of the Palestine Jew. A conflict between wearied, worn British and German armies unfolding in the burning deserts of North Africa, at an Egyptian railway halt on the desert plains, where the second battle of El Alamein would decide if Rommel broke through on to Egypt and Cairo.

And, eventually, Palestine.

19

'The Wretched Refuge'

'The children, they're not the enemy at the moment. The enemy is the blood inside them.'

-SS Private Oskar Gröning[447]

'...I say that we have to accept all of them. All of them are the children of Israel...'[448]

-Henrietta Szold, February 1943

The war remained the focus of the world, and the citizens of Palestine; it consumed daily discussions on the streets, in the crowded coffee shops; it consumed the newspapers; and it consumed the Youth Aliyah office. News from the war front seemed to always be bad for the allies. In the last part of the previous year, Germany had launched a massive offensive against reeling Russian forces and drove toward Stalingrad. Allied shipping had taken a brutal beating in the Atlantic as German submarines sank the ships at an alarming rate. However, there was good news, finally throughout the last week of October until 11 November 1942—General Bernard Montgomery, leading the British Eighth Army in North Africa, had routed Rommel and his Panzer Army Africa forces at El Alamein. And with Rommel's defeat, the *Yishuv* of *Eretz Israel*, sighed in collective relief.

In January 1943, Szold sent nephew Benjamin an article from *The Palestine Post* that Americans residing in Palestine could volunteer to register in the United States Army. Benjamin joined at an enlistment office in Tel Aviv, was accepted, took the oath on 27 April, and then wrote his brother Jastrow on 4 May: 'My whole life had changed suddenly and radically. At present my artillery consists of a battery of typewriter keys and the hand grenades I sling around the bulky files. I have the distinction of being a private in a camp where nearly everybody is an officer or at least an NCO,' he admitted. 'Instead of worrying over how to throw bombs at Germans my biggest worry is how to know when to salute an officer.

'I don't know whether I am in Palestine or America. I can say "Presto, Vanish America!" and I am among Valencia oranges, Histadrut members,

Hebrew, German and Yiddish conversation; and then I can say "Abracadabra" and I am among Old Golds, Camels, fig newtons, gingersnaps, *The New Yorker*, and middle Western twang. Right now, I am in Pittsburgh and not Nahalal."[449]

Updated information, sent by the British army in Iran, and forwarded through the Jewish Agency to the Youth Aliyah office, portrayed a dismal image concerning the Jewish children. Szold was prompted to speak out, appealing to the mother-instinct of those who would listen: 'At this very moment, the hearts of the Jewish women of Palestine are torn between hope and apprehension while message after message reaches them from nine hundred children at Teheran, most of them parentless, who are waiting to complete the last lap of their toilsome, long journey from Poland through Russia and Persia to Palestine.

> I would have Jewish women everywhere appeal in this fashion in turn to the motherhood instinct of all women, the creative instinct that abhors destruction. The women of the world cannot but recognize that the cause of the Jewish child is their cause. Is it necessary to remind them that the horrors that envelop our days and nights at present began with the designs against the Jews? Perhaps if the world had not sat by silent and unconcerned when the torture of the German Jews was begun and the extermination of all Jews promised, there would not have been a Second World War claiming its millions of precious young lives. They should ponder that the devilish work beginning with Jewish children may easily extend, if it has not already extended, to the children of all races and nationalities. Ay, here is proof of the prognosis—the Jewish child refugees at Teheran are encamped with hundreds of Polish Christian child refugees! The women should be asked: if we Jewish women need to assure ourselves of future bearers of the Jewish spirit and if we must train exponents of Jewish values, do not they, likewise, and we together with them, require builders of the new postwar order of the four freedoms we dream of?[450]

✳✳✳

The journey that had brought the Tehran Children to Iran had begun in the spring of 1941, over a year before. Over twenty thousand Polish soldiers and civilians were released from Siberian camps by Stalin as a recourse of Hitler invading Russia. The soldiers were prisoners of war, who Winston

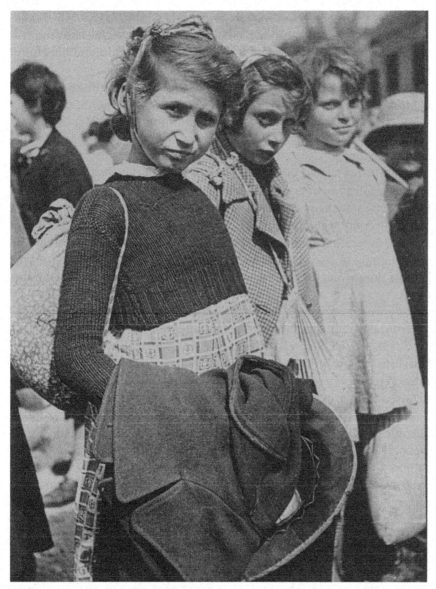

Three young Jewish refugee girls who are part of the Teheran children's transport just prior to the departure from Iran, January 1943.

Churchill knew could be used to fight against Germany's armies. The drawback was the fact that Allied commanders were aware that the Poles and Russians would never fight alongside each other. Since the beginning of the century, too much bad blood had been spilled. However, Churchill

knew the value of the Polish soldiers, and persuaded Stalin that, if he would release them, he would send them to Iran and onto Palestine to be trained to fight with the British against Rommel in North Africa, and hopefully, into Italy as that front opened up.

As an afterthought, Stalin realized it was a way to rid himself of a number of undesirables, releasing over ten thousand refugees, many who were Jewish, including the children. By the summer of 1942, located in camps outside Teheran, Iran—children were, by a chain of events, now the concern of Szold.

Photo reporter and journalist Nachum T. Gidal, witnessed the refugees in the late fall as a war correspondent of the British Eighth Army ... 'it was there that I saw them in November of the same year, as I came through Teheran on my way north,' Gidal wrote. 'I saw hordes of children, half starved, in rags, recovering in the care of the American Red Cross and of a small group of Jewish workers sent from Palestine. Moshe Sharett's wife led this group. She told me the story of the children, and took me to the camp.

'We were many, many,' one of the children told us, 'When we first set out from Poland. Eight thousand perhaps, may be ten thousand.'[451]

Szold had, in fact, learned of these children as they were led out of Siberia to Pahlevi, a Persian port on the Caspian Sea. How they had arrived at the Persian port was, itself, a story describing the human will to survive. Released from horrific labor camps in Siberia, the refugees had wandered down from Siberia to Samarkand and Uzbekistan finding only more horrible conditions, starving conditions, and waves of disease including typhoid, which killed hundreds. Some relief finally arrived when, under the authority of the Jewish Agency, they were put onboard trains, transported to the Caspian coast, and finally by ship to Pahlavi. Sadly, there at an army camp, Polish adults and children were placed in separate camps that furnished showers, cots, and food, while many times the Jewish children were left to fend for themselves on the beaches. The weather was terribly hot, the food again scarce, and the only hospital to provide medical aid was a converted supply tent. Finally, they were loaded on trucks and delivered to the camps outside Teheran. By late September, despite her best efforts, certificates allowing them to travel to Palestine had not yet been secured. However, there was good news—the Polish government-in-exile had promised funds to support the children until the end of the war, and Hadassah, with representatives in Washington D.C., had promised its support. On 16 October, Szold wrote: 'My sole interest at the moment is the children in Teheran,' she confessed. 'The more I enter into the details

of the task, the better I realize the difficulties we are facing. This week the *Mitzvah* chasers opened new problem vistas before me. The *Agudat* Israel sets up the claim that these children from Poland doubtless belong to it. But the *Mizrachi* Organization claims no less. Then come the parties and the institutions, and the individuals with theories and projects. How are we going to do justice to them all? How are we going to avoid doing injustice to the children?'[452]

In October 1942 Szold sent her personal representative, Mrs. Zipporah Shertok (who journalist Gidal in Teheran had referred to in his report) with the purpose of assessing the situation. One story that came out of the camp was heartbreaking. It was on *Yom Kippur*, the Day of Atonement, a day that began as calmly as a day could under such harsh circumstances. The children appeared to be acclimating to their surroundings when they began weeping uncontrollably. Soon, it had spread throughout and hundreds were crying out: 'We cried for our lost childhood, and for our mothers and fathers,' a youth told them. 'And when we thought we had cried ourselves out, another awful truth hit us all at once—we children had deserted our fathers and mothers to save our own lives. And then we discovered we still had more tears to shed.'[453]

Shertok had been there several days when she returned to her Teheran hotel room one afternoon, and wrote out a report to the Aliyah Department of Jerusalem: 'The children are housed in one big hut and six big tents. In the big room, sleep 98 small children up to age eight. Each child has three woolen blankets. Under the mattress are spread mats… in the isolation room children, too, sleep on the floor. There are few white sheets, but mostly they sleep on dark blankets. The children over age eight sleep in the tents, but they do not have any mattresses or cushions but only blankets and mats. The tents are torn and cold and rain penetrates and the children are often sick,' Shertok wrote. 'The autumn has already set in and it is chilly. The children complain that it is cold. The children receive food from the kitchen three times a day. In the morning, ½ kg. bread per child for the whole day, a dab of butter, a bit of jam and an apple. At noon: soup and cereal. At five: tea and an egg. Some get extra rations by medical prescription. They eat in the tents, without table or a cloth, on the blankets. Some children built themselves tables of brick. The children are shorter than their age, underdeveloped and pale, some of them very pale…twice a week they take a warm shower and one of their blankets is disinfected. Some of them have skin rashes and sick eyes and one child has pneumonia. Some two hundred children go barefoot; other have worn-out shoes and very shabby and insufficient clothing.'[454]

The report was immediately forwarded to Szold's desk. When she read it, the situation was clear and simple—if the children weren't removed from Iran, many would perish.

Anticipating that the Hadassah negotiations would eventually be successful, Szold, in November, traveled from Jerusalem out into the countryside arranging for provisional locations for the Teheran children to be received, and wrote on the 21st of these efforts:

> We had to seek places which offered kitchen and dining room accommodations ready-made. Every plate and glass costs fortunes these days. The places secured are not sufficient for the 933 children waiting at Teheran. We are hoping that they will come, not all at once, but in age groups, so as to give us a chance to dispose of a number of them before their successors appear. So far as certificates are concerned, we could bring out 1000 children from France, and hundreds from Holland and Bulgaria, whence cries of distress reach us. But there is Hitler, and there are blocked routes, and there is no money! Meanwhile the descriptions that come through are inconceivable.[455]

By December, Szold heard from one of the original eyewitnesses, interviewed in November 1942, to the horror transpiring in Europe. Szold wrote on the eleventh:

> During the past week luck would have it that I was brought in contact with one of the "exchangees" from Poland, a mother of three children, who succeeded in bringing with her only one of them; the other two had disappeared according to the well-known formula worked out by the Gestapo. From her I heard details so gruesome that I cannot recover my balance. Meanwhile the children waiting at Teheran do not receive a transit visa from the Iraqian Government. So, they suffer from the cruel (so I am told) Persian winter. The children at Teheran are the only subject I can think about.[456]

December did present a reprieve for Szold concerning her worries about the children stranded in Teheran. *Kfar Szold* had relocated, after securing permanent land in the north, near the Syrian border. And, to celebrate her eighty-second birthday, the Henrietta Szold Forest was planted at *Maaleh Hahamisha*, close to the highway running from Jersualem to Tel-Aviv.

Since early fall, Hadassah had wisely shifted their efforts to assist in the rescue to Washington D.C., placing those endeavors in the hands of three women. Tamar de Sola Pool, a visionary born in Jerusalem, was the Hadassah national president; Gisela Warburg, a refugee herself from Germany, was chairman of the National Board of Hadassah. The third woman, was New Orleans born Denise Tourover. She was Hadassah's first Washington representative, had lived there since 1920, was well aware of the internal workings of the political machine, and had created a wealth of contacts.

The three went to work immediately, running into roadblocks at every meeting. However, refusing to give up, by January their efforts appeared close to a breakthrough. Tourover sent several telegrams to Jerusalem detailing their failures and the apathy of officials to listen, angering Szold— 'didn't anyone care about these children?' She wondered aloud.

Refusing to give up, Tourover had simply shifted from seeking assistance from the American government to, the most unlikely of candidates, the British; namely Lord Halifax the British ambassador at the embassy. Two days after a brief meeting, Tourover received a telegram from the British government. Lord Halifax had signed off on permission for the Teheran children to depart Iran for Palestine.

Later that day, Szold, remembering the warning Shertok had sent three months ago that children would surely die if they weren't taken to Teheran, was wired the good news.[457]

January again reminded her of how delicate the Teheran situation was. She would write about it on 31 January 1943: 'I must admit that the Teheran children are overwhelming me—not they, really, but the people who are desperately interested in their welfare—the Polish residents in Palestine, who are of the opinion that, though possibly I may know how to deal with German youth and children,' she wrote, 'or those from Austria, Czechoslovakia, Bulgaria, Roumania, Italy, Yugoslavia, Latvia, and the two or three hundred Poles whom I brought in clandestinely, I cannot be trusted to take care of the Polish refugee children. And the *Agudat* Israel and the *Mizrachi* have constituted themselves the keepers of their souls. Even without the endless discussions I am compelled to carry on with these doubters of my competence.'[458]

Finally, after months of desperate work, on 7 January 1943, a telegram by Moshe Sharett from his London office to Eliahu Dobkin at the Jewish Agency, gave Szold and others the news they had been anticipating: 'HAVE DEFINITE PROMISE TRANSPORT BY AVAILABLE EARLY JANUARY SENIOR NAVAL OFFICER INSTRUCTED. CONTACT YOUR TEHERAN STOP. CABLE SIPPORAH.

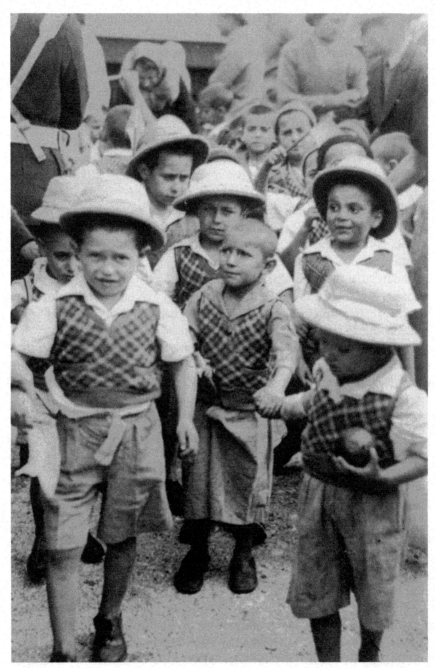

Younger members of the Teheran children's transport are led away from the train after their arrival at the station in Athlit, February 1943.

Szold sent a telegram to the Hadassah office in New York: 600 CHILDREN WITH 60 GUARDIANS LEFT YESTERDAY FOR AHVAZ ON SEA ROUTE PALESTINE OTHERS LEAVE IN FEW DAYS. HENRIETTA SZOLD

Still, there were problems. The Arab nations refused to let the children travel over land to Palestine. The Iraqi government refused travel visas; finally, a ship was provided and the children, at last, departed to Karachi, a British military base, and then to Port Said where they landed on 17 February 1943. Beyth and a unit of Jewish Brigade training nearby, met them.

After showers, the children were given food and clothing, and after almost five years, a warm, comfortable bed to sleep. 'The next morning, the soldiers raised a blue and white flag on a pole just outside the huge building and they sang "*Hatikvah*." That night the children camped by the Wells of Moses, on the east side of the Gulf. It was the traditional camping site of the children of Israel after the crossing of the Red Sea when they came out of Egypt.'[459]

The next morning, as a clear dawn rose over the desert, two trains headed north with the children onboard.

Finally, the children reached Athlit Clearance Camp on 18 February. Szold was there to meet them. She described the place as 'a barren, ugly government quarantine station,'[460] however, she had made plans to disperse them to better conditions, soon. At least, Szold told herself, the children would sleep in Palestine tonight. Ten days later, she wrote of that experience: 'The Teheran Children! I was in Haifa-Athlit for nine days full to repletion. If my Athlit days were full, the dictionary offers no word conveying adequately what my days are now,' Szold recalled waiting at the train station, Beyth and Emma standing close by. 'Chiefly I tell people, curiosity-mongers, that they can't visit the children and interview them. The whole country seems to have gone plumb crazy. The children's arrival was an historic event, I admit. I should like to have the leisure to write up a full description of all the attendant circumstances. I would, indeed, make a document for the histories of the future.'[461]

After Szold had conducted personal interviews of each child, they were then sent out to eleven preparation centers where they were expected to stay for five to six weeks. Everywhere the children traveled, they were met as heroes. On a street in Jerusalem a large crowd greeted them with cheers. Arabs were throughout the crowd, school children excused from school with small sacks of oranges: 'May Allah be with you, you are now the children of all mankind…'[462]

Szold, exhausted and sick with bronchitis, went to bed.

The children, who were now at the preparation camps, were satisfied beyond the dreams: 'We were sixty little savages…Our eyes fairly popped at the abundance of food on the table—piles of fresh bread, as much as we wanted, more than anyone of us could have possibly have eaten. We just stood and stared at the tables, and each of us had the same thought—it must be some sort of a trick, a hoax… At first we were suspicious of everyone around us.'

Still remained the nightmares of their journey, and the growing pains of homesickness, the 'rich warm atmosphere of Jewish life they had been forced to leave behind: 'It was as if all the years in which I hadn't dared to give in had caught up with me at last. At fourteen I'd seen people dying and dead around me without ever being afraid for myself. Here in Palestine at seventeen I found myself getting panicky at the slightest headache or scratch… In Siberia I'd worked eighteen hours each day without any time off. In the kibbutz I was pretending to be sick all the time.'[463]

The Tehran Children was a story of tremendous success, created national heroes throughout the *Yishuv*, though at times, the odds had seemed overwhelming. Even, at times, drawing Szold's fury, it seemed that the world was against the Jew—then, at that right moment, as peril and disaster lingered closely, good men had finally committed a good deed. Such thoughts gave Palestine hope, as victory against darkness gave Szold long pause and reflection. She wrote to her friend Dr. Friedenwald:

> There is not a vestige of self-esteem in my agreement with your judgment that the Youth Aliyah is the best thing we Jews are doing. I have never been concerned with anything in the way of public work which as impressively as Youth Aliya made me feel that I am an instrument in the hands of a Higher Power; hence, no self-esteem. As for its value in all respects, one has but to look at the brawny young men and the spirited young women the movement develops to be impressed with the human and citizenship material shaping itself to the uses of a New Palestine.[464]

With the Teheran Children safely in Palestine, many thought that the situation was complete. Szold knew better, aware of the factions with the *Yishuv*. 'I ought to tell you of my troubles, my long-drawn-out agony connected with the Teheran children and their religious education,' Szold confessed to Rose Jacobs in the summer of 1943. 'I have had six months of poignant struggle, and the end is not in sight. I can't write about it. As soon

as the most important arrears in my correspondence are made up, I shall write a full report. My strength has returned after a severe illness which laid me low when the seven hundred children were in camps seething with devastating propaganda...'[465]

Irving Fineman observed the complexities of the problems confronting Szold each day, a situation that she took as personal as any mother with her own child: 'Miss Szold was not spared the agonies of child-bearing; she, who had so wanted children— "many of them"—suffered in good measure.'[466]

Not long afterwards, she received a letter from a young Zionist from the Bronx, who, as controversies surfaced in Palestine, had written to Szold with great concern. 'There were always differences of opinion among Jews,' Szold assured the writer. 'The most learned of them, Maimonides, had his opponents; the Pharisees and the Sadducees approached Jewish discussions from widely different points of view. There were basic distinctions between them and their attitudes. But always in all ages and epochs there evolved a system which we call Judaism, which Dr. Schechter, the renowned scholar, called "Catholic Judaism," meaning an all-embracing Judaism which gave a place to all Jews and to their Jewish living,' Szold explained '... My firm conviction is that the solution of what we call the Jewish problem, the external and the internal, can be achieved only through Zionism, the object of which is, indeed, to give us a self-dependent form of life in Palestine ... One more word... seeing that you are young and I am old, that I have the right to say: "Don't Despair."'[467]

By 18 June, despite her dismay surrounding political and religious efforts on the children's destinies laid out to Rose Jacobs, the future appeared brighter for the children, and Szold was glad, expressed in her words: 'I spent the week rushing hither and thither, and succeeded practically in completing the survey of the Teheran children in their permanent placements. On the whole I am pleased with what I have seen of them,' she admitted. 'They are apparently making good progress toward normality. The study with vim. Most of them have already acquired enough Hebrew to carry on a conversation. They are no less ready to do the work assigned to them.' Her last words in this letter reflected that Szold, worn and ill, but fighting for every bit of sanity to be available to these children, believed, at last, the saga of the Teheran children, would be one of victory. 'What pleases me most is that they are beginning to frolic, to be children. They will snatch back a little of the heritage of youth that the Hitler war robbed them of.'[468]

Beyond the Teheran children situation, Szold again took to the road, with Hans Beyth. One day, at a children's village on Mount Carmel, *Meir Shefeyah*, while visiting a Youth Aliyah group (from Iraq, Syria, and Aden Yemenite), they met a Swiss journalist, who was researching so to write several commentaries on Palestine.

It prompted Szold to write on 16 July: 'I am buried under details crowding in upon my attention. It's not only Youth Aliyah that makes constant demands upon my time and strength. I wonder whether there is a single person in Palestine who suffers, or whose children suffer, or who is out of work who doesn't turn to me. I can help very, very few, and the fact that my answers perforce are negative in the large majority of cases is a drain upon my mental and emotional strength.

'I was away from Jerusalem Wednesday and Thursday, returning last evening. My trip this time was devoted to quelling discontent in a *moshav* [a cooperative community of farmers], in a Palestinian group. Initially the boys and girls resist going into a *moshav*. It is the kibbutz that wears the halo of romance. There is besides the difficulty of adjustment to an individual family. Many of the families are not prepared intellectually for the duty of training the adolescent youths. In *Beit Shearim* the only solution was to take the youths out of the *moshav* and assign them to various kibbutzim. The rest of my trip was devoted to visits to families and individuals, relatives of Teheran children who have accepted them as members of their families. It was interesting.'[469]

By early May, the German army abandonment of North Africa was complete, and by late August Allied forces had obtained victory in Sicily. What that meant for Szold was that, once again, there would be an outpouring of refugee children. 'I was in Haifa from Monday until Thursday evening attending to the 108 Polish children who arrived from Teheran yesterday a week ago,' she wrote on 4 September referring to the last group of Teheran children, who had traveled overland to reach Palestine. 'They were taken to Athlit, stayed there only on Saturday, and then were transferred to Ahava, all but 23 for whom there was no room there.

'As quickly as could be, they were settled, and those who could not be assigned at once to their permanent places were transferred to Ahava as soon as places could be cleaned. In spite of our mighty efforts and the removal of Ahava from the city, the propagandists found their way to the children and did as much mischief as they could in spite of our vigilance. The children themselves also made even greater demands than the previous group, and were rebellious because they were not getting the public reception as their predecessors. We succeeded however in interviewing 90;

only 18 are left to be interviewed. But we could settle only 43 due to the lack of religious places, especially for the little children of whom there is a large number.'[470]

One day Szold had a surprise. It seemed that two Americans wanted to visit with her. Jack Benny, a movie actor, and Larry Adler, a skillful player of the harmonica, who happened to be from Szold's home town of Baltimore. 'I had never heard of them,' she admitted. 'And today Erica Mann, war correspondent and daughter of Thomas Mann, came in. A breath from another world.' Edward Cone of Baltimore was another visitor, which connected Szold with her early days. 'The Cone family was very close to me,' Henrietta would write. 'They lived on Lombard Street opposite us, and one of the daughters was my schoolmate. I fancy the young man must be the son or descendant of Caesar Cone; he and his older brother went to North Carolina and established large industries there.'[471]

Szold couldn't imagine that she would ever see the end in sight; there were thousands of poor children still out there in this harsh world the war had created. Even with some good news from the battlefronts, their work load reached staggering proportions. 'Our work at the office had grown gigantically; we have 2500 children and youths in training,' Szold wrote in a letter dated 17 September. 'They are difficult material—the Teheran children—as well as the Turkish immigration which we have been receiving lately.'[472] On 13 October, while traveling with Norman Bentwich, a writer researching a book on Youth Aliyah, Szold exposed her self-assurances of just how much the organization had changed. 'Youth Aliyah has become very exacting. It bristles with demands and problems, and those ideal days in which I was mistress of the situation, without interference from the public and its leaders, are in the past.'[473]

In late October, twenty-one Turkish children sailed into Haifa; forty Yemenite boys and girls headed toward Suez. Annoyances and impenetrable circumstances haunted Szold, as she sensed that the battle over religious children were now centered in the political arena, instead of religion— 'The *Agudat* business will drive me mad—eight little boys kidnapped in less than two weeks, and from a *Mizrachi* institution,' Szold wrote on 20 November. 'The Central authorities of the Agudat deny all complicity in the deed, and avow that they can't be the abductors.'[474]

Upon finding that her nephew Benjamin was now stationed in Egypt, Szold wrote him in early 1944, asking did he fancy Cairo as much as she once had. 'I loved it and I hated it …' she confessed to him, '… it's exquisite and it's intolerable from the human-humane point of view. I made up my mind if I ever got another opportunity to visit Cairo, I'd develop myself to

the study of the mosques through the centuries. The oldest one there is a marvel and stands far above many of the later ones as an art monument.'[475]

The tenth anniversary of the arrival of the first Youth Aliyah group from Berlin approached. Szold and Beyth led a tour of over thirty journalists, explaining that there were many different types of Youth Aliyah settlements in Palestine. In Haifa, a press conference was scheduled, set up by Mr. Beyth and Mr. Spector of the *Keren Ha-Yesod*, the financial department of the World Zionist Organization and the Jewish Agency of Palestine.

On 20 February, concerning the celebration, Szold wrote: 'It was most successful—all the arrangements turned out perfectly, including the weather, with the result that Youth Aliyah has been given more publicity than in all the ten years of its existence together. The journalists knew nothing, nothing at all, of the movement. I was amazed at their utter ignorance. It served a purpose. The necessity of seeing our work through their uninstructed eyes brought home to me anew the importance and achievements of the undertaking. Last night, on the actual anniversary day, we had a broadcasting performance. I think it was universally considered successful.'[476]

On the afternoon of 13 March, Szold's sister Bertha stood on the platform at Boston University to accept an honorary degree of Doctor of Humanities for Henrietta Szold. The president of the University, Dr. Daniel L. Marsh, made the presentation as Szold listened through a two-way shortwave radio connection as he portrayed her:

> Distinguished for social settlement work in America and in Palestine; scholar, classicist, journalist; Founder of Hadassah; accomplisher of unparalleled reclamation and rehabilitation work in Palestine; a mother of Israel—through organizing and directing the Youth Aliyah, the joyful mother of ten thousand motherless children; you have spent your years as a tale that is told, and the tale is one of a life devoted to the pursuit of the beautiful, the true, and the good; by reason of strength, the days of your years are four score years and more, yet is their strength labor and joy…

Szold replied over the radio at 3:30 A.M. east coast time:

> Humbly I express my deep appreciation in these days of men's inhumanity to man, to bear the title of Doctor of Humanities. It is not a slight honor. You promise me privileges connected with the honor…Is it possible to add to the privilege to represent the

thousands of parents whose children have been educated for intelligent democratic citizenship in the homeland of the Jewish renaissance, and the tens of thousands who look for the rescue of their tortured children...?

The last honor was when President Franklin Roosevelt sent Szold an admiring message:

Hearty congratulations as you celebrate the tenth anniversary of the Youth Aliyah movement, of which you are the honored founder. Since 1889 when you organized the first English and Americanization classes in your native Baltimore, you have devoted yourself to the best social and educational ideals, both here and in Palestine. Your direction of Youth Aliyah has been characteristic of the qualities that have won you such respect and affection... The coming liberation of Europe will present us all with unparalleled problems. We must heal broken bodies, rebuild shattered lives and faith. I am sure that in this task Youth Aliyah with your guidance will take its place to the forefront, as in the past.[477]

20

Illness

The fever was upon her again; much worse today, a pulsing, terribly draining weakness that accompanied these sorts of things. This time it was more severe than before. She could not deny it this time.[478]

Szold moved about slowly that morning. Sleep had been fitful, off and on during the night, the constant drumming ache in her joints, and she knew that on this morning they would insist on taking her to the hospital.

She went and sat in the chair by the window. For the longest time, she stared out past her small garden, and into a shadowy darkness. Her precious plants—the pink hydrangea and scattered pots of varied cacti—even the pots of dried up, dead flowers—for she could never bring herself to throw away even the dead ones—waited for the dawn of another hot day in Jerusalem. She would miss them terribly, for to watch anything to have life within it and to grow always gave her a flicker of hope.

Later, as the light of the false dawn broke over the valley below the city, Szold recognized the gray sketch of her garden, and for that moment, she was very content.

Drawing in a deep breath, there was a rattling deep within her chest, and she closed her eyes, drawing close to those memories of living in this strange land, this Palestine. Twenty-five years. And each year she had always spoken and written of a promise within her to return to America and her beloved sisters. 'Last spring, I determined to cut loose from Palestine and return to America for my remaining years, to be coddled by my sisters. Hitler disposed otherwise,' she had written in October 1933; yes, she remembered writing those words with the realization that, suddenly, that home would only grow more distant.

Once, years ago, she had lived in a little stone house that stood outside Jerusalem, north of the old city. Her mornings then were filled with views of the Vale of Jehoshaphat, and then to gaze upon Mount Scopus and the Mount of Olives, that traditional burial place with its row upon row of timeworn stones. How many times had she stared at this wonderful, mysterious land, and at the same moment, thinking back to those colorful,

autumn Maryland woods? Oh, for Adele's coal stove or for an over-steam heated New York apartment.

She had never felt ashamed, not for one moment, that had she dreamed of such things; that Szold had always planned on returning to America, to her sisters, to Baltimore and Lombard Street; her wonderful childhood that unfolded there, the house with gracious lawns, and dark shade trees, and manicured scrubs. And, of course, Papa's library with dark, rich wood walls, bookcases lined with books (mostly history, mostly Jewish) with black-cloth covers, but 'things' always seemed to have a way of becoming disrupted, seemed to block that path homeward—an event, a crisis, a critical need that should be addressed with swift action. Only periodic visits, brief times of visiting and laughing with sisters, could ever weaken her longings.

Gradually, the morning light awakened the room around her. The thought came to her, would she see her office again? Would she ever be able to return? This had been her world, her life for so long. There were more plants, out on the window sill, on the cupboard, on the floor. A photograph of Papa there on the bookcase where it could catch sunlight from a close window. "My father's daughter," she whispered. There had not been a single day in her long life, since his death, that she hadn't missed him. Along the shelf below, were family photographs, Sabbath candlesticks, and of course, her books that were a deep love in her life, for she loved the silence of reading a book. And then, there was her secret, things not laid out, but brought out for only her to view. Down the narrow hallway, the letters from Louis Ginzberg, stored away in a distance, pale room.

The bookcase before her was of a wide assortment and variety. Szold, it was said, would read any book, if only she had the time. The five parchment-bound volumes of the Hebrew Bible and Jewish works mingled in with the *History of Egypt*. The letters of Gertrude Bell, writer and archaeologist in the Middle East, and numerous modern novels. On the next shelf, was Heinrich Graetz's *History of the Jews*. Her stare froze on the four books purposely placed apart from the others—for these books had been the labor of her love in the younger years—Professor Louis Ginzberg's *Legend of the Jews*, and she was aware, that, to take the moment and ponder on his books, drew her back much further than she wanted to go this morning.

Rising slowly from the chair, Szold walked to her desk and sat. Fleeting second thoughts arose. Why not this morning, why shouldn't she remember? What if she never came back and had passed up this one last opportunity to let her feelings arise? Opening the bottom drawer, she removed two objects wrapped in cloth. For a long moment, she lingered,

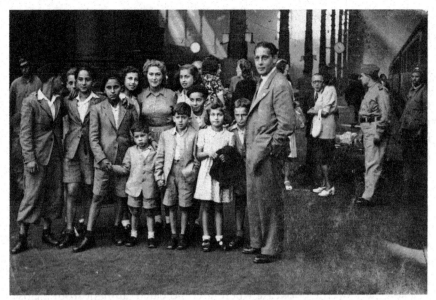

Jewish Refugee children gather in a train station in Lisbon prior to departure for Palestine.

the cloth resting in her lap, then sat it on the desk and unwrapped the cloth.

A porcelain belt buckle; an olive Purim scroll.

Treasured possessions, deeply-loved landmarks that had taken her life, uncharted and lost then, off into what she now considered predestined directions; transitions of unbearable pain, lifted up from life's ruins, and used by God to direct her toward a purpose in life.

Picking up the belt buckle, Szold drew it close to her. She could smell his cologne, this Professor Ginzberg, hear his clear, crisp voice—that of a lecturer, distinctive—echoing through the lecture hall; his clear, blue eyes staring at her as he bragged on the strength of her translation of the last sheath of texts. No. It was not just a belt buckle, but a porcelain art nouveau Royal Copenhagen belt buckle, and the thought of such elegance made her smile and proud. Its value, of which she had never asked, didn't rest in monetary value, for precious things from one's past hold their worth in memories, after all. That it was a present, one from Ginzberg, yes, that was its true wealth. Brought to her in her New York apartment, by the only man she had ever loved, he presented the gift to her upon his return from Europe and that day was the happiest of her life. When he told her that he had something to tell her, why, Szold remembered that something had moved

close to her heart. In another moment, Ginzberg announced that he had become engaged, during his travels, to another in Berlin. The following weeks boiled over into dark periods of confusion and hurt. Gradually, a hot anger arose in her, a fury that she tried to hold back, but somehow, couldn't. Her will against such feelings, such disappointment, simply could not be restrained. Szold sunk lower into depression, sleep unobtainable, days seemed like weeks, until later, in November 1908, she wrote, 'it is four weeks since my only real happiness in life was killed by a single word.'

So long ago.

She gave herself a moment, slipped the belt buckle in the drawer, and replaced it with the embroidered velvet sheath on the desk top. From this, Szold removed an olive-wood Purim scroll. It told the story of Esther, the Jewish queen in ancient Persia who saved her people through a heroic act. It was a story that Henrietta had always cherished, encouraged that a woman could change the course of history through her own power and courage. This gift stirred much different emotions and memories than the belt buckle, in that it had been bought as a souvenir during her first visit to Palestine while accompanying her mother in 1909. Henrietta was forty-eight then, a time when she was certain that her life was meaningless.

Yes, a different memory.

One November morning along the Old Jaffa Road, she and her mother wandered upon a group of sick children, a wreath of flies caked in their eyes. When her mother asked the nurse why these children weren't being treated, they were informed that there was no medical assistance available to them.

Then there came that moment—an instant when words are spoken, and life spins off in another direction. Her mother turned to her, 'this is what your group ought to do,' she said. 'You should do practical work in Palestine.' Her mother was referring to Szold's Bible study group back in New York, the nucleus of what would become Hadassah. Szold had always believed that her mother's words were not spoken with true purpose, but that of a loving mother who simply wanted to lead her away from the despair of a lost love. The words had ended up meaning so much more than that—it was an awakening, rather late in life, but a stirring, a birthing of an urgency that remained with Szold throughout her life. Years later, reflecting on how old she was at that time, Szold wrote of this experience: 'It seems to me I have lived not one life, but several, each bearing its own character and insignia.' From that day forward, no matter how much she attempted to deflect its strength, its power over her, no matter the cost to her, her mother's words had bonded her daughter to Palestine.

She looked up, around the room.

How long had she been lost in her thoughts? The sun was up in the sky, a sanguine marble over the hazy, awakening this consecrated land. Szold wrapped the objects in the cloth, walked to the desk drawer, and placed them away. Then, over the next thirty minutes, she went about making her bed, packing a suitcase, and carefully folding several dresses, placing them on the bed.

There was nothing to do now but wait for them.

She sat in her favorite chair; hands crossed in her lap like a schoolgirl. Perhaps one last memory. Yes. Lombard Street. Baltimore. Her father's study, book-lined from floor to ceiling, the lingering smell of furniture polish. Fresh-cut flowers from garden to desk. The second-floor sitting room with the piano. The garden overflowing with fruit trees, overgrown grapevines, bushes burdened with crimson berries, and the constant parade of dogs and cats, and chickens and children. Memories that warmed her.

It was there, in that garden, when spring finally arrived, in a burst of sunlight and colors, after a dark winter, that Szold took her Hebrew and German and French books and sat beneath a tree, and spent a morning reading.

Yes, memories that always quieted her, even on this morning when she was aware that her life was changing once again. Possibly the last chapter. Childhood memories as it should be for all children.

She was ill, and frail, and weary. But even then, as she thought back, she was that little girl once more. The study. The shaded garden.

Yes, she would wait.

And think of Lombard Street.

21

Finally, Rest on the Mountain

The 'house of life is waiting
There on the slope of the hill
Who knows, today, if not tomorrow
Sleep there he will
It is wonderful to be resting
Beneath the radiant sky,
Where the sun sings his song to the mountains,
And the birds pour out their cry
Some morn, from my narrow bestead
Arise I also will
And then I shall sleep in the evening
There... on the slope of the hill.
"On the Slope of The Hill" (*Bemorad Hahar*) Jessie Sampter's last
Hebrew song

After the German defeat at El Alamein, and the Nazi threat to Palestine removed, the British military looked upon any Jewish military activity with a jaundiced view. Zionists leaders, mainly Weizmann, proposed assembling the smaller fighting units into 'a Jewish strike-force.' British headquarters prevented the scheme. But Churchill was in favor of the endeavor, and so it moved forward. 'I like the idea,' Churchill informed the Secretary of State for War on 12 July 1944, 'of the Jews trying to get at the murderers of their fellow countrymen in Central Europe. It is with the Germans that they have their quarrel...I cannot conceive why this martyred race scattered about the world and suffering as no other race had done at this juncture should be denied the satisfaction of having a flag.'[479]

By March 1944, Szold again was sick, this time submitting to a severe attack of dysentery and then gout.

The next week, Dr. Kleeberg, cancelled her trip to Haifa where she was to greet children arriving from Turkey; instead, he sent her to bed in Hadassah Hospital. 'My trouble seems to be exhaustion traceable, in my opinion, to the tra-ra-ram that has been raised round about the religious question,' Szold wrote on the first day of April. 'Today Mr. Beyth goes to Haifa to meet a group of 50 children from Turkey; he will have to decide the religious status of each one of them, and that is my responsibility.'[480]

When her physician Dr. Kleeberg had suggested hospital, she, at first, refused, with the excuse that she couldn't perform her work there. Besides, she stated that she was well aware that there was a shortage of beds. However, as Kleeberg laid out her treatment—special diet, three visits per day from himself, along with injections and medicines, Szold slowly relented. "I see,' she told him, 'You want me to make it easier for you. You want me to say I will go to the hospital. May I work?'[481]

Kleeberg relented. Szold was sent to the Hadassah Hospital on Mount Scopus. The view from her hospital bed was eternal, unchanging—the Dead Sea far away, 'the purple hills of Moab,' and occasionally she was allowed onto the balcony.

'You don't know how it hurts me that I can't see it many more; describe it to me,' she once admitted to another patient, as she listened for birds in the morning air. 'We ought to have a little fountain in the garden so that the birds can come in from the desert and refresh themselves.'

After some weeks, after she had improved, Szold was allowed to return home. Then, a storm blew in with high winds, and it seemed to settle another illness on her frail body. She fought back fever and fatigue. Her health declined each day, aggravated by advancing respiratory problems and worries over the religious and political battles over the children. 'In Jerusalem we are living under curfew regulations,' she wrote on 26 March 1944 of the violence. 'I am told that the havoc wrought by the bombs in Jerusalem, in the heart of the city, is appalling. Private property has been ravaged for blocks. Madmen!'[482]

By the middle of May, Szold was moved to an apartment at the Hadassah Nurses' Training School. Ehrlich and Beyth had continued to visit with her while she was in the hospital, and now at the Training School, Szold had both a Hebrew and an English secretary present for dictation. To the surprise of many, by June, Szold was working a limited workload—in the Youth Aliyah office in the mornings, and, in the afternoons, working at the Training School. Dr. Kleeberg guarded her activities closely, however. 'But, alas, my physician forbids all traveling, whether to Haifa to meet the

new arrivals or the reception places of the groups,' she wrote. 'I am not able to have the heart-to-heart relation with the work as hitherto.'[483]

On 4 June Rome fell to the Allies, and then just two days later, the much-anticipated invasion of Europe commenced on a cold, overcast morning along the Normandy coast. Six weeks later, the Allied armies had driven into southern France. The tide of the long, hard war had finally dramatically shifted. 'I am very glad that Aunt Henrietta is able to hear the glorious war news of these days,' Benjamin wrote on 5 September to Jastrow. 'She can see "the red dawn of the day" and we hope she may be spared to lay her stone among the foundation stones of the new era of peace.'[484]

In September, Bulgaria and Finland surrendered to the sweeping Russian armies. That month also, the Jewish Brigade, a contingent of Jewish military units located in Palestine, joined in with the British Army, as the Russian forces pushed into Finland and Bulgaria. Szold, during that time, returned to the hospital. On 22 September, Szold wrote Benjamin: 'I sit up outside of bed twice a day. I walk—just now I managed three hundred steps (notice "managed'—it's not easy)—and before returning to bed I walk again. I must confess that getting back to bed is like getting home after a tiring journey.'

Szold read her prayers, remaining in bed, for what would be her last *Yom Kippur*, the Jewish Day of Atonement. She also wrote a letter to Bertha, admiring the work of her nurse, a Youth Aliyah child who had lost mother, father, and three brothers in the *Shoah*: 'Yesterday she and my night nurse were graduated from the Nurses Training School, the twenty-fourth class to be sent out by Hadassah,' Szold wrote her sister. 'As a rule, you may remember, I confess the diplomas on the graduates. This year, of all years, the year in which I have had such outstanding opportunity to judge the value of the training…I had to content myself with a written greeting which was read out by Dr. Magnes. The authorities tried to compensate me by arranging to have the procession of the nurses defile past the porch on which I spend my afternoons. It was a charming sight.'[485]

She read the newspapers each day, curious as to how the war was going. Of happenings in Palestine. It did her good to read of the exhilaration in the air after a long five years '... But the fighting situation is still cruel, and the end is not so clearly in sight as it seemed to be a few weeks ago. I should very much like to hear your views on the Jewish Brigade,' she asked Benjamin in a last September letter. 'It goes down in history as a landmark on our steep road to national existence of the accepted kind.'[486]

Once again, Szold was well enough to return to the Nurses' Training School.

Norman Bentwich came to visit, his last call with his friend, the admired head of Youth Aliyah, what he described as 'the greatest work of child rescue in our day.'

'I had my last talk with her,' he later wrote, 'as she lay on her deathbed in the Nurses Home on Scopus, which was also her creation, and bore her name, she spoke with animation of the new and large burden Youth Aliyah must undertake at the end of the war, when the remnant of Jewish children was liberated from Nazi thraldom,' Bentwich wrote. 'She insisted on the need of careful preparation before they were brought to the land. There was no need for hurry. Always order and reason inspired her humanity; always she demanded thorough planning for an emergency. Wendell Willkie appraised his talk with her in Jerusalem on his One World tour in 1941,' he reflected. 'She had more wisdom, he thought, about the problems of Palestine—and of other countries—than all the civil servants and politicians. She initiated an epoch when the Land of Israel should be a model of social conditions, and a Law of Humanity should go forth from Zion.'[487]

On another visit with Magnes, after a hard night of attacks of breathlessness, and 'nightmares in which her sisters and her family had deserted her, Szold asked him, 'Do you realize what a struggle I am having…It is very hard. Can you imagine how hard?'

The last week of July she came down with pneumonia. Szold first went to the hospital and then to the Nurses Home. After doses of penicillin were flown in from Egypt, through efforts of Dr. Magnes and the British military, Szold would become the first civilian patient in Palestine to be treated with the drug. She improved, and was a marvel to those attending her: 'skin white, smooth, and firm, like that of a young woman; muscles good, and, except for the lines on the face, no wrinkle anywhere or other sign of age.' Later, 'Let me think' she would respond to the doctor's question of how she felt, on good days. 'I think my head aches, and my joints, and my fingers a little. Do you want my diagnosis? If you have a medicine against age, give it to me; if not, let me alone.'

One day, during a discussion with the supervisor of nurses, Mrs. Shulamith Cantor, Szold gave instructions: 'When I get well, I will permit nobody to come and lay burdens on me. I will do my work, only my work.'

'Very well, Miss Szold, I promise you that I will not come to bother you.'

'Oh, no, I don't mean you. Certainly, you may come.'

Emma Ehrlich and Hans Beyth visited and gave Szold daily updates on Youth Aliyah activities, though they tried not to approach her with any problems. Dr. Magnes and Dr. Weizmann visited, also. Lord Gort, High

Commissioner, sent word that he was planning a visit to the hospital and would like to see Szold. The nurse told her, 'Lord Gort is a gentleman... he will not object to climbing these stairs to meet you.' Szold then told her, 'If he is gentleman enough to climb the stairs for me, I am lady enough to go down to meet him.'

Their meeting took place in the Great Hall.

Dr. Magnes visited her frequently, and told a friend of one visit with Szold: 'The morning was sunny and her chair was tucked into the one shady corner of the balcony. She suddenly turned to him and announced, unexpectedly, 'I lived a rich life, but not a happy life,' she told him.[488] Magnes, caught off guard, remained silent for a moment and then changed the conversation and mood. 'After fifteen minutes or so of talk, which was very lively on her part, I suggested that it was too sunny and that, since the room was made up, we go in. I approached her, made a mock courteous bow, crooked my arm and said: "May I have this dance with you?" She took my arm, rose from her chair, and shook her finger at me: "You think you are going to get out of this, don't you? I shall show you." She took both my hands and led me about in gentle circles, singing a German ditty...We could hardly get over the brightness of her whole being that sunny morning.'[489]

With the fever and the illness, her mind was filled with thoughts of family. Of worry over her niece who was moving into a new home, and missing her husband who was overseas as a Red Cross worker: '... nothing adds to the twinges of homesickness so much as change of locale.' Of Bertha's two-year old granddaughter playing in her garden: 'I am sure she gambols in the garden at Mount Washington ... and imagine only her fat little legs, moving nimbly about as my matchsticks cannot.'

And then there were the dreams: 'I have been dreaming a great deal, as I haven't dreamed since my youth. There is hardly a night in which I don't have some sort of contact with our mother,' Szold admitted in a letter. 'She isn't always the central figure of the dream, but she is there...It is a nightly experience, this dipping into the past. It is natural because my bed leisure, of which there is a great deal, is filled with pictures of the past. I don't dismiss them, because their place would be taken in vain worry over the work I am neglecting perforce.'

At those times when she felt better, Szold would reawaken to problems in Palestine, and gave thoughts and planning concerning the huge immigration that would take place to Palestine once the war was over. 'I wonder, where you could send me something that could put me on the track of wise planning,' she wrote. 'Don't say it's all a manner of means. It isn't—

that is my experience. Or, I should say, the money will not be withheld if there is wisdom and strength in my purpose.'

As for Bertha, her writing of letters to her sister held of certain events, especially when she learned that she was considered 'a pin-up girl' for some of the soldiers in the Jewish Brigade. She bragged when her hair began to return. 'They say it is coming back. I hope so. I do not want to be a bald-headed hag.' And her constant battle with the doctors and nurses who demanded she rest, and not work. 'It appears I am "contrary"—I don't want sympathy, and thought, and care, and consideration. I want to work!'

There were those moments, when she worked at addressing that more children come to Palestine, yes, even after the war; there were moments of growing weakness; drifting in and out of clear thinking blanketed with fever and chills...

Szold had written to Bertha the month before.

> I need not tell you how much I long to see you. There hasn't been a day since you left me, in 1940, that I haven't cast up the chances of being reunited with you, but never at the expense of your seven grandchildren. After all, you too, like me, are not a young woman. The claims of your family upon you by far supersede mine... I write in direct language, without circumlocution. You will understand from my style that I feel strongly on the subject. I remember well how insistent your children were that you come back from Palestine before doors were closed. But not the memory of their urgence influences my attitude; it is my full acceptance of the rightness of their insistence. The same feeling ought to dominate them, and me along with them, to object to your undertaking the trip to me.[490]

On 26 November Szold would write her last letter, one of hundreds since that winter morning in 1865 when five-year-old Henrietta discovered that her father wasn't yet home, writing him... 'I am so glad my dear Papa...'; Szold wrote on that late evening in 1944, 'I want to add that there is no cause for worry about me ... I feel that I am improving.'[491]

Then there was the day, 27 December, when Dr. Weizmann sent word that he wanted to visit her. At first, she refused; she didn't want him to see her weak and sick. Magnes and Shulamit Cantor finally convinced her, saying that Weizmann was departing for a Zionist meeting in London. Later that day, the two men who had been estranged for many years, Weizmann and Magnes, walked in together, greeted her, and then Magnes stepped out of the bedroom and waited in a sitting room.

'The attitude of the *Yishuv* toward England is very bad,' she said to Weizmann, words of great difficulty. He agreed with her stating that he had always hoped the Jewish state would be birthed beneath the protection of the British mandate. Szold noticed, through the partially opened door, that Magnes was waiting just outside. She motioned over the nurse and asked that she tell him to come in. As Magnes stood by her bed, Szold took his hand. Then, she grasped the hand of Weizmann. She told them how them coming together brought her great joy.

After several moments visiting with Szold, they walked together, moved by the reunion; stopped in the hallway downstairs, both impressed with the words spoken in her hospital room. 'We must never quarrel,'Weizmann said. Magnes, hesitated, then replied, 'No, that seems to be an injunction from on high.'[492]

In late December, Dr. Magnes began chronicling his daily visits and, in an attempt to portray an image of Szold's uplifting spirit, the notes instead painted the 'progress of a great soul moving toward death': 'This morning I visited Miss Szold again…She wanted to [have] the text of the telegram I had sent to Hadassah in order that she might know what her sister Bertha had heard about her,' Magnes explained. 'I said that the text itself could really be of no importance to her, and that we had telegraphed just what the doctors suggested. She said that she would have a long, long road to travel, and would she have the strength to travel it?… She asked about the Hungarian children, and I told her that there were prospects of many thousands being saved… She asked if there had been any meetings of the Hadassah Emergency Council. I said that there had been one on vocational training…She said, "Why must I be so dependent upon everyone?"[493]

In the beginning of 1945, Akiva Lewinsky, a leading member of the Zionist Executive, traveled from Turkey to visit Szold in Jerusalem. Just over forty years later, Lewinsky would be asked to write the preface to her niece's book, a collection of Szold's letters written to family members during the years 1934-1944; a period that was an anxious, pressing time for Youth Aliyah in its rescue of the children.

'Henrietta Szold was ill and her health declining,' Lewinsky wrote. 'I came to visit her in the Hadassah Hospital on Mount Scopus. She was tired and weak, but her mind was clear and alert. Her thoughts centered already on the tasks ahead, the challenges of bringing home the Remnants and making them whole again. She talked about the Jewish communities in Turkey, in Syria and in Iraq, and the dangers they would face with the realization of the Jewish State. She talked about the hard road to peace.

'Henrietta Szold used to weigh every word she uttered. She probed each one for its meaning. Never did she use a word in vain.

'The effort of talking made her breathing heavier. Suddenly she said to me: "I have always wondered about the connection between *neshima* and *neshama*— [the Hebrew words for *breathing* and for *soul*]. Now, I understand."

'Reading the letters in this book [*Henrietta Szold and Youth Aliyah: Family Letters, 1934-1944*], the final meeting came back to me as clearly as dozens of other memories, of her courage, her devotion to life, and her unconquerable soul.'[494]

By February, the tide of battle in the Second World War, had unmistakably turned and the end was in sight. On the island of Mauritius, located in the Indian Ocean, the British had finally ended the internment of Jewish refugees. Several months later, Hadassah medical units were allowed to provide care for the 1,250 refugees interned there. The Jewish Brigade, numbering 22,207 Palestinian Jews, including 2,000 women, fighting under their own Star of David flag, had been transferred to the Italian campaign and fought with the British and other Allied armies.[495]

Nephew Benjamin Levin and his wife, Sarah, visited his aunt, and were encouraged as to how Szold appeared. Benjamin was now in the Jewish Brigade stationed in Egypt. He told her that she was 'a pin-up girl now because the Palestine troops had hung pictures of her in their barracks. The visit gave her something to laugh about; humor was for her 'the quality which harmonizes contrasts, conciliates contradictions, uncovers the likenesses hidden in the antagonisms.'[496]

Within several weeks, weakness lingered without any sign of her regaining her strength. 'A darkness fell over the garden, blanketed the view of the Mount of Olives with its row upon row of etched grave stones,' one writer told of that diminishing time. 'A warm silence fell over her room, disturbed by quiet lingering whispers from those who came to visit, for what they knew would be the last time. It was a recognition that a great, pleasing radiance from one who had given so much for this ancient land, was slowly burning out of that vivid lifetime.'

Emma Ehrlich would write to Bertha, assuring the sister of Szold's love for her: 'Henrietta thought of you and spoke of you always. Either "Bertha" or "Betsy, that dear." No one ever had a more loving sister than you. On that dreadful Thursday, December 14, when the physicians sentenced us to but a few more hours of her presence, she kept murmuring, "Bertha, Bertha." And then she said to me slowly, painfully, word by word gasps, "Tell Bertha I thought of her with my last breath ..."[497]

At last, from beneath a single lamp casting a circle of vague light over the hospital bed, Szold called out for her beloved Betsy to come to her from beyond a vast ocean.

The illness subsided the next morning, and Szold rested comfortably, breathing was an easier effort, her face calm … it was thirty-five years to the day since Szold and her mother had arrived back in New York, welcomed by friends, Szold arriving with a destiny for her future with that one comment by her mother along a crowded Palestine street… 'this is what you should be doing…'

To those who had gathered close, lingering in the hallways and at the room door, doctors told them it wouldn't be long now.

On 13 February 1945, at around 7:40 that afternoon, Szold's breathing slowed, labored with effort. People quietly gathered around her bed. 'Two, three, four times at long intervals a slight breath in the throat, and then that stopped,' Magnes later wrote. 'She was gone. I took her hand for the last time.'[498]

The Baltimore Sun, the next morning, printed the news of her passing as 'the foremost Jewish woman of modern times.'[499]

<p style="text-align:center">✦✦✦</p>

After dawn the next morning, her body was prepared by nurses and Emma, wrapped in the shroud she had prepared, covered by a blue embroidered pall. Then they waited for those who wanted to come and pay their respects.

'The news had spread rapidly over the little country, and thousands came, "from Dan to Beersheba," from the towns and the colonies, though the day was wintry and overcast with gusts of fitful rain,' Fineman wrote. 'All day they climbed Mount Scopus—throngs of men and women, sorrowful and grieving, from all walks of life, her friends and colleagues, her children, some bearing their own children—and silently circled the bier to look upon her for the last time. Her face was gaunt, but beautifully carved by life, the great eyes hooded, as if still brooding upon the need and suffering of others, the mobile lips slightly parted as if still read to utter hopeful and healing words of wisdom.'[500]

Friend and photographer Nachum T. Gidal was also there, and described the mood of the moment: 'Henrietta Szold's mortal remains lie in a hall of the Hadassah Nursing School, on a wooden bier, "close to the ground," as prescribed by Jewish tradition,' he wrote. 'The next morning, Emma and several nurses carried Szold's body downstairs and rested her

in the middle of the room, atop a low platform. She was covered with a curtain of the sacred Torah ark, and eight candles are lit at her head. Thousands have come. Professor Weizmann and his wife stand before her… an endless line of children passes by to pay their last respects to the woman who saved their lives and their souls, when they had almost been lost.'[501]

Arieh Lifshutz, was there also, lingering close by, remembering the first time he had seen Mrs. Szold. It was a fall day in the early 1920s, he and two friends, just young boys, were working on the *kvish* (road) between Afuleh and Nazareth. They lived in tents, 'without beds, without food…' and their work was breaking up the rocks, with chisels and hammers, to shape the roadbed. A man and a woman appeared. The man was a Russian Jew named Pinchas Rutenberg. The woman was Szold dressed in 'heavy sweaters, breeches and thick woolen stockings under boots. She walked across the stony foundation, and began to ask them about their living conditions, the food, their medical needs. Lifshutz remembered that she was the first in Palestine to ask them such questions. Later, Rutenberg delivered shoes for them, purchased from the Egyptian army. Szold secured, for the kvish builders, hospital barracks.

Now, the Hebrew secretary of Youth Aliyah, who had become a master mason, and a worker for Szold, remembered the day of her death: 'With her death a sigh of anguish passed through the world, the hearts of parents and children were filled with sorrow. Because that vitality came to an end,' he wrote, 'that vitality of a tree with roots.

'Crowds flowed to the assembly hall in the nurses' residence bearing her name on Mount Scopus. They came to honor her. They surrounded in silence her minute body, like that of a young girl…covered with a light blue cloth adorned with Hebrew verses, and at her head candles for the departed were placed in silver Sabbath candlesticks. They came from all walks of life, young and old, whispering prayers, reading psalms, crying, silent, they looked at the small body which houses a great spirit. Most orphaned were the children of Youth Aliyah and its graduates, they came and went and were lost, confused. … A girl stood in a corner as if nailed to the spot, her body immobile and tears streaming from her eyes.'[502]

Recha Freier, the woman from Berlin, the poet, the teacher, the writer of children's fairy tales, the visionary of children's survival, came—Szold's longtime adversary—and stood alone in a shadowed corner of the room. She watched over the body for hours.

<p style="text-align:center">✶✶✶</p>

The day was chilled, cold, a wind blew in over the crest of Mount of Olives. From the east, where there were the back grounds of the Hebrew University, and the grounds slants down to the Desert of Judea. The funeral procession, in the thousands, followed the bier, stretching from Hadassah Hospital to the Mount of Olives beneath 'tall roadside cypresses blowing like black plumes.' Nachum Gidal was one of the funeral-goers and described: 'Below, behind medieval walls, rises the city of Jerusalem, and the Dome of the Rock stands out clearly against the stone pavement of the Temple Square. For a few seconds, the sun breaks through the heavy layer of clouds and then disappears again…

'… A rainbow arches across the sky, and Jerusalem glows in the afternoon sun.

'The mourners hurry to the open grave of Henrietta Szold.

'A child from Youth Aliyah, [fifteen-year-old Simon Kresz], recited the prayer that is said at the open grave of a mother.'[503]

The burial crew moved forward to place the body in the grave, finding the 'steep stony ground was wet and slippery with rain, and Hans Beyth, among the pallbearers,' sounded out "Achtung, Achtung!" until the bier rested safely by the grave.

As were her wishes expressed to Emma Ehrlich, there was no eulogy spoken. However, words expressing the forlornness that had overcome Jewry with the passing of other leaders who had passed before her, for whom Szold spoke—Louis D. Brandeis, Menahem Ussischkin—gave that pause of loss: 'Such mourners seem to me to fail to understand that the pessimist Koheleth who tells us that one generation passeth away and another generation cometh,' Szold had assured with her words, 'must have been an optimist, for he ends his sentence with the conclusion that the earth abideth forever. They who refuse to draw strength from his conclusion are of little faith, and they lack full appreciation of the leaders we have had to lose. Because Brandeis and Ussischkin lived and worked among us, leaders will continue to exist, rising from the masses or from the recesses from which Herzl and Brandeis emerged. Leadership will not be lacking. That is the meaning to me of their work, their faith, their vision, their leadership. This audience is the witness.'[504]

The body was lowered into the ground. The earth was then packed around her until the grave was complete. 'They filled the grave and left her there within sight of Mount Nebo where Moses had last looked into this Promised Land' … on the Mount of Olives, the place where Szold gazed upon on those late afternoons, years before, from her apartment window, often awfully homesick…

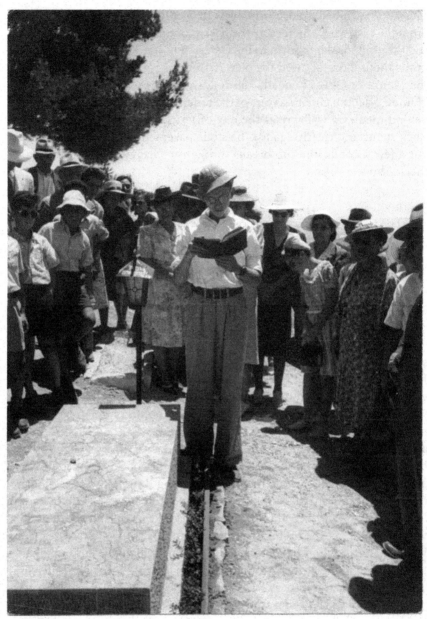

Youth Aliyah Boy Saying Mourner's Kiddish at Henrietta Szold's Grave, 1946.

On her tombstone, simply: 'Here rests Henrietta Szold, daughter of Rabbi Benjamin, *5 Tevet, 5621-1 Adar, 5705.*' [21 December 1860-13 February 1945].

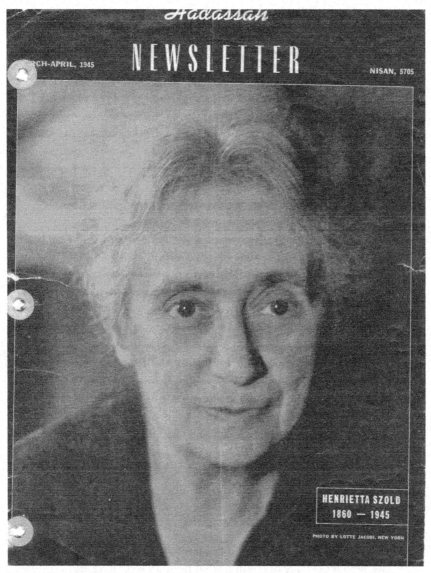

Henrietta Szold, 1945, Hadassah Newsletter March-April, 1945 issue upon her death.

Epilogue

The Light of Israel will become a fire.

<div align="right">Isaiah 10:17</div>

A week after Szold's death, Dr. Magnes spoke at the memorial service:

> If you wish to know what is meant by the ethics of Judaism, search within the conscience of Henrietta Szold. If you wish to gain insight into the Jewish conscience, listen to her voice—a voice inspired by the lightning of Sinai and the Prophets of Israel and by the still, small voice of the traditionally compassionate woman in Israel, who, throughout the generations, hearkens to the weeping of mothers and children.
>
> That thin, frail frame was the embodiment of Jewish morality. Every word that passed her lips was carefully weighed and had its source in an innate purity—even the words spoken in the asperity of argument and the pleasantries of her lighter moods. The motive of her every act was honest and pure, completely without thought of self.
>
> In her parents' home she learned to hold fast to the ancient bonds of Jewish ethical and religious tradition, a tradition containing the often opposing qualities of justice and mercy. Only those endowed with a divine gift have the power of carrying out both precepts together.
>
> Along with her austere obedience to the dictates of the moral law, which delicacy of feeling, what nobility were hers and how great the compassion that enveloped her entire being like a mantle of holiness.
>
> In all the annuals of mankind I know of no greater, more sacred devotion, and in this integrity of purpose she walked all her life… without aspiration to greatness, she was great…She aspired to the sources of true life, and her own life would have been impossible and meaningless without her belief in eternity, in the God of Israel. She

tried, with might and main, with body and soul, to walk humbly with her God.[505]

Later that month, another memorial service was held paying tribute to Szold, this time in New York City's Carnegie Hall. Five scriptures were read from her father's favorite book in the Bible, one he had written a commentary on many years before. Strangely, it personified his daughter's life—from the Book of Job, the twenty-ninth chapter: 'I delivered the poor who cried, and the fatherless who had none to help him. He who was about to perish, blessed me. I caused the widow's heart to sing for joy. Righteousness was my garment and justice my robe. I was eyes to the blind, feet to the lame, a father to those in need. I searched out the cause of those whom I did not know. I dared reach out to the fangs of the wicked and pluck the victims from his grasp...'[506]

Years later, the Jordanians built a road over Szold's grave, desecrating the site and removing the tombstone. The location was lost for nineteen years, but nothing could wipe away Szold's spirit. On 15 February 1968, as former president of Hadassah, Tamar del Sola Pool spoke of her memory, and Rabbi Rakovksy, the Hadassah chaplain, recited a prayer for the dead.

As the Hadassah women cried, two young people laid flowers on Szold's new grave.

Youth Aliyah and Hadassah continued their work after the war, and beyond.

Hadassah, the small Bible study started by Henrietta Szold in New York in 1912, who mostly spent their evenings watching stereopticon slides, has now grown to over 300,000 in memberships and 700 chapters. The Hadassah hospitals are some of the most highly regarded medical centers in the world, leading in research and innovations throughout the medical community.

Youth Aliyah today is still supported by Hadassah and Youth Aliyah villages thrive throughout Israel, where many at-risk youths are nurtured and heal at-risk youth by setting them on a path to a successful future. It is estimated that before the Second World War over 5,000 teenagers were brought to Palestine from Hitler's Europe. After the war, 15,000, mostly Holocaust survivors, came to Palestine. Since 1934, over 300,000 young people in 80 lands have graduated from the Hadassah-supported youth villages.

Recha Freier, after being told that there was no position for her by Henrietta Szold upon arriving in Palestine in March 1941, departed from Youth Aliyah. Later, the desire to teach and improve children's lives still dwelled within, and she founded the Agricultural Training Center for Israeli children. Freier also founded The Israel Composer's Fund, encouraging musical works from local artists.

Freier lived late in life, that shallow bitterness within that her founding of Youth Aliyah, which began in her Berlin apartment, was largely ignored. Though Szold made heartfelt efforts, especially during the late 1930s, recognizing Freier as the original pioneer of the movements, it proved to not be enough. In an effort to heal her wound, in 1975, the eighty-three-year-old writer of children's fairy tales, was acknowledged with the award of an honorary doctorate from the Hebrew University in Jerusalem for her idea of 'organized transport of youth into kibbutzim.' In 1981, she was awarded the Israel Prize for her achievements.

Recha Freier died in Jerusalem on 2 April 1984.

Today, if one visits Jerusalem, and walks along Rahel Imenu in the Katamon neighborhood next to the Germany Colony, until you come upon

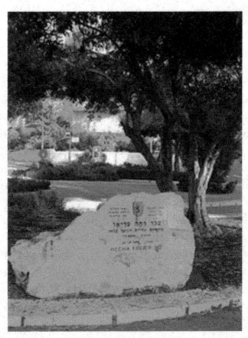

Recha Freier Square in the Katamon neighborhood of Jerusalem, at the intersection of Rachel Imenu and Katamon streets.

Mishmar Ha'am, you are standing at Recha Freier Square. Along Emek Refaim Street, one may choose a coffee shop and read the last words in Freier's book, *Let the Children Come*, as it reveals that Freier did come to realize that Youth Aliyah was larger than either of them…

'A short time after my arrival in Palestine Miss Szold informed me in the name of the Youth Aliyah in Jerusalem that there was no place for me in Youth Aliyah. Thus, my services on behalf of the movement were terminated … yet the movement itself became ever bigger and dealt with tens of thousands of children from all parts of the world, rooting them in the soil of Palestine, in accordance with its destiny.'[507]

Hans Beyth that 'strong, handsome man' who walked into Szold's life one morning in 1934, continued the work of Youth Aliyah for three years after her death.

On 27 December 1947, Beyth was traveling with two members of the Jewish Agency Executive, to welcome children recently released from the Cyprus detention camp. During their return to Jerusalem, the convoy was attacked in which he was traveling through the Judean hills among hostile Arab villages. Golda Meir was in the car following when they were attacked. Beyth drew his revolver and returned fire. He was struck in the head and died instantly.

On 24 November 1942, Stephen Wise had been one of the first Zionist leaders to hold a press conference in Washington D.C. announcing that the Nazi plan, to murder all European Jews, had already killed over two million. To his dismay, the account didn't make the front-page news on any American newspapers. During the Second World War, Wise was elected co-chair of the American Zionist Emergency Council, the forerunner of the American Israeli Public Affairs Committee (AIPAC).

On 19 April 1949, Wise died in New York, and was buried in Westchester Hill Cemetery in Hastings-on-Hudson, New York. He was seventy-five. A street is named after him next to the Israel Museum in Jerusalem.

After the Second World War, Rose Jacobs took a top role in the ESCO Foundation that raised funds for the development of industry in Palestine, and later as Israel.

On 14 August 1975 Rose Gell Jacobs died in New York.

The obituary, published in the *Jewish Telegraphic Agency on* 18 August read: 'Funeral services were held today for Mrs. Rose G. Jacobs, one of the charter members of Hadassah at its founding in 1912 and the Zionist organization's second president after Henrietta Szold. She died Thursday in her home here at the age of 87. Mrs. Jacobs devoted herself to the expansion of Hadassah. From 1920 to 1923 she was acting president; from 1930 to 1932 and again from 1935 to 1937 as president.'[508]

Marian Greenberg was the first national chairman of Youth Aliyah from 1936 to 1941. It is noted that she devoted sixty years, the majority of her life, volunteering her efforts at Hadassah. Between 1931 to 1952, she was national vice president and a Hadassah delegate to five world Zionist Congresses. She served as national chairman of the Hadassah-Hebrew University Medical Building Fund. She retired in Amherst in 1976, and taught Bible courses and modern Jewish thought, sponsored by the University of Massachusetts.

Greenberg died on 24 February 1987, one week before she was to receive the Hadassah Woman of Distinction Award. She was eighty-nine.

Tamar de Sola Pool died on 1 June 1981 after a long life as an author, educator, and a former president of Hadassah.

The obituary printed the next day in *The New York Times* included the following quote: 'with the rise of Nazism, Mrs. De Sola Pool urged that Palestine be viewed as "a practicable and successful haven where Jews may once again remake their national culture and draw together the dispersed segments of Israel."'

She was ninety years old.

Barbara Board wrote as a journalist and broadcaster to occupied Europe and remained in Palestine until late 1946. She died in 1986. After her death,

her daughter, Jacqueline Karp, wrote in the foreword of her book detailing her mother's time in the Middle East, *Reporting from Palestine* in 2007, that she had found in her mother's apartment, 'she had meticulously cleared her small apartment but left everything connected with her truncated writing career stacked under her bed.'

During the last part of her life, Dorothy Kahn Bar-Adon (she married in 1939) she continued to describe life in Palestine, during and after the war. In July 1945 she would interview European refugees arriving in Haifa, among them 242 orphans. Most were Holocaust survivors. Later, she wrote about the events in 1948 that led to Israel becoming a nation and the 1948 Arab-Israeli War. After the war, Bar-Adon, by then an Israeli housewife living in the countryside, wrote of life in the small village.

In July 1950, Bar-Adon became ill and entered the Hadassah Hospital in Jerusalem. Tests revealed that she was suffering from a kidney disease, depicted by uremia, an ailment which at that time was terminal. She died on 7 August 1950 and was buried in a small cemetery outside the village of Merhavia, surrounded by the land she loved and wrote beautifully about.

After the end of the war, Eva Michaelis Stern and her family returned to Palestine where she served as director of the International Relations Department of Youth Aliyah until 1952. After retirement, she founded *Hovevei Yerushalayim*, promoting civic improvement projects in Jerusalem. Remaining active in civic activity, she was involved in the National Association for the Habitation of the Mentally Handicapped, and founded the Clara and William Stern Memorial Fund at the Hebrew University of Jerusalem.

In 1979, on her 75th birthday, Stern was honored by the Israel Ministry of Social Welfare, Dr. Israel Katz, for her contribution of the rescue of Youth Aliyah children. Katz wished, 'her many more years of family happiness and of strength to continue her work which brings relief to so many.'

A contributor to the German-language periodical *Mitteilungsblatt*, in 1989 she wrote a book about her work in England after leaving Berlin, *Emissaries in Wartime London*.

Eva Michaelis Stern died in Jerusalem in 1992.

In Search of Darkness…

Polish survivors, now that the war was finally over, believed that they had survived the worst that had begun for them in 1942; killing camps, gas chambers, working as a slave labor until one dropped from hunger or thirst—then to be shot. Family members were either dead, or forever lost in the fog of war and inhumanity that had consumed their lives for those horrific years.

Now that the war was over, the killing camps liberated and mostly destroyed, all those Jewish refugees wanted was a long-yearned for peace, to return to the safety of their town and homes, and to begin their lives again. They could be assured that they had, somehow, survived the worst. They were wrong, terribly wrong.

On 4 July 1946, in the Polish town of Kielce, in south-central Poland along the banks of the Silnica River, the Holocaust survivors returned. Forty-two Jews were killed that morning, beaten to death by an antisemitic Polish mob. Four were teenagers who were simply passing through on their way to Palestine. Two victims were small children.

Within two days after the heinous event, over five thousand Polish Jews fled west toward Górno, determined to make their way to Palestine, and safety. Thousands would follow in the following months.

This was not the only incident throughout Europe as survivors were released from detention camps, all the while believing that they would return to their homes and begin life again. In a way, they couldn't understand how the darkness could have returned so quickly now that the Nazis were defeated, Hitler dead. How could it have happened so quickly?

Then again, perhaps the darkness had never departed, only lingering

…

Endnotes

Sonata Passionata

1. R. Freier, *Let the Children Come: The Origins of Youth Aliyah* (London: Weidenfeld and Nicolson, 1961), p. 75.
2. Carl Herman Voss, editor, *Stephen S. Wise: Servant of the People*. Philadelphia: The Jewish Publication Society of America, 1969) p. 177.
3. R. Payne, *The Life and Death of Adolf Hitler* (New York: Praeger Publishers, 1973) p. *ix.*
4. A letter to the Dean of Bonn University, January 1, 1937, Thomas Mann, *Briefe 1937-1947*, ed. Erika Mann (Frankfurt am Main, 1963) p. 13.
5. G. Sereny, *Into That Darkness: An Examination of Conscience* (New York: Vintage Books, 1983) p. 149.
6. R. Grigsby, *A Train to Palestine*. Joe Rosenbaum, telephone interview, Oct. 14, 2014; Simon Rosenbaum, 'My Saba.' London: Vallentine Mitchell, 2019. P. 4-5.
7. N. Bentwich, *Jewish Youth Come Home* (London: Victor Gollancz LTD, 1944) p. 50.
8. B. Badt-Strauss, *White Fire: The Life and Works of Jessie Sampter* (New York: The Reconstructionist Press, 1956) p. 129-130.
9. Jesse Sampter, "Anti-Semitism Is War," Opinion: *A Journal of Jewish Life and Letters*, (May 1937):16.

Chapter 1

10. A. Lee Levin, *The Szolds of Lombard Street*. New York: The Jewish Publication Society of America, 1960. pp. 53-54.
11. A. Lee Levin, *The Szolds of Lombard Street: A Baltimore Family: 1859-1909*. Philadelphia: The Jewish Publication Society of America, 1960. P. viii.
12. Louis Lipsky, *Memoirs in Profile*. Philadelphia: Jewish Publication Society of America, 1975. p. 188.
13. Abraham Goldberg, *Pioneers and Builders: Biographical Studies and Essays*. New York: Abraham Goldberg Publication Committee, 1943. pp. 323-327.
14. C. Heilbrun, *Writing A Woman's Life*. New York: W. W. Norton & Co., 1988. p. 48.
15. Rose Zeitlin, *Henrietta Szold: Record of Life*. New York: The Dial Press, 1952. P. iix.
16. H. Szold diary, 1908.
17. I. Fineman, *Woman of Valor*, p. 178-179.
18. *Ibid.*, 184.
19. *Ibid.*, Notes on the visit to Alt-Neu Shul, p. 57-59.
20. M. Lowenthal, *Henrietta Szold: Life and Letters*, p. 64.

21. *Ibid.*, p. 67.
22. *Ibid.*, p. 68.
23. *Ibid.*, p. 67-68.
24. Hani A. Faris, *Journal of Palestine Studies*, Vol. 4, No. 3 (Spring 1975), p. 81.
25. Speech opening a Palestine Exhibition at Basingstoke, 1908, reprinted in *Subjects of the Day*, Earl Curzon of Kedleston, London, 1915.
26. N. Bentwich, *My Seventy-Seven Years*. Philadelphia: Jewish Publication Society, 1961. p. 200.
27. N. Bentwich, *Jewish Youth Comes Home*. London: Victor Gollancz LTD, 1944. p. 49.
28. American Jewish Achieves/ Reviews.
29. I. Fineman, *Woman of Valor*, p. 438.
30. N. Bentwich., *Jewish Youth Comes Home*. p. 44.
31. M. Lowenthal, *Life and Letters*. p. 60.
32. *Ibid.*, p. 56.
33. Tamar de Sola Pool, *Henrietta Szold: Founder of Hadassah*, p. 20.
34. *Henrietta Szold: A Century of Jewish Thought*. Baltimore: Zion Association, 1896. p. 12-13.
35. N. Bentwich, *Jewish Youth Come Home*, p. 48.
36. M. Lowenthal, *Letters*, p. 224.
37. J. Dash, *Summoned*, p. 219-220.
38. In Memoriam Nathan Straus, *Hadassah Newsletter* 11 January 1931.
39. M. Lowenthal, *Letters*, p. 224.
40. I. Fineman, *Woman of Valor*. p. 356.
41. M. Lowenthal, *Life and Letters*. p. 244.
42. M. Greenberg, *There is Hope for Your Children*. New York: Hadassah, The Women's Zionist Organization of America, 1986, p. v.

Chapter 2

43. Marion Sanders, *Dorothy Thompson: A Legend in Her Time*. New York: Avon Books, 1974. p. 168.
44. DT, 'Something Must Happen,' *Saturday Evening Post*, May 23, 1931.
45. *Ibid.*
46. DT, 'Good-by to Germany,' *Harper's*, Dec. 1934. Martha Dodd letter to Thornton Wilder, Wilder papers. December 14, 1933.
47. W. Shirer, *Berlin Diary*. Pg. 16-23.
48. Sir Philip Gibbs, *European Journey*, 229-230.
49. R. Gellately, *The Gestapo and German Society*, p. 129.
50. DT speech, 'The Developments of Our Times,' 1948, John B. Stetson University, Deland, Florida, a part of the Merrill Lectures. Published 1948 by the University Press, Deland.
51. E. Mowrer, *Triumph and Turmoil*. New York: Weybright and Talley, 1968. P. 226.
52. Q. Reynolds, *By Quentin Reynolds* (New York: McGraw-Hill, 1963) p. 309.

Chapter 3

53. R. Freier, *Let the Children Come: The Origins of Youth Aliyah*. Translated from the Hebrew (London: Weidenfeld and Nicolson, 1961) p. 9.

54. M. Levin, *It Takes A Dream* (Jerusalem: Gefen Publishing House, 2002) p. 134.
55. N. Bentwich, *Jewish Youth Comes Home*, 1944. P.39-43.
56. R. Freier, *Let the Children Come*. P. 9.
57. R. Freier, *Let the Children Come*. P. 8.
58. M. Levin, *It Takes A Dream* (Jerusalem: Gefen Publishing, 2002) p. 134.
59. Strauss, "Emigration," 1, p. 316-317; *Between Dignity and Despair*, p. 10.
60. J. Dash. Interview with Recha Freier, Jerusalem, 1975.
61. K. Stern, *Pillar of Fire* (New York, 1951), p. 66.
62. M. Levin, *It Takes A Dream*, p. 135.
63. R. Freier, *Let the Children Come*, p. 14-15.
64. *Ibid.*, p. 15.
65. *Ibid.*, p. 16.
66. N. Shepherd, *A Refuge from Darkness: Wilfrid Israel and the Rescue of The Jews* (New York: Pantheon, 1984).
67. M. Levin, *It Takes a Dream*, p. 136.
68. David Ben-Gurion: diary entry.
69. Franz and Ruth Ollendorf memories of the train station first published in *Let the Children Come*, p. 94-96. Later published in *The Lost Generation*, Azriel Eisenberg, 1982, p.26-27.
70. R. Freier, *Let the Children Come*, p. 17.

Chapter 4

71. I. Fineman, *Woman of Valor*, personal observation, p. 356.
72. J. Dash, *Summoned*, p. 224.
73. *Ibid.*, p. 224.
74. R. Zeitlin, *Record of A Life*, p. 84.
75. M. Lowenthal, *Life and Letters*, p. 227.
76. Israeli Labor Party Archive, file no. 2-1931-23; David Ben-Gurion at Mapai central committee meeting, 23 March 1931.
77. M. Lowenthal, *Life and Letters*, p. 231-232.
78. *Ibid.*, p. 232.
79. *Ibid.*, pg. 232-233.
80. Joan Dash interview with Sylva Gelber, London, 1974.
81. Joan Dash interview with Shulamith Cantor, *Summoned* p. 224.
82. I. Fineman, *Woman of Valor*, p. 357.
83. Dorothy Ruth Kahn, *Spring Up, O Well* (New York: Henry Holt and Company, 1936) pp. 159-160.
84. M. Lowenthal, *Life and Letters*. p. 232.
85. *Ibid.*, p. 225.
86. Description of the Dr. Kagan home, J. Dash, *Summoned*, p. 147.
87. *Life and Letters*. July 23, 1909, p. 62.
88. Sladowsky, Marilyn, J. "Alice Lillie Seligsberg." *Jewish Women: A Comprehensive Historical Encyclopedia*. 20 March. 2009. Jewish Women's Archive.
89. Joan Dash interview with Helena Kagan, Jerusalem, 1974.
90. "The Legacy of Henrietta Szold". *Commentary Magazine*, 2015.
91. J. Dash, *Summoned*, p. 154.
92. Joan Dash interview with Jonathan Magnes, Jerusalem, 1975.

93. Joan Dash interview with Leah Becker, Jerusalem, 1975.
94. J. Dash, *Summoned*, personal description, p. 154
95. *Ibid.*, p. 156.
96. M. Lowenthal, *Life and Letters*, p. 6.
97. H. Szold letter to Bertha, August 1905, The Exhibit Text, Barry Kessler, p. 61.
98. R. Zeitlin, *Record of Life*, p. 6.

Chapter 5

99. I. Fineman, *Woman of Valor*, p. 366.
100. *Ibid.*, p. 363-364.
101. R. Freier, *Let the Children Come*, p.2-21.
102. L. Mowrer, *Journalist's Wife*, p. 258.
103. From a speech given 31 January 1933, titled "Die Wege der Jüdische Jugend."
104. John Toland, *Adolf Hitler: Volume 1*(Garden City: Doubleday & Co. 1976) p. 306.
105. W. Shirer, *The Rise and Fall of the Third Reich* (New York: Simon & Schuster, 1960) p. 5.
106. "Hitler is Chancellor of Germany," *Haaretz*, 31 January 1933, p. 1.
107. *Haaretz*, 8 February 1933, p. 1.
108. B.K., "What Time Will Do," *Haaretz*, 8 March 1933.
109. *Doar Hayom*, editorial, 1. February 1933, p. 1.

Chapter 6

110. Tom Segev, *The Seventh Million*, p. 15; "The Red Flag was Lowered from Atop the German Consulate in Jerusalem," *Hazit Haam*, 2 June 1933, p. 1
111. R. Freier, *Let the Children Come*, p. 27.
112. *Ibid.*, p. 30-31.
113. Szold to Arthur Biram and Ernest Simon, 17 June 1932. CZA, S 256/2.
114. Joan Dash interview with Freier.
115. *Davar*, May 4 issue; reprinted as "Hatza'ah, in *Sefer Aliyat Ha-No'ar*.
116. *Ibid.*, p. 31.
117. Khali al-Sakakini, *Such Am I, O World* (Hebrew) (Jerusalem: Keter, 1990). P. 167.
118. C.G. Eastwood (Private Secretary to General Sir Arthur Wauchope, High Commissioner), Diary, 4 April 1933. Mss. Brit. Emp. S 509, I/IA RH.
119. B. Tuchman, *Bible and Sword*, p. xvi.
120. Israel Cohen, *The Zionist Movement* (New York: Zionist Organization f America, 1946) p. 51.
121. Gabriel Barkai, "The Archaeological Remains in the Area of the Gobat School: [in Hebrew] in *The Old City of Jerusalem*, ed. Eli Schiller and Gideon Biger (Jerusalem: Ariel, 1988) p. 152ff.
122. R. Freier, *Let the Children Come*, p. 32.
123. I. Fineman, *Woman of Valor*, p. 369.
124. *Ibid.*, p. 369.
125. J. Dash, *Summoned to Jerusalem*, p. 237.
126. M. Lowenthal, *Life and Letters*, p. 253.

127. I. Fineman, *Woman of Valor*, p. 370
128. Carl Hermann Voss, editor of Selected Letters, *Stephen S. Wise: Servant of the People* (Philadelphia: The Jewish Publication Society of America, 1969) p. 189-190.
129. Dorothy Ruth Kahn, *Spring Up, O Well* (New York: Henry Holt and Company, 1936) p. 96-97.
130. R. Zeitlin, *Record of A Life*, p. 243.

Chapter 7

131. M. Lowenthal, *Life and Letters*, p. 248.
132. J. Dash, *Summoned*, p. 238.
133. *Ibid.*, p. 238.
134. M. Lowenthal, *Life and Letters*, p. 252-253.
135. D. Kahn, *Spring up, O' Well*, p. 17.
136. M. Lowenthal, *Life and Letters*, p. 248.
137. *Ibid.*, p. 248-249.
138. *Ibid.*, p. 249.
139. *Ibid.*, p. 249.
140. *Ibid.*, p. 249-250.
141. *Ibid.*, p. 254.
142. *Ibid.*, p. 255.
143. J. Dash, *Summoned* p. 238: Lowenthal interview with HS.

Chapter 8

144. I. Fineman, *Woman of Valor*. The author's description of Berlin, 1933. Pp. 370-371.
145. M. Lowenthal, *Life and Letters*, p. 256-257.
146. *Ibid.*, p. 257.
147. *Ibid.*, p. 257-258.
148. *Ibid.*, p. 257.
149. Oliver Lubrich, editor. *Travels in the Reich, 1933-1945: Foreign Authors Report from Germany* (Chicago: The University of Chicago Press, 2004), p.28.
150. *Ibid.*, p. 29,31.
151. L. Mowrer, *Journalist's Wife*, p. 187.
152. J. Dash, *Summoned*, p. 239.
153. N. Bentwich, *Jewish Children Come Home*, p. 49.
154. *Ibid.*, p. 240.
155. Eric Johnson, Karl-Heinz Reuband, *What We Knew: Terror, Mass Murder, and Everyday Life in Nazi Germany* (Cambridge, MA: Perseus Book Group, 2005) William Benson, "Never to Forget, Never to Forgive" p. 3-4.
156. Hanna Bergas experience: M. Kaplan, Between Dignity and Despair, p. 25.
157. M. Lowenthal, *Life and Letters*, p. 257.
158. N. Gidal, Woman *Henrietta Szold: The Saga of an American Woman*. P. 11.
159. Story of Ruppin's sickness in Jaffa, J. Dash *Summoned*, p.89.
160. J. Dash, *Summoned*, p. 242.
161. *Ibid.*, p. 242.

162. *Ibid.*, p. 242,
163. M. Lowenthal, *Life and Letters*, p. 258-259.
164. *Ibid.*, p. 259.
165. I. Fineman, *Woman of Valor*. Author's description of Szold at Ain Harod, p. 371.
166. *Ibid.*, p. 419.

Chapter 9

167. From *Youth Aliyah Letters* by Henrietta Szold. Collected by Zena Harman, Bulletin No. 2, 25 February 1934.
168. M. Lowenthal, *Life and Letters*, p. 264-265.
169. J. Dash, *Summoned*, description of children's clothing, p. 244.
170. Chasya Pincus, *Come from the Four Winds: The Story of Youth 'Aliya* (New York: Herzl Press, 1970) p. 19-20; Quoted in report of the World Conference of Youth 'Aliya, Jerusalem, 1964.
171. *Ibid.*, p. 20.
172. Ben-Gurion, *Memoirs*, vol. 111, pp. 24,28, 41, 64, 85.
173. *Ibid.*, vol. V, p. 398.
174. *Ibid.*, p. 402ff.
175. Dorothy Kahn. From an unpublished manuscript, 1935.
176. I. Fineman, *Woman of Valor*, p. 372.
177. J. Dash, *Summoned*, p. 244.
178. *Youth Aliyah Letters*, Henrietta Szold, collected by Zena Harman, Bulletin No. 2, 25 February, 1934.
179. J. Dash, *Summoned*, p. 244.
180. I. Fineman, *Woman of Valor*, p. 373.
181. Alexandra Levin, edited by, *Henrietta Szold and Youth Aliyah: Family Letters 1934-1944* (New York: Herzl Press, 1986) p. 2.
182. A. Levin, *Henrietta Szold and Youth Aliyah*, p. 2.
183. D. Kahn, *Spring Up, O Well*, p. 266-267.
184. *Ibid.*, p. 181.
185. I. Fineman, *Woman of Valor*, p. 374.
186. J. Dash, *Summoned*, p. 244.
187. J. Dash, interview, Jerusalem, 1975.
188. R. Zeitlin, *Record of Life*, p. 58.
189. Account of Mendelson in Palestine: Adina Hoffman, *Till We Have Built Jerusalem*, p. 15: M. Levin, *It Takes a Dream*, p. 176.
190. W. Shirer, *Berlin Diary*, p. 14-15.

Chapter 10

191. J. Dash, *Summoned*, p. 249.
192. *Ibid.*, p. 248-249.
193. Barbara Board, *Newsgirl in Palestine*. (London: Michael Joseph LTD, 1937) p. 35.
194. I. Fineman, *Woman of Valor*, p. 375.

195. T. Segev, *One Palestine, Complete*, p. 369 as a footnote; Ya'akov Solomon to the Royal Commission, 4 November 1936, CZA S25/4675.
196. Marlin Levin, *Balm in Gilead* (New York: Schocken Books, 1973) p. 151.
197. *Ibid.*, p. 151.
198. Writer Marlin Levin's personal observation, *Balm in Gilead*, p. 151.
199. M. Lowenthal, *Life and Letters*, p. 272-273.
200. A. Levin, *Henrietta Szold and Youth Aliyah*, p. 3.
201. *Life and Letters*, p. 278.
202. *Henrietta Szold and Youth Aliyah*, p. 4.
203. M. Greenberg, *There is Hope*, p. 9.
204. *Ibid.*, p.4.
205. *Ibid.*, p. 4.
206. *Ibid.*, p. 5.
207. J. Dash, *Summoned*, p. 250.
208. I. Fineman, *Life and Letters*, p. 279.
209. Szold letter to her sisters, May 1, 1936. CZA, A125/265.
210. J. Dash, personal entry, p. 259-260.
211. J. Dash, *Summoned*, p. 246.
212. Lotte Steigbügl interview, Haifa, 1975.
213. Marvin Lowenthal interview with Emma Ehrlich.
214. Joan Dash interview with Lotte Beyth, Jerusalem, 1975.
215. I. Fineman, *Woman of Valor*, p. 376.
216. *Ibid.* p. 363.
217. Levin et al., 'MS Notes on HS.'
218. Emma Ehrlich, typescript, 'Notes on Impressions,' March 1941, CZA.
219. I. Fineman, *Woman of Valor*, p. 363-364.
220. *Life and Letters*, p. 279-280.
221. *Ibid.*, p. 280.
222. J. Dash, *Summoned*, p. 251.
223. I. Fineman, *Woman of Valor*, p. 376.
224. J. Dash. Lotte Beyth interview.
225. J. Dash. observation and writing, *Summoned*, p. 260.
226. A. Hoffman, *Till We Build Jerusalem*. P. 135. A. Harrison description from his notebook, "The Dome of the Rock," *The Sphinx*, 1946.

Chapter 11

227. Jessie Sampter, *White Fire*, p. 133.
228. D. Kahn, *Spring Up, O Well*, p. 254-255.
229. *Life and Letters*, p. 281.
230. *Founder*, p. 28.
231. *Ibid.*, p. 28.
232. J. Dash, *Summoned* p. 253-254; HS at the Lucerne Congress: *See Protocol of the 19th Zionist Congress*, CZA A125/94.
233. *Founder*, p. 28.
234. HS to Lola Hahn-Warburg, 14 September 1936, CZA A125/94.

235. *Life and Letters*, p. 282-283.
236. Rose Jacobs, "Looking Ahead," *Hadassah News Letter*, November 1935, p. 6-7. Jacobs served two terms as national president: 1930-1932 and 1934-1937.
237. *Ibid.*, p. 283.
238. *HS and Youth Aliyah*, p. 5.
239. From unpublished manuscript from Bar-Adon's personal archive, *Writing Palestine*, p. 80
240. J. Dash, *Summoned*, p. 254.
241. *Life and Letters*, p. 284.
242. I. Fineman, *Woman of Valor*, p.377.
243. *HS and Youth Aliyah*, p. 6
244. Documents on Miss Szold's speech, contained in CZA A125/83.
245. J. Dash, *Summoned*, p. 256; A series of interviews by the author with Eva Stern Michaelis, Jerusalem, 1975.
246. Background information was collected from a questionnaire filled out by Eva Michaelis- Stern, CZA A440/Box 7; also, ICJOHP interview.
247. *Ibid.*, p. 257; Interview with Franz Ollendorff, Haifa, 1975.
248. *Ibid.*, p. 257; Interview with Eva Stern Michaelis, Jerusalem, 1975.
249. M. Kaplan, *Between Dignity and Despair*, p. 57 League in Edinger Letter in the Schoenewald coll., LBI, IV, 1 and *BJFB*, Oct. 1935.
250. *Ibid.*, p. 58; Becker-Kohen, LBI, p. 4.
251. M. Kaplan, *Between Dignity and Despair*, p. 62.
252. *Ibid.*, p. 67.
253. *Life and Letters*, p. 284.
254. I. Fineman, *Woman of Valor*, p. 379.
255. *Ibid.*, p. 285.
256. D. Kahn, *Writing Palestine*, p. 82.
257. W. Shirer, *The Midnight Years*, p. 123.
258. *Life and Letters*, p. 287-288.

Chapter 12

259. *Life and Letters*, p. 290.
260. *HS and Youth Aliyah*, p. 6-7.
261. *Ibid.*, p. 7.
262. *Ibid.*, p. 7.
263. *Ibid.*, p. 7.
264. *Life and Letters*, p. 291.
265. *Ibid.*, p. 291.
266. HS "News Reel Speech," December 1935. RG7/HS/Sub-series 6, HWZDA.
267. Joan Dash interviews with Tamar de Sola Pool and Marian Greenberg detailing HS visit to America, New York, 1975.
268. I. Fineman, *Woman of Valor*, p. 379-380.
269. J. Dash, *Summoned*, p. 259; CZAA125/83.
270. I. Fineman, *Woman of Valor*, p. 381.
271. T. Segev, *One Palestine, Complete*, p. 378. Kisch to the high commissioner, 25 August 1933, CZA S25/16; Ben-Gurion and Sharett to the high commissioner, 20 Oct. 1933,

CZA S25/2596; Sharett with the chief secretary, 0 Nov. 1934, CZA s25/2441, CZA S25/2651; Dalia Ofer, *Way Through the Sea* (Jerusalem: Yikzhak Ben-Zvi, 1988) p. 474.

272. B. Board, *Newsgirl in Palestine*, p. 5.
273. D. Kahn, *Writing Palestine*, p. 85.
274. J. Dash, *Summoned*, p. 262.
275. *Ibid.*, p. 262.
276. *Daughter of Zion*, Letter to Harry Friedenwald, September 1936.
277. *Life and Letters*, p. 307.
278. *Summoned*, p. 263.
279. *Woman of Valor*, p. 383.
280. *Life and Letters*, p. 307.
281. *Ibid.*, p. 312.
282. Irving Fineman observation of violence, *Woman of Valor*, p. 324.
283. *Woman of Valor*, p. 324.
284. *Ibid.*, p. 324-326.
285. *HS & Youth Aliyah*, p. 26.
286. W. Shirer, *Berlin Diary*, p. 65.
287. Berlin, summer 1936; Anthony Read, David Fisher, *The Fall of Berlin*, p. 3-16.
288. Marianne MacKinnon, *The Naked Years: Growing Up in Nazi Germany*, p. 38.
289. *Berlin Diary*, p. 65-67.
290. *The Fall of Berlin*, p. 11-12.
291. *Travels in the Reich, 1933-1945*, p.131; quoted from Thomas Wolfe, *I Have A Thing to Tell You*, 1937.

Chapter 13

292. *Travels in the Reich*, Observations by editor Oliver Lubrich, concerning and contributed to author Theo Findahl, p. 17.
293. CZA A125/30.
294. Szold letter to Magnes; October 10, 1937, CZAA125/30.
295. R. Freier, *Let the Children Come*, Appendix One, p. 79.
296. Marian Greenberg, *There is Hope for Your Children*, p. 23.
297. *Life and Letters*, p. 327.
298. Simon Noveck, ed. *Henrietta Szold: 1860-1945*, Tamar de Sola Pool; from Great Jewish Personalities in Modern Times: (Washington, D.C.: B'nai B'rith Dept. of Adult Jewish Education, 1960), p. 27-28.
299. *Founder*, p. 28.
300. Quotes are the observations of Irving Fineman, *Woman of Valor*, p. 390.
301. J. Dash, *Summoned*, pp. 266-267.
302. *Ibid.*, 'definite warnings': CZA N file, 13 April 1938.
303. M. Kaplan, *Between Dignity and Despair*, p. 71.
304. Bella Fromm, *Blood & Banquets*, p. 227.
305. *Ibid.*, p. 197; "parents" in Marks, LBI, p.8.
306. Nachum T. Gidal, *Henrietta Szold: The Saga of An American Woman*, p. 31.

Chapter 14

307. Bernard Lewis, "The New Anti-Semitism." *American Scholar*. Vol. 75. Issue 1: Winter 2006. p.32.
308. Raoul Aglion, *The Fighting French*. New York, 1943. Cited by Stephen Wild. "National Socialism in the Arab Near East Between 1933 and 1939." *Die Welt des Islams*, Brill: 1985. p. 217.
309. A. Kershaw, *The Envoy*, p. 17.
310. Barbara Tuchman, *Practicing History: Select Essays*. (New York: Alfred A. Knopf, 1981) p. 120.
311. *Ibid.*, p. 121.
312. Political theorist Hannah Arendt, sister-in-law of Eva Stern, 1961; "evil acts are not necessarily perpetrated by evil people—simply the result of bureaucrats dutifully obeying orders."
313. David Cesarini, *Becoming Eichmann: Rethinking the Life, Crimes, and Trial of a "Desk Murderer."* (Cambridge, MA: Da Capo Press, 2004) p. 54.
314. Emerson Vermaat, July 5, 2011.
315. *Ibid.*
316. *Woman of Valor*, p. 390.
317. *Life and Letters*, p. 328.
318. *Henrietta Szold and Youth Aliyah*, p. 28.
319. Gerald M. Lady, ed. *D.H. Lawrence, Letters to Thomas and Adele Seltzer* (Santa Barbara, CA, 1976) p. 179.
320. *Life and Letters*, p. 329.
321. I. Fineman, *Woman of Valor*, p. 329.
322. *Woman of Valor*, p. 391.
323. *Summoned*, p. 268.
324. *HS & Youth Aliyah*, p. 29.
325. CZA N file, 13 April 1938.
326. Joan Dash, Eva Stern Michaelis interviews.
327. *Life and Letters*, p. 329-330.
328. *HS & Youth Aliyah*, P.29.
329. Dorothy Kahn, 1937; an article from personal archive.
330. *Life and Letters*, p. 331.
331. HS to Marian Greenberg, 2 June 1938, CZA S75/536.
332. Sykes's account of the Evian conference, *Crossroads to Israel*, p. 22.
333. *Summoned*, p. 272; Shulamit Cantor interview.
334. *The New York Times*, June 1938.
335. M. Greenberg, *There is Hope*, p. 35.
336. Joan Dash, Lotte Beyth interview.
337. *HS & YA*, p. 30.
338. *Life and Letters*, p. 331-332.
339. *Ibid.*, p. 326.
340. *White Fire*, p. 152-153.
341. *Life and Letters*, p. 332-333.
342. Barbara Board, *Newsgirl in Palestine*. (London: Michael Joseph, LTD., 1937) p. 5
343. *Newsgirl in Palestine*. Chapter VII. The Szold interview, p. 156-164; visit to Hadassah institutes, p. 164-169.

344. Julia A. Dushkin, wrote an account of the funeral "Farewell to Jessie Sampter," *Hadassah Magazine*, January 1939; HS to Mrs. Wackenheim, 10 December 1938, CZA.

345. Bertha Badt-Strauss description of HS speaking at Beth Hatarbuth; *White Fire, p. 158.*

Chapter 15

346. *Life and Letters*, p. 333.
347. I. Fineman personal observation, *Woman of Valor*, p. 392.
348. *Woman of Valor*, 392-393.
349. Notes on the sister's visit are included in Joan Dash, *Summoned*, pp. 273-275.
350. *HS & YA*, p. 34-35.
351. *Ibid.*, p, 35-36.
352. Joan Dash, observation, p. 278.
353. Joan Dash, Kegan interview.
354. *HS & YA*, p. 37.
355. *Ibid.*, p. 38.
356. *Woman of Valor, 394.*
357. *Ibid.*, p. 395.
358. *Record of a Life*, p. 213.
359. I. Fineman, observation, *Woman of Valor*, p. 393.
360. Dorothy Thompson's event: *New York Times*, 25 January 1939.
361. Events unfolding that last day between Stern and Berlin, detailed in *Summoned*, pp. 279-281.
362. Joan Dash, *Summoned p.279-281*: the first days of the war at London Youth Aliyah office, detailed in Eva Stern's unpublished diary—25 August to 7 September.
363. Notes on the August 1939 meeting: M. Levin, *Balm in Gilead*, p. 164-165.

Chapter 16

364. *Woman of Valor*, I. Fineman observations, p. 400.
365. Nachum T. Gidal, *Henrietta Szold: A Documentation in Photos and Texts* (Jerusalem: Gefen Publishing House, 1996, p. 112.
366. HS "The New Year of Trees," 1903 CZA, A125/268.
367. *Life and Letters*, p. 84-88, quote from p. 81; HS to Mrs. Julius Rosenwald, 17 January 1915.
368. W. Shirer, *Berlin Diary*, p. 198-199.
369. S. Gorlik, "The Good Soldier and the Enlistment Poster," *Haaretz*, 13 September 1939, p. 2.
370. R. Freier, *Let the Children Come*, p. 64.
371. *Palestine Post*, September 4, 1939: Sykes (1965), p. 246.
372. *HS & YA*, p. 49.
373. *Life and Letters*, p. 334-335.
374. *HS & YA*, p. 49-50.
375. Anita Shapira, *Yigal Allon, Native Son: A Biography* (Philadelphia: University of Pennsylvania Press, 2008) p.105; *Berl* (Tel Aviv, 1980) p. 643.

376. Eric Seal, Churchill's Principal Private Secretary, note: 23 May 1940: Premier Papers 3/348.
377. Joan Dash, observations, *Summoned*, p. 288-289.
378. R. Freier, *Let the Children Come*, p. 64.
379. *Summoned*, p. 389.
380. Joan Dash, Steigbügl interview.
381. Joan Dash, interviews with Simon and Rinott.
382. Joan Dash, interview with Shalhevet Freier.
383. *Summoned*, p. 291; Joan Dash interview with Recha Freier.
384. R. Freier, *Let the Children Come*, p. 75.
385. *Ibid.*, p. 50.
386. *Life and Letters*, p. 335-336.
387. Szold learning of Adele's death; Joan Dash interview with Lotte Beyth.
388. *HS & YA.* p. 51.
389. *Summoned*, p. 285.
390. *Record of Life*, p. 200.
391. *Woman of Valor*, p. 401.
392. On the explosion: Sykes, *Crossroads*, p. 269-270.
393. *Encyclopedia Judaica* (Jerusalem: Keter Publishing House 1971), Vol. 13, p. 181.
394. *HS & YA*, p. 52.
395. *Ibid.*, p. 53.

Chapter 17

396. *Summoned*, Joan Dash p. 283.
397. *Summoned*, p. 283-284; Joan Dash interview with Arieh Lifshutz.
398. *HS & YA*, p. 53.
399. *Life and Letters*, p. 337.
400. *Ibid.*, p. 53; Kathleen McLaughlin, *The New York Times Magazine*, 15 December 1940.
401. I. Fineman, *Woman of Valor*, observations, p. 404.
402. Barbara Sofer, "Letter from Mount of Olives: Keeping a Promise," *Hadassah Magazine*, August/Sept. 2012.
403. *Ibid.*, p. 404-405.
404. *HS & YA*, p. 56.
405. *Life and Letters*, 31 January 1941, p. 337.
406. M. Gilbert, *Churchill: A Life*, p. 704.
407. *Ibid.*, p. 57-58.
408. *Ibid.*, p. 58.
409. *Woman of Valor*, p. 407.
410. *Ibid.*, p. 340-341.
411. *Ibid.*, p. 58.
412. *Summoned*, p. 407.
413. *HS & YA*, p. 59.
414. *Life and Letters*, p. 342-343.
415. *Summoned*, p. 294-295.
416. *Ibid.*, p. 294.

417. *Woman of Valor*, p. 402-403.
418. *Ibid.*, p. 408.
419. *Life and Letters*, p. 343-344.

Chapter 18

420. 2 plays: "The Dance of Death," part one; "The Dance of Death" part two, written in 1900
421. *HS & YA*, p. 59-60.
422. Mark Roseman, *The Wannsee Conference and the Final Solution: A Reconsideration* (New York: Picador,2002) p. 157-162.
423. *Goebbels's Diary.*
424. Max Domarus, ed. *Hitler: Speeches and Proclamations 1932-1945: The Chronicle of a Dictatorship* (4 Volumes, London, 1990) 30 January 1942.
425. R. Evans, *The Third Reich at War*, p. 258; Quoted in Klee et al. (eds.) *Those Were the Days*, p. 72-74.
426. *HS & YA*, p. 61.
427. *Ibid.*, p. 60.
428. *Ibid.*, p. 61
429. *Ibid.*, p. 62.
430. *Ibid.*, p. 62.
431. *Woman of Valor*, p. 417.
432. *Ibid.*, p. 417.
433. *Summoned*, Joan Dash observation, p. 295.
434. *Ibid.*, p. 295-296.
435. *Woman of Valor*, p. 411-412.
436. *Ibid.*, p. 410.
437. *Ibid.*, p. 411.
438. Laqueur, *History of Zionism*, p. 377 and Sykes, *Crossroads to Israel*, p. 294.
439. HS to Landauer, Jerusalem, 28 January 1942, RG 11B 2F/8, HW-ZOA; J. Dash, *Summoned*, p. 312.
440. *Woman of Valor*, p. 408-409.
441. Records of the JAE, Central Zionist Archives, Jerusalem, Nov. 22, 1942.
442. Deborah Lipstadt, *Beyond Belief* (New York: Free Press, 1993) p. 181.
443. DBG to M. Cohen, 23 November 1942; S. Teveth, *Ben-Gurion: The Burning Ground*, p. 846.
444. M. Greenberg, *There is Hope*, pp. 74-75.
445. Meeting of Willkie and Szold detailed, *Woman of Valor*, p. 413-415.
446. Additional information on the meeting: R. Zeitlin, *Record of A Life*, pp. 139-140.

Chapter 19

447. Private Oskar Gröning served at Auschwitz; BBC interview, January 2005, "Auschwitz: Inside the Nazi State: Factories of Death," Episode 3 "Factories of Death."
448. *Woman of Valor*, p. 420.
449. *HS & YA*, p. 69-70.

450. *Woman of Valor*, November 1942, p. 418-419.
451. *HS Saga*, p. 57.
452. *HS &YA*, p. 66.
453. C. Pincus. *Come from the Four Winds*, p. 85.
454. Shertok's report to Jerusalem: CZA, Archive of the Youth Aliyah Department, Jerusalem: File No. S75/4852. Sourced from D. Bader Whitman, *Escape via Siberia*.
455. *HS& YA*. p. 66.
456. *Ibid*. p. 67.
457. Negotiations in Washington: R. Grigsby, *A Train to Palestine*, chapters 16-17
458. *HS & YA*. p. 67.
459. Camping at the Wells of Moses: N. Bentwich, *Jewish Youth Come Home*, p. 107.
460. J. Dash, *Summoned*, p. 301.
461. *HS &YA*. p. 68.
462. *Summoned*, p. 306.
463. *Ibid*. p. 306.
464. *Record of Life*, p. 167.
465. *Woman of Valor*, p. 422.
466. Irving Fineman, personal observation, p. 422.
467. *Woman of Valor*, p. 422-423.
468. HS & YA. p. 68.
469. *Ibid.*, p. 70.
470. *Ibid.*, p. 70-71.
471. *Ibid.*, p. 71.
472. *Ibid.*, p. 71.
473. *Ibid.*, p. 72.
474. *Ibid.*, p. 73.
475. *Ibid.*, p. 73.
476. *Ibid.*, p. 73-74.
477. *Ibid.*, p. 74-75.

Chapter 20

478. This chapter is based on selected research on Henrietta Szold's eventful life; Making use of these notes collected during the writing of her life from 1933-1945, this gave me the opportunity, without disrupting the narrative of that story, to create a story within—on that day she truly admitted to herself how ill she was. Drawing on a unique writing technique, '*a priori imagination*,' that of basing scene on deduction (from letters and diary entries) rather than observation. It is a method utilized effectively by Dan Porat in his book, *The Boy: A Holocaust Story*.

Chapter 21

479. Monty Noam Penkower, *The Jews were Expendable: Free World Diplomacy and the Holocaust* (Chicago, 1983); Churchill to Sir Edward Grigg, 12 July 1944.
480. *Ibid.*, p. 76.
481. Szold March 1944 hospital stay; R. Zeitlin, *Record of Life*, p. 216-221.

482. *HS&YA*. P. 76.
483. *There is Hope*, p. 79.
484. *HS & YA*, p. 77.
485. *Record of Life*, p. 221.
486. *HS & YA*, p. 77.
487. N. Bentwich, *My Seventy-Seven Years*, p. 202.
488. *To Repair*, p. 7; HS to Judah Magnes, 8 Dec. 1944, Judah Magnes Archive, National Library of Israel, Jerusalem.
489. *Record of Life*, p. 218.
490. *Ibid.*, p. 219.
491. *Ibid.*, p. 221.
492. Judah Magnes, "*Last Days*," diary sent to Hadassah describing Miss Szold's last days.
493. *Ibid. Last Days.*
494. Akiva Lewinsky, preface in *Henrietta Szold and Youth Aliyah*, p. x.
495. *It Takes a Dream*, p. 198.
496. *Woman of Valor*, p. 426.
497. *HS & YA*. 78.
498. Judah Magnes, *Last Days*.
499. *HS & YA*, p. 77.
500. *Woman of Valor*, p. 431.
501. *Henrietta Szold: Saga*, p. 130.
502. Arieh Lifshutz, *Henrietta Szold: The Educator of Youth Aliyah* (Jerusalem, 1955) p. 27.
503. *Henrietta Szold: Saga*, P. 130.
504. *Record of Life*, p. 230.

Epilogue

505. *Henrietta Szold: Saga*, p. 131.
506. *HS & YA*. p. 78.
507. R. Freier, *Let the Children Come*, p. 73-74.
508. *Jewish Telegraphic Agency*, 18 August 1975.

Select Bibliography/Resources

ARCHIVES:

American Jewish Historical Society, AJHS.
Baltimore Hebrew College
Hadassah organization, archive
Jewish Women's Archive
Radcliffe College. Szold, Henrietta, 1860-1945. Papers, 1889-1960. Radcliffe College.
Spielberg Jewish Film Archive
United States Holocaust Museum website
Women's Zionist Organization of Women
Yad Vashem website, archives
Zionist Archives
Eva Michaelis-Stern, United States Holocaust Museum

PERIODICALS

'Hadassah Preludes', *Hadassah Magazine*, June/July 1990.
Decter, Midge. 'The Legacy of Henrietta Szold', *Commentary Magazine*, December 1, 1960.
'Jewish Women on the Road', *Jewish Women's Archive*.
Maryland Historical Magazine, "Henrietta Szold and the Russian Immigrant School", March 1962.

BOOKS:

Amkraut, Dr. Brian, *Between Home and Homeland: Youth Aliyah from Nazi Germany*. Judaic Studies Series (Tuscaloosa, AL: University Alabama Press, 2006).
Antler, Joyce, *The Journey Home: Jewish Women and the American Century* (New York: Free Press, 1997).
Badt-Strauss, Bertha, *White Fire: The Life and Works of Jessie Sampter* (New York: The Reconstructionist Press) 1956.
Baldwin, Neil, *Henry Ford and the Jews: The Mass Production of Hate* (New York: Public Affairs Books, 2001).
Ben-Gurion, David, *Memoirs* (New York: The World Publishing Company, 1970).
Bentwich, Norman, *Solomon Schechter: A Biography* (Philadelphia: The Jewish Publication Society, 1938).
Bentwich, Norman, *Jewish Youth Comes Home: The Story of the Youth Aliyah, 1933-1943.* (London: Victor Gollancz Ltd, 1944).

Bentwich, Norman, *For Zion's Sake: A biography of Judah L. Magnes* (Jerusalem: The Jewish Publication Society, 1954).

Bentwich, Norman, *My Seventy-Seven Years* (Philadelphia: Jewish Publication Society of America, 1961).

Bernstein, Deborah S., *Pioneers and Homemakers: Jewish Women in Pre-State Israel* (Albany, NY: State University of New York, 1992).

Bethell, Nicholas, *The Palestine Triangle: The Struggle for the Holy Land, 1935-1948* (New York: Putnam, 1979).

Board, Barbara, *Newsgirl in Palestine* (London: Michael Joseph LTD, 1937).

Board, Barbara, *Reporting from Palestine, 1943-1945* (Great Britain: Nottingham, 2008).

Breitman, Richard, *FDR and the Jews* (Cambridge, Ma: Belknap Press (of Harvard University), 2013).

Brighton, Terry, *Patton, Montgomery, Rommel: Masters of War* (New York: Crown Publishers, 2008).

Brinner, William M., Rischin, Moses, *Like All the Nations? The Life and Legacy of Judah L. Magnes* (Albany: State University of New York, 1987).

Cahill, Thomas, *The Gift of the Jews: How a Tribe of Desert Nomads Changed the Way Everyone Thinks and Feels* (New York: Nan A. Talese, 1998.)

Cesarani, David, *Becoming Eichmann: Rethinking the Life, Crimes, and Trial of a "Desk Murder"* (Cambridge, MA.: Da Capo Press, 2007).

Clifford, James L, *Biography as an Art* (New York: Oxford, 1962.)

Dash, Joan, *Summoned to Jerusalem: The Life of Henrietta Szold* (New York: Harper and Row Publishers, 1979).

De Sola Pool, Tamar, *Henrietta Szold: 1860-1945*. Reprinted from Great Jewish Personalities in Modern Times (New York: Colonial Press, 1960).

Dwork, Deborah, Van Pelt, Robert Van, *Flight from the Reich: Refugee Jews, 1933-1946* (New York: W.W. Norton & Co., 2009).

Dwork, Deborah, *Children with a Star: Jewish Youth in Nazi Europe* (New Haven: Yale University Press, 1991).

Eisenberg, Azriel, *The Lost Generation: Children of the Holocaust* (New York: The Pilgrim Press, 1982).

Elon, Amos, *Herzl* (New York: Holt, Rinehart, and Winston, 1975).

Emmerson, Charles, *1913: In Search of the World Before the Great War* (New York: Public Affairs, 2013).

Evans, Richard J., *The Third Reich at War* (New York: The Penguin Press, 2009)

Fineman, Irving, *Woman of Valor: The Life of Henrietta Szold 1860-1945* (New York: Simon and Schuster, 1961).

Fraser, David, *Knight's Cross: A Life of Field Marshal Erwin Rommel* (New York: Harper Perennial, 1994).

Freier, Recha, *Let the Children Come: The Origins of Youth Aliyah* (London: Weidenfeld and Nicolson, 1961).

Friedlander, Saul, *Nazi Germany and the Jews: The Years of Persecution, 1933-1939* (Volume One. New York: Harper Collins, 1997).

Friedlander, Saul, *The Years of Extermination: Nazi Germany and the Jews, 1939-1945* (New York: Harper Collins, 2007).

Fromm, Bella, *Blood & Banquets: A Berlin Social Diary* (New York: Birch Lane Press Book, 1990).

Gidal, Nachum T., *Henrietta Szold: The Saga of an American Woman*. New York (Jerusalem: Gefen Publishing House, 1996).

Gilbert, Martin, *The Holocaust: A History of the Jews of Europe during the Second World War* (New York: Holt, Rinehart and Winston, 1985).

Gilbert, Martin, *Churchill: A Life* (New York: Henry Holt & Company, 1991).

Gilbert, Martin, *Churchill and the Jews: A Lifelong Friendship* (New York: Henry Holt & Company, 2007).

Ginzberg, Eli, *Louis Ginzberg: Keeper of the Law* (Philadelphia: The Jewish Publication Society, 1966).

Gordis, Daniel, *Israel: A Concise History of a Nation Reborn* (New York: HarperCollins, 2016).

Goren, Arthur A., *Dissenter in Zion: From the Writings of Judah L. Magnes* (Cambridge, MA: Harvard University Press, 1982).

Greenberg, Marian G., *There is Hope for Your Children: Youth Aliyah, Henrietta Szold and Hadassah* (New York: Hadassah, The Women's Zionist Organization of America, 1986).

Hacohen, Dvora, *To Repair a Broken World: The Life of Henrietta Szold, founder of Hadassah* (Cambridge, MA; Harvard University Press, 2021).

Halprin, Ben, *A Clash of Heroes: Brandeis, Weizmann, and American Zionism* (New York: Oxford University Press, 1987).

Hastings, Max, *Armageddon: The Battle for Germany, 1944-1945* (New York: Alfred A. Knopf, 2004).

Heilbrun, Carolyn G., *Writing a Woman's Life* (New York: W.W. Norton & Company, 1988).

Hoffman, Adina, *Till We Have Built Jerusalem: Architects of a New City* (New York: Farrar, Straus and Giroux; reprint edition, 2017).

Hoffman, Bruce, *Anonymous Soldiers: The Struggle for Israel, 1917-1947* (New York: Knopf, 2015).

Johnson, Eric A., *What We Knew: Terror, Mass Murder, and Everyday Life in Nazi Germany* (New York: Basic Books, 2006).

Johnson, Paul, *A History of the Jews* (New York: Harper & Row, 1987).

Kahn, (Bar-Adon), Dorothy, *Spring Up, O Well* (New York: Henry Holt & Co., 1936).

Kahn (Bar-Adon), Dorothy, *Writing Palestine: 1933-1950* (Brighton, MA.: Academic Studies Press, 2017).

Kaplan, Marion A. *Between Dignity and Despair: Jewish Life in Nazi Germany* (New York: Oxford University Press, 1998).

Klagsbrun, Francine, *Lioness: Gold Meir and the Nation of Israel* (New York: Schocken, 2017).

Kark, Ruth (editor); Shilo, Margalit (editor); Hasan-Rokem, Galit (editor); Reinharz, Shulamit (contributor), *Jewish Woman in Pre-State Israel: Life History, Politics, and Culture* (Waltham, MA.: Brandeis Publishing, 2008).

Kessler, Barry, editor and curator, *Daughter of Zion: Henrietta Szold and American Jewish Womanhood*. (Baltimore: Jewish Historical Society of Maryland, 1995).

Klemperer, Victor, *I Will Bear Witness: A Diary of the Nazi Years, 1933-1941* (New York: Random House, 1998).

Krantz, Hazel, *Daughter of My People: Henrietta Szold and Hadassah* (New York: Lodestar Book, 1987).

Kurth, Peter, *American Cassandra: The Life of Dorothy Thompson* (Boston: Little, Brown, & Company, 1990).

Kurtzman, Dan, *Ben-Gurion: Prophet of Fire* (New York: Simon & Schuster, 1983).

Kustanowitz, Shulamit, E., *Henrietta Szold: Israel's Helping Hand* (New York: Viking Press, 1990).

Larson, Erik, *In the Garden of the Beasts: Love, Terror, and an American Family in Hitler's Berlin* (New York: Crown Publishers, 2011).

Levin, Alexandra Lee, *Henrietta Szold and Youth Aliyah* (New York: Herzl Press,1986).

Levin, Alexandra Lee, *The Szolds of Lombard Street* (Philadelphia: The Jewish Publication Society, 1960).

Levin, Marlin, *Balm in Gilead: The Story of Hadassah* (New York: Schocken Books, 1961).

Levin, Marlin, *It Takes A Dream: The Story of Hadassah* (New York (Jerusalem): Gefen Publishing House, 2002).

Levinger, Elma Ehrlich, *Fighting Angel: The Story of Henrietta Szold* (New York: Behrman House, 1946).

Lipstadt, Deborah, *Beyond Belief: The American Press & the Coming of the Holocaust 1933-1945* (New York: Free Press, 1985).

Litvinoff, Barnet (Compiled and edit by), *The Essential Chaim Weizmann* (New York: Holmes and Meier Publishers, 1982).

Lowenthal, Marvin, *Henrietta Szold: Life and Letters* (New York: The Viking Press, 1942).

Lubrich, Oliver (ed.): Northcott Kenneth J. (translator); Wichmann, Sonia (translator); Krouk, Dean (translator), *Travels in the Reich, 1933-1945: Foreign Authors Report from Germany* (Chicago: University of Chicago Press, 2010).

Makovsky, Michael, *Churchill's Promised Land: Zionism and Statecraft* (New Haven: Yale University Press, 2007).

Mallmann, Klaus-Michael; Cuppers, Martin; Smith, Krista (translator), *Nazi Palestine: The Plans for the Extermination of the Jews of Palestine* (New York: Enigma Books, 2010).

Meir, Golda, *My Life* (New York: G.P. Putnam's Sons, 1975).

Metaxas, Eric, *Bonhoeffer: Pastor, Martyr, Prophet, Spy* (Nashville, TN: Thomas Nelson, 2011).

Nagorski, Andrew, *Hitlerland: American Eyewitnesses to the Nazi Rise of Power* (New York: Simon & Schuster, 2013).

Payne, Robert, *The Life and Death of Adolf Hitler* (New York: Praeger Publishers, 1973).

Perkul, Debbi, *Winds Over Jerusalem: The Story of Rae Lindy, Pioneer Nurse of Hadassah* (London: Vallentine Mitchell, 2017).

Pincus, Chasya, *Come from the Four Winds: The Story of Youth Aliya* (New York: Herzl Press, 1970).

Raider, Mark A., Reinharz, Shulamit (editors), *American Jewish Women and the Zionist Enterprise* (Waltham, MA: Brandeis, 2004).

Read, Anthony; Fischer, David, *The Fall of Berlin* (New York: W.W. Norton & Company, 1992).

Reifler, David M., *Days of Ticho: Empire, Mandate, Medicine and Art in the Holy Land.* (Jerusalem: Gefen Publishing House, 2015).

Rose, Norman, *Chaim Weizmann* (New York: Viking, 1986).

Rubinstein, William D., *The Myth of Rescue* (New York: Rutledge, 1997).

Ruppin, Arthur, *Memoirs, Diaries, Letters* (London: Weidenfield and Nicolson, 1971).

Segev, Tom, *The Seventh Million: The Israelis and the Holocaust* (New York: Henry Holt and Company, 1991).

Segev, Tom, *One Palestine, Complete* (London: Picador, 2001).

Sereny, Gitta, *Into That Darkness: An Examination of Conscience* (New York: Vintage Books, 1983).

Shapira, Anita, *Ben-Gurion: Father of Modern Israel* (New Haven: Yale University Press, 1971).

Shargel, Baila Round, *Lost Love: The Untold Story of Henrietta Szold* (Philadelphia: The Jewish Publication Society, 1997).

Shvarts, Shifra, Shehory-Rubin. *Hadassah: For the Health of the People* (Tel Aviv: Dekel Academic Press, 2012).

Shepherd, Naomi, *Ploughing Sand: British Rule in Palestine 1917-1948* (New Brunswick: Rutgers University Press, 2000).

Sherman, A.J., *Mandate Days: British Lives in Palestine 1918-1948* (Baltimore, MD, 2001).

Shirer, William L., *20th Century Journey: A Memoir of a Life and the Times* (New York: Little, Brown & Company, 1984).

Shirer, William L., *Berlin Diary: The Journal of a Foreign Correspondent 1934-1941* (New York: Alfred A. Knopf, 1941).

Shirer, William L., *The Nightmare Years, 1930-1940* (Boston: Little, Brown, and Company, 1984).

Shirer, William L., *The Rise and Fall of the Third Reich: A History of Nazi Germany* (New York: Simon and Schuster, 1960).

Simmons, Erica B, *Hadassah and the Zionist Project* (New York: Rowman & Littlefield, 2006).

Stafford, David, *Endgame, 1945* (New York: Little, Brown and Company, 2007).

Steckoll, Solomon, *The Gates of Jerusalem* (London: George Allen & Unwin Ltd., 1968).

Teveth, Shabtai, *Ben-Gurion: The Burning Ground 1886-1948* (Boston: Houghton Mifflin Publishing, 1987).

Teveth, Shabtai, *Ben-Gurion and the Holocaust* (New York: Harcourt Brace & Company, 1996).

Toland, John, *Adolf Hitler, Volumes 1 & 2* (New York: Doubleday & Co., 1976).

Trevor-Roper (editor), *Final Entries 1945: The Diaries of Joseph Goebbels* (New York: G.P. Putnam's Sons, 1978).

Tsur, Jacob, *Sunrise in Zion: Childhood and youth in Europe and Palestine Between the Wars* (Crow's Nest, Australia: Allen & Unwin, 1968).

Tuchman, Barbara W., *Bible and Sword: England and Palestine from the Bronze Age to Balfour.* (New York: New York University Press, 1956).

Tuchman, Barbara W., *Practicing History: Selected Essays* (New York: Alfred A. Knopf, 1981).

Urofsky, Melvin, *American Zionism from Herzl to the Holocaust* (New York: Doubleday, 1975).

Vester, Bertha Spafford, *Our Jerusalem: An American Family in the Holy City, 1881-1949* (Garden City, NY: Doubleday & Company, Inc., 1950).

Voss, Carl Hermann, *Stephen S. Wise: Servant of the People* (Philadelphia: The Jewish Publication Society of America, 1969).

Wasserstein, Bernard, *On the Eve: The Jews of Europe before the Second World War* (New York: Simon & Schuster, 2012).

Waugh, Evelyn, *The Holy Places* (London: Queen Anne Press, 1953).

Wise, Stephen S., *Challenging Years: The Autobiography of Stephen Wise* (New York: Putnam's Sons, 1949).

Wyman, David S., *The Abandonment of the Jews; America and the Holocaust, 1941-1945* (New York: Pantheon Books, 1984).

Yahil, Leni, *The Holocaust: The Fate of European Jewry* (New York: Oxford University Press, 1987).

Zeitlin, Rose, *Henrietta Szold: Record of Life* (New York: The Dial Press, 1952).

Index

Note: Page numbers in italics are figures.